WOMEN & ART

WOMEN & ART

A History of Women Painters and Sculptors
from the Renaissance to the 20th Century

by ELSA HONIG FINE

ALLANHELD & SCHRAM

ABNER SCHRAM LTD.
Montclair, New Jersey

Published in the United States of America in 1978
by Allanheld, Osmun & Co., 19 Brunswick Road, Montclair, N.J. 07042
and by Abner Schram Ltd., 36 Park Street, Montclair, N.J. 07042
Distribution: Abner Schram Ltd.

Library of Congress Cataloging in Publication Data

Fine, Elsa Honig.
 Women and art—the 15th to the 20th century.

 Bibliography
 Includes index.
 1. Women artists—Biography. 2. Art, Renaissance.
3. Art, Modern. I. Title.
N43.F56 709'.2'2 [B] 77-15897
ISBN 0-8390-0187-8
ISBN 0-8390-0212-2 pbk.

Sixth printing, 1988

Printed in the United States of America

*To my mother
and my daughters*

Preface

Seventy-two years ago, in *Women Painters of the World* (London: Hodder & Stafford, 1905), W. S. Sparrow sought to prove that although male and female "genius" differs, "there is room in the garden of art for flowers of every kind," and that only those who do not think would dare to ask "Where is there a woman artist equal to any man among the greatest masters?" Linda Nochlin poses a similar question in her essay "Why have there been no great women artists?" in the January 1971 issue of *Art News*, devoted to women. This study will attempt to answer her question by reviewing the accomplishments of outstanding female artists past and present, and by searching out the reasons for their successes as well as the overwhelming obstacles that precluded most from achieving greatness.

Dabbling in the arts has long been accepted as a useful activity to occupy a woman's time before she marries or if she remains single (Mary Cassatt's mother was delighted that her daughter had such a fine hobby), and more recently, to fill the idle hours while her children are at school. Drawing and painting, needlework and pottery are still considered desirable feminine "accomplishments." While their husbands are engaged in the world of finance, women of leisure work as docents in art museums; those who have professional training are usually underpaid and outranked. Women's colleges have always had excellent art history programs to prepare their graduates to be connoisseurs and volunteers, but only recently to be professionals. Today, many women are gallery owners—an extension of their other traditional role of patron—but even they are sometimes reluctant to handle "too much" women's work. Women's art does not sell well, states the myth; therefore, their work is a bad investment. Fearful that their criticism would not be taken seriously, many women art critics have hesitated to be supportive of or to identify with the struggle of women artists. (In a complete about-face, the critic Lucy Lippard will now write only of women artists.) A large percentage of Ph.D. art historians on college faculties are now women, but they are discriminated against and usually hold a lower rank and earn less pay than their male peers.

Typically, women have never been encouraged to become professionals in their field; commitment to any work was equated with loss of femininity. Male art professors rarely encouraged their female students to enter graduate school, and women felt hesitant and apologetic when presenting their work. These attitudes are a continuation of the Renaissance idea of the artist as "genius," a quality a woman could not possibly possess "by her very nature." Women were not allowed to study at the prestigious academies, such as the École des Beaux-Arts; they were not allowed to draw from the nude model until late in the 19th century when two American women audaciously walked into a Parisian life class, thereby breaking a centuries-old taboo. Without access to the live model, how could they possibly have mastered the drawing of anatomy necessary to create the history paintings considered the only form of "high" art by the Salon juries? Women were allowed to study the "nude" animal and several became first-rate animal painters and sculptors.

In the lives of many women artists there was a strong male artist figure: father, brother, husband, lover, or mentor. However, in most of the husband-wife teams, the husband was assumed to be the more serious artist. Those women who pursued careers often suffered from role conflict; psychologists have documented the problems of the creative woman. Art critics and art historians have had difficulty treating the female artist objectively. Many look for feminine qualities in their work, no matter what the mode of expression. John Canaday, in several books, patronizes both Rosalba Carriera and Berthe Morisot, while James T. Flexner, in his series on American art, writes of the gentle condition of ladies and how it affects their work.

The women artists of the past who achieved recognition did so by conforming to prevailing academic standards; indeed, to gain acceptance by the academicians was in itself frequently a debilitating struggle. None joined radical movements until the last quarter of the 19th century when Bertha Morisot and Mary Cassatt became part of the Impressionist challenge to the Salon system. Women have been part of radical movements since but—with the exception of the pre-Revolutionary Russian avant-garde (and until the current feminist movement)—usually as appendages to male innovators and not as innovators themselves. Despite the strictures placed on women in society and the conflicts they face in breaking away from traditional roles, many have persevered and produced outstanding art. Role conflict continues and

most likely always will, but women are beginning to stand more steadily apart from traditional roles and are perhaps ready to assume leadership in the arts as well as in other areas.

In an attempt to illuminate the society in which the woman artist lives and works, each chapter will begin with an exploration of the role and status of women in the particular period under investigation. The lives and works of women artists of note will be analyzed and, when available, their most significant works illustrated. The survey is as much concerned with how the woman artist coped with her various responsibilities as it is with the art she produced. The overwhelming number of outstanding women artists active in the 20th century has made the selection for the last two chapters extremely difficult. Since it was decided to include only artists who have matured in their search and have achieved wide recognition, no artist born after 1930 is represented (the sole exception is Bridget Riley, born in 1931). The artists finally selected for this period fall into two categories: those women working mostly in the early years of the 20th century whose achievements were significant but are now largely forgotten, and those whose significance is so great that no history of modern art would be complete without them.

Every effort was made to secure quality reproductions to illustrate the paintings and sculpture and to obtain complete descriptive information for each work. Because of the inadequate scholarship surrounding women's art, this was not always possible. Nor was it possible to see every work chosen to represent the artists. Some exist only in reproduction, others are in obscure, private collections not available to the public and could be seen only in the photographic files of museum libraries. For the same reason, complete information on certain works could not be obtained. In captions accompanying reproductions, all works are in oil unless otherwise noted, and height precedes width in the dimensions.

This investigation has been a long, fascinating, and often lonely experience, but there are several people who aided me along the way, and I would like to thank them: the women in the inter-library loan service at the University of Tennessee, who found books I was not sure really existed; Lynne Brown Walker, who searched the libraries of London; Karen Hirschfeld Ralston, who graciously translated necessary books and articles from the French; Margaret Guttmann Barlow, who not only gave me moral support, but tirelessly edited every word I wrote before the manuscript was sent to the publisher; and my husband, Harold J. Fine, Ph.D., without whose continued support this book could not have been written.

Contents

CHAPTER THREE The French Academic Tradition 39

CHAPTER FOUR The English School: Portraiture 62

CHAPTER FIVE The American Experience 89

CHAPTER SIX The Impressionist Period 122

WOMEN & ART

The Italians: From Renaissance to Rococo

We have all heard of the Renaissance man. But what of the Renaissance woman? Proud, aristocratic, and confident, she was praised in the art, literature, and history of the period. A product of the Humanist philosophy that began emerging in the early 15th century, she developed as a result of the general Renaissance interest in the individual and of the Humanists' specific regard for women as individuals. She represented, moreover, a startlingly new view of femininity as compared with that prevailing since medieval times.

TRADITIONAL REARING OF WOMEN

During the Middle Ages young girls were betrothed shortly after birth. Arrangements were made for dynastic or economic reasons, and at thirteen or fourteen, her education completed, a girl faced her husband-to-be for the first time and was wed. In every guide or treatise written for women during the Middle Ages and Renaissance the need for chastity was emphasized: the books a woman was instructed to read did not include romances that might stimulate her desires; she could read elementary books on morality and religion and become acquainted with a few of the great philosophical issues of the period and with a bit of physics, agriculture, and medicine. Needlework, music, and dancing were also taught and formed part of the activities of all classes. With the Humanist stirrings of the Renaissance and its emphasis on individualism, this traditional form of

education was challenged as new ideas for enlightening the minds of young girls began to take hold.

THE HUMANIST INFLUENCE

The Humanist scholar emerged as a reaction to the turmoil of the late 14th and 15th centuries—the period of the Hundred Years' War, the Black Death, the eviction of the papacy from Rome and the subsequent loss of faith in the Church and its narrow disputations. Finding inspiration in Greek and Roman ideals, the Humanists tried to incorporate these ideals into their concept of early Christianity, the purity of which they believed was lost during the "darkness" of the Middle Ages. The ideals of the Renaissance—the rebirth of all that was glorious in ancient Greece and Rome—spread from the philosophers and poets of Italy to its artists and architects and eventually, by the 16th century, throughout Europe.[1]

The first rumblings of the need for universal education were soon heard: by the 16th century there was a near consensus as to the virtue of educating not only women from the nobility, but middle-class women as well. There was hardly a town in all of Europe that was not affected by the changes in education effected by the Humanists. Girls' schools were established, with the wife of the schoolmaster often serving as an instructor of elementary reading and writing. In their desire to educate women to be more interesting companions to men, the Humanists

were defying the old idea that the best mate was a silent, solicitous one. Women were expected to be virtuous, and the Humanists maintained that education could be a conduit to virtue.[2]

One of the first treatises on the education of women was written in 1405 by the Florentine scholar, Leonardo Bruni. The course of study was strictly circumscribed, not because of a presumed lack of ability on the part of the female student, but to protect her innocence and guide her in her prescribed role. Precluding rhetoric, mathematics, and the sciences in "their more subtle and obscure reaches" as not necessary for women, Bruni encouraged the study of religion, moral philosophy, and the classics.[3]

Queen Isabella of Spain engaged the Humanist scholar Juan Luis Vives (1492-1540) to prepare a textbook and to tutor her four daughters. His program was also adopted by the English nobility. In Spain, according to R. de Maulde la Claviere, a scholar of the Renaissance, "little girls sucked in Latin with their mother's milk . . . They were given a tutor at an age when they ought to have been learning nothing but how to walk; at seven they were expected to be able to maintain a conversation, and at thirteen to have finished their studies and be ripe for matrimony."[4]

Another of Vives' books, *Instruction of a Christian Woman* (1523), was translated into English several years later by a tutor in the household of Sir Thomas More[5] and subsequently into all the major European languages. Stressing the Humanist attitude that learning leads to virtue, Vives concluded:

the study of learning is such a thing that it occupieth one's mind wholly, and lifteth it up into the knowledge of most goodly matters and plucketh it from the remembrance of such things as be foul.[6]

In his *Duties of Husbands* (1529) Vives concluded that men have the responsibility to instruct women (he objected to women instructing young girls in the newly emerging schools). The father ought to instruct his children and the husband, as "the woman's head, mind, the father, the Christ," his wife. The well-educated woman was an asset, "fruitful and profitable unto her husband, for so shall his house be wisely governed, his children virtuously instructed, the affections less ensued and followed, so that they shall live in tranquility and virtue."[7] Although Vives was considered a liberal thinker, his course of study for women was meager compared to what he prescribed for men. He ruled out grammar, logic, history, the literature of romance and war, and the Greek and Latin poets. Acceptable reading materials

for virtuous women were the holy books, the Old and New Testaments, the Christian poets, and books on moral philosophy "that teach them to subdue passions and quiet the tempest of their minds."[8] Nothing was allowed that would encourage women to compete with men.

From the courts of the North Italian Renaissance princes, where the Humanist philosophy first took hold, there emerged a new type of woman with a less submissive and less confined role. Taught by the Humanist scholars, she began to write—not only letters, but poetry. She became the center of philosophical and literary salons and a patron of the arts. One of the most learned women of her time, Christine de Pisan (c. 1363–c. 1431), the daughter of an Italian astrologer and physician who took pleasure in her intellectual development (her mother insisted she be immersed only in traditionally feminine preoccupations), was an early advocate of increased opportunities for women. In her book *Cité des Dames* she explained:

If it were customary to send little girls to school and to teach them the same subjects as are taught to boys, they would learn just as fully and would understand the subtleties of all arts and sciences. . . . If they understand less it is because they do not go out and see so many different places and things but stay home and mind their work. For there is nothing which teaches a reasonable creature so much as the experience of many different things.[9]

The Humanists demanded that upper-class women be versed in Latin in order to read Church literature, and in Greek so as to know the classics. They also studied astrology, geometry, and arithmetic. According to Jacob Burckhardt (one of the first historians to consider women worthy of inclusion in a history text), as women began to be educated in the same way as men, they began to develop "distinct, recognizable personalities." A few gained reputations as poets and writers and were it not for the names attached to their works, Burckhardt would "not hesitate to attribute them to male authors." As with the painters, many learned their craft from indulgent fathers who encouraged their daughters' intellectual development. Burckhardt continued:

There was no question of "woman's rights" or "emancipation," simply because the thing itself was a matter of course. The educated woman of that time strove, exactly like a man, after a characteristic and complete individuality. The same intellectual and emotional development that perfected the man was demanded for the perfection of the woman. . . .[10]

With increased education women no longer viewed themselves as burdens that their fathers must get rid

of; nor did they conceive of themselves as the absolute property of their husbands. In the upper classes the age of marriage began to be delayed until sixteen or seventeen, and a voice in the choice of a spouse was often demanded by women.[11]

THE ORDINARY WOMAN

The women of the court served as models for the newly wealthy wives of merchants and bankers. They were not as well educated and their life was more circumscribed by household duties, yet, as viewed by the artists of the period, they were self-assured and proud women often depicted keeping the accounts and assisting at all levels of their husbands' business affairs.

Little documentation exists describing the life of the peasantry and the lower classes. Unable to read or write, they left no letters or journals revealing their daily chores, their pleasures or pains. Lower-class women worked alongside their men (few were employed as domestic servants before the 15th century). They were water carriers, hawkers, tavern and brothel keepers, barbers, dressmakers, shoemakers, and weavers. Many joined guilds of their own, and during the Middle Ages some were grudgingly admitted to all-male guilds. Due to an economic crisis in the late 15th century, women were gradually excluded from the guilds, and weaving—a craft formerly dominated by women—became, outside the home, an exclusively male occupation. The artisan's wife continued to sell her husband's goods at fairs, however.[12]

THE RENAISSANCE IDEAL OF BEAUTY

The Platonic concept of beauty, as interpreted by the Humanists, became the Renaissance ideal. In the Neo-Platonic sense, the mind and the body were closely related. A beautiful body was said to contain a beautiful soul, while ugliness was considered a reflection of evil.

Renaissance women strove to recreate the ideal beauty portrayed by the painters and poets of the period. The ideal female in Early Renaissance paintings was a slim young beauty on the brink of maturity (the Venuses of the High Renaissance show a more robust figure). Even paintings of the Virgin and Child reflected this changing ideal. The most influential book of the time was *Il Cortegiano* (1528), written by the North Italian courtier Baldassare Castiglione (1478–1529). Translated into many lan-

guages, the book described the ideal court lady. In addition to being a naturally graceful, mannerly, clever, and prudent wife, mother, and homemaker— while not being arrogant, slanderous, vain, contentious, or inept—she had to be beautiful, for "truly that woman lacks much who lacks beauty."[13]

A monk and lawyer, Agnolo Firezulo (1493–1548), in writing of the ideal woman, reflected the taste of the period:

. . . the hair must be long, thick and fair, of a soft yellow turning brown, the skin light and clear, but not pale; the eyes dark brown, large and somewhat vaulted, their sclera shimmering blue. The nose ought not be curved, as aquiline noses do not suit women; the mouth should be small, the lips round, the chin round with a dimple, the neck rounded and fairly long, the Adams's apple not protruding[14]

The attainment of beauty occupied many hours: women used potions to whiten their skin and bleaches to aid the sun in lightening their hair.[15] In order to appear more intellectual they broadened their brows artificially by shaving the hair in front and piling it elaborately in back. The elaborate fashions of the Italian court were imitated by other European courts, and at various times decrees were issued limiting expenditures on clothing according to rank. How many Renaissance portraits have survived that fulfill this ideal? If these women all look alike to contemporary eyes, it is because the sitter wanted to be remembered as embodying this ideal.

The Renaissance emphasis on the individual as opposed to the medieval emphasis on the community brought about an upsurge in portrait painting which provides a pictorial record of many of the notable individuals of the 15th and 16th centuries. Interestingly enough, the female portrait existed in a more generalized medieval style long after the male was painted with all his individual characteristics.

INFLUENTIAL RENAISSANCE WOMEN

The period was dominated by a group of queens and princesses "who represent the female counterpart of the man of the Renaissance, equally outstanding through energy, intelligence and unscrupulous character."[16] In Italy there were Beatrice d'Este (1475–1497) and her sister Isabella (1474–1539); Vittoria Colonna (1490–1547); and Caterina Sforza—the latter was known for her book on beauty but also as a "tigress" on the battlefield. In Spain the court of Queen Isabella (1451–1504) sponsored Columbus' search for a new sea passage to India, while England's

Elizabeth I (1533-1603) gave her name to a period that saw the extension of British mercantile and naval power and a flowering of cultural activity. In France there was Anne de Beaujeu (1460-1522), regent for her brother—the future King Charles VIII; Queen Anne of Brittany (1477-1514); and Marguerite d'Angoulême (1492-1549), a poet and writer and sister to Francis I, who was considered her intellectual inferior. Marguerite (also known as Margaret of Navarre) sheltered many persecuted Reformers and held court for Humanist scholars. And one must not forget Caterina de' Medici (1519-1589) of the famous Florentine family, who through marriage became queen mother and regent of France and a dominant influence on the French politics of her time. Involved with political intrigue and diplomacy as well as with the social and cultural lives of the courts, these women were the object of adulation. (Those from the Protestant countries will be reviewed in Chapter II.) Whether as patrons, poets, or political activists, they took themselves seriously and profoundly influenced the arts, literature, and social life of the period.[17]

Isabella d'Este, wed to the Duke of Mantua, continued her education after her marriage. She developed an extensive library, kept up with her interest in philosophy, history, and poetry, and corresponded with and entertained the leading artists and scholars in Italy. An avid art collector, she shared her contemporaries' interest in the antique. At times labeled a female Machiavelli, Isabella was unscrupulous in her methods of acquiring both Italian contemporary art and 15th-century Flemish works, which were then fashionable among Italian art lovers. Often dictating the subject matter to artists she patronized, she also detailed the size of a painting, the number of figures, and how they were to be placed and draped (see Lorenzo Costa, *Court of the Muses*). An astute politician and businesswoman, she ruled Mantua in her husband's absence and developed manufacturing industries which employed most of the townspeople.[18]

Vittoria Colonna was a daughter of one of the most illustrious Roman families. Betrothed at 3, married at 17 (she became the Marchioness de Pescara), and widowed at 35, she refused to remarry and devoted herself to literature, writing lyric poems based on Petrarch. Michelangelo fell in love with her when he was 51 and she 36. They maintained a platonic relationship until her death. She may have acted as Michelangelo's patron and was known to have had influence with other prominent figures. Castiglione, for example, before publishing *Il Cortegiano*, submitted his manuscript to her; she had few criticisms.[19]

THE ARTISTS

Painting was considered the lowest form of the arts, music nobler, and poetry the most transcendent. While the nobility were patrons of the arts, and women of the nobility were educated in and often dabbled in the arts, none became serious artists. Painting grew out of the artisan tradition, and until the Renaissance few of the nobility would consort with anyone who worked with his hands. The Humanists, however, viewed art as a noble pursuit. The Renaissance interest in man as a unique force led to the concept of the artist as creative genius and conferred unique status on the greatest painters. Thus Michelangelo could demand to be courted by the nobility, rather than being himself a courtier.

During the Middle Ages, painting as well as other crafts had been regulated by the guilds. These "jealous corporations" made it difficult for women painters to achieve recognition. With the decay of the guild hegemony over the arts during the High Renaissance, women began to establish themselves as professional artists. Most of the women surveyed in this chapter were the daughters of painters and learned their art in their fathers' studios, since no others would have been open to them. They competed for commissions and became court painters while remaining, for the most part, chaste, demure, and domesticated—virtues admired more than talent.

CATERINA DEI VIGRI (1413-1463)

Born into a noble family in Ferrara, St. Catherine of Bologna (Caterina dei Vigri) spent her early years in the court of the Marchese Niccolò II, where her father served as a lawyer. Described as a shy, fragile child, she was taught to read and write Latin, to paint and illuminate. play an instrument, and sing. However, she lacked the worldly spirit of the Renaissance court lady. Soon after her father's death in 1427 she entered the convent of the Poor Clares of Corpus Domini, a retreat for well-born ladies in Ferrara. She was chosen abbess when the Poor Clares were colonized in Bologna and remained so until her death. In 1707 her canonization was decreed. Her grave and her paintings at the convent in Bologna were objects of pilgrimages through the 19th century. Among her paintings, at least one—a canvas depicting the Infant Jesus—was said to produce miraculous cures.[20] Were it not for her subsequent sainthood, the identity of the "painting nun" of Ferrara and Bologna might never have been known, and she would have joined

the ranks of the countless anonymous religious women of the times who expressed their visions in paint.[21]

The details of the inner life of St. Catherine of Bologna are revealed in her book of religious instructions, *The Seven Weapons*, which she began to compose in secret when she was twenty-five. It describes the torments and fantasies of a 15th-century religious celibate. Her visions were a primary source for the imagery of her painted works. From her biographer and companion, Sister Illuminato Bembo, we learn of the outer circumstances of her life. Sister Illuminato dismisses her art in a single sentence: "She delighted in painting the Divine Word as a swaddled child, and for many places in the monastery at Ferrara and for the books she did for Him thus." The earliest "Life" of the saint, published in 1503, merely reports that "her hands were singularly skillful in the writing of fair books and in illumination in various colors."

Essentially a miniaturist, Caterina is best placed in a period earlier than her own: the curiosity and observation of the natural world evolving in Renaissance art are absent from her work. Her withdrawal from contemporary life is also revealed in the primitive character of her work. The *Madonna of the Apples* at the convent of the Poor Clares of Corpus Domini in Bologna is unsigned, but convent tradition attributes it to the first abbess. (In keeping with the anonymity of her cloistered life, few of her paintings were signed.) The flesh tints have been described as "clear, fresh, and beautiful . . . , the crimson tones of the Virgin's robes . . . wonderfully rich and harmonious." The miniature on vellum of a half-length Christ, also at the convent, has two small circular scenes representing the Annunciation in the corners of the painting's upper half. In one the Virgin is seated, in the other the Angel is kneeling. Contrary to the usual indoor or cloistered interpretation of such a theme, Caterina painted her Annunciation in a green meadow, perhaps reminiscent of one of her visions in which the Heavenly Court appeared as "a great meadow of such beauty as human speech cannot describe." The Christ, painted in "pale transparent tints with golden aureole and collar, against an opaque dull blue background faintly lined with gold" holds a book in which is written:

> In me omnis gratia
> in me omnis vie et veritatis
>
> In me omnis spes
> Vite et virtuitis.[22]

One of Caterina's best paintings is of *St. Ursula and her Maidens* (Fig. 1-1) in the Pinacoteca at Bologna. St. Ursula looms over the virgins, who, kneeling in prayer, are crowded together in Gothic fashion within the folds of the saint's sumptuously painted cloak.[23]

FIG. 1-1. Caterina dei Vigri, *Saint Ursula and Her Maidens.* The Pinacoteca, Bologna.

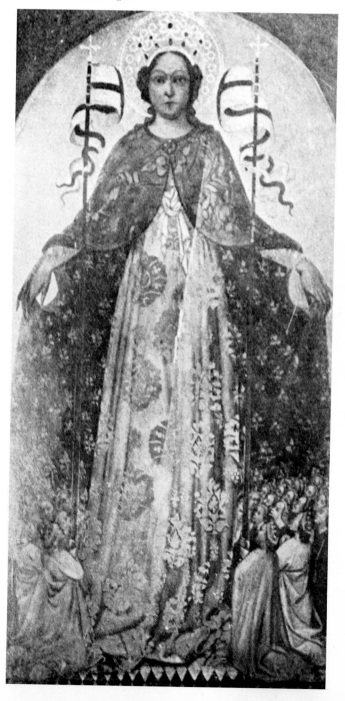

PROPERZIA DI ROSSI (c. 1490–1530)

Most of the information about Properzia di Rossi comes from Vasari, who was visiting Bologna at the time of her death. His *Lives of the Painters, Sculptors, and Architects* contains first-hand "laments and reminiscences" from the townspeople. Though there is much myth and disputation concerning her biography, Vasari is considered the authoritative source on the artist.

The daughter of a notary, Properzia di Rossi was born in Bologna. Her date of birth can only be approximated—her admirers claimed she was "cut off in the fullness of her beauty"—but the date of her death is well documented (she died on February 24, 1530, the day of Charles V's coronation). Little is known of her early life except that her drawing master was Marcantonio Raimondi, a talented friend of Raphael's who did engravings after the master's paintings.

Vasari described Properzia: "She was a talented maiden both in household duties and in other things, so skilled in sciences that all men might envy her. She was beautiful in person, and could sing and play better than any woman in the city."[24] She had a keen interest in carving—on apricot, peach, and cherry stones—and her delicate work on such small surfaces was described by Vasari as "miraculous." The Museo Civico in Bologna has on display a carving of eleven peach stones set in filigreed silver and suspended so that both sides can be viewed. On one side are the twelve apostles, each identified by name and a clause from the Apostle's creed; on the other are virgin saints, each labeled with a phrase referring to their special virtues (Fig. 1-2).

By the 1520s Properzia had given up such delicate "feminine accomplishments" to enter competitions as a professional. In 1534 she was commissioned to decorate the canopy of the high altar of the newly restored church of S. Maria del Baraccano. There she created, according to Ragg, "a beautiful specimen of the best period of Renaissance carving . . . [with] lovely intertwining of flambeaux and birds heads, of fruit and foliage and sphinxes."

During this same period the town fathers held a competition to complete the decoration of the west facade of the church of S. Petronio. Properzia was so encouraged with the reception of her work that she requested, through her husband, a share in decorating the facade of S. Petronio with marble carvings.

FIG. 1-2. Properzia di Rossi, *Minute Carvings on Eleven Peach Stones*. Museo Civico, Bologna.

After submitting a portrait of Count Guido Pepoli as her test work she was commissioned to execute several pieces.[25] It is not known which sections of the portals were done by Properzia, but the following records of payment exist:

1. June 1, 1525. To Madonna Properzia di Rossi, 11 lire for a Sibyl in marble executed by her.
2. September 8, 1525. To Madonna Properzia di Rossi, for an Angel executed by her, 10 lire and 19 soldi.
3. August 4, 1526. To Properzia, 40 lire and 3 soldi for remaining two Sibyls, an Angel, and two pictures.[26]

The angels are now in the Chapel of Tribolo's Assumption; the Sibyls have been lost. In all probability the "pictures" refer to two bas-reliefs, one depicting the visit of the Queen of Sheba to Solomon and the other Joseph and Potiphar's wife, now in the museum of S. Petronio (Fig. 1-3). The grace and balance of the figures, as well as their attire, suggest

Properzia's familiarity with the antique. In the first, the King sits on his throne surrounded by his guards and advisers. At his feet a kneeling figure offers him a garment, and aloof from it all stands the Queen and her maidens. The second panel shows Joseph fleeing from a seductress seated on a canopied couch. Her arm reaches out to stop him. According to Vasari, the Biblical scene was a metaphor for Properzia's private despair: she was in love with a young nobleman, Anton Galeazzo Malvasia, who rejected her because he "disdained to own as his wife one who bore a less ancient name."[27] A law suit brought against her for damages done to a neighbor's garden cited her as Malvasia's mistress.

Properzia was maligned and persecuted by a jealous painter, Amico Aspertini, who had "no grudge against [her] beyond the fact that she was an artist of rare talent." Her reputation thus ruined, she began experimenting with another medium, copper engraving, which, according to Ragg, "she did to great perfection." Elaborating on Properzia's plight, Ragg stated:

To suppose that [Amico Aspertini] disapproved of female competition and was indignant that a woman should have a share in the work going forward on the west front of S. Petronio is to endow the sixteenth century with one of the most curious and ugly features of recent times. For "the notion of rivalry between the sexes" is foreign to the Italian Renaissance. . . . All were at liberty to do their best.[28]

In her thirtieth year Properzia fell terminally ill and was cared for and then buried at the Spedale della Morte. Since the sick were usually nursed at home, her presence at this hospital suggests that she may have been either poverty-stricken or friendless.[29] Vasari claims that the burial was in accordance with her will.[30]

An important commission came too late. Clement VII, a member of the Medici family, was elected to the papacy. In true Medici fashion, he sought out the best artists of his time and sent emissaries to the famous woman sculptor whose work had impressed his advisers. Properzia was dead before they arrived. According to the early 19th-century Neo-Classical sculptor Antonio Canova, her untimely death was one of the greatest losses Italian art had suffered.[31]

SOFONISBA ANGUISSOLA (1532/35–1625)

Born into a noble Cremonese family, Sofonisba Anguissola was the eldest of six sisters, all of whom were painters. Sofonisba is one of the few artists

FIG. 1-3. Properzia de Rossi, *Joseph and the Wife of Pontiphar* (c. 1570). Marble bas-relief; 230⅛″ × 212½″. Courtesy of Alinari-Scala.

in the history of western art to come from the nobility. Her father Amilcare, who was not himself a painter, gave every encouragement to his daughters. They had as their first drawing master Bernadino Campi, a Mannerist painter of portraits and religious subjects, and after 1549 Bernadino Gatti, a follower of Correggio. Considered a child prodigy, Sofonisba gained a reputation throughout Italy. After her father wrote to Michelangelo in 1557, the master offered the young woman drawings which she reproduced in oil and returned to him for critiques. One of her most popular and widely reproduced drawings may be the same *Boy Pinched by a Crayfish* that she sent to Michelangelo, which he in turn sent to Cosimo de' Medici. Many artists made copies of this drawing, and it may have been the inspiration for Caravaggio's *Boy Bitten by a Lizard*. Beautifully drawn, it is a lively re-creation of a scene from everyday life, a rare occurrence in the Renaissance.

Vasari wrote that Sofonisba had "done more in design and more gracefully than any other lady of our day, for not only has she designed, coloured and drawn from life, and copied the works of others most excellently, but has produced rare and beautiful paintings of her own."[32] In 1566 he made a pilgrim-

age to the Anguissola home in Cremona, where he viewed for the first time the painting "most carefully finished, representing her three sisters playing at chess, in the company of an old lady of the house, making them appear alive and lacking speech only" (Fig. 1-4). One of the earliest "conversation pieces," it shows the players quarreling, not unusual in paintings of game playing during the period. The face of the older woman appears in many of her paintings. Vasari also noted a double portrait of her father and sister Minerva, "distinguished in painting and letters," and a portrait of her brother Asdrubale, "also a breathing likeness."[33] There are at least two extant self-portraits showing her playing the spinet (Fig. 1-5). Indeed, the number of self-portraits she painted was unusual for an Italian artist of that period. Straightforward, frank, and lively in the manner of Titian and the North Italian Renaissance, many of them were sent to her father, who used them to promote her work.[34]

In 1559 Sofonisba was summoned to the court of Philip II of Spain in Madrid. With a retinue of ten attendants, she arrived the following year and stayed for ten, first as lady-in-waiting to the Queen, then as personal painter to the King. She also assisted in the education of Infanta Isabella Clara Eugenia. Among the portraits completed in Spain are one of Philip II (National Portrait Gallery, London; attribution) and another of the Queen (Kunsthistorisches Museum, Vienna) which bears her signature. Many of her other portraits of the Spanish royal family were lost during a 17th-century palace fire. Her fame while in Spain was such that Pope Pius IV asked her to send him a portrait of the Queen. She complied, and he in turn responded with a letter, part of which reads: "We thank you and assure you that we shall treasure it among our choicest possessions, and commend your marvelous talent which is the least among your numerous qualities."[35]

Sofonisba's royal patrons wished her to marry a Spanish nobleman so she would remain in Spain. However, she was pledged to Don Fabrizio de Moncada, a feudal lord of Sicily, and in about 1570 went to the island with him. After four years of retirement in Palermo she was widowed. The Spanish royal family summoned her back to Madrid, but she refused, pleading nostalgia for Italy, and sailed home. The captain of the sailing vessel, a member of the noble Lomellino family, proved exceptionally charming and upon debarkation at Genoa, Sofonisba Anguissola was a widow no longer.[36]

Her home in Genoa became a center for artistic, social, and intellectual life. Royalty visited, bearing gifts, and she painted their portraits; distinguished artists from all over Europe paid her court. When Anthony Van Dyck was in Genoa in 1622 to paint portraits of several members of her husband's family, he visited the now blind artist many times, commenting that he had learned more from her talk than from his teachers. A likeness of her is preserved in his Italian sketchbook at Chatsworth House in England. The following notation accompanies the drawing:

Portrait of Signora Sofonisba, painter. Copied from life in Palermo on the 12th day of July of the year 1624, when she was 96 (?) years of age, still of good memory, clear senses and kind. . . . While I painted her portrait, she gave me advice as to the light, which should not be directed from too high as not to cause too strong a shadow on her wrinkles, and many more good speeches, as well as telling me parts of her life-story, in which one could see that she was a wonderful painter after nature. . . .[37]

There are at least fifty paintings in collections throughout the world that are attributed to Sofonisba Anguissola. Like most creative women who work within the confines of their home, she took her subject matter from her immediate environment—an older child comforting a younger one, her sisters playing chess, her father and a sister interacting. Although primarily known as a portrait painter, she showed great resourcefulness in using commonly available imagery and thus contributed to genre painting, which was to find its greatest expression in the 17th century (her series of chess players have been described as "genre paintings with metaphysical overtones"). She was the first woman artist to achieve international renown, and the first for whom a large body of work is still extant.

LAVINIA FONTANA (1552–1614)

Lavinia Fontana exemplifies the flowering of Bolognese womanhood in the 16th and 17th centuries. (The University of Bologna had as early as the 13th century opened its doors to women, who were, however, required to dress in men's clothing for their own protection. A few became lecturers and several were renowned for their scholarship.) Her father Prospero was a successful though mediocre painter in whose home gathered many of the foreign artists and architects then working on the city's newly commissioned public buildings, as well as Bologna's own men of letters. It was at such gatherings that she received much of her early education.[38] Lavinia's

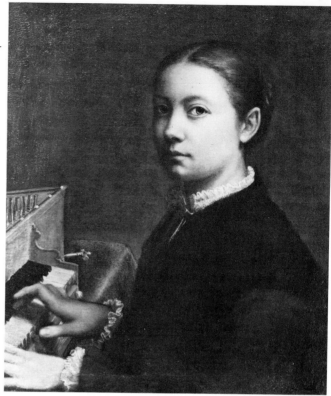

FIG. 1-5. Sofinisba Anguissola, *Self-Portrait at a Spinet*. Gallerie Nazionali di Capdimonte, Naples.

FIG. 1-4. Sofonisba Anguissola, *Three Sisters Playing Chess* (1555). 27³/₁₆″ × 35⅞″. Museum Narodowe W. Poznaniu, Poznan, Poland.

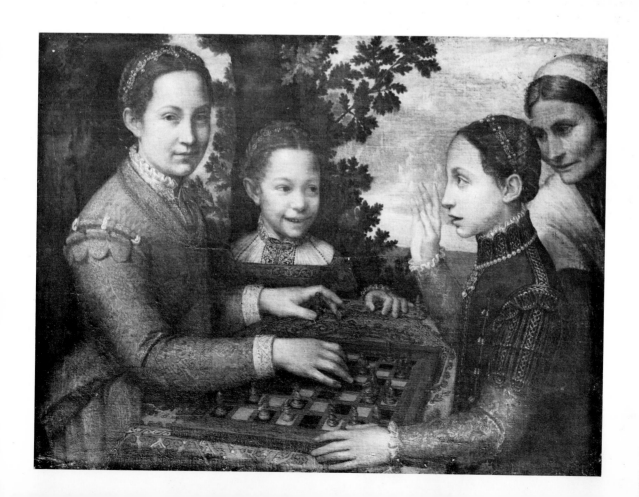

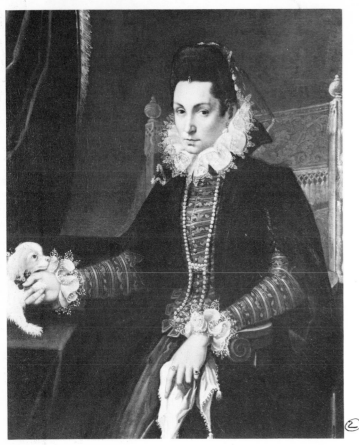

FIG. 1-6. Lavinia Fontana, *Portrait of a Lady with a Lap Dog.* 44⅞″ × 37″. Walters Art Gallery, Baltimore.

father was also a teacher, and it was in his studio that—along with Ludovico Carracci—she learned the techniques of painting.

While still quite young Lavinia gained fame as a portrait painter; the fashionable ladies of Bologna were pleased with her ability to be both "truthful and pleasing," and they also liked the way she painted their finery. Her *Portrait of a Lady with a Lapdog* (Fig. 1-6) at the Walters Art Gallery in Baltimore has many of the characteristics of a Fontana portrait: the elegantly attired woman is seated in an elaborately carved arm chair; her long tapering hands and fingers pet an alert small dog. The minute attention to detail of costume and jewelry is also present in her self-portrait at the Uffizi Gallery in Florence (Fig. 1-7). The palette and easel in the artist's hands identify her profession. As with many of her portraits of women, the background is plain; her portraits of men usually incorporate background details that suggest the status or professional affiliations of the sitter.

When Ugo Buoncompagni, a Bolognese, succeeded to the papal throne as Pope Gregory XIII in 1572, he sought out Bolognese artists. Lavinia received commissions first from the local branch of the family, and at the climax of her growing reputation she was summoned to Rome. However, because of a variety of family demands, she was not able to move there permanently until 1603 and by that time Clement VIII had succeeded to the papacy. Her first commission after arriving in Rome, an over life-sized *Stoning of St. Stephen* for the altar outside the walls at St. Paul's, was apparently not too successful: since drawing from the nude was proscribed in a woman's art education, she found it difficult to represent the vigorous action and musculature of the male body.[39] In Rome, too, she was in demand as a portrait painter. With her election to the old Roman Academy her prices soared. She began charging as much as Van Dyck and could afford to pursue her interest in art and antiquity as a collector. (A self-portrait of 1579 shows her surrounded by artifacts from her growing collection.) Enchanted by both her art and her personality (charm was a necessary component for the successful woman artist), well-to-do Romans beseiged her with commissions.

One of Fontana's loveliest religious paintings is *Noli Me Tangere* (1581) at the Uffizi Gallery. Here the artist reveals her appreciation for Correggio whose painting of the same subject (and identical title) was then in Bologna. All is bathed in a golden light. In the Fontana, the Magdalene kneels securely on the ground certain of her right to receive Christ's blessing; in the Correggio she sinks to the ground in "sinuous ecstasy" waiting for Christ's word.

Her best-known and, according to Ragg, most characteristic painting is the *Infant Francis I of France Presented by his Mother Louise de Savoie for the Blessing of S. Francesco de Paola* (1590). The Calabrian saint is presented as a tall, gaunt figure, his height emphasized by the clogs he is wearing. Kneeling on the left, creating a diagonal thrust toward the uncomfortable-looking infant, is his mother and her three ladies-in-waiting, their fashionable garments painted with the attention to detail that so captivated Lavinia's patrons. Even the pillow cover and edging of lace can be recognized as the kind of "fancy work" peculiar to the school of Bologna. This attention to detail never, however, detracts from the overall broad planes and masses of the painting.

In the group portrait commissioned by the Goz-

zadini family in 1584, three men and two women sit in self-conscious poses and formal attire. Again, using rich harmonious colors, Lavinia faithfully records the costumes and jewelry of the period. Several of the subjects were already dead at the time the portrait was painted, perhaps accounting for the stiffness and artificiality of the posed group.[40]

Fontana received many marriage proposals from noblemen, yet knowing what marriage might do to her career, she explained she "would never take a husband unless he were willing to leave her the mistress of her first-beloved Art." Eventually (in 1577) Lavinia did marry: her husband was Gian Paolo Zappi, the rather untalented son of a wealthy grain merchant who had studied briefly in Prospero's studio. As Ragg stated, "He was found to be lacking, not only in genius, but in ordinary capacity." Occasionally he filled in a background or added to a drapery in one of his wife's canvases or assisted her in domestic chores. Of the eleven children born of this union, only three outlived their mother.[41]

Lavinia Fontana expanded the traditional role of the woman artist. Commissioned to do altarpieces as well as other religious paintings, she proved herself capable of handling complex pictorial problems. However, she painted in a conservative style that was made obsolete by two of her contemporaries—Caravaggio and Annabile Carracci. Shortly before her death a medal was struck in her honor. One side shows in profile a proper 17th-century matron; the other an artist in frenzy, at work, her hair in wild disarray. Considering her eleven pregnancies and the fact that at least 135 works have been attributed to her, she was indeed a harried, but productive woman.[42]

MARIETTA ROBUSTI TINTORETTO (1560–1590)

Marietta Robusti Tintoretto was the pride and joy of her father, the celebrated Venetian painter. A beautiful, vivacious young woman, she had a fine voice and was a talented instrumentalist. Dressed in boys' clothing, Marietta would accompany her father everywhere. By watching him paint and by working at his side, she learned the secrets of her father's precise drawing, rich color, and impassioned brush stroke. She copied his pictures until she felt competent enough to create her own compositions; often she filled in his background. Expressing an attitude still prevalent in the mid-19th century, Ellet wrote: "She chose the kind of painting suited to her sex. Historical pieces demanded too much study and application, and it was wearying to design nude figures in imitation of the antique."[43] Thus, like so many female artists, Marietta turned to portraiture to achieve success. A likeness of Jacopo Strada, Emperor Maximilians's antiquarian, so impressed the emperor that she was invited to become his court painter. The Archduke Ferdinand and Philip II of Spain made the same offer. At the request of her father, who did not want to part with her, she refused them all. A marriage with a wealthy German jeweler was arranged "under the condition that she remain under the paternal roof." This she did, but only for a short time, for she died soon after.

Many works assigned to her father have since been reattributed to Marietta. Once considered a masterpiece by Jacopo Tintoretto, the *Portrait of an Old Man and Boy* (Fig. 1-8) was assigned to his daughter

FIG. 1-7. Lavinia Fontana, *Self-Portrait*. Galleria Uffizi, Florence. Courtesy of Alinari-Scala.

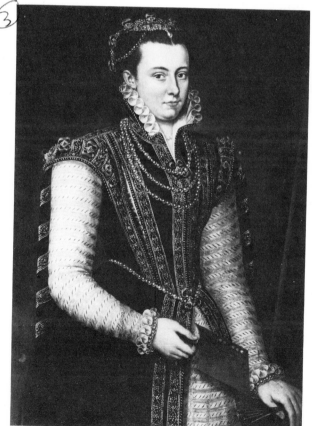

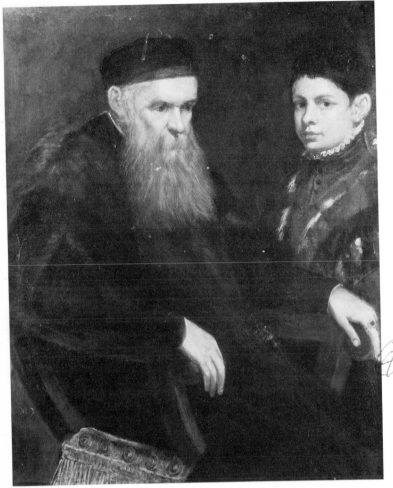

FIG. 1-8. Maria Robusti Tintoretto, *Old Man and Boy*. Kunsthistorischen Museums, Vienna.

in 1920 when it was discovered that it was signed with her characteristic "M".

ARTEMISIA GENTILESCHI
(1593–1652/53)

Unfortunately, Artemisia Gentileschi has been known more for the scandal in her early life than for her contribution to the Baroque style in Italy. According to Ward Bissell, author of a recent documented chronology of the artist, her presence and influence in Florence had by 1614 led to the development of the Tuscan Caravaggesque style and her presence in Genoa in 1621 to Genoese Caravaggism. One Gentileschi scholar even claims that "the im-

portance of Artemisia to the Neapolitan school was second only to the impact made by Caravaggio himself."[44]

The first child of Prudentia Montani and of the painter Orazio Gentileschi, Artemisia was born in Naples and raised in Bologna. (Orazio was a gifted Caravaggist well enough known to be summoned to London as court painter to Charles I and the Duke of Buckingham. He eventually became an English citizen and died in his adopted land in 1638.) In 1612 Orazio accused his friend and colleague Agostino Tassi of raping his daughter. Hired to teach Artemisia drawing and perspective, Tassi denied the assault, claiming her assailant to be another artist, one Cosimo Quali. Tortured by thumbscrews, the young girl protested in court that the screws were a poor substitute for the wedding band her attacker had

promised. Artemisia's trial titillated the Roman gossips and the verdict of guilty handed down to Tassi did nothing to harm his reputation.

One month after the trial Artemisia was married to Pietro Antonio de Vincenzo Stiattesi, a Florentine. He returned with her to his native city, where she enrolled in the Accademia del Disegno; at twenty-three she was made a member of the Florence Academy. They had at least one daughter, Palerma (born c. 1618), who—like her grandfather and mother—also became a painter. In 1633 Artemisia asked her friend, Cardinal Maffeo Barberini, to help her sell some paintings in order to pay for her daughter's wedding. The marriage to Stiattesi apparently was not an enduring one, for in 1637 she is known to have written to a friend asking if her husband were still alive.

Her earliest known painting is *Judith with her Maidservant*, now at the Palazzo Pitti in Florence. According to Bissell,

In this accomplished painting Artemisia had already formulated the major features of her first manner, a Caravaggism with penetrating observation of the model and use of tenebrist lighting, which is tempered by a decorative handling of materials in golden yellow and rich maroon worn by buxom, seemingly contemporary women.[45]

In this version of the Biblical story the foul deed has already been done: Judith's right hand is still gripping the sword; her maidservant carries the head of Holofernes in a basket. The figures burst through the picture plane; nothing separates the spectator from the action. The version at the Uffizi in Florence is a dazzling display of the artist's virtuosity. Here, the robust and angry Judith has just plunged the sword through the neck of Holofernes. The brilliant play of chiaroscuro over the interlocking forms, the ruby red of the spurting blood, and the severe foreshortening of the male figure enhance the drama of one of the most violent paintings in the history of Western art.[46] A third interpretation of this theme, painted in Rome in 1625, is today at the Detroit Institute of Art (Fig. 1-9). Judith's right arm holds the sword while her left one shields the light from a candle. The interplay of arms and sword makes an otherwise passive scene quite tense. Technically and conceptually more advanced than the Florentine versions, "with bold coloring and with almost abstract patterning of lights and darks, Artemisia created what may well be her masterpiece."[47]

Although the Old Testament story of Judith and Holofernes was a popular theme in Baroque art, Artemisia's frequent use of this universal symbol of castration possibly reflects her rage at the man who assaulted her and the subsequent humiliation of her trial. She painted no Madonnas, and in her religious scenes there was "nothing of the profound spirituality of the work of the artist to whom she owed many outward features of her style—Caravaggio." After viewing one of her *Judith* paintings, the 19th-century English art historian Mrs. Jameson denounced it, saying: "This dreadful picture is a proof of her genius, and let me add, of its atrocious misdirection."[48]

Artemisia's representation of another Old Testament scene, *Susanna and the Elders* (1610), is at variance with the traditional male renditions of such scenes. Rather than using the subject as an opportunity to paint a gorgeous nude (as did Tintoretto), she contrasts the vulnerability of the isolated, nude Susanna with the lasciviousness of the scheming old men. Susanna does not tease or taunt, nor is she sexually suggestive; interpreted from a woman's point of view, she is shown as being frightened.

As early as 1635 Artemisia received an invitation to join her father in England at the court of Charles I. Finally arriving there in 1638, she assisted her father in painting nine canvases set into the ceilings of the Queen's House at Greenwich (they are now in the salon at Marlborough House). These decorative pieces are the only known works of her English period. The self-portrait known as *La Pittura* in the Royal Collection, St. James's Palace (Fig. 1-10), has not been definitively assigned to her English years. Although well into her forties during those years she is here represented as a young woman in the allegorical imagery prescribed for painting by Cesare Ripa in his 17th-century handbook *Iconologia*: she wears a gold chain around her neck, from which hangs a mask—the imitation of a human face as painting imitates life. As Mary D. Garrard has suggested, Artemisia has done what no male artist could, combining "in a single image two artistic traditions, the artist's self-portrait and the female personification of an abstract idea." The artist also boldly suggests what she had previously written: "And this will show Your Highness what a woman can do."[49]

Shortly after her father's death, Artemisia left England and spent the next ten years in Naples. The most important painting of this period is *Esther and Ahasuerus*, now at the Metropolitan Museum of Art in New York. None of the heightened drama of her earlier paintings is present. Artemisia has chosen to

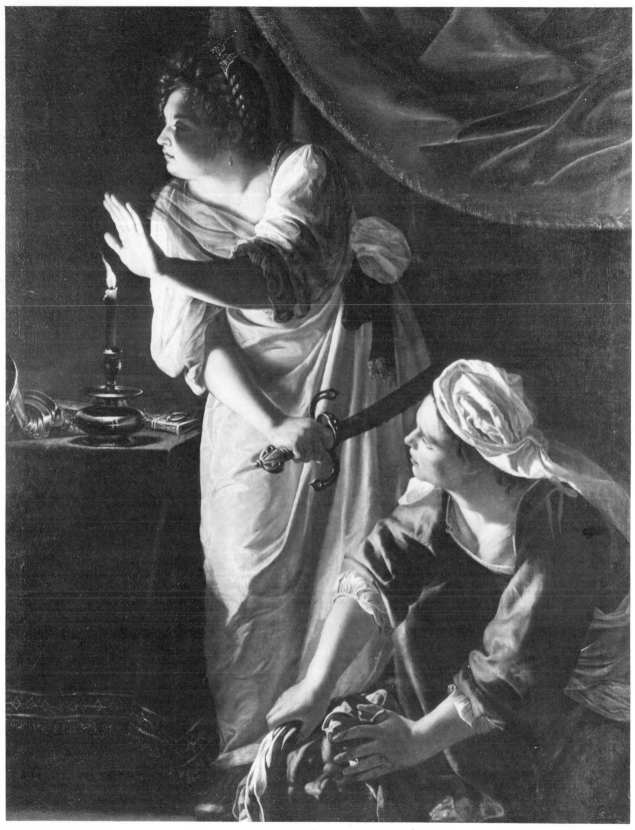

FIG. 1-9. Artemisia Gentileschi, *Judith and Maid-Servant with Head of Holofernes* (ca.1618). 72½″ × 55¾″. Courtesy of The Detroit Institute of Arts, Gift of Leslie H. Green.

portray the scene wherein Queen Esther, a Jew, has just presented a petition to her husband pleading with him not to slaughter her people. Though committing a heroic act, she is shown in an unheroic pose, fainting into the arms of her two attendants as her husband rises from his throne to assist her. The figures are all full-length, and set back into the picture plane.

By the 1630s the bold realism of Caravaggio had begun to lose favor and the classicism of the Bolognese Guido Reni was beginning to take hold. Artemisia's *David and Bathsheba* (Gallery of Fine Arts, Columbus, Ohio), painted in the 1640s, demonstrates her complete break with Caravaggesque naturalism and her surrender to classicism. (She painted at least six versions of the subject.) The figures are more slender, less compressed, and less powerful now—a far cry from the earthy, robust earlier figures of Judith.

ELISABETTA SIRANI (1638–1665)

The little that is known of Elisabetta's early life derives from Malvasia's *Felsina Pittrice*, a history of Bolognese painting. The count, a frequent visitor to the Siranis' middle-class household, noticed the young girl's artistic abilities and persuaded her father, Giovanni Andrea, to accept her as a student. Giovanni had been Guido Reni's favorite pupil. Elisabetta's early education included Bible study and an acquaintance with Greek and Roman mythology and with the lives of the saints. She also studied harp and voice. Described as a pleasant, pious, unassuming woman with a gracious manner, she believed in "plain living and high thinking." A 19th-century German art historian explained:

She never permitted her passion for Art to interfere with the fulfillment of her homely duties. She would rise at dawn to perform those lowly domestic tasks, for which her constant occupation during the day afforded little leisure; and was equally admirable in the circle of daily life, as in the loftier regions to which her spirit loved to aspire.[50]

Elisabetta had her own atelier and taught a large number of female students, among them her sisters Anna Maria and Barbara. Between her students' fees and her portrait commissions, she made a large amount of money and eventually became sole support of her family. Her father, ill and irritable with the rheumatic gout which crippled his hands, could no longer work. Because he tyrannized the household, there is no accurate catalogue of her work. Although she listed her complete works in order to

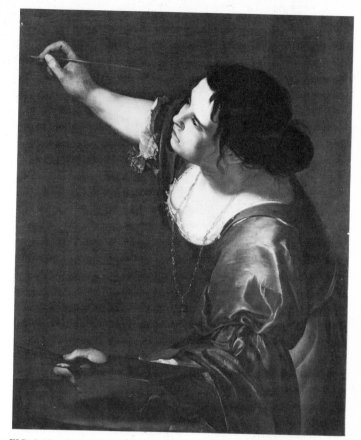

FIG. 1-10. Artemisia Gentileschi, *Self-Portrait as "La Pittura."* St. James's Palace, London. (Copyright reserved.)

prove their authenticity (a practice that began in the 17th century, when forgeries abounded), she sold many small heads and figures surreptitiously in order to provide her mother with additional funds to manage the household.[51] The fact that at 27 Elisabetta had not married perplexed the citizens of Bologna. As Ragg comments, she died at "an age regarded as young indeed for death, but hopelessly late for marriage." Some claimed her father prevented her from marrying for fear he would lose her financial support; others were convinced that for the sake of her art she chose to remain single. No longer sequestered in a convent, the 17th-century Italian woman was permitted to retire to the seclusion of her home and pray for her reward in the next world. Elisabetta's narrow existence in her father's home was broadened only by the visits of occasional foreign guests to her studio.[52]

In 1665 Elisabetta died of suspected poisoning. The accused was a maid in the Sirani household who, after a lengthy trial, was acquitted. The citizens of Bologna honored the "girl-artist" with a sumptu-

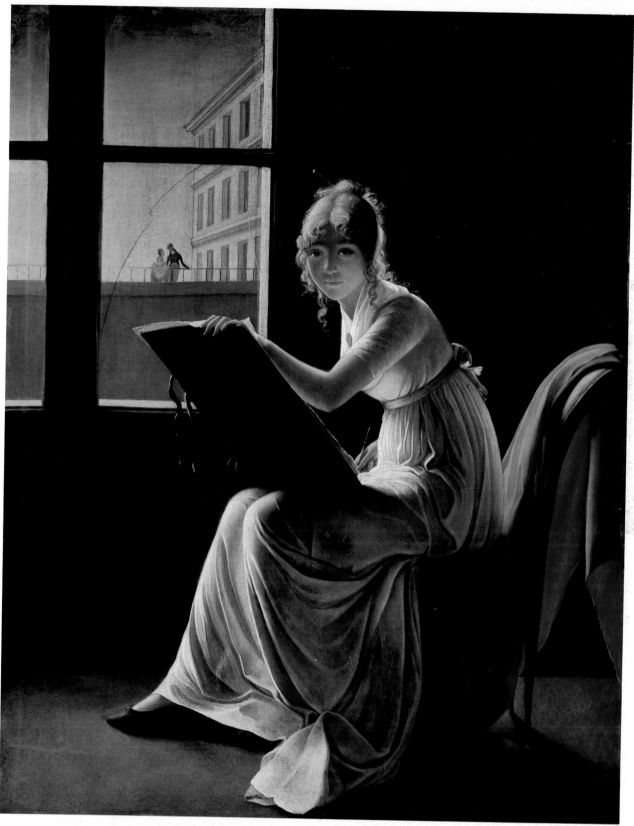

PLATE 1. Constance Marie Charpentier, *Mlle. Charlotte du Val-d'Ognes.* 63½″ × 50⅝″. Metropolitan Museum of Art, New York. The Mr. and Mrs. Isaac D. Fletcher Collection, bequest of Isaac D. Fletcher, 1917.

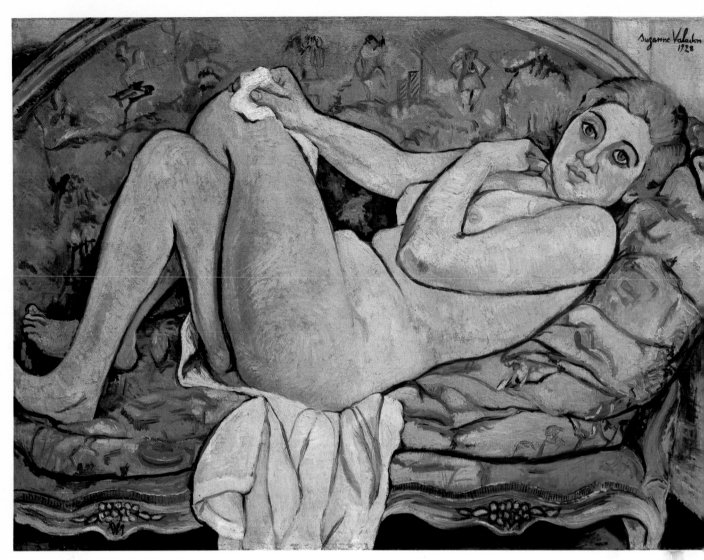

PLATE 2. Suzanne Valadon, *Reclining Nude* (1928). Metropolitan Museum of Art, New York. Robert Lehman Collection, 1975.

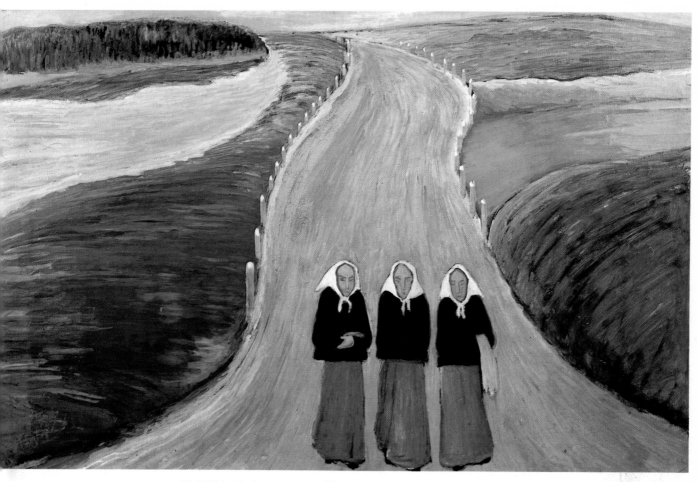

PLATE 3. Marianne von Werefkin, *The Country Road* (1909). 26¾″ × 41⅞″. Courtesy Leonard Hutton Galleries, New York.

PLATE 4. Helen Frankenthaler, *Mountain and Sea* (1952). Collection of the Artist (On loan to the National Gallery of Art, Washington, D.C.).

ous "public expression of admiration and grief." "She is mourned by all," wrote a city official, "the ladies especially whose portraits she flattered, cannot hold their peace about it. Indeed, it is a great misfortune to lose such a great artist in so strange a manner." She was buried next to her idol, Guido Reni, in the chapel of the Madonna del Rosario.[53] Secret poisoning societies flourished in 17th-century Italy, yet Malvasia suggests that Elisabetta's condition arose spontaneously in the body of a "vivacious and spirited woman, concealing to the highest degree her craving for a perhaps coveted husband denied to her by her father."[54]

Elisabetta received her first important commission—a *Baptism of Christ* which was to be a companion painting to one done earlier at the Campo Santo of Bologna by her father—while still in her teens. Legend holds that the watercolor study for it was done while the elders were still negotiating with her father. In fact, Elisabetta worked with such speed and dexterity and was so productive (150 paintings have been substantiated) that male rivals accused her of being dishonest, of having others, including her invalid father, paint the pictures that won her fame and eventually fortune. To refute their accusations, on May 13, 1664, she invited a group of distinguished persons to view her painting the portrait of Prince Leopold of Tuscany, which she completed in one sitting![55]

Hung in the Pinacoteca in Bologna near the work of Guido Reni is one of Elisabetta's most important paintings, *St. Anthony of Padua* (1662; Fig. 1-11). The young, gentle saint is presented not as an ascetic dreamer, but as a lover of children. Rarely before have celestial children been portrayed with such earthly delight. The kneeling saint creates a diagonal thrust as he caresses the foot of a cherub, while another creates a counterforce on the right. In the same gallery are a *St. Jerome* and a *Magdalene*, both commissioned in 1660 by one Giovanni Battista Cremonese, a jeweler. St. Jerome is shown repairing a pen. He is using the head of a lion as a book rest. The *Magdalene* reveals the difficulties of the inadequately trained female artist of the 17th century: not allowed to study the nude, she rarely succeeds in her attempt even to paint the partially draped figure. Lying on a rough mat while contemplating a crucifix, the semi-nude Mary Magdalene—surrounded by the traditional skull, flailing rope, rough clothing, religious text, and roots and water—is poorly drawn.

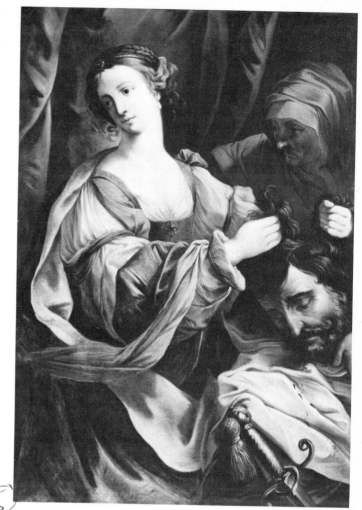

FIG. 1-12. Elisabetta Sirani, *Judith with the Head of Holofernes.* 50¼″ × 35⅞″. Walters Art Gallery, Baltimore.

As Ann Harris points out in her catalogue essay for the "Women Artists: 1550–1950" exhibit, Sirani did not only paint repentant saints and ethereal Madonnas and sibyls. She also created at least three feminist versions of ancient history. In *Porcia Wounding her Thigh* (1664), from Plutarch's *Life of Brutus*, Porcia is demonstrating her superiority to pain in order to convince her husband, Brutus, that she is capable of sharing his terrible secret. In *Timoclea* (1659), the defiant heroine is depicted shoving the enemy into the well of her house rather than as a servile captive of Alexander the Great. A *Judith Triumphant* (1658), done for the same patron as the *Timoclea*, has as its heroine the Biblical slayer of Holofernes.[56] The artist did at least one other version of the tale. However, Sirani's *Judith with the Head of Holofernes* (Fig. 1-12) at the Walters Art Gallery in Baltimore, lacks the

FIG. 1-11. Elisabetta Sirani, *St. Anthony of Padua.* Pinacoteca, Bologna. Courtesy of Alinari-Scala.

violence of the extant Gentileschi interpretations of the biblical story. Here Judith is portrayed as a gentle and delicate woman who discreetly turns her head away from the decapitated head, which she displays like a new garment. While the Gentileschi's maidservants are as youthful and robust as the slayer as well as active participants in the foul deed, the Sirani maidservant is a craggy, older woman deep in shadow, like a lurking evil presence.

Although Elisabetta Sirani was an accomplished etcher, she seems to have abandoned this art form when she began painting seriously. A finely executed etching of *The Conversion of St. Eustace* was produced by the artist at the age of seventeen. A book of her sketches is preserved in the Uffizi in Florence.

Many artists copied her paintings in order to better understand her technique. The works of her students decorate many churches and monasteries in Bologna. Ellet concludes:

So illustrious an example as she presented must naturally have contributed greatly to the encouragement and development of female talent, and many were the women whom her success, in a greater or less degree, stimulated to exertion.[57]

ROSALBA CARRIERA (1675–1757)

Rosalba Carriera was a great favorite of the nobility in the early 18th century, and few titled persons failed to have their portraits done by her. Her influence was vast; she helped introduce the Rococo style in Italy and France. So prolific was she that her work is found in most major museums throughout the world. The largest collection, 174 pieces, is in the Dresden Gallery. When the King of Poland visited her studio to have his likeness drawn, he bought its entire contents at a high price.

Born Rosa Alba, she came from a family of Venetian painters. Although he supported his family as a government official, Rosalba's father never lost his interest in art and encouraged his three daughters when they displayed talent. Not content to play childish games, Rosalba spent her youth learning French and Latin, drawing and copying her father's designs, and assisting her mother in designing patterns for her lace-making. A course of study was arranged for her with the Venetian artist Antonio Nazari and later with Giuseppe Diamantini. From Antonio Balestra she learned anatomy and technique and from her sister Angela's husband, Antonio Pellegrini, the details of miniature painting. She attained rare skill as a miniaturist and introduced the use of ivory as a support for that exacting medium, but eventually had to abandon this delicate and accepted "lady's" form of art because of her weak eyes. According to Ellet:

Her miniatures were noted particularly for severe accuracy of drawing, united with rare softness and delicacy of touch; they had the perfection of proportion, and the brilliancy and warmth of coloring for which her pastels were remarkable. Her tints were blended with great tenderness; her heads had a lovely expression of truth and nature.[58]

In her early twenties Rosalba was introduced to pastels by the Venetian artist Gian Antonio Lazzari, who was supporting himself by making pastel copies of famous paintings. She was impressed with the speed and subtlety of the medium and became so adept in its use that by 1705 she was unanimously elected to membership in Rome's Academy of St. Luke. Similar honors were bestowed on her in Paris and Bologna, a rare distinction for a woman of her day. Success did not corrupt her, however. Although she spent most of her life in her home on the Grand Canal in Venice ("the most luxurious and licentious" of European cities), "the deep seriousness, and even enthusiastic melancholy of her character— dispositions that find expression in many of her works—kept her aloof from contact with vice, and her moral purity and worth were as conspicuous and as universally recognized as her genius."[59]

Rosalba never married. She devoted much of her time to her mother and younger sisters Angela and Giovanna, who were both her students. After her father's death in 1719 she left for Paris with her family and settled in a large apartment with studio space in the palace of Pierre Crozat, the art collector and financier who had arranged her visit. Her first commission was to paint King Louis XV (Fig. 1-13). Many copies were made, and several versions of this portrait of the ten-year-old monarch exist. Such an auspicious beginning created a demand for her work. The French aristocracy soon flocked to her studio, fascinated by the virtuosity of her chalk strokes, by her ability to render lace, and by the dazzling way she handled their powdered wigs. She thus created a fashion for pastel portraiture which lasted into the 19th century (her technique was adopted by the 18th-century French pastellist, Maurice Quentin De La Tour, whose work in turn influenced Mary Cassatt).

In 1730 Charles VI, ruler of the Holy Roman Empire, invited Rosalba to Vienna. There she painted his portrait, that of his empress, and other members of the aristocracy. The trip was the last that she and Giovanna, her assistant in many of her paintings, made together before Giovanna died in 1737. The

FIG. 1-13. Rosalba Carriera, *Louis XV as a Boy* (1720-21). Pastel. Courtesy of the Museum of Fine Arts, Boston, Forsyth Wickes Collection.

FIG. 1-14. Rosalba Carriera, *Self-Portrait*. Pastel. Rovigo, Accademia dei Concordi, Florence. Courtesy of Alinari-Scala.

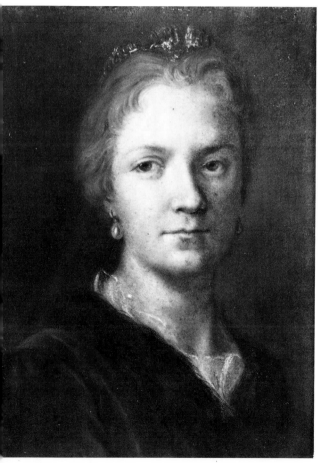

bereaved older sister was unable to work for a long period, but gradually, with the assistance of her students, she began accepting commissions again. This reprieve was brief, however. By the time Rosalba was seventy her eyesight had worsened. After submitting to several unsuccessful cataract operations, she became totally blind. Depressed by her fate, she lingered on for more than ten years and died in Venice in 1757.[60]

Rosalba Carriera's pastel portraits abound in Rococo prettiness. Little of the character of her sitters is revealed in their "delicate, powdery faces." However, the refined flattery and superficiality of her conceptions reflected precisely the values of the age that honored her. Ironically, it is her self-portraits—portraying an extremely plain woman indeed—that testify to her capacity for interpreting the human face with an often brutal honesty (Fig. 1-14).

Several other Italian women who achieved renown during this period included Irene di Spilimberg (1540-1559), Barbara Longhi (1552-c. 1638), Fede Galizia (1578-1630), Lucrina Fetti (active c. 1614-c. 1651), and Giovanna Garzoni (1600-1670). Irene di Spilimberg was born into a noble and distinguished Venetian family. Blessed with beauty, charm, and talent, she was the pride of Venice. Titian was so

captivated by her loveliness and creative abilities that he not only painted her portrait, but took her on as a student. Her potential was never realized, however, for she died before her nineteenth birthday.[61]

Barbara Longhi was the daughter of the Mannerist painter Luca Longhi of Ravenna. Her work is based on her father's style, although she tended to simplify his complex compositions. Her *Madonna and Child* now at the Walters Art Gallery in Baltimore is typical of religious paintings after the Counter-Reformation: "Its formalized character and unambiguous meaning invite devout contemplation rather than presenting the pictorial puzzles which so engaged earlier Mannerist painters."[62]

The daughter of the miniaturist Nunzio Galizia, the precocious Fede Galizia had an international reputation as a portrait painter while still in her teens. She also did still-life and religious paintings. Lucrina Fetti's reputation has been eclipsed by that of her older brother Domenico. Although she was a nun in the convent of S. Orsola, she painted portraits and religious compositions that attracted the patronage of Duke Ferdinando Gonzaga. Giovanna Garzoni was a portrait painter and a miniaturist, but is best known today for her studies of fruit, vegetables, and small species of animal life that are a cross between still-life paintings and scientific studies.[63]

NOTES

1. Susan G. Bell, *Women: From the Greeks to the French Revolution* (N.Y.: Wadsworth Publishing Co., Inc., 1973), 181.

2. Hannelore Sachs, *The Renaissance Woman* (N.Y.: McGraw-Hill & Co., 1973), 14.

3. Bell, *Women*, 182; Ruth Kelso, *Doctrine for the Lady of the Renaissance* (Urbana: University of Illinois Press, 1956), 69.

4. Renè de Maulde la Claviere, *The Women of the Renaissance: A Study of Feminism* (N.Y.: Putnam's Sons, 1905), 91.

5. Sir Thomas More (1478-1538) not only saw to his daughter's education, but recommended ordination for older women and widows.

6. Quoted in Bell, *Women*, 184.

7. *Ibid.*, 189.

8. Kelso, *Doctrine for the Lady . . .* , 71-74.

9. Quoted in Julia O'Faolain and Laura Martines, eds., *Not in God's Image* (N.Y.: Harper Torch Books, 1973), 180.

10. Jacob Burckhardt, *The Civilization of the Renaissance*, Vol. 2 (1910) (N.Y.: Harper & Brothers, American edition, 1929), 280-83.

11. The unmarried daughters of the upper classes entered convents of "high standing;" the lower-class unmarrieds worked as servants in these orders or cared for the poor and infirm. Few stayed at home.

12. William Boulting, *Woman in Italy* (London: Methuen & Co., 1910), quoted in Bell, *Women*, 206-7; Sachs, *Renaissance Woman*, 15-41.

13. Quoted in O'Faolain and Martines, *Not in God's Image*, 190.

14. Quoted in Sachs, *Renaissance Woman*, 10.

15. In 16th-century Venice if a woman was a brunette she was considered past her prime.

16. Sachs, *Renaissance Woman*, 44.

17. *Ibid.*, 52. Many courtesans enjoyed the same influence as the ladies of the court. They conducted literary and artistic salons where eminent men gathered to enjoy conversation as well as amorous favors.

18. *Ibid.*, 15, 39, 46.

19. de Maulde, *Women of the Renaissance*, 182-83, 395-96; Sachs, *Renaissance Woman*, 37.

20. Laura M. Ragg, *The Women Artists of Bologna* (London: Methuen & Co., 1907), 137, 148; a review of Ernst Guhl, *Die Frauen in der Kunstgeschichte*, in *Westminster Review* (American edition, July 1858), 96.

21. *Ibid.*, 137, 151.

22. *Ibid.*, 152-54. Within me is all grace
 Within me every path to truth
 Within me is all hope of
 Life and virtue.

23. *Ibid.*, 155. A *St. Ursula and Her Maidens* at the Accademia in Venice, previously identified as Caterina's, has been reattributed to the school of Giovanni Bellini. See S. Moschoni Marconi, *Gallerie dell' Accademia di Venezia, XV Secolo* (Rome, 1955), 88-89.

24. Giorgio Vasari, *The Lives of the Painters, Sculptors and Architects*, trans. by J. M. Dent, 8 vols. (London, 1900), Vol. 4, 205.

25. Ragg, *. . . Bologna*, 170; Vasari, *Lives*, 205.

26. *Ibid.*, 174.

27. *Ibid.*, 175; Vasari, *Lives*, 205; Elizabeth Ellet, *Women Artists in All Ages and Countries* (N.Y.: Harper & Co., 1859), 41.

28. *Ibid.*, 181.
(I would like to thank Jack Barlow for the translation.)

29. *Ibid.*, 183-84.

30. Vasari, *Lives*, 205.

31. Boulting, quoted in Bell, *Women*, 207.

32. Vasari, *Lives*, 207.

33. Eleanor Tufts, *Our Hidden Heritage: Five Centuries of Women Artists* (N.Y.: Paddington Press, Ltd., 1974), 21-22; Vasari, *Lives*, Vol. 7, 57; "Old Mistresses: Women Artists of the Past," Baltimore, Walters Art Gallery (April 17-June 19, 1972), 1.

34. Ann Sutherland Harris, "Sofonisba Anguissola," in "Women Artists: 1550-1950" (Los Angeles County Museum of Art, December 21, 1976-March 13, 1977), 106-7.

35. Quoted in Vasari, *Lives*, Vol. 7, 58.

36. Ellet, *Women Artists*, 52-53: Tufts, *Hidden Heritage*, 24; W. S. Sparrow, *Women Painters of the World* (London: Hodden & Stoughten, 1905), 27.

37. Ellet, *Women Artists*, 53; Sparrow, *Women Painters*, 27-28; quoted in Tufts, *Hidden Heritage*, 24.

38. Sparrow, *Women Painters*, 22; Ragg,. . . *Bologna*, 195-96.

39. Ragg, . . . *Bologna*, 205-6.

40. *Ibid.*, 218.

41. *Ibid.*, 207-8, 194; Sparrow, *Women Painters*, 28; Harris, "Lavinia Fontana," in "Women Artists," 111.

42. Tufts, *Hidden Heritage*, 34.

43. Since women could not study from the nude and were not awarded large commissions, they rarely bothered to do historical paintings. As we now know, great art can also have as its source humble subject matter.

44. Ward Bissell, "Artemisia Gentileschi—A New Documented Chronology," in *Art Bulletin*, V (June 1968), 164-65.

45. *Ibid.*, 155.

46. *Ibid.*, 156.

47. *Ibid.*, 157.

48. *Ibid.*, 159; quoted in Ellet, *Women Artists*, 66.

49. Bissell, "Artemisia Gentileschi," 161-62; Tufts, *Hidden Heritage*, 61; Mary D. Garrard, "'Sono Io la Pittura:' a 17th-Century Idea Whose Time Has Come." Paper presented at College Art Association conference, February 1977.

50. Guhl, *Die Frauen*, 97.

51. Ragg,. . . *Bologna*, 241-44, 248; Tufts, *Hidden Heritage*, 81.

52. Ragg,. . . *Bologna*, 246.

53. *Ibid.*, 230-34.

54. Quoted in Tufts, *Hidden Heritage*, 83.

55. Sparrow, *Women Painters*, 29.

56. Harris, "Elisabetta Sirani," in "Women Artists," 150.

57. Ellet, *Women Artists*, 72.

58. *Ibid.*, 107; 227.

59. *Ibid.*, 227-28.

60. *Ibid.*, 230; Tufts, *Hidden Heritage*, 110.

61. Guhl, *Die Frauen*, 97; Ellet, *Women Artists*, 44.

62. "Old Mistresses: Women Artists of the Past," 2.

63. Galizia, Fetti, and Garzoni are given more extensive coverage in Harris, "Women Artists" catalogue.

Flemish and Dutch Artists: Still Life and Genre

Portraits of the Northern Renaissance and Baroque periods show a type of woman distinct from those painted in Italy. Rather than appearing proud and aristocratic, she is shown as the domestic-looking, plain-featured wife or daughter of a well-to-do burgher. The newly emerged middle class was indeed the source of a new ideal, and fashion for the lady of the Reformation conformed to the medieval image of the chaste and obedient woman. The décolletage of Italian court circles was replaced by a severely simple frock. The pubescent goddesses of the Early Renaisance and the ripe beauties of the High Renaissance were also replaced by a sober, realistic image of woman. In fact, the first women portrayed as distinct personalities rather than mere types were the 15th-century burgher women of the Netherlands. Surrounded by their worldly possessions, they frequently shared the canvas with an equally solemn spouse. In the 16th and 17th centuries, they were often shown engaged in some occupation: reading, letter writing, preparing household accounts (indicating some learning), playing an instrument, or preparing food.[1]

THE REFORMATION AND ITS EFFECT ON WOMEN

The Reformation was no sudden revolution. Reform movements had sprung up periodically in the centuries prior to 1500, but a combination of social, political, and economic forces, the spread of literacy, the translation of the Bible into the vernacular, and the development of the printing process which could cheaply disseminate new ideas created the successful movement known as the Reformation. Conflict arose between a centralized papacy and the emerging nationalism of many states; there was a growing distrust of the papacy's aristocratic wealth while it preached Christ's poverty and humility; there was simultaneously an affirmation of the individualism of the Renaissance Humanists and a rejection of the communal spirit of the Middle Ages. However, the Reformation brand of individualism was religious rather than secular in that it allowed each individual a personal communication with God without the clergy as mediator.[2]

Although documents of the period reveal that many women supported and actively fought alongside the Reformers (Margaret of Navarre, while maintaining her Catholic faith, harbored some of them in her court), none were invited into the inner circles of the Reformist leaders. A statement made in 1531 reveals the startling limitations of Luther's respect for women:

Men have broad shoulders and narrow hips, and accordingly they possess intelligence. Women have narrow shoulders and broad hips. Women ought to stay at home; the way they were created indicates this, for they have broad hips and a wide fundament to sit upon, keep house and bear and raise children.[3]

According to Roland Bainton, the Reformation had "greater influence on the family than on the political and economic spheres." Monasteries and convents were disbanded, and the cloister was no longer the center of intellectual life for women. The power of the clergy was diminished and celibacy was no longer considered a desired state of being. Consequently, the home became the place where the Christian virtues of "love, tenderness, sharing of goods, self-effacement, humility, reconciliation, compassion, and the bearing of one another's burdens" were

exemplified. Priests were urged to marry, and many, like Martin Luther, married former nuns. The abolition of the cloistered existence brought a new emphasis on the "dignity and spirituality of marriage," which became a partnership blessed by God for rearing children "in the fear of the Lord."[4]

The Reformers encouraged sex within marriage: recognizing that women too had "needs of the flesh." Luther wrote in a letter to three nuns that "No women should be ashamed of that for which God intended her."[5] The older double standard of sexual behavior was abandoned, fidelity being demanded from both partners. For the first time divorce became a possibility. Rejecting the traditional sacrament of marriage, Luther allowed for divorce on the grounds of adultery, impotence or disbelief.

Whereas the Renaissance stressed woman's outer beauty, the Reformation was concerned with her inner goodness and virtue. Witness Luther's description of the ideal woman in his *Praise for a Pious Wife*:

A pious, God-fearing wife is a rare treasure, more noble and precious than a pearl. Her husband relies on her and trusts her in every respect. She gives him joy and makes him happy, does not distress him, shows loving kindness to him all through his life, and never gives him pain. She handles flax and wool, likes to work with her hands; she benefits the house and resembles the merchant's ship which brings many goods from far-away countries. She rises early, feeds her servants and gives the maids what is their due. She likes working and caring for what concerns her and does not busy herself with what is not her concern. She girds her loins and stretches her arms, works with energy in the house. She notices what is convenient and prevents damage. Her light is not extinguished at night She puts her hand to the distaff and her fingers grip the spindle, she works with pleasure and diligence. She holds her hands over the poor and needy.[6]

The long-term effects of the Protestant Reformation on women were quite beneficial in the field of education. Luther insisted that public schools for girls be established in order that they learn enough reading to interpret the Bible for themselves and eventually for their children. However, the immediate effect was not so beneficial. The Reformers held the restrictive Pauline view of the Early Christians with regard to women, who were expected "to be obedient to their husbands, to keep silent in public and to busy themselves with their households."[7] Literacy for women was thus strictly in the service of the new religion: they were encouraged to read the Scriptures in order that they might instill the Christian virtues and the fear of God into their progeny.

(The literacy rate of women in the Protestant countries surpassed that of the Catholic ones, and it was from this educated group of Protestants that the radical feminist reformers of the 19th century emerged.)

EDUCATION AND WORK

The Humanist spirit spread from Italy to the Netherlands, where the new middle classes were found to be ripe for education. Most women could not, however, afford the luxury of a Humanist education. While girls' schools continued to be established, classes met for no more than one or two hours a day (boys had a longer day). Instruction was limited to religion, household management, reading, writing, arithmetic (to encourage thrifty wives and businesswomen), and needlework—enough to make young ladies into "useful, skillfull, friendly, obedient, God-fearing and not self-willed housewives."[8] English travelers were astonished at the role Netherlandish women played in their husbands' businesses, especially in their ability to keep the accounts (English women of the 17th century were not yet taught arithmetic). One wrote in 1668 that the reason for the increase in productivitiy in the Netherlands was the education of their children by the middle classes. In this way, claimed the Englishman, husbands could be secure in the knowledge that their wives could manage their businesses in their stead.

Erasmus of Rotterdam, the leading Dutch Humanist, advocated educating the daughters of the nobility. In a series of satirical sketches he contrasted the wit of the learned woman with the denseness of the tradition-bound clergy. In *Christiani matrimoni institutio* he wrote:

The distaff and spindle are in truth the tools of all women and suitable for avoiding idleness. . . . Even people of wealth and birth train their daughters to weave tapestries or silken cloths. . . . it would be better if they taught them to study, for study busies the whole soul. . . . It is not only a weapon against idleness but also a means of impressing the best precepts upon a girl's mind and of leading her to virtue.[9]

While the teachings of the Humanists were recognized in theory by many educators of the period, in practice the conservative views of the Reformers toward women took hold, since they differed little from established tradition. Thus the controversy as to the desirability of educating women continued to rage. A writer from the Netherlands, Aegidius Albertinus, wrote in his popular *Weiblicher Lustgarten* in 1600:

As to what concerns the opinion that young girls or maidens ought to be encouraged to practice reading and writing, I found that there are divergent views. I for my part think it advisable for maidens to learn to read good and pious books and to use them for their prayer. But as to writing, this is not at all to be recommended for women, especially as it enables them to write and to answer love letters. . . . Although some women might make good and creditable use of the art of writing, yet it is so much abused that it would be better to abolish it on the quiet.[10]

So long as manufacturing was a home industry, women were active in the production as well as the merchandising aspects of the family business. But as the demand for goods grew and businesses expanded, guilds were formed; workshops left the home and guild halls were established. Women began to be excluded from the guilds, unless they were the wives or daughters of the master. Even those that originally accepted women, or were composed entirely of women, eventually became exclusively male. The daughters of the poor turned to prostitution in large numbers, thereby providing a popular theme for contemporary Dutch artists.[11]

As painting became more technically demanding it required a long apprenticeship, and the young girl who was needed at home was given little opportunity to learn the painter's craft unless her father allowed her into his studio (often the case with the successful woman artist). With the demise of the convents and cloistered workshops, many women were able to work at home as book illuminators and miniaturists with no need for large workshops or assistants. (New semireligious institutions such as the Beguines or Sisters of Joint-Life arose to accommodate the unmarried daughters of the middle classes.) Much of the work of the 16th century illuminators remains anonymous; few signed their names to the decorated page, but we know many were women. The spread of printing at the end of the 16th century lessened the demand for illuminated manuscripts, and many women turned to book engraving.[12]

GROWTH OF THE MIDDLE CLASS AND THE CULT OF THE HOME

After the Dutch had freed themselves from Spain, they organized into provinces under *stadtholders*, or governors. They became international traders and a new class of wealthy merchants arose with the funds to purchase the luxurious goods and services that were formerly the prerogative of the nobility. Nevertheless, having denounced all the aristocratic pomp of their former rulers—Spain and the papacy—this new rich class preferred simplicity to opulence. Under John Calvin and the Dutch Reformed Church the power of the clergy continued to be diminished. The iconoclastic fury that spread through the Netherlands in 1566 had a disastrous effect on Netherlandish art. Fanatics destroyed images of Catholicism wantonly: church walls were whitewashed, stained-glass windows shattered. Stripped of all décor that could distract the worshiper, churches became unpretentious gathering places to hear sermons. Taking the words of Christ literally, families began to pray in the privacy of their homes.

Since the focus now shifted to the home as the chief place of worship, of religious teaching, the place where music was heard, where books were read, and where possessions were enjoyed, it was natural that most art was produced for the home. Indeed, "the bourgeois aspect of baroque art [found] its unity in the cult of the home, and domesticity is the key to its understanding."[13] Since the home was almost exclusively the province of the woman, it was she who controlled its activities and determined its décor. It was she who selected the painting that would hang over the mantel in the "living room-kitchen," the most important room in the Dutch home. The subject matter she demanded was usually closely related to her own experience, hence the popularity of still-lifes, genre scenes, flower paintings, and topographical landscapes—all themes that reflected the well-being of the middle class.[14]

THE ROLE OF ART AND ARTISTS

Despite the fact that Holland was almost continually at war after its declaration of independence from Spain in 1581, it not only became an economic and imperial power, but a cultural center as well. Scholars from all over Europe were at work at the universities, poets were publishing their works as never before, and "painting became the most prominent expression of the national culture."[15] At the beginning of the 17th century, painters in the Netherlands were still organized in guilds together with embroiderers and woodcarvers. After traveling to Italy and discovering the enhanced position of painters there, Carel van Mander, who recorded the lives of Netherlandish artists, began echoing Leonardo's complaints: painting was a liberal art and not a craft, and artists should be honored as they were in antiquity. Van Mander and several of his colleagues started a private academy devoted to life

drawing. However, no official art academy was established in Holland until the late 17th century, when Dutch art was already in its decline.

Two significant factors shaped the art and social fabric of 17th-century Holland: the new Protestant religion and a bourgeois rather than courtly attitude. Works of art created for the home lacked the grand subject matter of Church commissions, yet many artists achieved a profundity in their rendering of the commonplace. Delighted in the objects of daily existence, they happily detailed their surroundings as if recording Luther's explanation of the phrase "our daily bread" from the Lord's Prayer: ". . . all that belongs to the maintenance of the body and the bare necessities of life, such as food and drink, clothes, house and home, cattle, furniture, money, a good wife, well-behaved children, faithful servants, a benevolent and just government, a suitable climate, peace, good health, honors and chastity, good friends, reliable neighbors, and many such things."[16]

Protestantism's restrictions against decorative work in churches had forced the artist to seek patronage elsewhere. There were some commissions to decorate civic or guild buildings, but it was mostly to the general populace that the artist turned for support. One may wonder why suddenly and uniquely in the course of the history of art the middle classes began acquiring art. For several reasons, according to Ingvar Bergstrom: the paintings were realistic interpretations of their daily existence and therefore easy to comprehend; because of an ever more limited supply of land in which to invest, works of art were considered a sound investment. By the 17th century art had become a commodity to be bought and sold in the open market. Some artists became attached to specific dealers and for a monthly wage painted according to the dealer's dictates. The relationship between supply and demand was thereby destroyed, resulting in an oversupply of artists. Many—including Hobbema, Vermeer, Steen, and Van Goyen—were forced to seek alternative employment in order to support themselves. An artist like Rembrandt suffered within this system: when he could appeal to bourgeois taste, he was very successful, but when his later work became more intense and personal, he found no buyers and died in poverty.[17]

Dutch paintings were of high quality because artists became specialists, thus freeing themselves to develop technical skill in their chosen field, such as landscape or portraiture. Still-life painting as a separate genre of Dutch art began developing around 1600, and was itself divided into special types—flower pieces, fruit pieces, breakfast pieces, *vanitas*

themes, fish pieces, banquet and game pieces. Each category followed well-defined rules, with no composition ever chosen at random. The "scientific naturalism" adopted by many still-life artists was an outgrowth of the Renaissance study of the natural sciences. The magnifying glass, and later the microscope, became popular in Holland and painters used them to study insect and plant life.

While many still-life paintings have symbolic interpretations, the *vanitas*, with its obvious moral message, may have been the Dutch answer to Catholic religious paintings. The objects in a *vanitas* contained symbols of earthly pleasures (books, jewelry, pipes, musical instruments), of mortality (skulls, hourglasses and other timepieces), and of the resurrection to eternal life (ears of corn, sprigs of laurel and ivy). These popular forms of still life may have reflected Holland's guilt regarding its prosperity and indulgence in material things.[18]

THE ARTISTS

As with the Italians, most Netherlandish women artists discussed in this chapter were members of artistic families and received their early training in family studios. All were celebrated in their lifetime and handsomely paid for their efforts; a few were equally renowned for their scholarship. However, when Carel van Mander published the first study of Dutch and Flemish painters in 1604, he included no women. Over a century later (1718–21), a similar study by Arnold Houbraken listed about two dozen. His title, *The Grand Theatre of Netherlands Painters and Women-Painters*, suggests their place apart from the mainstream. Only two, however,—Rachel Ruysch and Judith Leyster—have found their way into the popular histories of art, and in Walther Bernt's massive three-volume study of Netherlandish artists of the 17th century, there are only six women among the 800 artists surveyed.

LEVINA TEERLINC (c. 1520–1576)

Levina Teerlinc "is very well known to the history of art. Her name is always mentioned in connection with the portraiture of the sixteenth century."[19] Thus wrote Simone Bergmans in 1934. However, Teerlinc is not mentioned in Carel van Mander's study of 1604, or in any contemporary volume devoted to Flemish and Dutch painters of the 16th century. Born in Bruges, she was the eldest of the five

daughters of the miniaturist Simon Benninck and his wife, Catherine Stroo. Another daughter became an art dealer. Although few works are positively identified as Levina's, she was so well known as a miniaturist in the 16th century that she was invited to the court of Henry VIII in England, where large numbers of miniaturists were employed to meet the demands of a miniature-crazed public. She stayed on as court miniaturist for three successive monarchs— Edward VI, Mary I, and Elizabeth I—and was paid more for her tiny paintings than Hans Holbein for his court portraits. Both foreigners eventually received lifetime stipends: Teerlinc's was £.40 and Holbein's 34.

Although miniature painting has traditionally been acceptable "lady's art," Levina, in choosing this mode of expression, was following in the footsteps of both her father Simon and her grandfather, Alexander Benninck. Her first instruction was with her father in his Bruges studio, where she assisted him in his illuminations. She married George Teerlinc before 1545 and left with him for England shortly thereafter (Levina is listed as the "Kings paintrix" in the accounts of the Exchequer in 1546). They had one son, Marcus, and became English citizens in 1566.

In 1556 Levina presented Queen Mary with a New Year's gift—a small painting of the Trinity. Also recorded is a 1558 portrait presented to Queen Elizabeth during the first year of her reign and another in 1561 which the Queen greatly admired and kept for her personal use. Few portraits of Elizabeth I as a princess exist, and two, one miniature and the other full size, are attributed to Teerlinc. In each a rather attractive and poised young lady is shown dressed in finery befitting her royal station.

One of the few miniatures firmly attributed to Levina Teerlinc is the *Portrait of Lady Hunsdon* of 1575 (Fig. 2-1), today in the Rijksmuseum at Amsterdam. Against a traditional ultramarine background is a severe-looking woman suspiciously eyeing the viewer. In accordance with the fashion of the day, the sleeves of her black dress have delicately patterned insets which are painted beautifully.[20]

By deducing that the teetotum, or dice (which Teerlinc means in Flemish), found between two dress pleats of the *Portrait of a Lady* (c. 1575) in London's Victoria and Albert Museum was Levina's signature, Bergmans has identified a whole group of portrait miniatures as part of Teerlinc's oeuvre. All are exquisitely detailed with expressive faces and fresh color tones. Bergmans concludes that in all

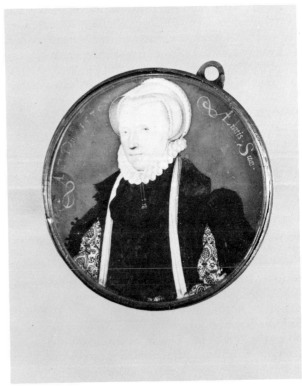

FIG. 2-1. Levina Teerlinc, *Portrait of Lady Hunsdon* (1575). Miniature on Ivory. Rijksmuseum, Amsterdam.

probability the *Portrait of a Lady* is a self-portrait, since no sitter would have agreed to be painted adorned with such a peculiar ornament as dice.

CATERINA VAN HEMESSEN (1528–AFTER 1587)

Caterina was the daughter of the famous Antwerp Mannerist Jan van Hemessen who was influenced by Michelangelo and other High Renaissance masters. She had her early training with her father and most likely assisted him in filling in the background details of his genre pieces.

The signed and dated self-portrait of 1548 at the Öffentliche Kunstsammlung in Basel reveals a rather intense young woman seated at an easel, a small palette and several fine brushes in her left hand; in her right hand is the painting brush resting on a mahlstick, the device painters used to steady their hand while doing delicate work. Her dress has a black bodice and deep red sleeves trimmed in pink.

Another painting of the same year, in the Wallraf-Richartz Museum, Cologne, shows a similarly attired woman whose age is designated as twenty-two. Since she resembles Caterina, many art historians have presumed this *Girl at the Spinet* to be another self-portrait; however, Tufts suggests that it is a painting of her older sister, Christina.[21] Although not a miniaturist, Caterina was a conservative painter working in the 15th and 16th century miniature tradition of Bruges and Ghent.

A pair of beautifully painted and signed portraits at the National Gallery in London reveals Caterina's skill in capturing the quality of her sitters' personalities. The male, the larger of the two, was painted in 1552, and the female pendant in 1551 (Fig. 2-2). They show a pensive pair, stylishly though not flamboyantly attired, their richly colored garments set against a dark background. The long, gaunt figures are three-quarter views filling up almost the entire picture space. The man clutches a sword in his right hand; the woman fondles beads and enfolds a miniature dog in her right arm. Unlike the typical Flemish portraits of the period, in which the sitter is posed in a specific environment, the artist gives no suggestion of place.

Caterina, a Catholic, also produced religious paintings. Several (all multifigured and abundantly detailed) are known, among them *The Rest on the Flight to Egypt* in a private collection in Mons; *Christ and Veronica* at a convent in Mons; *Christ's Entry into Jerusalem* in Stuttgart; a *Carrying of the Cross* at the Louvre, Paris; and a *Crucifixion* in Basel. Von der Osten and Vey consider the "Brunswick picture with the almost indecipherable monogram, the Parable of the Banquet, after St. Luke, chapter 14," to be her most important work. "Sonorous colours dominate the foreground, and a huge block of architecture is in the middle distance, its brick walls tinged with slate grey. The background is worked out with care. It is full of rustic bustle and dominated by a cool green which looks more grave than light."[22]

In 1554 Caterina married a "gentleman of breeding," Chrétien de Morien, an organist at Antwerp's cathedral. When Queen Mary of Hungary abdicated her regency of the Netherlands, she insisted that Caterina and Chrétien join her in Spain. Caterina was made painter to the Queen, who before she died left the couple enough funds for their return to Antwerp.[23] Of the ten paintings extant signed and dated by the artist, none were painted after 1552. No works from the Spanish period exist; those that have

been identified are the works of a very young woman who, most likely, painted little after she left the court of Queen Mary.

CLARA PEETERS (1594–AFTER 1657)

Little is known of the life of Clara Peeters except her birthdate, 1594, and that she was one of a small group of painters in Antwerp who specialized in breakfast pieces. Active in Amsterdam around 1612 and in The Hague around 1617, she was considered significant enough by Walther Bernt to be among the six women artists included in his three-volume study of Netherlandish painters in the 17th century.[24] Peeters did not marry until 1639, when she was forty-five. Harris suggests that a marriage so late in life would indicate that the artist was having financial difficulties.[25]

FIG. 2-2. Caterina van Hemmessen, *Portrait of a Lady* (1551). National Gallery, London. Courtesy of the Trustees.

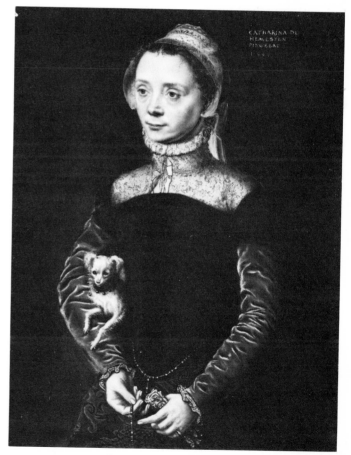

FIG. 2-3. Clara Peeters, *Breakfast Piece* (1611). The Prado Museum, Madrid.

It is not known whether her father was a painter, but her precocious talent for painting flower and still-life pieces when few other Flemish artists were so engaged suggests that her early training was received from painters who originated those genres. Her first signed painting is dated 1608, when she was only fourteen years old. In this painting Peeters displays the disdain for empty spaces of the early breakfast-piece painters. Seen from above and distributed evenly over the canvas are a pewter plate on which are placed a half-loaf of bread, prawns, and grapes; a roemer of wine; a pedestal for salt; an oyster, half-lemon, nuts, and a knife—a robust Dutch repast. Peeters usually arranged her objects on a wooden table against a simple dark background. While her earliest work often appears crowded, the elegant and austere *Still-Life with Gold Goblets* of 1612 is stringently composed of strong verticals and horizontals. Harris considers it her masterpiece. A kind of "Wunderkammer" (room of wonders), it shows the Dutchman's delight in the objects made by man. To demonstrate her skill in depicting light reflections,

Peeters painted her own portrait on the goblet seven times.[26]

Peeters was quite versatile: besides the breakfast piece, she painted flower and fish pieces and bird still-lifes. A combined breakfast piece and flower painting of 1611 now at the Prado in Madrid (Fig. 2-3) is powerfully drawn and executed with great clarity; according to Bergstrom, the bouquet shows "remarkable flexibility and rhythm, and little sign of stiffness. The composition is more evenly balanced than we should expect at this period."[27] There are three companion panels: a fish piece, game piece, and a meal piece, all large and remarkable, when one considers that the artist was only seventeen years old.

ANNA MARIA SCHURMANN (1607–1678)

Dutch poets called this extraordinary woman their Sappho and their Corneille. Her gifts were manifold; she could be described as a true "Renaissance wom-

an". She was not only one of the outstanding linguists of her time and a fine poet and musician, but also carved in wood and ivory, produced engravings on copper and crystal, and was an accomplished miniaturist.

Her family were Flemish Protestants who moved frequently to avoid persecution, and it was in Cologne that she was born. By 1615, when the Schurmanns had settled in Utrecht, they discovered Anna's talent. Although her mother tried to interest her in needlework and other feminine accomplishments, Anna preferred intellectual pursuits. At seven she quickly mastered Latin and at ten translated works from Latin into French and Flemish; by eleven she was familiar enough with Greek and Hebrew to read Homer and the Bible in the original texts. She became well versed in Arabic and other Semitic tongues as well as in all the modern European languages. As an adult her opinions were valued and she was sought out by all the learned men of her time. The University of Utrecht reserved a place of honor for her in its lecture halls, and the University of Leyden built her a special tribune "where she could hear without mixing with the audience."[28] "When it is added that she was of a lovable nature and attractive in manner, one is not surprised that her contemporaries called her 'the wonder of creation.'"[29] Yet despite her prominence, Schurmann ultimately rejected the life of a brilliant celebrity and retired to a country house where she lived in "utmost simplicity," dividing her time between her writing and her art.

After the sudden deaths of her brother and father around 1665, Schurmann became a follower of the French religious mystic Jean de Labadie, who saw himself as a new Christ. Renouncing her art, she devoted her last years to theological studies and after Labadie's death to spreading his word. She died in poverty in 1678.

Two self-portraits are the only works known to be from Schurmann's hand. One is an etching set in an oval frame. The artist's fashionably coiffed hair is pulled off her forehead, flows down her shoulders, and is again knotted in a bun at the top of her head. She wears a dark dress laced up the front and almost hidden by a large pointed white collar. The accompanying legend suggests that the etching may have served as a frontispiece for one of her published works. The other self-portrait, a painting in the collection of the city hall in Franeker, Holland, is also set in an oval frame (Fig. 2-4). Although the artist has not changed her hair style, she has por-

trayed herself as a much more attractive woman. Close attention is paid to details, in accordance with the style of the Northern artists of the 17th century. How much time she committed to her art is not known, for as Ellet explains: "Learning was her passion; the arts her recreation."[30] Nevertheless, Anna Maria Schurmann must be included in any chronicle of celebrated women artists.

JUDITH LEYSTER (1609–1660)

The daughter of a Flemish brewer, Judith Leyster was born in Haarlem in 1609. She evidently demonstrated a precocious talent: a book about life in Haarlem by Samuel Ampzing (1628) cites her as a painter active in that city in 1627. She was also mentioned again in 1648 in a book by Theodore Shrevel, who called her a "leading star in art"—an evident pun on her last name, which means lodestar in Dutch. In 1628 she moved with her family to Vreeland, a city ten miles from Utrecht. Her work of

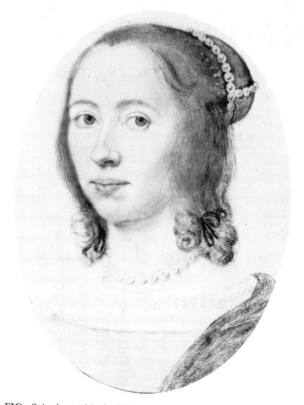

FIG. 2-4. Anna Maria Schurman, *Self-Portrait*. Collection of City Hall, Franeker, Holland.

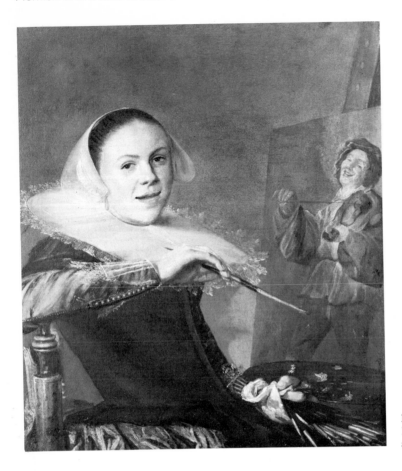

FIG. 2-5. Judith Leyster, *Self-Portrait.* 29⅝″ × 25⅝″. National Gallery of Art, Washington. Gift of Mr. and Mrs. Robert Woods Bliss.

this period shows the influence of Hendrick Terbrugghen and the Utrecht Caravaggisti. (Utrecht in the 1620s and Haarlem in the 1640s were centers of Caravaggesque realism.)

The family returned to Haarlem in 1629, when in all probability Leyster entered the studio of Frans Hals. Her paintings of 1629 and 1630 are so close to his style as to have become confused with his works.[31] She was admitted to the Guild of St. Luke in Haarlem in 1633, and had three male students by 1635. In that year she also sued Hals for accepting as an apprentice a student who had left her studio. They became estranged, and it was at this time too that Leyster departed from Hals's style.

In 1636 Leyster married the genre painter Jan Molenaer, by whom she eventually had three children. In the following year the couple moved to the prosperous port of Amsterdam. Though she continued to paint, her most productive years were behind her. There are no paintings of hers signed after 1652. There is ample evidence to indicate that initially both she and Molenaer were students of Hals and

shared a studio. For a period their subject matter and their style were similar, bearing the imprint of their master. However, in comparing Molenaer's *Youth Playing the Lute* (Adolphe Schloss Collection) with Leyster's *The Serenade* (1629; Rijksmuseum, Amsterdam) it is obvious that Leyster draws, composes, and paints with a power and certainty her husband lacks. Witness the hands that strum the instruments: in Molenaer it is weak and detached looking, while in Leyster it is well formed and structurally believable.

Although primarily a genre painter, Leyster also did portraits, still-lifes and flower paintings. There also exist several groups of children and "elegant colorful conversation pieces." Her palette tended toward pale blues and greys, but at times she employed the strong light effects of the Utrecht Caravaggisti. In 1643 she illustrated a successful book on tulips, the flower cultivated at the University of Leyden's botanical gardens in the late 16th century.

When modern cleaning methods revealed Leyster's distinctive signature—the initials "J. L." plus

a star—many paintings formerly attributed to Hals were rightfully reassigned to her, including *The Jolly Toper*. Several copies she made of Hals paintings have been confused with the original. That of *The Lute Player* (Rijksmuseum, Amsterdam), probably done in 1626, is a remarkable accomplishment for so young an artist; moreover, the copy is better known than the original. Her copy of Hals's *The Rommel Pot Players* (Art Institute of Chicago) is one of many copies after the lost original. The Leyster version has the fluidity of brushwork and expressiveness of features characteristic of the early Hals.

Leyster's self-portrait (Fig. 2-5) in the National Gallery of Art in Washington, D.C., reveals the vitality of the artist and her style. Painted in the Hals manner, the young artist is formally and fashionably attired in a starched bonnet; a stiff collar trimmed in lace frames her plain but cheerful face. Her painting arm rests on the back of a chair, while her left hand firmly grasps the palette resting on her lap. She has looked up from her work—a painting of a laughing fiddler—and turned to greet the spectator. The liveliness of the activity within the painting is matched by the freedom of the artist's technique.

In the small genre painting *Rejected Offer* (1631; Fig. 2-6)—sometimes referred to as *The Proposition* —Leyster uses the device of a candle to create dramatic light, a Caravaggesque convention she probably learned in Utrecht. The theme of the amorous proposition was popular among the Utrecht Caravaggisti and served as a moral lesson. Usually the woman is shown as the seducer, or at least the willing

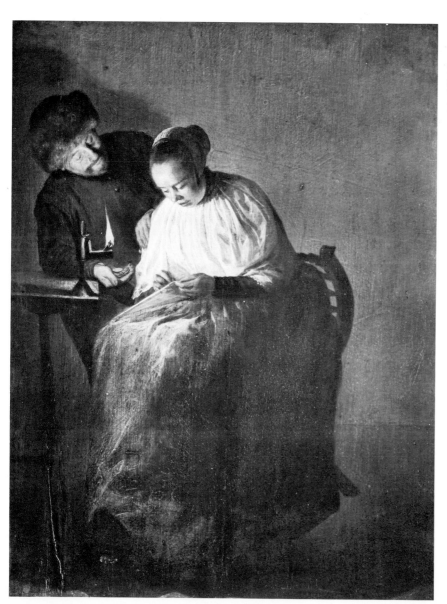

FIG. 2-6. Judith Leyster, *The Proposition* (1631). 11¹¹⁄₁₆″ × 9½″. Mauritshuis, The Hague. The Johan Maurits van Nassau Foundation.

participant entertaining the men who give her money. In the unprecedented Leyster version, the primly dressed seamstress seems embarrassed by the offer and continues sewing. This early feminist interpretation of a role women are often forced to play was the forerunner of a new version of the theme introduced in the latter half of the 17th century by Metsu and Vermeer.[32]

MARIA VAN OOSTERWYCK (1630–1693)

Maria van Oosterwyck was born in Nootdorp, near Delft, the daughter of a Dutch Reformed minister. Her father encouraged her intellectual development and was pleased to recognize her artistic talent. When he noted "her dissatisfaction, and even disgust, at the trifles that served to amuse other little girls of her age," he sent her to study with Jan de Heem, a leading still-life painter with followers both in Flanders and in Holland. After Louis XIV purchased one of her flower pieces, Emperor Leopold, William III of England and the King of Poland followed suit. Gifts and honors were showered upon her by royalty, who paid high sums for her canvases.

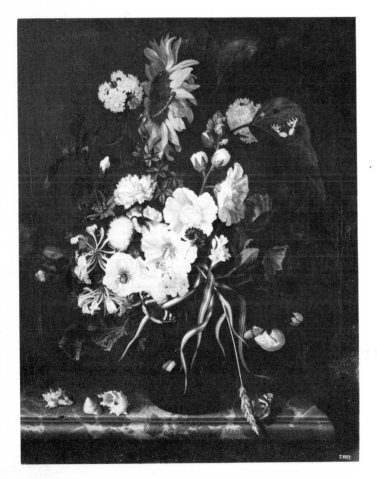

Despite such worldly acclaim, Oosterwyck led an orderly, productive, and uneventful life. One of her suitors was the painter Willem van Aelst. When he declared his love for both the artist and her art, Oosterwyck—who had resolved not to marry—devised a plan to curtail his ardor. If he were to work diligently for ten hours a day every day for one year, she would reconsider his proposal. He took a studio across from hers and she recorded his work habits. Van Aelst failed to fulfill his requirement and finally left her in peace, a "confounded" and "disappointed" young man.[33]

Although Oosterwyck had a fairly long career (she died at 63), she had a limited output, each painting being treated like a rare jewel. Often set against a dark background, her bouquets are carefully composed and brilliantly executed. Her works can often be identified by the sunflower which almost always appears at the top of the bouquet. Occasionally she did fruit or *vanitas* still-lifes.[34] *Flowers and Shells* in the Gemäldegalerie at Dresden (Fig. 2-7) has a fluidly arranged floral group centered on a marble table. Butterflies rest on several leaves and on the table; the ubiquitous sunflower is graced by a large insect. Her earliest dated work is the *Vanitas* of 1668 at the Kunsthistorisches Museum in Vienna. In addition to the floral arrangement, the complete repertoire of *vanitas* objects includes an hourglass, skull, globe, fly, mouse, butterfly, knapsack, and a partially eaten ear of corn—the latter a recent discovery from America. On the light reflection on the glass flask, the artist represented herself in the act of painting the picture.

MARIA SIBYLLA MERIAN (1647–1717)

Although she expressed an early interest in art and entomology, much to her mother's distress, it may have been the twenty years that Maria Sibylla Merian remained in an unhappy marriage in virtual seclusion that helped sharpen her powers of observation. As she explained in the preface to one of her books, these years were devoted "to the examination and study of various insects, watching their transformations and making drawings from them."[35]

Merian was born in Frankfurt-am-Main, the daughter of Matthäus Merian the Elder, a Swiss engraver and geographer. After his death, her mother married Jacob Marell, a Flemish flower painter. One of Marell's students was Johann Andreas Graff, whom

FIG. 2-7. Maria van Oosterwyck, *Flowers and Shells.* Staatliche Kunstsammlungen, Dresden-Gemäldegalerie Alte Meister.

Merian married in 1665. Their first daughter was born in 1668, their second ten years later. The marriage ended in separation in 1684.

Merian's first book, *The Wonderful Transformation of Caterpillars*, which she illustrated in exquisitely detailed copper engravings, was published in 1679. (A second volume appeared in 1683, and a third shortly after her death in 1717.) Her greatest achievement, however, was *The Metamorphosis of the Insects of Surinam*, which was translated into several languages. (Though German by birth, she is included in this chapter on Dutch artists because the work was sponsored by the Dutch government and she spent much of her life in Holland.) In 1699, when she was almost 55, she set sail for Surinam in Dutch Guiana to study the insect and plant life of the exotic Dutch possession. She had earlier become a disciple of the French mystic Jean de Labadie, as had Anna Maria Schurmann, and she was able to take refuge in the Labadist settlement in Surinam upon her arrival there with her younger daughter Dorothea. The elder daughter, Johanna Helena, was already living in Surinam with her businessman husband. Ill-health caused her to leave after two years, but she had gathered enough material to illustrate and write *The Metamorphosis*. Etchings were made after her watercolor studies; there were 60 plates in all (Fig. 2-8). With it her reputation as a scientist was firmly established.

Merian's drawings and engravings, although admired by scientists and art historians alike, were always in the service of her scientific research. There were occasional water colors of fruits and nuts—typical still-life subjects—that seem oddly unrelated to her scientific investigations. Harris suggests that her fame as an illustrator was so widespread that she attracted patrons who were interested in her work for aesthetic rather than scientific reasons.[36] Even the purely scientific work must be admired for its elegant design and precise technique.

Merian spent her remaining years in Amsterdam living with her elder daughter and continuing her research, writing, and engraving. Although she died in poverty, her daughters continued her work and today the few copies of her books are carefully preserved in rare book collections in Europe and in the Beinecke Library at Yale University.[37]

RACHEL RUYSCH (1664–1750)

Considered, along with Jan van Huysum, the last of the great flower and fruit painters,[38] Rachel Ruysch was born in Amsterdam, where her father was a

FIG. 2-8. Maria Sibylla Merian, *Metamorphosis Insectorium Surinamensium*, plate 25. The Beinecke Rare Book and Manuscript Library, Yale University, New Haven.

distinguished professor of anatomy and botany. Her mother Maria was the daughter of the well-known architect Pieter Post. When as a young girl she displayed a talent for drawing, her father placed her in the studio of the flower painter Willem van Aelst, the erstwhile suitor of Maria van Oosterwyck. His influence can be seen in her work until mid-career. According to one authority, her "compositions were less elegant than van Aelst's, but this was counterbalanced by a richer and deeper sense of colour."[39]

In 1693 Ruysch married the portrait painter Juriaen Pool. Both were elected members of the Guild of Painters at The Hague in 1701 and were twice summoned to the German courts, where they spent the years 1708–16 as Court Painters to the Elector Palatine in Düsseldorf. Most of the paintings done during their German sojourn remained in the Elector

Johann Wilhelm's collection when the couple returned to Holland after his death. Rachel bore and raised ten children, whom, we are assured, "she brought up . . . with the most laudable care," and continued to paint until her eightieth year.

Ruysch's works are always "painterly in spite of their delicate almost over-precise execution."[40] Naturalistic in style, but often communicating hidden meanings as to the transcience of life, her vases and bouquets are usually centered on the canvas and set on a wooden or marbleized table parallel to the picture plane. Menacing insects lurk around the fruit placed on the table. Flower stems are arranged asymmetrically to form a gentle S-curve, a device Ruysch adapted from Van Aelst and subsequently a cliché with many 18th-century flower painters. As in *A Vase of Flowers* (Fig. 2-9) at the North Carolina Museum of Art in Raleigh, her backgrounds are usually dark and suggestive of evening light.

Ruysch's early work often featured architectural backgrounds with the date incised in Roman numerals. Her later compositions, such as the *Still-Life with Fruit and Insects* of 1711 at the Uffizi in Florence (Fig. 2-10) and the similar *Fruit Still-Life with Bird's Nest and Stag Beetle* of 1718 in Dresden are quite different from her floral pieces: the objects are set further back in the picture plane and the diagonal thrust of the table or cloth takes the viewer's eye even deeper into space. Often too the groupings are set in the open air and incorporate extended vistas. The compositions are livelier, the contrasts in texture more vibrant, and the activity of the animals more menacing.

Also active during the period under investigation were Margaretha van Eyck (1370–?), Susanna Horebout (1503–1545), Catherina van Knibbergen (active middle of 17th century), Margaretha van Godewyck (1627–1677), and Maria Verelst (1680–1744). Hopefully, this study will stimulate further research into their lives and work.

While many of the women discussed here have been members of artistic families, none were quite so overshadowed by their siblings as Margaretha van Eyck, older sister to Jan and Hubert. Her birth is usually given as 1370, Jan's about 1390, and Hubert's somewhere in between. Carel van Mander refers to her as a "gifted Minerva" who scorned the "bands of Hymen" and never married. Margaretha was a miniaturist at the court of Burgundy, but her fame spread beyond Flanders and many of her works illustrated the "manuscript romances" of the period. Brothers and sister did work together on rare occasions: one of their finest collaborations was the breviary prepared

for the Duke of Bedford upon his marriage in 1423 to the sister of Philip the Good. It is today in the Bibliothèque Nationale in Paris. A *Madonna and Child* at the National Gallery in London has been attributed to Margaretha, but, according to Sparrow, the only work extant to bear witness to her skill is a drawing after a miniature by Margaretha of St. Agnes and St. Catherine; it is reproduced in M. J. du Jardin's *L'Art Flamand*. Investigation beyond the scope of this book must be undertaken to reveal the mystery of Margaretha van Eyck.[41]

Albrecht Dürer wrote in his diary about his meeting in Antwerp in 1521 with the talented young Susanna Horebout: "She is called Susanna, she has illuminated a book, a *Salvator*; I gave her a ducat for it. It is a great wonder that a woman should be able to do so much."[42] Horebout was only eighteen at the time of the transaction. The daughter of Gerard Horebout of Ghent, court painter to Henry VIII, Susanna traveled with her father to England, where she married well. She "died full of honors in her adopted country."[43]

One of only six women artists cited in Bernt's massive three-volume study of Netherlandish painters of the 17th century, Catherina van Knibbergen was active in The Hague in the middle of the century. Her life dates are not known, but in all probability she was related to François van Knibbergen (1597–after 1665), a landscape painter in the manner of Van Goyen. Catherina was herself a landscape painter and a member of the Guild of St. Luke. "Her mountain landscapes with waterfalls and distant prospects are non-naturalistic, and the trees and brushwood are depicted in a curiously mannered fashion."[44]

Although few signed pictures of hers are extant, during her lifetime Margaretha van Godewyck was greatly admired in Dordrecht, her birthplace. In addition to painting landscapes and portraits, she etched on glass and was an accomplished embroiderer. In *Landscape with Angler*, the title figure is placed in the center of the painting; an awkwardly drawn child holding a fishing rod is to his right. The trees in the foreground as well as those in the distance across the lake all have a similarity of form.[45]

Maria Verelst was a member of a painting dynasty. Her father was the painter Herman Verelst, and she received her first instruction from her uncle Simon, who was the son of the genre, portrait, and still-life painter Pieter Verelst, a pupil of Gerrit Dou. Maria was celebrated for her skill as a portrait painter and for her successful attempts at history painting. Like many of her female contemporaries, she excelled in a variety of fields, including music and languages.

FIG. 2-9. Rachel Ruysch, *A Vase of Flowers*. 22″ ×
18″. Collection of the North Carolina Museum of
Art, Raleigh.

FIG. 2-10. Rachel Ruysch, *Still Life with Fruit
and Insects.* Galleria Uffizi, Florence. Courtesy of
Alinari-Scala.

Much of her life was spent in England, where her father and uncle had settled. An anecdote about her helped spread her fame and introduced her to English society: six Germans sitting near her at the theater were extravagant in their praises of her beauty. She reprimanded them for their "bad man-ners." They became equally intrusive again, but this time in Latin. Again, she made them aware of her annoyance. The Germans, impressed, insisted on knowing who this extraordinary woman was. Ultimately, she painted all their portraits.[46]

NOTES

1. Sachs, *Renaissance Woman*, 7, 12, 13, 33.

2. George L. Mosse, *The Reformation* (New York: Holt, Rinehart & Winston, Inc., 1966), 25.

3. Quoted in O'Faolain and Martines, *Not in God's Image*, 196–97.

4. *Ibid.*, 195–96.

5. Roland H. Bainton, *Women of the Reformation* (Minneapolis: Augsburg Publishing House, 1971), 9–10.

6. Quoted in Sachs, *Renaissance Woman*, 11.

7. Bell, *Women*, 199.

8. Sachs, *Renaissance Woman*, 8, 19.

9. Quoted in O'Faolain and Martines, *Not in God's Image*, 182.

10. Quoted in Sachs, *Renaissance Woman*, 17.

11. Helen K. Affauser, "The Role of Women in the Art of the Netherlands in the 16th and 17th Centuries." Unpublished master's thesis, Smith College, 1947; Sachs, *Renaissance Woman*, 52.

12. See Annemarie Weyl Carr, "Women Artists in the Middle Ages," *Feminist Art Journal* (Spring 1976), 5–10, for more information on women book illuminators.

13. William Fleming, *Arts & Ideas* (New York: Holt, Rinehart & Winston, Inc., 1974), 258–71.

14. Affauser, "The Role of Women in the Art of the Netherlands," 43.

15. Ingvar Bergström, *Dutch Still-Life Painting in the Seventeenth Century* (New York: Thomas Yoseloff, Inc., 1956), 1.

16. Quoted in *Ibid.*, 1.

17. Bernard Myers, *Art and Civilization* (New York: McGraw-Hill & Co., 1967), 305; Nikolaus Pevsner, *Academies of Art, Past and Present* (Cambridge, England: University of Cambridge Press, 1940), 135–36.

18. Bergström, *Dutch Still-Life Painting*, 3, 5, 40, 154, 158.

19. Simone Bergmans, "The Miniatures of Levina Teerlinc," *Burlington Magazine* (1934), 232–36.

20. Until 1950 a locket containing two portraits of young girls at the Victoria and Albert were attributed to Teerlinc, but recent scholarship has identified the painter of the miniatures as the English miniaturist Isaac Oliver.

21. Tufts, *Hidden Heritage*, 51.

22. Gert von der Osten and Horst Vey, *Painting and Sculpture in Germany and the Netherlands: 1500–1600* (Baltimore: Penguin Books, 1969), 199.

23. Ellet, *Women Artists*, 57; Tufts, *Hidden Heritage*, 53.

24. Walther Bernt, *The Netherlandish Painters of the Seventeenth Century*, Vol. 2 (London: Phaidon Press, Ltd., 1970), 92. The others are Margaretha van Godewyck, Judith Leyster, Maria van Oosterwyck, Catherina van Knibbergen, and Rachel Ruysch.

25. Harris, "Clara Peeters," in "Women Artists," 132.

26. *Ibid.*

27. Bergström, *Dutch Still-Life Painting*, 106.

28. Ellet, *Women Artists*, 100.

29. Clara E. Clement, *Women in the Fine Arts* (New York: Houghton, Mifflin & Co., 1904), 309.

30. Ellet, *Women Artists*, 100.

31. Although she has been called the most significant artist of her sex in 17th-century Holland, she is only now emerging from the shadow of her teacher. The first *catalogue raisonné* of her work in English is currently being prepared by Frima Fox Hofrichter, a doctoral student at Rutgers University.

32. Neil Maclaren, *The Dutch School* (London: National Gallery of Art, 1960), 218; Bernt, *Netherlandish Painters*, Vol. 2, 71–72; Seymour Slive, *Frans Hals* (London: Phaidon Press, Ltd., 1970), 19–20, 37, 86; Tufts, *Hidden Heritage*, 71–74; Clement, *Women in the Fine Arts*, 382–83; Frima Fox Hofrichter, "Judith Leyster's 'Proposition,'" *Feminist Art Journal* (Fall 1975), 22–26.

33. Ellet, *Women Artists*, 104–5.

34. Bergström, *Dutch Still-Life Painting*, 191, 220; Bernt, *Netherlandish Painters*, 89.

35. Clement, *Women in the Fine Arts*, 238.

36. Harris, "Maria Sibylla Merian," in "Women Artists," 155.

37. Clement, *Women in the Fine Arts*, 238–40; Tufts, *Hidden Heritage*, 89–93; 244.

38. Bergström, *Dutch Still-Life Painting*, 228; Ruysch's sister Anna Maria also became a still-life painter, but little is known of her career.

39. R. Renraw, "The Art of Rachel Ruysch," in *Connoisseur*, XCII (1933), 397–99.

40. Bernt, *Netherlandish Painters*, Vol. 1, 100.

41. Ellet, *Women Artists*, 34; Guhl, *Die Frauen*, 96; Sparrow, *Women Painters*, 253; Clement, *Women in the Fine Arts*, 119.

42. Quoted in Guhl, *Die Frauen*, 97.

43. Sparrow, *Women Painters*, 253.

44. Bernt, *Netherlandish Painters*, Vol. 2, 68.

45. *Ibid.*, Vol. 1, 44.

46. Ellet, *Women Artists*, 165; Clement, *Women in the Fine Arts*, 339–40.

CHAPTER THREE

The French Academic Tradition

The 18th century has been called the period of Enlightenment or the Age of Reason. With the spread of wealth and education, there erupted challenges to the privileges of the aristocracy and to age-old beliefs and traditions that had controlled people's lives for centuries. New political and economic theories emerged in the wake of revolution and governmental change; an anti-clerical fervor swept Europe; progress, change, and the perfectibility of humanity were the new ideals. The Encyclopedists—Voltaire, Diderot, d'Alembert, Rousseau—authored the first comprehensive reference work for literate Frenchmen in an attempt to "assemble the knowledge scattered over the face of the earth." France tasted democracy, empire, a restoration of the monarchy, and then new revolution as ordinary men and women demanded and fought for personal freedoms that had formerly been the privileges of a few. There, as elsewhere in Europe, the male population slowly was granted individual civil rights, but the lot of the average woman changed little.

EDUCATION AND WORK

Education along class lines was the norm in 18th-century France. In 1683 François Fénelon, a distinguished author and ordained priest, wrote his *Traité de l'éducation des filles*. Primarily concerned with the education of the children of the aristocracy (he was tutor to Louis XIV's grandson), he thought it a disgrace the way "women of wit and good manners" could not pronounce what they read nor spell what they attempted to write. His recommendations for improvement were on the practical side: arithmetic to keep accounts and run an efficient household; law to understand property rights; knowledge of the duties, rights, and responsibilities of lords of the manor; and of the history of France to "enlarge the

mind and inspire the soul with noble feelings." He allowed for the reading of poetry and novels, but only sober works that would not excite the imagination or stimulate the passions.[1]

Madame de Maintenon (a follower of Fénelon), founder of the elite École de St-Cyr, a school for girls, advised former students heading a middle-class convent modeled on the principles of St-Cyr in a series of letters published in 1713 as *Lettres sur l'éducation des filles*. "Educate middle-class girls in the middle-class way," was her urgent advice. This, of course, meant that they should not be concerned with fine pronunciation, elegant handwriting, or the exigencies of grammar. All young girls needed to know was a little arithmetic and their domestic responsibilities. Consistent with contemporary attitudes, Madame de Maintenon warned further: "Tell them that nothing is more displeasing to God and men than stepping out of one's social station—all are ordained by providence, and God resists our endeavors to be other than He intended us to be."[2]

Many feminists of the day felt women's problems were linked to their lack of education or training for trades, which led them into early marriages, work in the lowest paying jobs, or prostitution. The lack of education also precluded their eligibility for political and judicial rights. When in 1792, during the most intense phase of the Revolution, Madame Etta Palm van Aelder presented a petition to the legislative assembly listing the demands of the women of the bourgeoisie, educational reform was a priority. (Also included were legal majority for women at twenty-one, political freedom for women, and legally sanctioned divorce.) The deputies were split on what constituted adequate education for women. While Talleyrand maintained the traditional view that girls should be educated only for domestic life, Condorcet, in agreement with the feminists, declared that "education should be the same for men and

women." He argued that women should be barred from neither higher education nor the professions, nor should they be denied appointments to teach even on the highest levels. And in agreement with the advocates of education for women in all periods of history, he reasoned that an educated woman is apt to be an intelligent mother.[3]

For the poor rural woman in the 18th century there were no schools and little choice of work. The unmarried went into domestic service, where they received room and board and occasionally saved enough for a dowry; married women were engaged in a home industry, such as lacemaking or spinning. The French peasant woman was viewed by her spouse as little more than a slave, doing chores in the field as well as caring for the children.

In the towns women worked mainly in the fashion trades. The poorest did the heaviest and most menial work, and often trained their children to beg. The women of the lower classes were the mainstay of the family. In fact, so important was the peasant and working-class woman to the survival of her family that a contemporary feminist, Madame de Coicy, scolded middle-class and aristocratic women for allowing themselves to be less than equal in the marital arrangement.[4]

According to the Goncourt brothers, the chroniclers of 18th-century womanhood, an over-intellectualized monstrosity developed in the 18th century among certain women of the upper classes. Excessively concerned with the activity of the mind, they became disenchanted with real life; their letters speak frequently of an enervating ennui. To fulfill their intellectual needs a newspaper, *Journal Polytypique*, was founded. It reviewed the "ornamental arts," had digressions on poetry, astronomy, physics, chemistry, botany, physiology, mathematics, the state of the economy, agriculture, navigation and naval architecture, history, and law. Women frequented museums and lecture halls; in 1786 they stormed the doors of the Royal College. The Goncourts attributed this zealous pursuit of the intellect to a spiritual void; love, passion, and the joys of motherhood were prescribed by Rousseau to fill this void and bring women to their "natural state."

In actuality, there were two opposing forces at work in the women of the upper classes during the 18th century—the refined artificiality of the salons and the voracious pursuit of knowledge, neither of which, according to many male writers of the period, was the "natural state of women." The woman whose salon challenged both these currents was Madame Geoffrin, a middle-class woman whose motto was "nothing conspicuous." She advocated simplicity, naturalness, and sincerity as the social virtues that surpassed all others.[5]

WOMEN AND THE SALONS

The salon concept in France emerged gradually during the 17th century, reaching its height in the 18th. The aim of the first powerful salon, the Salon Bleu of Madame de Rambouillet in the 17th century, was to civilize a raw society. By the time of the salons' demise during the Revolution, "manners, and their by-product, artificiality, reigned supreme." (Ironically, the ideas that eventually toppled the *ancien régime* were popularized in the salons.)

Usually in her forties and not necessarily beautiful, well-educated, or exceptionally wealthy (although setting a good table was an asset), the hostess of a salon was judged successful if she had "cleverness, tact, and charm," and an ability to create an environment in which her guests could relax with music and food and exchange ideas on philosophy, art, literature, and politics—often as prelude to publication. Some salon hostesses were creative in their own right: Madame de La Fayette and Mademoiselle de Scudéry were novelists; Madame de Sévigné a famed letter writer; Madame du Châlelet an astronomer and mathematician of note; Madame Elisabeth Vigée-Lebrun a painter; and Madame de Staël, an outstanding literary figure of the period.[6]

Thus, for one brief period in French history, a certain class of women was rewarded for following the advice offered in manuals on appropriate feminine behavior. "Stay at home," they were advised, and "be feminine. Use your charms, and men will bring you the best of themselves and leave the rest of the crude world outside your doors."[7] According to the Goncourts, "Woman was the governing principle, the directing reason and the commanding voice of the 18th century. . . . She held the revolutions of alliances and political systems, peace and war, the literature, the arts and the fashions of the 18th century, as well as its destinies, in the folds of her gown." She was powerful not only in the affairs of state but in her home as well, yet when her guests were gone she resumed the traditional role of subservience to her husband.

Toward the end of the century the ideas of Rousseau began to take hold among the women of the salons. Due to his influence, a barrage of literature and art by male propagandists began to convince women of their innate need for domesticity instead of intellec-

tual pursuits. Coupled with the Revolution itself, Rousseau's philosophy helped topple salon society. Writing nostalgically of this period in her 1835 memoirs, Madame Vigée-Lebrun could say that it was "difficult to convey an idea today of the urbanity, the graceful ease, in a word the affability of manner which made the charm of Parisian society forty years ago. The women reigned then; the Revolution dethroned them."[8]

ROUSSEAU, ROMANTICISM AND THE CULT OF FAMILY

The romanticism of Jean-Jacques Rousseau, which spurned the intellectuality of the Age of Reason, was an anti-urban, anti-civilization attitude that urged men and women to go back to nature and to their natural state of being. While Mary Wollstonecraft, in her *Vindication of the Rights of Women*, supported Rousseau's controversial philosophy, she attacked his contempt for women. The Goncourt brothers, on the other hand, were among his most ardent supporters. To them, Rousseau restored tenderness, voluptuousness, and passion to the heart of women —all the elements they had found lacking in the over-intellectualized women who had dominated 18th-century society.

In *Émile* (1762), Rousseau set forth his philosophy of education: since man is "active and strong," woman should be "passive and weak"; it is man who needs "power and will" while woman needs "little power of resistance." In keeping with the laws of nature, "it follows that woman is especially constituted to please man," and to educate her in the same way as a man is to make her less of a woman and still inferior to man. Therefore, Rousseau continues, "The whole education of woman ought to be relative to man. To please them, to be useful to them, to make themselves loved and honored by them, to educate them when young, to care for them when grown, to counsel them, to console them, and to make life agreeable and sweet to them."[9] In *La Nouvelle Héloïse*, Rousseau embodies the ideal of the new woman in his heroine. Julia, a contented housewife, organizes her day according to the needs of her family. She educates her young children—her daughter in her own image and her son until he reaches the "age of reason" (when he becomes her husband's responsibility). Rousseau has Julie explain: "I nurse children, but I am not presumptuous enough to wish to train men. . . . More worthy hands will be charged

with this noble task. I am a woman and a mother and I know how to keep my proper sphere."[10]

Along with other writers of the Enlightenment, Rousseau severely challenged the traditional child-rearing practices in France, claiming they were responsible for the country's moral degeneration. Childhood now came to be regarded as an important stage of life; homes became more child-centered and parents were encouraged to care for their children at home. In the past, caring for children had been regarded as "debilitating, obnoxious, and coarsening" by both men and women. Children were often kept in servants' quarters until the age of four, and at seven, if they were boys, were apprenticed or sent away to school.

This new promotion of the ideas of romantic love, conjugal bliss, and joyful child rearing echoed 17th-century Holland's view of the home as a place of warmth and intimacy, a refuge from the harsh outside world. French paintings of the late 18th century reflect this new "cult of domesticity"— Greuze's *The Beloved Mother* was a popular attraction at the Salon of 1765—and despite its bourgeois origins, the trend reached the ranks of the aristocracy; even royal families commissioned portraits to celebrate familial life.

These paintings, however, did not truly reflect home life in the 18th century: after an arranged marriage and the production of an heir, the upper-class woman felt free to take lovers and indulge in the pursuit of pleasure, as did her husband. In all strata of society "natural" children were produced in abundance and frequently recognized legally. In fact, artists continued to celebrate illicit love as often as conjugal love. Afraid that women would not conform to their new ideal, male writers of the day extolled the virtues of home and family. Their propaganda actually took hold in the 19th century during the Victorian era, when for a time most women found fulfillment serving husband and children.

WOMEN AND THE REVOLUTION

Although feminism was discussed by all the wits of the 18th century, it became a serious issue during the French Revolution. With promises of liberty, equality, and fraternity, the nascent women's rights movement gained impetus. Many women, spurred by rising expectations, fought alongside their men to end the oppression of the *ancien régime*. Tons of household and dowry linens were stripped for ban-

dages; gold wedding rings helped finance the near-bankrupt revolutionary forces. Women participated in bread riots and marched on the palace of Versailles. Yet, at the Revolution's end, women were neglected: the new reforms applied only to men. The austerity which resulted from the Revolution and the departure from France of the royal family denied many women their jobs in such luxury trades as lacemaking, dressmaking, millinery work, and flower vending. Mothers watched as their children endured malnutrition and then starvation. Homes were destroyed and the future looked dim. With their world crumbling, many women turned to the Church, which upheld the sanctity of marriage, home, and family.[11]

On the political front, both working-class and middle-class women attempted to influence official policy. Since they could not vote, they let their views be known through pamphlets and petitions. Their recommendations included a more equitable arrangement of dowries, a double tax on bachelors, barring men from certain trades (like dressmaking, hairdressing), education for girls, political representation for women by women, and the abolition of male legal rights over wives and daughters. When in 1789 the constituent assembly published the revolutionary "Declaration of the Rights of Man," it was followed quickly by the even more revolutionary "Declaration of the Rights of Women," prepared by Olympe de Gouges, the *nom de plume* of Marie Gouze. Modeled after the earlier document, it began: "This revolution will not be completed until all women are conscious of their deplorable lot and of the rights they have lost in society." Olympe de Gouges viewed the relationship of the sexes as a class struggle between the male oppressor and the female victim. A critic of the Revolution's excesses, she openly attacked Marat and Robespierre, and was guillotined in November 1793.[12]

Various women's societies emerged according to class aims: middle-class women, for example, organized charities to care for the ill, the impoverished, and the displaced victims of the Revolution; their jewels and dowries were used to amortize the war debt. In 1793 the Société des Républicaines was formed, the only independent political party exclusively for women during the Revolution. Its members believed that women's rights were closely related to workers' rights. Firm exponents of the dignity of women, they wanted prostitutes placed in national homes and reeducated. Their militancy helped overthrow the counter-revolutionary Girondists, although when they demanded participation in the delibera-

tions of the Revolutionary Committee of the Commune, they were denied access to the policy-making body. Later, the Jacobins—despite their political radicalism—were hostile to the women's movement. Women's societies were declared illegal and the feminist cause took another step backward.[13] With the enactment of the Napoleonic Code women were further repressed.

FEMINISM AFTER THE REVOLUTION

Early 19th-century feminism was often associated with socialism. Although not all socialists supported the fight for women's rights,[14] it was in the socialist-oriented papers of the Fourierists and Saint-Simonians (a group to which Rosa Bonheur's father belonged) that the writings of the first militant feminists appeared in print. Both groups incorporated feminist concerns in their utopian vision. Fourier claimed that "Social advances and changes of periods are affected by virtue of the progress of women towards liberty, and decadence in the social order is brought about by virtue of the decrease in women's liberty."[15] The Saint-Simonians, too, argued for equal political, legal, and educational rights for women. To facilitate this anticipated freedom the dress of its female constituency was reformed: a uniform was worn consisting of a short skirt or dress over trousers, similar to the attire adopted by American feminists in mid-century.[16]

The Saint-Simonians revered artists, and many were attracted to the movement. Concerned primarily with the social aspects of art, they endorsed the kind of art that would "move the masses." Although they ceased to exist as a formal entity after 1832, their ideas pervaded French thought throughout the century. Indeed many women writers and artists, including George Sand and Rosa Bonheur, traced their intellectual development to either the Fourierists or the Saint-Simonians.[17]

Yet women themselves were divided in their loyalties. Socialist Flora Tristan (1803–1844) found herself alternately abused by French working-class women for her feminist dogma and by the middle-class feminists for her socialism. She proclaimed that the place "to begin [is] by educating women, for it is they who are responsible for bringing up both male and female children."[18]

The feminist groups that arose during the Revolution of 1848 were also rooted in utopian thought. One of the reforms instituted after the Revolution's

failure was the granting of universal suffrage for men. Feminists were outraged, insisting not only on the right to vote, but on running members of their own sex for public office. Jeanne Deroin, a teacher, journalist, and feminist activist, ran for Parliament in 1849. Although she succeeded in publicizing her followers' demands, her candidacy was declared unconstitutional; in 1851, after Louis Napoleon's *coup d'état*, she fled to England.

THE STATE OF THE ARTS AND WOMEN ARTISTS

Based on the academies of Rome and Florence, the Académie Royale de Peinture et de Sculpture was founded in 1648 during the reign of Louis XIV with Charles Le Brun as the first director. Designed to free artists from the regulations and restrictions of the medieval craft guilds and to raise their intellectual and social status, it incorporated a school, the École des Beaux-Arts, to train artists to meet the needs of the developing French Empire and to serve as the arbiter and transmitter of a national style and taste. Its annual Salons exhibited only those paintings that conformed to the Academy's standards.

The first woman to be elected to the Academy (in 1663) was Catherine Duchemin, wife of the sculptor Girardon. Louis XIV applauded her admittance, claiming it was his wish "to extend his support to all those who are excellent in the arts of Painting and Sculpture and to include all worthy of judgment without regard to the difference of sex."[19] However, during the first eighty years of its existence, only fifteen women were admitted. In 1770 the decision was made to limit membership to four women to prevent the Academy from being "overrun" by females. Women were never offered the kind of training granted to men. They could not study at the École des Beaux-Arts or work from the nude model, and they were unable to compete for the Prix de Rome until the end of the 19th century, by which time it was a meaningless award. It was not until Jacques-Louis David opened the Louvre's royal collections to the public that women were able to study the art of the past. During the Revolution the Academy was abolished, but when its doors reopened under David's directorship, more women submitted paintings for exhibition than ever before. The Salon of 1808 had 46 women among the 311 exhibitors and was mockingly called the Salon des Dames; by mid-century there were a third as many women artists as

men. However, no women were awarded the prestigious Legion of Honor until the last years of the century.

The inability to study the live nude model led women artists to perfect the so-called minor forms of painting: portraiture, still-life, floral and animal pieces, and intimate genre scenes. According to Robert Rosenblum, "Such painstaking craftsmanship and unpretentious subject matter seemed particularly appropriate to what the early 19th century viewed as the proper domain for women artists, whose numbers, especially in David's studio, increased at a startling rate around 1800."[20] They rarely painted large historical, religious, or allegorical canvases because these were usually commissioned by Church or State from Prix de Rome winners, and women were prohibited from following this route to success.[21]

LOUISE MOILLON (1610–1696)

One of seven children of the Protestant painter and picture dealer Nicolas Moillon, and Marie Gilbert, a goldsmith's daughter, Louise Moillon was born in Paris. Her early training was probably with her father and stepfather, François Garnier, also a painter and picture dealer. Louise's talents must have developed early: in her mother's effects when she died was a written agreement dated 1620 stating that the profits from the sale of the ten-year-old's paintings were to be shared equally with her stepfather-to-be. Her brother Isaac was also a painter and became a member of the Académie Royale in the 1660s. In 1640 she married Etienne Girardot, also a Protestant, and they had at least three children, two of whom left France for England because of religious persecution. The third, like her mother, converted to Catholicism under duress.[22] Most of the thirty paintings extant attributed to Moillon were painted before 1642, when her first child was probably born.

Primarily a specialist in fruit still-lifes, Moillon was one of the few French artists before 1650 to combine the human figure with still-life. In *At the Greengrocer*, (1630; Louvre) two women are examining fruit plucked from the lavish display set on the table before them. The *Basket of Fruit with a Bunch of Asparagus*, also of 1630 (Fig. 3-1; Art Institute of Chicago), is meticulously painted, with great attention to detail and a bold use of color. Nevertheless, the awkwardly handled volumes and

FIG. 3-1. Louise Moillon, *Basket of Fruit with Bunch of Asparagus* (1630). 21″ × 28⅛″. Courtesy of the Art Institute of Chicago.

space give it a primitive quality. Yet her work has great charm.

Still-life painters did not command the market in 17th-century France that they did in 17th-century Holland, and with the introduction of the hierarchy of styles by the Academy, still-life was ranked below portraiture.

SOPHIE CHÉRON (1648–1711)

At twenty-six Sophie Chéron was admitted to the Académie Royale with a portrait of the Academy's founder (and her sponsor), Charles Le Brun. Her first instruction, in miniatures and enamel painting, had been with her father, a strict Calvinist. Her mother, a Catholic, insisted on sending her to a convent for a year, after which she adopted her faith. Her brother, who did not convert, fled to England because of the religious persecution in France. Chéron supported

him, as well as her family, through the sale of her paintings. Her emotions, according to Ellet, "seemed to have been altogether spiritual," since she did not marry until she was sixty, and was said to have remarked that "esteem, not romantic love, [had] influenced her choice." True to the tradition of the female artist before the late 19th century, Chéron was charming and accomplished. She was a poet, played the lute, translated many of the Psalms into French, and was well-mannered and modest in light of her honors.

Although known mostly for her allegorical portraits, she also did history paintings. Beneath her self-portrait in the Church of St-Sulpice, where she is buried, the Abbé Bosquillon had inscribed: "The unusual possession of two exquisite talents will render Chéron an ornament to France for all time. Nothing save the grace of her brush could equal the excellencies of her pen."[23] Another self-portrait painted at the time of her acceptance by the Academy is at the palace of Versailles (Fig. 3-2).

ANNE VALLAYER-COSTER (1744–1818)

Anne Vallayer received her early training from her father, who was the King's goldsmith and later a designer of Gobelins tapestries before establishing his own studio in Paris in 1754. A precocious and mature talent, praised as well for her beauty and singing voice as for "painting like a man," she was elected to the Académie Royale when she was only twenty-six. Her sponsor was Jean-Baptiste Pierre, painter to the King; her two qualifying works, *Allegory of the Visual Arts* and *Allegory of Music* (now at the Louvre), were exhibited at the Salon of 1771. An unknown at the time, she captured the imagination of critics (Diderot among them) and public alike. In 1781 she married the wealthy lawyer and member of Parliament Jean-Pierre-Silvestre Coster, and thereafter signed her work Vallayer-Coster.

At the request of Marie-Antoinette, whose portrait she had painted, Vallayer-Coster was given a studio in the Grande Galerie at the Louvre. Although she remained sympathetic to the Bourbons, she survived the Revolution, and began showing again in the Salon of 1795.[24] She showed only twice (1804 and 1810) under the Empire; her last Salon appearance was in 1817, the year before her death. Her output was varied and large—444 paintings are attributed to her, many still in private collections—yet she was all but forgotten by the later 19th century.

Ranked with the best of the 18th-century still-life painters, "she created a pleasant and familiar style, of a reassuring poetic realism, opening moderately to neo-classical influences, even figuring belatedly in the period of the Revolution and Empire, which joins the Flemish tradition and the tradition of 'bien peint' so dear to the French 18th century, a thick color with the virtues of subtle lighting and unifying harmony."[25] She often painted in the manner of Chardin, and was frequently accused of plagiarizing from the master, though she was recently exonerated by a biographer, who showed that while her "manner, agreeable and rich with color, is equally precise and firm, it is less mysterious and more detailed than that of Chardin."[26] Although her preference in subject matter was for elegant porcelains and silver and sumptuous fabrics, the artist could also be a poet of the commonplace. *The White Soup Bowl* (1771; private collection, Paris), with dark bread and red wine, shows her delight in the heartiness of the French peasant cuisine.

Allegory of Music (Fig. 3-3), Vallayer-Coster's qualifying piece for her reception into the Académie Royale, is characteristic of the paintings she produced in the next two decades. It is a large painting, composed of strong diagonals and luxurious in color and texture. A lute leans against a music stand in the center of the composition. On the brilliant ultramarine tablecloth are a violin and assorted wind instruments that carry the eye to the rear of the picture space; only the round, flat end of the horn is visible, repeating the circular opening of the lute and wind instruments. In *Still-Life with Sea Shells* (1789) copies of statuettes from the antique are shown on a Louis XVI commode along with shells, corals, and flowers; the exquisitely rendered forms from the sea echo those of the flowers, creating a pleasing unity.

ADÉLAÏDE LABILLE-GUIARD (1749–1803)

Adélaïde Labille-Guiard was admitted to the Académie Royale on May 31, 1783, at the same time as Madame Vigée-Lebrun, considered her arch rival. The Parisian art world had created an artificial competition between the two women which mounted with each Salon. Their work was hung together, their lifestyles were impugned, bawdy poems were written about them and reviews bordered on the

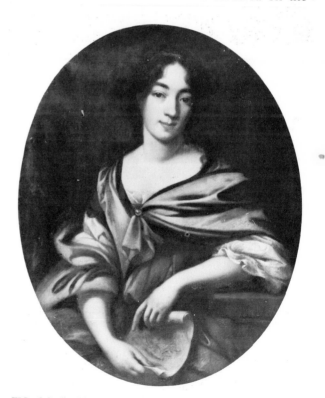

FIG. 3-2. Sophie Cheron, *Self-Portrait* (1672). Copy by Léon Olivie. Musée National du château de Versailles.

FIG. 3-3. Anne Vallayer-Coster, *Allegory of Music* (1770). Musée du Louvre, Paris.

libelous. One critic suggested Vigée-Lebrun had "intimate" knowledge of her male sitters, and was really "mistress of her subject"; others accused La-bille-Guiard of not painting her own pictures, or of having them retouched by a male friend. To silence these rumors Labille-Guiard painted her judges, the Academicians, "under their very eyes . . . so that they could see for themselves if all her talent belonged to her." The publicity surrounding both women at-tracted crowds of to the Salons.[27]

Labille-Guiard lacked the grace and beauty of Vigée-Lebrun, whose fame overshadowed her own during their lifetime and afterward as well. Labille-Guiard's biographer holds Vigée-Lebrun responsi-ble: "She outlived her rival by more than forty years, and it is apparent that she did not encourage the renown of an artist to whom she had always been hostile."[28]

Born in Paris to a father who was a cloth merchant to the courts, Labille-Guiard was surrounded as a child by the ribbons, laces, and satins that she was later to paint with such authority. Since her mother was constantly ill, the neglected child frequented the atéliers of the sculptors in her neighborhood and the studio of the celebrated miniaturist Élie Vincent. (She herself became a minaturist, but abandoned this field for pastels when she sought a more elegant clientele.) She also studied with the pastellist Maur-ice Quentin de la Tour and with Élie's son François-Andre with whom she had a lengthy alliance despite her marriage to Louis Nicolas Guiard, a civil servant with the Department of Finance. She was not free to marry Vincent until divorce was legalized during the Revolution.

Labille-Guiard's first success as a pastellist was in 1774 at an exhibit at the Academy of St. Luke. In 1782, when she applied for admittance to the Ac-adémie her colleagues urged her to ask the Minister of Arts, a friend, to intervene. (Marie-Antoinette intervened on behalf of Vigée-Lebrun.) Her accept-

FIG. 3-4. Adélaïde Labille-Guiard, *Portrait of the Artist with Two Pupils, Mlle. Marie Gabrielle Capet and Mlle. Carreaux de Rosemond* (1785). 83″ × 59½″. Metropolitan Museum of Art, New York. Gift of Julia A. Berwind, 1963.

FIG. 3-5. Adélaïde Labille-Guiard, *Portrait of
Dublin-Tornelle* (c. 1799). 28½″ × 22½″. Courtesy of
the Fogg Art Museum, Harvard University,
Cambridge. Grenville L. Winthrop Bequest.

ance piece was *Pajou Modeling the Portrait of
Lemoine, His Master,* in which she was said to have
surpassed herself with her brilliant color, careful
drawing, and "intensity of life."[29] The pastel medi-
um had long been ignored by the Academy when
Labille-Guiard presented herself; her pastels were
described as having all the vigor of oil paintings.

The *Self-Portrait with Two Pupils* (Fig. 3-4;
Metropolitan Museum of Art) created a sensation at
the Salon of 1785. The artist has shown herself
fashionably dressed while working at her easel. Two
students hover over her—one looking at the canvas,
the other at the viewer.[30] A bust of her father and casts
from antiquity are in the background. One critic
gave her what to him must have been extraordinary
praise—". . . this artist is of very distinguished and
rare merit, since she joins to the graces of her sex the
vigor and the force which characterize the work of a
man." To which a woman writer retorted:

That woman is a man, I hear endlessly in my ear. What
strength in her work, what decision in her tone and what
knowledge of effects, of perspective of bodies, of groups

and finally of all parts of her art. It's a man, there is
something there; it's a man! As if my sex were eternally
condemned to mediocrity and its works to always hear the
stamp of its weakness and old-fashioned ignorance.[31]

At this time Labille-Guiard was given a royal
pension and appointed official painter to the Mes-
dames of France—Elisabeth, Victoire, and Adélaïde,
the King's aunts. Their portraits were shown at the
Salons of 1787 and 1789; none had the grace or flair of
Vigée-Lebrun's likenesses. Indeed, their very lack of
flattery may explain why all the most beautiful
women of the day preferred to have her rival paint
their portraits.

When the Revolution broke out, Labille-Guiard
supported its reforms, especially its promise of a new
role for women. She urged reforms in the Académie
Royale as well, helping to pass a resolution that
admitted women "without a predetermined quota"
and fighting for their right to be professors in its
schools. But the Académie was abolished, and when
reorganized under David's directorship, women were
denied membership. Labille-Guiard adapted well to
the taste of Revolutionary France and turned to new
ideas and new heroes. She painted the portraits of
Robespierre, Talleyrand, and all the deputies of the
Assembly. Now in a private collection in France, the
Portrait of Robespierre reveals none of the sadistic
qualities of the Revolutionary leader, who looks
instead like an engaging and mischievous dandy.
This oil is believed to be a copy of the pastel
exhibited at the Salon of 1791.

In 1971 the *Portrait of Dublin-Tornelle* (Fig. 3-5;
Fogg Art Museum, Harvard University), attributed
to David since 1851, was reassigned to Labille-
Guiard. The actor, in brown coat and "Brutus" style
haircut, poses with his arms folded; in one hand he
holds a manuscript. The catalogue of the Salon of
1799, in fact listed a portrait of the actor by "Cito-
yenne Labille dit Guiard." When the painting was
submitted to microscopic and ultraviolet examina-
tion, the remnants of what appears to be Labille-
Guiard's signature were found on the manuscript
near Dublin's pointing finger. David's signature was
adjudged a later addition.[32]

ELISABETH-LOUISE VIGÉE-LEBRUN (1755–1842)

As with countless other talented children, Elisabeth-
Louise Vigée-Lebrun recounts her earliest interest in
drawing by writing in her memoirs that at the
boarding school she attended from age six through

eleven, she "scrawled on everything at all seasons; my copy-books, and even my school mates, I decorated with marginal drawings of heads, some full-faces, others in profile." But unlike many such children, she was the daughter of an artist—a well-known pastellist and professor at the Academy of St. Luke. In her father's studio she met many famous artists and men of letters who encouraged her; after his premature death when she was twelve, she was advised by Joseph Vernet to "not follow any system of schools," but to "consult only the works of the great Italian and Flemish masters" and above all to "make many studies from Nature. Nature is the supreme master."[33] She went to see the Rubenses in the Luxembourg Palace and the Italian old masters at the Palais Royal and made copies from Rubens, Rembrandt, and Van Dyck heads, "as well as several heads of girls by Greuze, because these last were a good lesson to me in the demi-tints to be found in delicate flesh coloring."[34]

By the time she was fifteen Vigée-Lebrun left Gabriel Briard's studio and began her professional career. Enchanted by her talent and beauty, patrons flocked to her studio. So lovely was she that she could walk nowhere without attracting admirers who often commissioned portraits from her in hopes of securing her "good graces." Her mother urged her into marriage with the picture dealer Jean Baptiste Pierre Lebrun. She was full of doubt on her wedding day and later wrote: "I was earning a great deal of money so that I felt no manner of inclination for matrimony." Her hesitation was justified, for Lebrun used all his wife's earnings to repay his creditors and support his flamboyant lifestyle. He also insisted she give lessons to supplement the income from her commissions. Although she had earned over a million francs before the Revolution, she had but twenty to her name when she was forced into exile in 1789. The couple lived independent existences, occupying separate quarters in the same house, where she held her famous evening parties to which musicians, poets, artists, and high society flocked. Lebrun was considered a tolerant husband, never interfering with the sometimes questionable persons who visited his wife. He did not follow her into exile, and she divorced him while in Vienna in 1794.[35]

Vigée-Lebrun's fame extended to dukes and duchesses, princes and princesses, and heads of state—all of whom came to her studio to have their visages recorded for posterity in a highly flattering manner. In 1779 she was called to Versailles to paint Marie-Antoinette and was named official painter to the Queen, with whom she developed a close relation-ship. Vigée-Lebrun painted at least twenty portraits of the Queen, including the imperious *Portrait of Marie-Antoinette with a Rose*.

When Vernet submitted her name for membership in the Académie Royale, Jean-Baptiste Pierre, First Painter to the King, objected; her acceptance in 1783 came only after the intervention of the Queen. Vigée-Lebrun's reception piece was the allegory *Peace Bringing Back Plenty*. In an attempt to discredit her, Pierre spread rumors to the effect that the painter Ménageot had retouched the work as well as others to which she signed her name.[36]

The last canvas Vigée-Lebrun painted of the doomed Queen, still in the palace of Versailles, was *Marie-Antoinette and Her Children* (Fig. 3-6; 1788). Seated regally with delicate feet resting on a brocaded cushion and dressed in brilliant red satin trimmed in fur, her hair elegantly coiffed and hat fully plumed, the Queen is surrounded by her three children. (In the interim she had given birth to a malformed daughter who subsequently died; the young Dauphin is shown pointing to the empty cradle where the new princess would have rested.) Because of her extravagances and the country's financial difficulties, Marie-Antoinette was so unpopular by now that she could no longer show her face in Paris. Vigée-Lebrun's canvas was hung near Labille-Guiard's *Portrait of Madame Adélaïde* at the Salon of 1788, and—given the political situation—the iconography of the two paintings may be compared. The Labille-Guiard painting refers to the past, to a nobler period in French history: Madame Adélaïde is surrounded by her virtuous relatives—father, mother, and brother. Marie-Antoinette is surrounded by her children, symbols of the future of a now corrupt dynasty.[37]

On the fateful day in 1789 when the masses marched on Versailles, Vigée-Lebrun and her daughter became part of the stream of refugees pouring out of France to escape the guillotine. Since her fame was already great, she was welcomed by the nobility and flooded with commissions wherever she journeyed in her ensuing twelve years of exile. Her first stop was Turin, where she stayed briefly. In Bologna she examined the old masterpieces and was made a member of the Academy, an honor repeated in each city she visited. In Florence she was asked to add her own portrait to the collection of self-portraits of the famous in the Uffizi. Completed in Rome (where she stayed eight months), it was immediately recognized as one of her best paintings. Ménageot, by then director of the French Academy in Rome, wrote ". . . it is one of the most beautiful things she has ever done; I found that she has extended her ability since

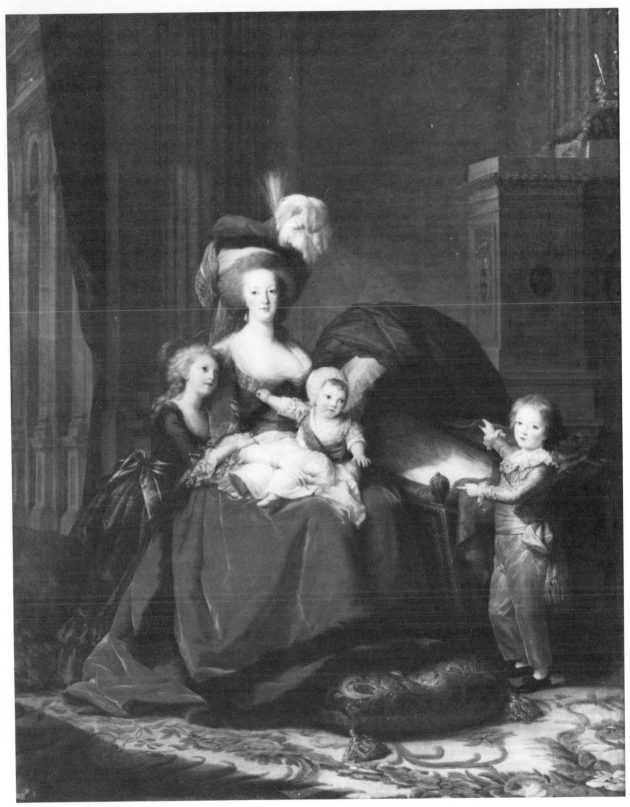

FIG. 3-6. Elizabeth-Louise Vigée-Lebrun, *Marie -Antoinette and Her Children* (1788). Musé National du chateau de Versaillès.

her departure from Paris." Indeed, the self-portrait created a sensation, the artist being hailed as "Madame Van Dyck" and "Madame Rubens." From Naples Vigée-Lebrun sent a portrait of Paisiello to the Salon, where it was hung as a pendant to one of David's portraits. When David viewed her work, he is reported to have said to his students: "They will think that my canvas was painted by a woman, and the portrait of Paisiello by a man." After a total of three years in Italy, she visited Vienna, Prague, Dresden, and Berlin on route to St. Petersburg, where she lived for six years and painted almost fifty portraits.

The Revolution finally over, Vigée-Lebrun returned to Paris at the age of forty-six. She tried to resume her old style of life, but compared to the opulence of foreign court life, democratic Paris seemed dull. After a mere six months she was off to London, where the demand for her work kept her busy for three years and won her the praise of Sir

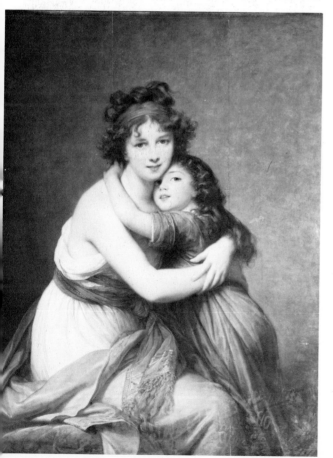

FIG. 3-7. Elizabeth-Louise Vigée-Lebrun, *Madame Vigée-Lebrun and Child (in Greek Toga)*. Musée du Louvre, Paris.

Joshua Reynolds. In 1805 she was again in Paris, and aside from two visits to Switzerland (where she executed almost 200 pastel landscapes), her remaining days were divided between her country house in Louveciennes and Paris, where she died in her 87th year.[38] Her extensive oeuvre included 662 portraits, 15 large history and allegorical paintings, and over 200 landscapes.

Vigée-Lebrun was often criticized for the superficial quality of her portraits, which were said to lack psychological depth. Aware of the problems facing the portrait painter desiring both to please the sitter and to create an interesting composition, she wrote in her memoirs: "I endeavored to capture the women I was painting, and whenever possible, the attitude and expression of their countenance; with those who lacked character (they exist), I painted dreamy and languid poses." The *Portrait of Madame Grant* (1783; Metropolitan Museum of Art) is typical of the many portraits of insipid women in which she concentrated on creating delicate flesh tones and a virtuoso rendition of fabrics and feathers. She was not, however, incapable of capturing the aggressive qualities of some of her male subjects, as in the portrait of the painter Hubert Robert (1788). Nor was she immune to the Neoclassical ideals pervading French art before the Revolution: her *Self-Portrait with Her Daughter* (Fig. 3-7; Louvre) is set against a minimal background, and she is sporting a Greek toga and the hair style made fashionable by David in his portrait of Madame Récamier.

MARGUERITE GÉRARD (1761-1847)

Marguerite Gérard has usually been dismissed as Fragonard's mistress and frequent collaborator. Paraphrasing David, George Levitine wrote in a 1968 article: "In neglecting Marguerite Gérard, one would risk exposing oneself to the lasting reproaches of history."[39]

Born in Grasse in Provence, she was the daughter of a perfume distiller. Her sister, eleven years her senior, was married to the celebrated Rococo artist, Jean Honoré Fragonard. When at fourteen she moved to Paris to live with her sister, she became Fragonard's pupil. Recently, their amorous relationship has been questioned: the only affectionate letters from Gérard to Fragonard that have been recovered date from 1803, when she was in her prime and the old master already seventy-one and retired. They collaborated on at least two paintings—*The Kiss*, usually attributed to Fragonard, and *La Liseuse*,

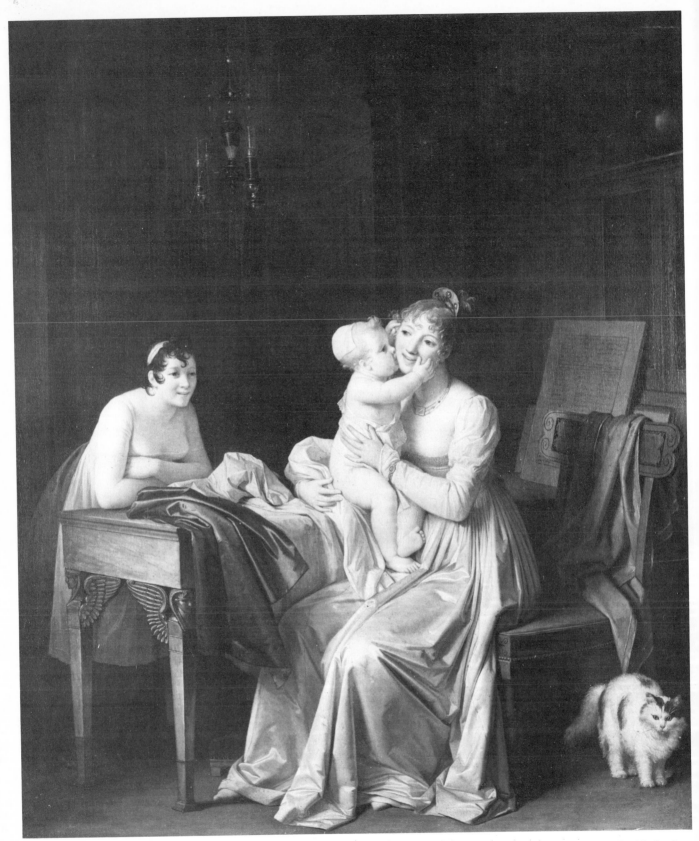

FIG. 3-8. Margueriet Gerard, *Motherhood* (c. 1805). 24″ × 20″. Baltimore Museum of Art. Mrs. Elise Daingerfield Collection.

generally thought to be by Gérard; however, no extant paintings have joint signatures.[40]

Although denied admittance to the Académie Royale because of its restriction against female membership, Gérard developed a reputation before the Revolution that was on a par with that of Labille-Guiard, Vigée-Lebrun, and Vallayer-Coster. Despite her illustrious brother-in-law's royal connections, she survived the Revolution and was among the many women who presented their valuables to the National Assembly to help amortize the war debt. She exhibited with regularity in the Salons from 1799 through 1824, retiring when critics accused her of being repetitious and outmoded. At the Salon of 1801 she was awarded a Prix d'Encouragement, in 1804 a gold medal, and in 1808 her only known contemporary history painting—La Clémence de Napoléon à Berlin, was purchased by the Emperor, who subsequently commissioned additional works. Her intimate genre scenes were popular with both critics and middle-class patrons. Their small size made them suitable for hanging in the home, while their familiar subject matter and adherence to reality made them easily appreciated. Prints after her paintings helped spread her reputation among the general populace.

Because Gérard never married, critics have interpreted her preoccupation with themes of "courtship, motherhood, and domesticity" as a sign of feminine frustration. But Sarah Robinson suggests her single state was chosen deliberately in order that she might immerse herself in her work without familial distractions. Moreover, the themes of motherhood and domesticity were also dominant in the art of Boucher, Fragonard, Greuze, and countless other male artists bent on promoting the new concepts of childhood and the family as presented by the philosophers of the Enlightenment. Gérard, however, never succumbed to the extravagant sentimentality of many of her male colleagues. The "jewel-like" First Step (c. 1780; Fogg Art Museum, Harvard University) demonstrates her early debt to Fragonard. A chubby baby is the focus of female adulation; the women, as always, are elegantly gowned and coiffed, indicating that the joys and not the burdens of parenting were her preoccupation.[41]

By 1785, when Gérard began to study the Dutch 17th-century genre painters then so popular with the French aristocracy (and in the Royal Collections to which she had access), the influence of Fragonard disappeared from her work. She had also left the home of her sister and teacher and was ensconced in her own studio and lodgings. The style developed by Gérard and Louis Boilly in the 1780s merged the clarity, order, and rationalism of French Neoclassicism with the intimacy of Metsu and his circle. (Motifs such as wall maps, Oriental rugs, convex mirrors, and the brilliant use of a single source of light—all Dutch devices—are found in many of Gérard's paintings.) This mature style characterizes Motherhood of c. 1805 (Fig. 3-8; Baltimore Museum). There is a general "neatness" in the painting, with form, composition, and brushstrokes all firmly controlled. The classical handling of drapery has none of the exuberant movement of her style in the early 1780's.[42]

Gérard's success as a genre painter inspired many younger women, and an unprecedented number of them exhibited in the Salons during the Empire and Restoration, some even venturing into large-scale history paintings, a traditional male preserve. Indeed, genre painting was viewed by the Academicians as only slightly less demanding than history painting, and several notches above still-life and portraiture, the traditional preserves of the female artist.

CONSTANCE MARIE CHARPENTIER (1767–1849)

Best known in the 19th century for her life-sized heroic paintings of Ulysses Finding Young Astyanax at Hector's Grave and Alexander Weeping at the Death of the Wife of Darius—considered "extraordinary as the work of a woman"—Madame Charpentier (née Blondelu) was born in Paris in 1767. She studied with Lafitte, Gérard, and Bouillon, but the artist with whom she is traditionally associated is David. In 1788 she received a Prix d'Encouragement and in 1819, at her last Salon, a gold medal. Between 1795 and 1819 she exhibited over thirty genre scenes and portraits of women and children in at least ten Salons.

Marie Charpentier emerged from obscurity when in 1951 the Portrait of Mlle. Charlotte du Val d'Ognes (Plate 1), bequeathed to the Metropolitan Museum of Art as a work by David and for many years one of its most popular paintings, was reattributed to her by Charles Sterling. David scholars had long been impressed by this work, which Andreé Malraux once described as ". . . a merciless portrait of an intelligent, homely woman against the light and bathed in shadow and mystery, . . . The colors have

the subtlety and singularity of those of Vermeer. A perfect picture, unforgettable."[43]

An appealing young woman, perhaps sixteen or seventeen, is shown sitting near a window holding a large sketch pad in her lap as she gazes at the viewer. Her hair, skin, dress, and the rose-colored cloth draped carefully on a blue chair are enlivened by the light emanating from the window with its broken pane of glass. The room in which she is sitting is bare, suggesting a studio; outside the window is a building and a balcony where an animated couple stands. The picture conveys all the earnestness and innocence of youth.

Sterling, who himself considered the painting a work by David (albeit quite at variance with his oeuvre) began to question the attribution when he found the d'Ognes portrait among the paintings reproduced in an engraving illustrating the Salon of 1801, a Salon that David deliberately boycotted. After examining the records for that year, and then comparing the Metropolitan's portrait with *Melancholy* (Amiens Museum)—one of only two works signed by Charpentier—which was exhibited in the same Salon, he found similarities in drawing, proportions, the luminosity of skin tones, and the handling of fabric details, thereby deducing that the painting was the work of Charpentier.[44] Ironically, the painting that had for years been admired by scholars and public alike as one of David's most astonishing portraits of a woman had suddenly acquired feminine attributes: "Its poetry, literary rather than plastic, its very evident charms, and its cleverly concealed weakness, its ensemble made up from a thousand subtle attitudes, all seem to reveal the feminine spirit."[45]

The painting *Melancholy* has as its source the figure of Camilla in David's *Oath of the Horatii*. A classically inspired figure is silhouetted alone against an almost monochromatic setting. The arch of the body is echoed in that of the romantic landscape on the left. Classifiable in neither the Neoclassical nor the Romantic mold, it "is a telling indication of how the artists of the next generation could change their masters' emphasis upon public, politically oriented emotions to a new exploration of states of private feeling unrelated to the social goals that activated so many artists at the time of the Revolution."[46] Inspired by the writings of Rousseau and the growing Romantic movement in art, the isolated figure of Melancholy became a popular subject in late 18th-century and early 19th-century French and English art.

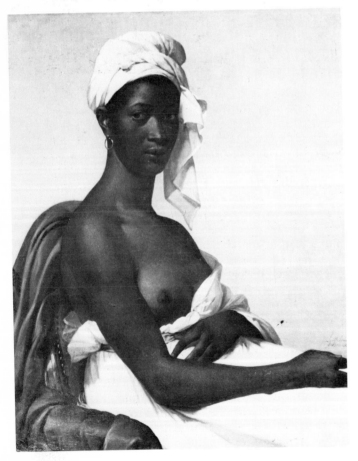

FIG. 3-9. Marie Guillemine Benoist, *Portrait of a Negress* (1800). 31⅛″ × 25⅝″. Musée du Louvre, Paris.

MARIE GUILLEMINE BENOIST (1768–1826)

There exists in the Louvre an extraordinary portrait of a young black woman in a white turban sitting in a green chair on which is draped a cloth of a darker green. The uninterrupted background adds to the power and beauty of this painting by Marie Guillemine Benoist, a student of Vigée-Lebrun and David. It is the influence of David, however, that permeates the *Portrait of a Negress* (Fig. 3-9) painted for the Salon of 1800.

Born Marie Guillemine Leroux de la Ville, the artist was the daughter of an administrative official. Her first works, exhibited at the Exposition de la Jeunesse from 1784 through 1788, were mostly pastel portraits in the soft modeling technique favored by

Vigée-Lebrun. However, when she was temporarily placed in David's atelier at the Louvre—much to the distress of the director, since the King had decreed that no women could study in the Louvre—while Vigée-Lebrun's studio was being remodeled, she adapted his more severe style. Emulating her new teacher, the young artist submitted two history paintings to the Salon of 1791: *Innocence between Virtue and Vice* and *The Farewell of Psyche*. In 1793 she married Pierre Vincent Benoist, an active supporter of the monarchy, thereby jeopardizing her career as well as her life during the Terror. But she exhibited again at the Salon of 1795, with two portraits and the painting *Sappho*, her last based on the antique.

In the early 1800s Benoist showed mostly sentimental scenes of family life, which had gained popularity among the middle classes. In 1803 or 1804 she was commissioned to paint Napoleon and members of his family. Following the best Neoclassical tradition, her portrait of Marie Pauline Bonaparte, now at the palace of Versailles, shows the royal lady sitting stiffly but regally on a settee. In 1804 Benoist was the recipient of a gold medal; her last Salon entry was in 1812. Evidently she painted little in the last years of her life. She did, however, establish a studio for women, about which little is known.[47]

ANTOINETTE CÉCILE HORTENSE HAUDEBOURT-LESCOT (1784–1845)

According to Bénédite, Haudebourt-Lescot was "a strange creature, who, at the start, owed the popularity she obtained as much to her personal charm as to her real talent."[48] A family friend, the artist Guillaume Guillon (also known as Lethière), was her first teacher and "mischievous tongues" insisted that he painted or retouched her work. Their relationship lasted for many years. Not only did he introduce her to high society—by whom she was admired for her dancing ability—but he allowed her to accompany him to Rome when he became director of the French Academy there. Although criticized for her scandalous liaison, she thereby became one of the few French female artists to benefit from study in Rome. Struck by the picturesque quality of the Italian countryside and its inhabitants, she was one of the earliest artists to show the Romantic interest in local color and customs.

The paintings she sent to the Salons from Italy delighted fashionable Parisians, and in 1810 (her first Salon) she won a second-class medal. Full of

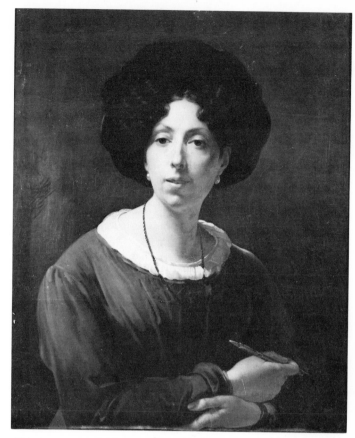

FIG. 3-10. Antoinette Cecile Hortense Haudebourt-Lescot, *Self-Portrait* (c. 1825). 29¼" × 23⅜". Musée du Louvre, Paris.

"wit and inventiveness, and at times a delicate grace," her paintings deteriorated when the demand for them caused her to begin producing "unduly hurried work." The lithographs she did after her own work, as well as engravings commissioned from her paintings, helped popularize her art. Since few of her paintings have been located, it is from these prints that we know her Italian genre scenes. Typical of the paintings on this period is *A Good Daughter*, known from the engraving by S.W. Reynolds. A young woman is shown assisting an elderly woman across a low, narrow bridge. Both are dressed in picturesque traditional costumes; it is a charming portrayal of peasant life.

In 1816, the artist returned to Paris and married the architect Haudebourt. During the next thirty years she exhibited over 110 paintings in the Salons, many scenes reminiscent of her Italian sojourn. However, after being acclaimed for two portraits shown at the Salon of 1827/28, she submitted only portraits. Her *Self-Portrait* (Fig. 3-10) painted in 1825 when she was

forty, is a refreshingly honest portrayal, especially when compared with those of Gentileschi and Vigée-Lebrun. According to a contemporary writer, "She was ugly and captivating, with crooked eyes and a charming expression, her mouth ill-shaped, but tender and inviting."[49] The beret and heavy chain are reminiscent of Rembrandt's self-portraits, and the moody atmosphere shows an entrenched Romantic at work.

Respected by her colleagues, Haudebourt-Lescot was the only female artist portrayed in François-Joseph Heim's painting showing Charles X presenting awards after the Salon of 1827. In 1830 she was one of the artists commissioned to paint the likenesses of French historic figures for the palace of Versailles.[50]

FÉLICIE DE FAUVEAU (1802–1886)

Félicie de Fauveau was alive when Elizabeth Ellet wrote her book on women artists in 1858. So highly esteemed was she then that Ellet devoted thirteen pages to describing her life and work; Labille-Guiard had a paragraph devoted to her, Gérard a sentence, and Vallayer-Coster was completely ignored.

Unlike the majority of artists in this survey who received their initial encouragement or training from their fathers, Félicie was stimulated by her mother, a woman of taste and intelligence with knowledge of both music and the arts. She was also one of the few not of the artisan class. Born in Tuscany, where her aristocratic parents had temporarily settled after being exiled as Royalists during the Revolution, she was taken back to Paris as an infant. (Her subsequent life was broken up into periods of exile and return, depending upon the fate of the Bourbons.) Her studies included ancient history, classic and modern languages, archaeology, and medieval heraldry. Following some experimentation with oils, she decided to pursue the study of sculpture after observing workers in a shop devoted to modeling figures for the churches of Besançon, where her family was then residing. She took for her inspiration the decorative Mannerist Benvenuto Cellini.

When her father died, this dilettante daughter of impoverished nobility became the sole support of a family of six. Her first exhibited piece was based on Sir Walter Scott's novel, *The Abbot*. Encouraged by its favorable reception, she next did a bas-relief with six figures, of Queen Christina of Sweden and Monaldeschi in the "fatal gallery of Fontainebleau"; for it she was awarded a gold medal. One of her goals was to renew interest in sculptural form, which had been the province of the goldsmith and silversmith in earlier periods. To this end she designed ornamental pieces that were in demand in England as well as France and helped revive the fashion for medieval ornaments which found its ultimate expression in the art of the Pre-Raphaelites.

The de Fauveau family thrived in Paris during the reign of Charles X (1824–30), playing host to some of the brightest literary and artistic luminaries of the period. Paul Delaroche, Baron Gros, and Ary Scheffer would gather around a large table and improvise drawings or model in clay or wax. Félicie was commissioned to model two doors for the Louvre and a baptistery and pulpit for a local church when the Revolution of 1830 erupted, forcing her again to be exiled from Paris. Still a supporter of the Bourbons, she incurred a seven-month term in jail because of her outspoken views and her activity on their behalf. Ever the artist, she worked diligently in prison, modeling small groups that often had a political theme.

Upon her release she journeyed to Florence, where she set up a studio near that of the American sculptor, Hiram Powers. Working in terra cotta, marble, wood, bronze, gold, silver, steel, and iron, the artist produced works with a "superabundant richness of ornament and allegorical device" that found their way into private and public collections in Italy, France, England, and Russia. A bronze *St. George* and a *St. Dorothea* were exhibited at the Paris World Exposition of 1855. An indefatigable worker, she filled her studio with the models for her countless commissions, as she continued to perfect her skill and develop new techniques for casting.

One of de Fauveau's most imposing works is the tomb of Louise Favreau (Fig. 3-11), commissioned around 1856 by the dead girl's parents. Now is the church of S. Croce, Florence, it is typical of her Gothic-inspired monuments. The architectural background is in three sections; in the center is an angel and on either side the family mottoes and crests.[51]

Félicie de Fauveau was unique among women artists of the 19th century in that she was a member of the aristocracy and a political activist who was jailed for her views. She was respected by the Romantic painters, was an early exponent of the Gothic Revival, and a progenitor of the Pre-Raphaelite move-

ment. Celebrated in mid-19th century, she was all but forgotten by its close, and little has been done since to shed light on her life and art.

ROSA BONHEUR (1822–1899)

Rosa Bonheur was the first woman artist to gain recognition on her own terms. Neither beautiful nor charming, nor endowed with the "feminine" talents for singing or dancing, she was judged, like her male colleagues, solely on the work she produced:

She revealed what woman was capable of in the matter of energy, of continuity of purpose, of method, of scientific direction. . . . Before her day, the woman-painter had always been looked upon rather as a phenomenon, or her place in the domain of art was conceded to her on the grounds that she was indulging in an elevating and tasteful pastime, coming under the category of "accomplishment." Rosa Bonheur gave to women a position equal to that of man. She won for herself unanimous admiration, based, not on social triumphs, not on friends at Court, but on her robust, virile, observant and well-considered talent, which in its turn was based on a primary study of anatomy and osteology, developed by a continuous observation of the constitution and life of the animal world.[52]

Highly independent, she broke many of the conventions of her day, smoking cigarettes when no "lady" did, purchasing an estate when few women owned property, bobbing her hair and wearing male attire in order to freely wander the streets and countryside, stockyards and horsefairs in search of new subject matter. She disdained marriage in favor of a career because, in her own words, "I well knew that I would lose my independence were I to take on household and wifely duties [and] I preferred to keep my own name. I believe I have been able to give to it some renown"[53]

Born Rosalie Marie Bonheur, she was the daughter of artists. Her mother, Sophie Marquis, was a student in Raymond Bonheur's drawing classes in Bordeaux and later married her teacher. In 1829 Raymond brought his growing family to Paris, but pupils were hard to come by on the eve of yet another revolution. It was during this period that Raymond left his family to live with the Saint-Simonian group at Ménilmontant. The children were exposed to many of the brilliant men associated with the movement. Although they were persecuted for their father's beliefs, Rosa was later to write: "The moral brace which I re-

FIG. 3-11. Félicie de Fauveau, *Tomb of Louise Favreau* (c. 1856). Church of Santa Croce, Florence.

FIG. 3-12. Rosa Bonheur, *Plowing at Nivernais* (1849). Musée du Louvre, Paris. On loan to Fontainbleau.

FIG. 3-13. Rosa Bonheur, *The Horse Fair* (1853–1855). 96¼″ × 199½″. Metropolitan Museum of Art, New York. Gift of Cornelius Vanderbilt, 1887.

ceived from the Saint-Simonian connections has remained with me to this day.''[54]

Rosa's education was sporadic, since she preferred the freedom of the countryside to the regimentation of the classroom. However, Raymond continued to enroll her in the schools where he gave drawing lessons in lieu of payment for his son's tuition. She explained in her memoirs:

This was, I believe, the first pronounced step in a course which my father always pursued with us children and which in modern times has been named co-education. The influence which it had on my life cannot be exaggerated. It emancipated me before I knew what emancipation meant and left me free to develop naturally and untrammelled. . . .[55]

After an abortive attempt to apprentice his daughter to a seamstress, Raymond allowed her to spend her time exploring the materials in his studio. Impressed with her progress, he devoted himself to her instruction and then sent her to the Louvre to study and copy the old masters. He was her only teacher. When her younger brothers finished their formal education, they too joined Rosa in their father's studio. Auguste became a painter and Isadore, a sculptor, though neither ever achieved the fame Rosa was to enjoy. Proud of her brothers' talents, Rosa wrote to Isadore in 1850: "What I want is for us to be known as the three Bonheurs. As for Juliette [the youngest child, born in 1830 and already married], she has too much of the motherly instinct in her for my taste, and I am afraid she will get less happiness out of having children than from an artistic career.''[56]

By the time she was seventeen, Rosa Bonheur was committed to a life in art. After working at landscapes, historical paintings, and genre scenes, she finally discovered the direction of her art with her first serious animal study—a goat. She procured limbs from the butcher in order to dissect and then study their masculature; as her fame spread, donkeys, mules, goats, and sheep were sent to her by admirers from all over Europe. Bonheur's first Salon appearance was in 1841, when her "two charming little groups of a goat, sheep, and rabbits" were greeted favorably by critics and public alike.[57] Her career accelerated when she received a gold medal for *Plowing in Nivernais* (1849), which was purchased by the government for permanent hanging in the Louvre (Fig. 3-12). It is a large painting showing weary oxen and equally weary men doing ordinary work. There is no drama and no conflict. Indeed, what excited the contemporary viewer was the absolute "truth and simplicity" of the scene. In his review of the Salon of

1849, the critic Théophile Thoré wrote: "Mlle. Rosa paints almost like a man,"—high praise in those times. Over one hundred years later, John Canaday echoed similar sentiments: "We frequently regard it as an accolade to say of a woman painter that she paints like a man, and this can be said of Rosa Bonheur."[58] At the time of this first success she also became director of the state-run School of Design for girls, succeeding her father.

Bonheur became internationally famous with her life-sized painting of the *Horse Fair* (1853; Fig. 3-13), now in the Metropolitan Museum of Art. Rather than painting the Parisian horse auctions in an anecdotal manner, as had many of her contemporaries, Bonheur captured the raw energy and force of the wild animals in captivity. She worked tirelessly on the painting for about eighteen months, making innumerable studies from life. It is reminiscent of the dramatic animal paintings of Théodore Géricault, whose study of horses she tacked to her wall while doing the painting. Awarded a first-class medal for the *Horse Fair*, she was also according to French tradition entitled to the Cross of the Legion of Honor. However, she was refused the decoration because she was a woman. Her admirers were indignant, but to no avail. When she was finally awarded the medal in 1864, Empress Eugenie, acting as Regent for her husband Napoleon III, came to her studio to personally deliver it. Bonheur thus became the first woman to be so honored. In 1894 another barrier was overcome when she was named an Officer of the Legion of Honor for her work the previous year at the Chicago Columbian Exposition.

During the latter part of her life, Bonheur was better known in England and the United States than in France; almost everything she painted found a market in the U.S. As a result of a misunderstanding with the French government over the *Horse Fair* (she was asked by the Minister of Fine Arts to make some alterations in the canvas before its purchase by the state and refused), she rarely exhibited in the Salons. In 1853 she travelled with the painting to England and, upon Queen Victoria's request, exhibited it at an audience in Buckingham Palace. It was purchased by an American for the magnificent sum of 268,000 francs and donated by a later owner, Cornelius Vanderbilt, to the Metropolitan Museum. A smaller version, now at the National Gallery in London, was sent to an engraver, and prints after the painting sold exceedingly well in both England and America, where it was hung on every schoolroom wall. A Rosa Bonheur doll dressed in the artist's unique attire, was

created and one of the proud possessors was the young Anna Elizabeth Klumpke, her future biographer, who was then a small child living in San Francisco.[59]

Bonheur was an indefatigable worker. In a letter to her brother Isadore she wrote (1869): "Life is awfully stupid, but we have got to live; and to live well, the best thing is to work." Fortunately, she had her life-long friend, Nathalie Micas, to handle the details of her life so that she was free to devote all her energies to her work. A friend, Princess Stirbey, wrote of their relationship:

Rosa Bonheur could never have remained the celebrated artist she was without someone beside her, at each instant, to spare her the material cares of the household, daily worries of existence, and to help her also with moral and physical support, as well as with advice in many things related to her art. Nathalie made herself small, ungrudgingly, so that Rosa might become greater. . . .[60]

Dependent upon direct observation of nature, Rosa Bonheur was a member of no school, and as far as is known was not acquainted with any of the Barbizon artists, her neighbors at the other end of the forest of Fontainebleau. Her advice to young artists was to study nature "ingenuously and honestly," and to "enrich their memories with constant and close study of the old masters," which provide "the grammar of all true art."[61] Bonheur's philosophy of art was in agreement with that of her favorite author, George Sand: "Art for art's sake is a vain word. But art for the truth, art for the beautiful and the good, that is the religion that I seek for."[62]

Technically a perfectionist, she was careful in her application of paint, sometimes allowing up to two years for her thickly applied underpainting to dry before completing a canvas. She kept some paintings for fifty years, checking the color changes yearly after having made notes on the original colors. In her last years she experimented, not too successfully, with Impressionism. Her anthropomorphic animal pictures, so popular with the middle-class audiences, did not appeal to the avant-garde sensibilities of the latter part of the 19th century, and failed to survive the Impressionist revolution.

Commenting on the growth of "our colleagues of the palette," as she referred to women artists, she wrote to a friend shortly before her death: "They prove that the Creator has made woman the noble companion of man, and that He has differentiated them only for the purpose of reproducing a noble race in this world."[63]

Bonheur's "colleagues of the palette" had indeed proliferated in late 18th and 19th-century France. At the so-called Salon de Dames of 1808, Jeanne-Élisabeth Chaudet (1767–1831) was among the most renowned; in 1812 she received a Prix d'Encouragement. Her reputation faded after her death, and almost all her paintings were destroyed when the Musée d'Arras was bombed during World War I. Typical of her sentimental themes is the *Young Girl Mourning the Death of Her Pigeon* (1808). Kneeling in a severe architectural setting relieved only by a few tree branches and the foliage in an extended vista, the girl gently clutches the dead pigeon as she appeals to the viewer for sympathy. Also represented was Constance Mayer (1778–1821), a student and later mistress of the painter Pierre Paul Prud'hon, who dramatically committed suicide in front of her lover when she felt he no longer needed her. Her painting of *The Happy Mother*, in the Louvre, shows a partially robed, classically inspired figure in a romantic woodland setting, gazing lovingly at her infant; a dramatic light focuses on mother and child.

In their study of women artists Nochlin and Harris included the following other 18th and 19th-century "colleagues": Marie Victoire Lemoine (1754–1820), a student of Ménageot and a Salon exhibitor between 1796 and 1814, whose *Interior of the Atelier of a Woman Painter* (1796) is a double portrait of the artist and Vigée-Lebrun; Marie Genvieve Bouliar (1762–1825), a portraitist and regular Salon exhibitor between 1791 and 1817, who won a Prix d'Encouragement in 1795 for the painting *Aspasia*; Jeanne-Philiberte Ledoux (1767–1832), a student of Greuze whose portraits of children and young girls have frequently been attributed to her teacher; Pauline Anzou (1775–1835), a specialist in portraiture, genre, and history painting who made her debut in the Salon of 1793 when she was only eighteen; the portraitist Marie Eléonore Godefroid (1778–1849), daughter of the popular pre-Revolutionary painter Francois Godefroid, who taught art in an exclusive girls' school from 1795 to 1805; and Adrienne Marie Louise Grandpierre-Deverzy (1798–after 1855), a specialist in interiors and literary subjects who made her Salon debut in 1822.[64]

NOTES

1. O'Faolain and Martines, *Not in God's Image*, 249–50.
2. *Ibid.*, 250–51.
3. Elizabeth Racz, "The Women's Rights Movement in the French Revolution," *Science and Society*, Vol. 16 (1952), 162–65.
4. Olwen Hufton, "Women in Revolution, 1789–1796," *Past and Present* (November 1971), 91–93.
5. Edmond and Jules de Goncourt, *The Women of the Eighteenth Century*, trans. by Jacques Le Clercy and Ralph Roeder

(1928), quoted in Bell, *Women*, 237, 245–49.

6. Bell, *Women*, 234.

7. O'Faolain and Martines, *Not in God's Image*, 277.

8. Elisabeth Vigée-Lebrun, *Memoirs*, trans. by Lionel Strachey (New York: Doubleday, Page & Co., 1903), 49.

9. Jean-Jacques Rousseau, *Emile*, 1762, quoted in Bell, *Women*, 263–65.

10. Jean-Jacques Rousseau, *La Nouvelle Héloise*, quoted in Carol Duncan, "Happy Mothers and Other New Ideas in French Art," *Art Bulletin* (December 1973), 582.

11. Racz, "Women's Rights Movement," 165–66; Hufton, "Women in Revolution," 98–108.

12. Racz, "Women's Rights Movement," 152–57; O'Faolain and Martines, *Not in God's Image*, 307–8.

13. Racz, "Women's Rights Movement," 168–72.

14. See Honoré Daumier, *Lib Women (Blue Stockings and Socialist Woman)* (Paris-New York: Leon Amiel, 1974).

15. Fourier, quoted in Racz, "Women's Rights Movement," 173.

16. Theodore Stanton, ed., *Reminiscences of Rosa Bonheur* (New York: D. Appleton & Co., 1910), 61. In fact, according to Theodore Stanton, many of the ideas expressed by the Saint-Simonians can be found in the writing of the American Transcendentalists and in the late writings of his mother, Elizabeth Cady Stanton, a pioneer in the American Feminist movement.

17. *Ibid.*, 68–72.

18. Flora Tristan, *L'Union Ouvrière* (Paris, 1844) quoted in O'Faolain and Martines, *Not In God's Image*, 210. Tristan was the grandmother of Paul Gauguin.

19. Quoted in Harris, "Introduction," in "Women Artists," 34.

20. Robert Rosenblum, "Painting Under Napoleon, 1800–1814," in " French Painting 1774–1830: The Age of Revolution," (Metropolitan Museum of Art, New York, June 12–September 7, 1975), 171.

21. Leonce Bénédite, "Women Painters of France," quoted in Sparrow, *Women Painters*, 169–76; Linda Nochlin, "Why Have There Been No Great Women Artists?", in Thomas B. Hess and Elizabeth C. Baker, eds., *Art and Sexual Politics* (New York: Collier Books, 1973), 26.

22. Harris, "Louise Moillon," in "Women Artists," 141.

23. Ellet, *Women Artists*, 90–92; Clement, *Women in the Fine Arts*, 81–82.

24. She was one of the signers of a petition in support of the return of Vigée-Lebrun, who had been living in exile since the onset of the Revolution.

25. Jacques Foucart, "Anne Vallayer-Coster," in "The Age of Revolution," 639.

26. *Ibid.*, 639; See also M. Roland-Michel, *Anne-Vallayer-Coster, 1744–1818* (Paris, 1970), "Old Mistresses: Women Artists of the Past" and catalogue essay by M. Brawley Hill, in *Women: A Historical Survey of Works by Artists* (North Carolina Museum of Art, Raleigh, March 25–April 20, 1972).

27. Roger Portalis, "Adélaïde Labille-Guiard," *Gazette des Beaux-Arts*, Vol. 26 (1901), 355,478,484–87; "Old Mistresses."

28. Portalis, "Labille-Guiard," Vol. 26, 488–92; Anne-Marie Passez, quoted in Pierre Rosenberg, "Adélaïde Labille-Guiard," in *The Age of Revolution*, 517.

29. Portalis, "Labille-Guiard," Vol. 26, 356–58, 478–79; Jean Cailleux, "Royal Portraits of Mme. Vigée-Lebrun and Mme. Labille-Guiard," *The Burlington Magazine*, CXI (March 1969), v.

30. Because of the difficulty young girls of moderate means had obtaining painting instruction, Labille-Guiard accepted students. Both girls portrayed with her became successful artists. Mlle. Capet began exhibiting in 1781 and gained critical acclaim for her miniatures and Mlle. Rosemond exhibited in the Salons of 1783 and 1784.

31. Quoted in Portalis, "Labille-Guiard," Vol. 27, 192.

32. Andrew Kagan, "A Fogg David Reattributed to Madame Adélaïde Labille-Guiard," *Fogg Art Museum* (1971), 31–40.

33. Quoted in Haldane MacFall, *Vigée-Lebrun* (London: T.C. & E.C. Jack), 22.

34. Vigée-Lebrun, *Memoirs* 8–9.

35. "Old Mistresses," Ellet, *Women Artists*, 208–9; Vigée-Lebrun, *Memoirs*, 20–21, 34.

36. Vigée-Lebrun, *Memoirs*, 25–28; MacFall, *Vigée-Lebrun*, 46.

37. Cailleaux, "Royal Portraits," iii, iv, vi.

38. MacFall, *Vigée-Lebrun*, 64–79; Nathale Volle, "Elizabeth Louise Vigée-Lebrun," in "The Age of Revolution," 667; Vigée-Lebrun, *Memoirs*, 85.

39. George Levitine, "Marguerite Gérard and her Stylistic Significance," *Baltimore Museum Annual*, III (1968), 31.

40. Sarah Robinson, "Marguerite Gérard," in "The Age of Revolution," 440.

41. *Ibid.*, 440–41.

42. Levitine, "Marguerite Gérard," 21–25; Robinson, "Marguerite Gérard," 443–44.

43. André Malraux, quoted in Charles Sterling, "A Fine 'David' Reattributed," *Metropolitan Museum of Art Bulletin*, IX (January 1951), 121.

44. *Ibid.*, 124–32.

45. *Ibid.*, 132.

46. Robert Rosenbloom, "Painting Under Napoleon 1800–1814," 167.

47. Nochlin, "Marie Guillemine Benoist," in "Women Artists," 209.

48. Quoted in Sparrow, *Women Painters*, 179

49. Quoted in *Ibid.*, 179.

50. Bénédite quoted in Sparrow, *Women Painters*, 179–80; Sarah Robinson and Isabelle Julia, "Antoinette Cécile Hortense Haudebourt-Lescot," in "The Age of Revolution," 486–87.

51. Ellet, *Women Artists*, 247–61.

52. Bénédite, quoted in Sparrow, *Women Painters*, 181.

53. Anna Elizabeth Klumpke, *Memoirs of an Artist*, ed. by Lillian Whiting (Boston: Wright & Potter Printing Co., 1940), 52.

54. Stanton, *Reminiscences*, 9.

55. *Ibid.*, 7.

56. *Ibid.*, 155.

57. Ellet, *Women Artists*, 269–71; 275–77.

58. Stanton, *Reminiscences*, 32; Canaday, *Lives of the Painters*, Vol. 3, 954.

59. Tufts, *Hidden Heritage*, 149–50; Stanton, *Reminiscences*, 380–84; Ellet, *Women Artists*, 275–77; Klumpke, *Memoirs*, 12–13.

60. Quoted in Stanton, *Reminiscences*, 97–98.

61. Stanton, *Reminiscences*, 304, 376, 274; Klumpke, *Memoirs*, 52, 69.

62. Quoted in Stanton, *Reminiscences*, 388.

63. *Ibid.*, 63.

64. Harris and Nochlin, "Women Artists," 188–89, 202, 210, 215, 219.

CHAPTER FOUR

The English School: Portraiture

The reigns of Elizabeth I and the first two Stuarts saw the blooming of English womanhood; women were now considered noble companions and many love poems were written in their honor. But by the late 17th century, the Reform movement in the Church and its influence on the English system of law led to their complete subjugation. A passage from a letter written by Lord Chesterfield in 1748/49 indicates an attitude that was not atypical of the period: "Women, then, are only children of a larger growth . . . A man of sense only trifles with them, plays with them, humours and flatters them, as he does with a sprightly, forward child."[1] This attitude predominated through the mid-19th century.

Marriage was woman's only goal, maternity her prime occupation. The married woman had status, and most young girls accepted this destiny. When little more than children, they were transferred from the charge of their fathers to the possession of a husband; their legal rights and identity were immediately merged with his. Everything they owned or earned belonged to their husbands, as did the children they bore. Men in turn, were legally responsible for the wrongs their wives committed. With this in mind, in 1765 Sir William Blackstone in his *Commentary on the Laws of England* stated that those laws were designed to protect women, "so great a favorite is the female sex." "By marriage, the very being or legal existence of a woman is suspended, or at least it is incorporated or consolidated into that of the husband, under whose wing, protection or cover she performs everything."[2] According to W. L. Blease, who wrote in 1910 on the emancipation of English women, "At its best [marriage] was subjugation tempered by generosity," but its alternative—spinsterhood—was worse. An object of pity and condescension, the unmarried woman lived at home and was used by other members of the family for their personal needs.[3]

Until the latter part of the 19th century, the only educational accomplishments deemed necessary for a young girl were those that would help her capture the heart of a young man. Many women of noble birth could do little better than write their own names, and if by some subterfuge a woman gained additional knowledge, she was advised to conceal it "with as much solicitude as she would hide crookedness or lameness."[4] As Blease summed it up bluntly: "The perfect woman must have at once an attractive exterior and an infinite capacity for self-suppression."[5] Much of the literature of the 18th and 19th century was bent on enervating the fair sex. In *On the Sublime and Beautiful* (1756), the Irish-born statesman and writer, Edmund Burke, wrote: "The beauty of women is considerable owing to their weakness or delicacy and is even enhanced by their timidity, a quality of mind analogous to it." First published in 1784 and often reprinted until 1877, Dr. Gregory's *Legacy to His Daughters* contained such statements as: "When a girl ceases to blush, she has lost the most powerful charm of beauty." "It is by the arts of pleasing only, that women can attain to any degree of consequence or of power . . . and hope to become objects of love and affection."[6] Following the precedent of Queen Victoria, who led an impeccable family life during her sixty-year reign, the 19th-century woman was urged to bear a large family and be faithful to her husband. The numerous articles on child care in the women's journals indicate that, at least in the middle classes, women were beginning to raise their own children. Home and family were popularized in the sentimental genre paintings and novels of the early Victorian period as they had been in France a generation earlier.

EDUCATION AND WORK

During the 16th century, for a brief period, the Humanist ideal of education for women took hold in England. Roger Ascham, tutor to Queen Elizabeth I,

and Sir Thomas More believed that women were as capable of learning as men. The Reformers, however, believed that women's place was in the home, and what little education they deemed necessary was in the direction of household management. Most women remained uneducated.

During the 18th century boarding schools were established for the daughters of the middle and upper classes, and in the mid-19th century these were the only schools for girls. Usually founded and staffed by impoverished gentlewomen (although some were sponsored by the Church of England or by dissenters), their standards were minimal; they often became "holding houses" where girls went to learn their accomplishments before being introduced to society. A student described her expensive education at one of these schools: "At the bottom of the scale were Morals and Religion and at the top were Music and Dancing, miserably poor music too. Our English studies embraced one long, awful lesson each week, to be repeated to the schoolmistress by a class, in history one week and geography the week following. . . All the pupils were daughters of men of standing, but all this fine human material was deplorably wasted. Nobody dreamed that any of us could in later life be more than an 'Ornament of Society.'"[7] Young ladies whose families could not afford boarding schools hired governesses who were often ill-trained; other families hired tutors for each of the accomplishments.

One of the first women to express concern about the "disabilities of her sex" was the author Mary Astell. In a *Serious Proposal to Ladies* (1697), she recognized the need for a women's college. Encouraged by Astell's vigor, Daniel Defoe, the novelist and political journalist, published an *Essay on Projects* (1697) concerning the education of women. In denouncing those who refused to educate women and then called them foolish, he wrote: "I have often thought of it as one of the most barbarous customs in the world, considering us as a civilized and Christian country. We reproach the sex every day with folly and impertinence; while I am confident had they advantages of education equal to us, they would be guilty of less than ourselves." Typical of many of the male "reformers," however, Defoe wanted women to be educated so that they would become fit companions for men.[8]

The late 18th century produced a remarkable woman in Lady Mary Wortley Montagu (1689–1762). After spending her early years browsing through her father's library learning to read, she was fortunate enough to have had an independent income as well

as a liberal and generous husband. Her letters from Venice (1739) to her daughter, the Countess of Bute, are filled with her ideas on literature, education, and the condition of women: "We are educated in the grossest of ignorance, and no art omitted to stifle our natural reason. If some few get above their nurse's instructions, our knowledge must rest concealed and be as useless to the world as gold in a mine." A remarkable pamphlet entitled *Women Not Inferior to Man*, by "Sophia, a Person of Quality," published anonymously in 1739, has been attributed to Lady Montagu. While exalting the role of mother—"There is not employment in a commonwealth which deserves more honour, or greater thanks and rewards"—she nevertheless proclaimed the importance of economic independence for women, demanded a liberal arts education for qualified women, and admittance into all the professions, the legislature, and the ranks of admirals and generals in the service of the King.[9] "Sophia" also attacked the circular argument against education for women so frequently expressed: "Why is learning useless to us? Because we have no share in public offices. And why do we have no share in public offices? Because we have no learning." Sophia's pleas were largely ignored by a society hardly receptive to change; those women capable of reading were incapable of action.[10]

After the French Revolution there was a proliferation in England of books on female education. Sparked by the middle classes, who were convinced that the freedom of women in 18th-century France had led to the decline of morality and the demand for liberty, writers made new efforts to encourage the subordination of women, the enforcement of their chastity, and the maintenance of their ignorance. Typical of the writers of the period was Mrs. Barbauld, who in her *Legacy to Young Ladies* wrote: "Men have various departments in active life; women have but one, and all have the same, differently modified indeed by their ranks in life and other incidental circumstances. It is, to be a wife, a mother, a mistress of a family." Attacking Lady Montagu's circular argument, she wrote in 1825: "A woman is not expected to understand the mysteries of politics, because she is not called to govern; she is not required to know anatomy because she is not to perform surgical operations . . ."[11]

The 18th-century essayists Addison and Steele, ahead of their time but hardly radical, criticized the system that left half of humanity ignorant. They suggested that learning was a better diversion than "accomplishments" and that a woman with a developed mind was a better conversationalist. Their

essays were widely read and had some effect on the women of the upper classes.[12]

Paralleling French Salon society, a group of charming, intelligent hostesses emerged in mid-century England. Referred to as "bluestockings" (from the color of the hose worn by one of the male guests), the ladies entertained the leading luminaries of the period, and their conversation sparkled with literary references (cards were banned from their drawing rooms because they destroyed conversation). The bluestockings moved in a world of comfort, wealth, and security. They excelled in the "accomplishments" and rarely intruded into the world beyond the drawing room. Merely using their education as a diversion, they made no demands for changes in the social structure. Yet from their ranks an unusual number of exceptional women emerged: Fanny Burney was an accomplished novelist and Mrs. Carter a classical scholar;[13] Hannah More wrote pamphlets in defense of the established order and, with her sister, started the Sunday School movement that educated several generations of poor children before the state system began in 1870. Bluestocking society faded before the end of the century, leaving as its legacy the right of women not only to read but to write books; it was also no longer unacceptable for them to display their knowledge.

The first steps toward improved education for women were taken in the mid-19th century. After the death of a father or brother, or during economic recessions, many unmarried middle-class women were forced to seek employment. Due to the high rate of male emigration, there was a growing army of these "spinsters." By birth and custom they could not work in factories, domestic service, or in the trades; the only career open to gentlewomen without loss of status was as governesses. It was to help these ill-prepared young women charged with the education of others that educational reforms were instituted. A Governess Benevolent Institution was set up in 1841, and in 1843 a school was founded to train governesses where many of the leading educators matriculated. With the assistance of lecturers from the University of London, Queen's College, designed for the betterment of teachers, opened its doors in 1848. A Ladies College in Bedford Square, founded by the Unitarians in 1849, subsequently became the senior women's college at the University of London. Other secondary and collegiate institutes followed. In all the new schools, such accomplishments as music and drawing were excluded when they interfered with "important studies."

Despite these reforms, progress was slow; in general, women were no better educated in 1860 than they were in 1660, and few had the organizational skills necessary to effectuate change. When, in 1867, a commission was appointed to study the condition of education in England, it found that only a few among the wealthy girls were sent to school and education at home was haphazard. The existing schools were derelict in every way. The commission concluded that there was a lack "of thoroughness and foundation, want of system, slovenliness and showy superficiality, inattention to rudiments, undue time given to accomplishments, and those not taught intelligently or in any scientific manner; [and] want of organization."[14]

WOMEN AND THE INDUSTRIAL REVOLUTION

It was customary for women to assist their fathers or husbands in farming, shopkeeping, innkeeping, and the like, and to run the business after their deaths. In addition, women often earned extra money from spinning, lacemaking, weaving, or straw plaiting at home. Spinning and weaving depended on water systems and the centers for these cottage industries were located near rivers. Dressmaking and millinery work were traditional female occupations. Young girls of thirteen or fourteen were apprenticed for a period of five to seven years, after which they were deemed ready to set up their own shop. This system worked satisfactorily until 1814, when the laws controlling apprenticeships were changed. Afterward, conditions deteriorated to such a deplorable degree that girls found themselves financially bound to their mistresses and so incapacitated physically that they were unable to work. The apprentices' plight was exposed in a series of novels by Elizabeth Gaskell, wife of a Unitarian minister in Manchester, and in 1843 the government issued new reforms.

The Industrial Revolution altered the traditional role of working-class women. With the invention of the "Spinning Jenny" and then the power loom, spinning and weaving were removed from the home to the factory, and the subsequent use of steam rather than water power moved the plants to the coal fields in the Midlands and northern England. Unemployed workers destroyed the machines, but new ones were built. First orphaned and poor children were imported to run the machines, and after 1800 entire families moved north to replace them. Women were often hired before their men because they would

work for lower wages; for the first time in English history the sphere of women was extended beyond the home. They met other women and were able to see themselves in relation to each other and not only as appendages to men. Conditions were deplorable in the factories: long hours, poor ventilation, and low pay took its toll on the working classes. Women joined their men to fight these abuses, but realizing eventually that they had grievances of their own, they created separate unions. In 1833 Parliament appointed a commission to investigate the working conditions in the factories, especially those employing women and girls. It was found that children began work when they were five or six; girls had no opportunity to learn home management and were so completely unprepared for matrimony that "The man who marries one of these has no home but the beer shop." Conditions improved in the following year.[15]

WRITERS AND REFORMERS

England has a literary rather than a visual tradition in the arts and women shared in it, beginning with Fanny Burney and the bluestockings. In exposing the conditions under which they were forced to live, women writers were in part responsible for reforming the system that oppressed them. What is most astonishing about the female writers of the 18th and 19th centuries is that they could write so well with little or no formal education. Many of these early supporters of women's independence were members of the urban intelligentisia. They were given publicity in the popular journals, which emphasized "their habits of industry and blameless private lives." (In 1858 the first journal devoted to serious feminine problems and needs—*The English Woman's Journal*—was founded.) In addition to their rounds of social calls and accomplishments, the middle- and upper-class Englishwoman was expected to spend several hours each week writing letters. Letter writing, private journals or diaries, short stories, pamphlets, and then novels—this was the path followed by many women writers. Most were also teachers or governesses at some time in their lives. Their initial efforts were often published anonymously, since there was still hostility toward cultivated women. A writer in the *Leader* (1850) asked: "Does it ever strike these delightful creatures that their little fingers were meant to be kissed, not to be inked?" He concluded: "My idea of a perfect woman is one who can write, but won't."[16]

While her sisters were sent to boarding school, the young Fanny Burney (1753–1840), daughter of a well-known organist and music teacher, spent her days poring over the books in her father's library or observing him teach. In the evenings she participated in the conversations of the famous men—among them Sir Joshua Reynolds, David Garrick, Dr. Johnson—who gathered at her father's house. Her mother was one of the few women in her village who could read and write, and Fanny devoted many hours to both; she started a diary at sixteen and spent her evenings writing a novel, *Evelina, A Young Lady's Entrance into the World*. Published anonymously in 1778, the book created a sensation and when the author was found to be a woman, Fanny Burney became a celebrity. After the success of her second novel, *Cecilia*, she was appointed lady-in-waiting (officially second Keeper of the Robes) to Queen Charlotte.[17]

Jane Austen (1775–1817), the seventh of eight children born into a well-educated family (her father was a teacher and rector), was sent to boarding schools, but from age eleven she was educated at home, where she read contemporary fiction and learned French, Italian, and the pianoforte. She began writing at twelve. Austen lived a quiet life within the family confines, writing with keen insight about the narrow world she knew. She did not receive wide popularity during her lifetime—only four of her books were published before she died, and those in the last six years of her life. Her characters often reflect the difficulties pervading the life of the middle-class woman. In *Emma*, Jane Fairfax abhors the idea of becoming a governess, it seeming tantamount to slavery. Another character prefers "any good man with a comfortable income" rather than being forced to join "the ignorant class of school mistresses."[18]

Stirred by the promises of liberty, fraternity, and equality, Mary Woolstonecraft (1759–1797) went to France in 1792 to observe the events that led to the end of the monarchy and the aristocracy. As a feminist, she questioned the divine rights of men, as men themselves questioned the divine rights of kings: her impassioned protest against the subjugation of women, *A Vindication of the Rights of Women* (1792), begins with an attack on Talleyrand's proposal for a system of national education for France in which girls and boys were to be educated together until they were eight, when girls would remain at home where their interests and activities would center for the rest of their lives. While claiming no special virtues for women, she stressed their individuality: women were human beings first and foremost. Mater-

nity, she agreed, was the noblest of duties, "but self-reverence [was] the first of virtues." She also urged the end of rank and privilege, a national system of co-educational schools, revision of the laws that made husband and wife a legal unit, and the representation of women in all the professions and in government. "The conclusion which I wish to draw is obvious," she wrote. "Make women rational creatures, and free citizens, and they will quickly become good wives and mothers . . ." Wollstonecraft's book had little impact in its day. Her ideas were frightening, and she herself was attacked as an atheist and revolutionary. (The fact that she did not marry the anarchist William Godwin until shortly before their daughter's birth, and their unconventional living arrangements, contributed to her lack of popularity.)

Among popular women writers in the mid-19th century were the Countess of Blessington, who made a considerable amount of money with her *Conversations with Byron*; Caroline Norton, a writer of romantic tales and celebrated pamphleteer who helped change English laws limiting the rights of married women; Catherine Francis Gore, a "satiric observer of the social scene;" Maria Edgeworth, the progenitor of the peculiar Victorian story with a moral; Charlotte Yonge, who wrote stories on ideal domestic life; Sarah Ellis, who glorified the duties and responsibilities of the Victorian housewife; Dina Maria Mulock (Mrs. Craik), whose stories of thrifty, industrious workers appealed to the middle-class patrons of the circulating libraries; and Mary Ann Evans, an assistant editor of the *Westminster Review* who at forty began a serious career as a novelist using the pen name George Eliot. One of the most remarkable women writers was Frances Trollope, who began writing in middle age to help support her large family. Her first success was a book written after visiting America in search of business opportunities for her expanding family. Her famous son, Anthony, described in his *Autobiography* how she continued writing while nursing his ailing father, sister, and brother. Elizabeth Barrett Browning, who first achieved fame for her love poems, produced a masterpiece in *Aurora Leigh*, a romance in verse which attempted to capture the temper of mid-19th century England.

The social protest novel was a powerful weapon in the hands of many women. Harriet Martineau had a reputation as a social reformer when she set sail for America at thirty-two. She wrote knowledgeably of the country and its problems and became identified with the abolitionist movement, writing an anti-slavery novel, *The Hour and the Man*, in 1840. In order to reach a wide audience, she often used the novel form to develop her ideas for social change. Elizabeth Gaskell wrote about working-class life in the Midlands in *Cranford* (1853) and other popular novels. While Martineau and Gaskell dealt objectively with the plight of the exploited, Charlotte Bronte adopted a dramatic personal style that brought to life woman's "frustrations, rebellions and passions." *Jane Eyre* (1847) was largely the story of her life at a boarding school and as a governess. When it was found that "Currer Bell" was Bronte herself, curiosity was followed by shock that a woman could articulate her feelings so clearly. Critics thought it an "unsuitable book for a woman to write."[19]

The first book which treated the problems of women in a rational, orderly way was written by a man—John Stuart Mill, a philosopher and economist. Although begun three years after the death of his wife, Harriet Taylor, *The Subjection of Women* (1869) must be viewed as a collaboration and as an expression of the ideas exchanged during their twenty years of intellectual intimacy. The work is a product of Enlightenment thinking: they believed education would change man's attitudes and that through reason, man would see the evils in the world and work for reforms. In the first paragraph of the essay Mills elaborates on an "opinion" he has long held and which grows "stronger by the progress of reflection and the experience of life":

The principle which regulates the existing social relations between the two sexes—the legal subordination of one sex to the other—is wrong in itself, and now one of the chief hindrances to human improvement; and that it ought to be replaced by a principle of perfect equality, admitting no power or privilege on the one side, nor disability on the other.[20]

Since Mill was at the height of his career when his book was published, he was ensured a wider audience than Wollstonecraft. And the women capable of reading the book were ready to join forces to effectuate change. Nothing new was proposed in the book, but since its ideas were clearly presented and rationally argued by a respected male literary figure, it became the Bible for feminists on both sides of the Atlantic and there was no turning back the tide of reform.

THE STATE OF THE ARTS AND WOMEN ARTISTS

Henry VIII scoured Europe for painters to decorate his palaces, miniaturists to satisfy the fad for miniatures, and portraitists to flatter the vanity of his

courtiers (portraiture dominated English art until the advent of Hogarth and Gainsborough; since England was a Protestant country, there were no monumental church commissions). It was he who began the practice of importing Italian, Dutch, Flemish, and German artists to become court painters. Charles I was an amateur artist and ardent collector. At Rubens' suggestion he purchased the entire collection of the Duke of Mantua, the most important in Europe. Rubens was invited to become court painter, but he declined, visiting England only as a messenger of peace from Spain. He stayed to paint the ceiling of the new Banqueting House at Whitehall, designed by Inigo Jones. His disciple, Anthony Van Dyck, fearful of the competition from his master in Flanders, agreed to become the court painter to Charles I and made his fame in England, setting a standard for English portraiture that lasted until the 20th century. Foreign artists were well treated and well paid in 17th-century England; both Rubens and Van Dyck were knighted. Much to the distress of native artists, the English royalty and nobility continued in the 18th century to import foreigners and to purchase old masters while their talent went unrewarded.

Sir Joshua Reynolds believed that before English artists could properly establish themselves, two needs had to be met: "for the students, an established and well staffed school of art; and for the artists, the encouragement and support that would come from a large-scale exhibition of works, held regularly and publicly in London." These goals were met when the Royal Academy opened its doors in 1768 with thirty-six founding members, among them two women—Mary Moser and Angelica Kauffmann. Annual exhibits were held there, the profits going to support its school. The basis of study was the nude, first from plaster casts and then from life. Although the nude female was allowed in the Academy's classrooms, no male under twenty was permitted to draw from her unless married, and none but Academicians could enter the Academy building while she was posing.[21]

The period in which the Royal Academy was founded witnessed the flowering of English art. Amateurs and professionals abounded. The Royal Academy became a fashionable place to meet, and gentle ladies, tutored in the accomplishments of drawing and painting, were heard talking of Correggio and Raphael. Leading Academicians were hired to teach the princesses and daughters of the nobility. A writer in a leading review recommended painting as an acceptable pastime for women: "It demands no sacrifice of maiden modesty nor of matronly reserve; ... it does not force her to stand up

to be stared at, commented on, clapped or hissed by a crowded and unmannered audience, who forget the woman in the artist. It leaves her, during a great portion of her time at least, beneath the protecting shelter of her home, beside her own quiet fireside, in the midst of those who love her and whom she loves. But, on the other hand, ... to attain high eminence, it demands the entire devotion of a life; it entails a toil and study, severe, continuous and unbroken."[22]

At the end of the 18th century about a dozen women were made honorary members of the Royal Academy. Many were invited to hang their work in the annual exhibits, but none were recognized for their merits. It was not until 1922 that another woman was elected to Academy membership—and by then it was a dubious honor. The first woman invited to attend the Academy's school was Laura Hereford (1831–1870), who began her studies in 1861/62. No woman was allowed to draw from the nude until after 1893, when the partially draped figure was introduced into the female life classes. The Society of Female Artists was founded in the 1850s and flourished under the guidance of Mary Atkinson, "a lady who devotes her life to the interests of lady artists in general, and rising young aspirants in particular." Many women artists owed their initial successes to her support and encouragement, and many others (including Lady Butler) studied at the Society's school.[23]

The first woman art historian appeared in 19th-century England. She was Anna Brownwell Murphy Jameson (1794–1860), born in Dublin where her father was a miniaturist. She became a governess at sixteen to help support her family and later took a similar post in Italy. It was there that she developed her interest in ecclesiastical art. Her four-volume *Sacred and Legendary Art* (1848), a pictorial history of religious art, established her reputation as an art historian. The last volume was published posthumously. She also wrote "Visits and Sketches at Home and Abroad," "Companion to the Most Celebrated Private Galleries of Art in London," and "Companion to the Public Galleries"—guidebooks for art lovers. A feminist, and colleague of the leading English activists, she first gained fame for her *Characteristics of Women* (1832), which was followed by several essays on the female characters in Shakespeare's plays.[24]

JOAN CARLILE (1600–1679)

Susanna Horebout, Levina Teerlinc, and Artemisia Gentileschi (accompanied by their fathers or husbands) were among the foreign artists invited to

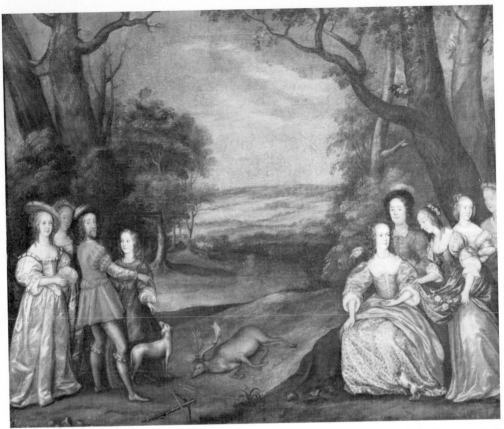

FIG. 4-1. Joan Carlile, *Stag Hunt at Lamport.* Courtesy of the Directors of the Lamport Hall Preservation Trust Ltd., United Kingdom.

England during the 16th and 17th centuries. The first English woman whose name appears in the history of English art is Joan Carlile, who along with Van Dyck, was a favorite of Charles I. An accomplished portrait painter and copyist (she specialized in "Italian masters" for the newly acquisitive royal patrons), she worked in oil as well as watercolor. When Charles I purchased 500 pounds of ultramarine, he split it between Van Dyck and Carlile. Little is known of her life. Virtue, an early chronicler of English artists, described a self-portrait with a student showing Carlile sitting with a book of drawings on her lap; the student stands behind her. A Lady Cotterel was said to have owned many of her paintings. Carlile died almost forty years after the death of her patron, Charles I.[25] Her *Stag Hunt at Lamport* (Fig. 4-1) was included in the 1972/73 "Age of Charles I" exhibit at the Tate Gallery, London.

MARY BEALE (1632–1697)

The most prominent of the group of female artists patronized by the circle of Charles II was Mary Beale.

Her father, the Reverend John Craddock of Suffolk, was an amateur painter and sought "personally to provide his daughter with the fullest possible education."[26] A number of artists—including the highly popular portraitists Sir Peter Lely and Robert Walker—were working in the Suffolk area during Mary's childhood. Walker, a close follower of Van Dyck's elegant style and official painter to Cromwell and the Puritans, painted the Reverend Craddock's portrait and may have been young Mary's first teacher. After her marriage in 1651 or 1652 to Charles Beale, a member of a leading Puritan family, Mary began her apprenticeship as a professional artist. She may have continued her studies with Walker, and probably studied with Thomas Flatman, a lawyer, poet, and miniaturist who referred to her as "My Scholar" in letters exchanged with her husband. Although she never studied with Lely, she was invited to view and copy from his collection, one of the most important in London, and sat for her portrait. Lely took great interest in her progress, and rumor had it that they became lovers (Elizabeth Walsh, her biographer, denies this).

Covent Garden in the mid-1650s was a center of artistic life, and it was there Charles and Mary Beale

settled; their two sons were born shortly thereafter. Activity in the house centered around Mary's "Paynting roome," where she worked while her sons played among the canvases. By 1658 she was known enough to be included in Sir William Sanderson's *The Excellent Art of Painting*, a survey of contemporary artists that also included Joan Carlile. Her husband, unemployed throughout most of their marriage, kept a comprehensive record of his wife's activity—her visitors, her patrons, her fees and expenditures, what part of the painting she worked on each day—and it is from these records, some still extant, that we know the details of their lives. Mary became the breadwinner while Charles ran the household and managed his wife's career. He primed her canvases (as well as canvases for other artists), mixed a special blend of colors for her (which he also sold to others), and became a dealer in paintings and prints and an expert on Italian art. As their sons grew older, they also assisted their mother in her work. The Beales lived an ordinary life and Mary was respected as a "talented artist, an irreproachable wife, and an excellent mother." According to Clayton, she was "only unlike thousands of other contented English wives and mothers in her distinguishing artistic talent."[27]

In 1670 Mary established herself as a professional painter, charging £.10 for a three-quarter length portrait and £.5 for a head and shoulders. She received commissions from their circle of friends at church, from the nobility, and from the landed gentry; from one family she received a commission for no less than thirty portraits. Most in demand were her charming likenesses of children. In 1681 she took in two pupils, a girl and a boy, and ten years later the young Sarah Curties (who subsequently achieved fame on her own) entered her studio. Beale worked in pastels, oils, and water colors; her drawing was vigorous, and often described as "masculine." According to Sparrow, Beale painted "broadly and well, drew with force and discrimination, and although she told the truth plainly at a time when other painters flattered and fawned, she yet achieved success, and was encouraged by the highest in the land."[28]

Beale's *Self-Portrait* (Fig. 4-2) of 1666 with her two sons has as its companion the most ambitious painting she ever did of her husband. They are extremely large for the period, and when hung together create an imposing family group. The color ranges from subdued brown to red tones. Her sons appear as small sketches on the canvas she holds in her right hand; on the wall to the right hangs a palette. Although there is a similarity in pose to Lely's portraits and some of his linear quality, his influence appears less here than in earlier works. Ironically, Beale's identification with Lely was strongest after his death in 1680, when there was a sudden demand for copies of his work. Mary Beale was the artist most frequently commissioned to do paintings "after Lely." Her copies were so accurate that confusion in attribution still exists.

ANNE KILLEGREW (1660–1685)

"A beauty, a wit, a verse-writer, an agreeable painter, maid of honor to a royal duchess standing next the throne, almost perfect in character, sweet and gracious in her manner"—such was a 19th-century description of Anne Killegrew. Her father, Dr. Henry Killegrew, a minister, had a mild success as a playwright (Ben Jonson had praised his work), and the family was living in St. Martin's Lane, then the

FIG. 4-2. Mary Beale, *Self-Portrait* (1666). 43″ × 34½″. National Portrait Gallery, London.

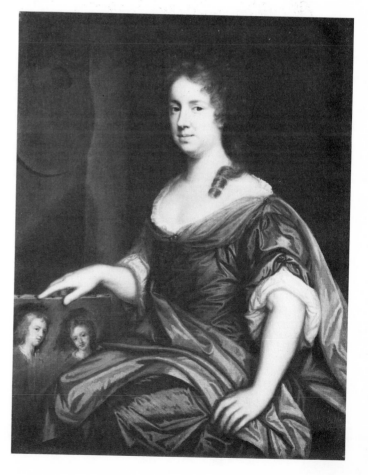

center of London's artistic life, when Anne was born. Nothing is known of her early training. She was placed as maid of honor to the Duchess of York, and, impressed by the "classical majestic loveliness of her royal mistress," Killegrew painted her portrait, we are told, as a "labor of Love." She also painted the Duke of York as well as James II (Fig. 4-3), whose portrait is still in the Royal Collections. Posed in the Van Dyck manner, the elegantly clad king stands near a grand staircase decorated with classical maidens and nymphs. It is a remarkable achievement when one considers that the artist was in her early twenties when awarded the commission. Her self-portrait reveals a fashionably dressed, slim, elegant figure with an oval face, straight nose, firm chin, and long wavy hair. An engraving by A. Blooteling after one of her self-portraits is in the Yale Center for British Art, Paul Mellon Collection.

Several works by Killegrew were based on myths and Biblical tales—*Diana's Nymphs, Venus and Adonis, St. John in the Wilderness, Judith and Holofernes*—and others on historical events. (A mezzotint by B. Lens after the *Venus and Adonis* is also in the Mellon Collection.) A slim volume of her verse was published posthumously (she died suddenly from smallpox when she was only twenty-five). Dryden wrote an ode to her memory, praising her poetry and her painting, then concluding:

Her pencil drew whate'er her soul designed,
And oft the happy draught surpassed the image
 of her mind.

Although one critic called Dryden's poem "harmonious hyperbole," another, Anthony Wood, wrote that "there is nothing spoken of her which she was not equal to, if not superior, and if there had not been more true history in her praises than compliment, her father never would have suffered them to pass the press."[29]

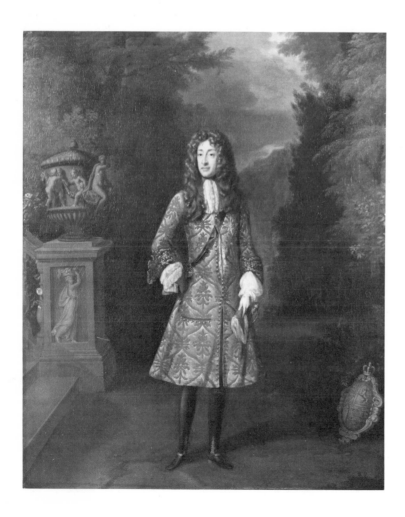

FIG. 4-3. Anne Killegrew, *Portrait of James II*. St. James's Palace, London.

CATHERINE READ (d. 1786)

Although little is known of her life, Catherine Read was considered a "distinguished professional" of the mid-18th century; engravings were made after her portraits, along with those by Reynolds and Gainsborough. (An engraving by Valentin Green after her portrait of *William, Lord Newbottle and His Sister*, is in the Yale Center for British Art, Paul Mellon Collection.) Working in both oils and pastels, she was a frequent exhibitor at the Academy, showing in 1773, 1774, and 1776. She had studied with Quentin de la Tour and was frequently referred to as the "English Rosalba." An early portrait of Queen Charlotte was considered among her best; she also painted the historian Catherine Macaulay as a "Roman matron weeping over the lost liberties of her country," as well as likenesses of the royal princes and Elizabeth, Duchess of Hamilton. Read spent time in the East Indies; whether or not she brought art to the colonies is not known.[30]

FIG. 4-4. Catherine Read, *Portrait of a Man with a Turban.* Present location unknown.

Sparrow illustrated engravings after two of her portraits, one of Miss Harriet Powell, the other of a Miss Jones, dated 1767. The half-length of Miss Powell shows her seated, tuning her mandolin; Miss Jones is shown deep in thought, her elbow resting on a table, where a book lies open. A great deal of attention is paid to details of fabric and hair, and they are both rendered in a rather linear way, perhaps a result of the reproduction medium rather than the artist's original conception. However, with the exception of the hands, they are well drawn and depict the sitters' individuality. A delightful portrait of the young Lady Georgiana Spencer, in the collection of the Earl of Spencer, shows a softness of touch and brushwork characteristic of Reynolds and his associates. The naturalistic *Portrait of a Man with a Turban* (Fig. 4-4) reveals her ability to capture the personality of her sitters. A letter dated 1792 to her brother from one of her patrons, while praising her talents, perceptively comments on why they would never be fully developed:

At the rate she goes on, I am truly hopeful she'll equal at least if not excel the most celebrated of her profession in Great Britain, particularly in "crayons" for which she seems to have a great talent. Was it not for the restrictions her sex obliges her to be under, I dare safely say she would shine wonderfully in history painting, too, but as it is impossible for her to attend public academies or even design or draw from nature, she is determined to confine herself to portraits.[31]

FRANCES REYNOLDS (1729-1807)

Perhaps Frances Reynolds' name would never have been recorded if she were not the younger sister of Sir Joshua Reynolds, whose household she managed for over twenty-five years; yet had she not lived under the shadow of a famous older sibling who was also extremely critical of her creative efforts, she might have had a distinguished career as an artist. She was a friend and intimate of Dr. Johnson and Oliver Goldsmith, and painted portraits of Dr. Johnson (Fig. 4-5) and his family, even though he thought "portrait painting an improper employment for a woman. Public practice of any art and staring in men's faces is very indelicate in a female."[32]

Descended from a long line of clergymen, Frances was born in 1729, when Joshua was six. There were eleven children in all (though not all reached maturity), and several displayed a talent for drawing. Since pencils and paper were luxuries, the children used burnt sticks to draw on the whitewashed walls of a

FIG. 4-5. Frances Reynolds, *Portrait of Dr. Johnson.* By courtesy of the President and Fellows, Trinity College, Oxford.

pathy, or, what she coveted, a little merited attention.''

Eventually trying her hand at literature, Frances wrote an elaborate essay on taste and a poem based on her early life called "A Melancholy Tale." While Dr. Johnson was "moved to tears" by the poem and "charmed" by the essay, he urged her not to publish them. After her mentor's death, both were printed.[33] In "An Enquiry Concerning the Principles of Taste and the Origin of Our Ideas of Beauty," which was dedicated to Mrs. Montague, Frances Reynolds wrote that "Perhaps the most perfect feminine mind habitually aims at nothing higher than an exemption from blame."[34]

ANGELICA KAUFFMANN (1741–1807)

While Maria Anna Angelica Caterina Kauffmann was born and educated on the Continent and spent the greater part of her life there, she is usually included in surveys of English art because it was in England that she reached her maturity as an artist and achieved her phenomenal success. Most of her work can still be found there.

Johann Josef Kauffmann was an itinerant Swiss painter working on a commission in the village of Chur in 1740 when he married a local girl; their only child, Angelica, was born a year later. During the family's seemingly endless wanderings, the elder Kauffmann was usually fulfilling painting obligations and giving his talented child drawing lessons and a sound classical background. As legend has it, Angelica was never content to play as other children did and was only happy with her pencils and paints. From her mother she learned not only the domestic skills, but how to speak and write Italian and German. When she was eleven, the family moved to Como, where Angelica read avidly in literature, history, and science, and also studied music. At twelve she painted the portrait of the Bishop of Como and was hailed as a prodigy. Her father's work next took the family to Milan, where Angelica made copies of the old masters and attracted the attention of Rinaldo d'Este, the Duke of Modena, who invited her to see his collection. After he introduced her to the Duchess Massa di Carrara—whose portrait she painted—Angelica found herself, at age sixteen, flooded with portrait commissions from the entire court. When her mother died suddenly the elder Kauffmann went home to Schwartzenburg with his talented daughter to decorate the parish church. Although a drastic change from court life, the move

hall in the parsonage until a friend of their mother's gave them pencils and paper. They then proceeded to copy all the prints in their father's library. When Joshua settled in St. Martin's Lane in London (1752), Frances joined him; she was determined to become a miniature painter "in spite of the contemptuous opinion expressed of her attempts by her brother." Although she was not a brilliant or original painter, her patrons were pleased with the likenesses she produced and she was capable of capturing the character of each sitter, including the eminent bluestockings Mrs. Montague and Hannah More. Dr. Johnson consulted her often and once said that her "mind was very near to purity itself." He listened to her with "deference and affection" but on matters of art, where she craved assistance, he was no help: imperfect eyesight had left him insensitive to even the old masters. "Fanny" continued to work, however, attempting oils and stealthily copying her brother's work. Although she lived in the company of one of the most famous artists England has produced, she worked "without one friend or instructor able or willing to give her advice or sym-

provided a rare opportunity for a sixteen-year-old: while Johann painted the ceiling, his daughter did wall frescoes of the twelve apostles. These were based on the popular prints made after engravings of the Venetian painter Piazzetta's original compositions.

Within a few years the restless pair were back in Italy, this time to make a "grand tour" so that Angelica could study the old masters in each art center. In Milan she was still remembered and it was there that she made the great decision so elegantly portrayed in a painting of about 1794—*Angelica Hesitating Between the Arts of Music and Painting.* She shows herself bidding farewell to Music, about to follow Painting to the Temple of Fame.[35] In 1762 she and her father were in Florence, where she met the American expatriate painter and later second president of the Royal Academy, Benjamin West. He introduced her to the English colony there and many became her patrons. At the Uffizi Gallery she was given a private room where she could copy much of the collection. After successfully exhibiting a historical painting and a portrait, she was invited to add her self-portrait to the distinguished collection; it hangs there now next to that of Vigée-Lebrun. In comparing the two portraits, Goethe, who became a close friend, wrote:

[Kauffmann's] has a truer tone in the coloring, the position is more pleasing, and the whole exhibits more correct taste and a higher spirit in art. But the work of Lebrun shows more careful execution, has more vigor in the drawing, and more delicate touches. It has, moreover, a clear though somewhat exaggerated coloring. The French-woman understands the art of adornment—the headdress, the hair, the folds of lace on the bosom, all are arranged with care— the piquant, handsome face . . . presents itself to the beholder's gaze as if coquettishly challenging his admiration while the hand holds the pencil as in the act of drawing. The picture of Angelica, with head gently inclined and a soft, intellectual melancholy pervading the countenance, evinces higher genius, even if, in point of artistic skill, the preference should be given the other.[36]

In Rome by 1763, Angelica studied perspective and architecture, and made the acquaintance of Johann Joachim Winckelmann, the German archaeologist and art historian whose discoveries inspired the neoclassical style of the latter part of the 18th century. In a letter dated 1764, Winckelmann described his young friend: "My portrait has been painted by a remarkable lady, a German artist. She is very strong in oil portraits; mine cost thirty sequins, and is a half-length, seated figure. She has etched it herself as a present to me . . . She speaks Italian as well as German . . . and is also fluent in French and English,

and therefore paints portraits of all the English visitors. She can claim to be beautiful, and sings to rival our best viruosi."[37]

Angelica's beauty, modesty, charm and talent had opened the doors to the best of Roman society, and the local nobility as well as foreign dignitaries flocked to her studio. In June of 1765, she was elected to the prestigious Academy of St. Luke in Rome. In Venice—where she and her father arrived the next month—Angelica became the darling of the English colony. When Lady Wentworth, wife of the former English ambassador to Venice, offered to sponsor her debut in London, the twenty-five-year-old celebrity left her father and travelled the hazardous route to England. She was immediately hailed as the successor to Van Dyck and a peer of Rubens; she was introduced to fashionable society and to the luminaries of the art world. Her great admiration for Reynolds was reciprocated, and both did portraits of each other. Kauffmann's work shows him sitting at a table, his head resting on his hand, with a bust of Michelangelo in the background—a remarkably relaxed interpretation of so formidable an artist. After a year in London, she was well enough established to settle in comfortable quarters and asked her father to join her. Her life-sized painting of Princess August of Brunswick, sister to George III, holding her infant son on a marble pedestal (1767), was so warmly applauded that the King's mother, the Princess of Wales, made an unprecedented visit to her studio. Angelica Kauffmann brought to London all that she had learned in Rome, and along with Gavin Hamilton and Benjamin West is credited with popularizing Neoclassicism in England.

Not content to be merely a portrait painter, Kauffmann showed four paintings based on classical mythology at the first exhibition of the Royal Academy in 1769. She often portrayed her sitters in allegorical or mythological settings. Typical is the life-sized half-length portrait of Lady Hamilton as Comedy (c.1786). She also did works based on English history and literature, Greek mythology, and themes from the Bible—the first woman painter to tackle such grand subjects on a grand scale—but none of these large canvases were as successful as her informal portraits of her friends.

Although the young artist had many suitors, among them Fuseli, Reynolds, and the painter Nathanial Dance, in 1767 she secretly married the Count de Horn, an adventurer and imposter, whom she later discovered had another wife. With that knowledge, Kauffmann could have had the marriage annulled, but she chose not to prosecute and re-

FIG. 4-6. Angelica Kauffmann, *Family of King Ferdinand IV and Queen Maria Carolina* (1784).
Gallerie Nazionali di Capodimonte, Naples.

mained legally married until his death fourteen years later. Although he demanded much more, he accepted a payment of 300 guineas in 1768 and agreed to make no further demands on her property or earnings, which, according to English law, were legally his.

The elder Kauffmann was aging and ailing and his physicians recommended a return to Italy, a trip the old man was reluctant to make with only his daughter. A husband was needed, and Antonio Zucchi—the Venetian decorative painter who, along with Angelica, had been decorating Robert Adam's Neoclassical mansions which were beginning to dot London and the countryside—was the admirer chosen to be her spouse. With his fortune and reputation already established, Zucchi was a safe choice; nevertheless, a marriage contract was drawn to insure Angelica's financial security. After Johann died (in Venice), the newlyweds stopped in Naples on their way to Rome. There Queen Maria Carolina not only commissioned a family portrait, but invited Kauffmann to become court painter, an honor she graciously declined, preferring her independence. Completed in 1784, the life-sized full-length portrait of the royal family (Fig. 4-6) in a rural outdoor setting is, per-

haps, the epitome of Rousseauian connubial bliss, and certainly one of her most charming paintings.

Rome was a cosmopolitan city when the Zucchis settled there in the 1780s. Artists from all over Europe and many from America came to study the antique and to attend the private academies. The Zucchis were at the center of this society, and while Angelica painted the passing parade of nobility, Antonio managed the household, ordered canvases and frames, arranged transportation for her completed canvases, and kept a careful account of patrons and payments, leaving his wife free to paint and entertain guests. Among them was the exiled Vigée-Lebrun. Although they dined together on several occasions, there is no evidence of a lasting relationship. In her *Memoirs*, Vigée-Lebrun wrote of their encounter:

I found her very interesting, apart from her fine talent, on account of her mind and her general culture. . . . Her manner is gentle; she is prodigiously learned, but has no enthusiasm, which, considering my ignorance, has not elect-ified me. . . . I have seen several of her works; her sketches please me more than her pictures, because they are of a Titianesque color.[38]

Another frequent visitor was Goethe. He wanted to study painting and sought the advice of the incomparable Angelica. They visited art galleries together; she painted a picture inspired by his play *Iphigenie auf Tauris* (in which, according to Goethe, she captured the crucial moment) as well as his portrait. Of her work of this period, Goethe commented: "Angelica's talent is incredible and for a woman truly immense. One must see and treasure what she does, not what she leaves undone." And again: "No living painter has excelled her either in the charms of what she represents or the taste and skill with which she handles her brush. On the other hand, her drawing is weak and uncertain, her figures have little variety or features, and her picturing of the emotions has no strength. Her heroes look like slender boys, or young girls in disguise, and her old people lack gravity and dignity." Indeed, Angelica Kauffmann chose to idealize her patrons. The Grand Duchess Amalia, a friend of Goethe's, wrote that her portrait, "or rather, the picture which Angelica has done, is the finest poetry that anyone has been able to make of me."[39] Yet she was also capable of truly first-rate conceptions. One of her most successful portraits of a woman is that of Cornelia Knight (Fig. 4-7), an English writer then living in Rome in straitened circumstances with her mother. The background is uncluttered, and the face shows a depth of character rare in her usual portraits of women (but found in the likenesses of her male friends Garrick, Reynolds, and Goethe). Though linear in conception, there is more activity in the brushwork than is usually found in Neoclassical portraits.

What were some of the reasons for Angelica Kauffmann's phenomenal success? Fuseli had one explanation: "She pleased, and desired to please, the age in which she lived."[40] Although she made her way in a competitive world, she knew she had to preserve those feminine qualities that endeared her to the men who supported her throughout her career and helped create the legend that surrounds her name. Otherwise she might easily have been forgotten like her friend, Mary Moser.

MARY MOSER (1744–1819)

As members of the Royal Academy, Mary Moser and Angelica Kauffmann were close friends; Moser was the only other woman in England whose reputation rivaled Kauffmann's. Although "as well known for her wit as for her art,"[41] Mary Moser was considered a plain girl; no poems or odes were written to her beauty and no famous men sought her hand or recorded her thoughts. A chronicler of the period described her as "so nearsighted, that her nose, when she was painting, was within an inch of the canvas; . . . it is astonishing, with such an infirmity . . . that she could display such harmony in her performances. Her pictures of flowers, for which she was so deservedly famed, possess a tasteful elegance of composition, a clearness of coloring, and, in most instances, exquisite finish."[42]

George Moser, an enamel painter and gold-chaser, migrated from his native Switzerland to England in 1721; Mary, his only child, demonstrated an early interest in drawing and it was from him that she received her first instruction. In 1758 and 1759 she won prizes for drawings submitted to the Society of Arts, founded in 1754 to "bestow premiums on a certain number of boys and girls under the age of sixteen, who shall produce the best pieces of drawings, and show themselves most capable when properly examined."[43]

When the Royal Academy was founded in 1768,

FIG. 4-7. Angelica Kauffmann, *Portrait of Cornelia Knight.* City of Manchester Art Galleries.

FIG. 4-8. Mary Moser, *Tulips*. Watercolor. Victoria and Albert Museum, London.

George Moser was elected keeper; he superintended its antique plaster casts and instructed students in drawing and modeling from them. Upon his death, Sir Joshua Reynolds eulogized him as "the father of the present race of artists." Reynolds also had praise for Mary: "She has distinguished herself by the admirable manner in which she composes pieces of flowers, of which many samples have been seen in the Exhibitions . . . and for her extraordinary merit has been received into the Royal Academy."[44] Moser and one other artist were the only floral painters to be accepted into the Academy. At the initial exhibit in 1769 she showed two floral pieces, one in oil, the other a water color which may have been similar to *Tulips* (Fig. 4-8); the following year she sent a floral piece as her presentation work. In 1771 she sent her first figure piece, *Hebe*, to be exhibited. A portrait of the sculptor Joseph Nollekens, c. 1770–77, at the Yale Center for British Art, Paul Mellon Collection, has been attributed to Moser. Listed in the 1823 sale of Nollekens' effects with the comment that it was painted by Moser in Rome, it shows the sculptor working on the figure of Bacchus which was exhibited at the Royal Academy in 1771. As a favorite of Queen Charlotte and Princess Elizabeth, who frequently visited her studio, she was commissioned to paint an entire room with flowers at the Queen's estate at Frogmore, known thereafter as "Miss Moser's Room." For this she received the magnificent sum of £900.

Until his marriage in 1788, Mary Moser carried on a lengthy correspondence with Henry Fuseli that revealed her infatuation with the Swiss-born painter of erotic nightmares and hallucinations. He in turn was an admirer of Kauffmann. In fact, it was because of Fuseli that Mary Moser and Angelica Kauffmann later parted ways: Moser could not forgive Kauffmann for rejecting Fuseli as a suitor. Several years later Mary married Captain Hugh Lloyd and thereafter painted only as an amateur. She entered a flower piece in the 1797 Academy exhibit, signing herself Mary Lloyd; her last entry was a figure subject in 1800. (When, in 1803, Benjamin West was elected the Academy's second president, one vote was cast for Mrs. Lloyd by Fuseli.)

Since most of Mary Moser's paintings are probably still in private collections or in provincial museums, it is difficult to assess her work and determine if her obscurity is deserved. An engraving after a *Vase of Flowers* (1764) is reproduced in Sparrow's book: set on a table whose edge runs parallel to the picture plane, the vase is filled with a profusion of flowers, heavy in the lower half and delicately light and filmy above. it is excessively detailed, but that may be due to the engraving.

ANNE SEYMOUR DAMER (1748–1828)

A 19th-century art critic captured what was unique about Anne Seymour Damer, who was a cousin of Horace Walpole and a granddaughter of the Duke of Argyle: "Her birth entitled her to a life of ease and luxury; her beauty exposed her to the assiduity of suitors and the temptations of courts; but it was her pleasure to forget all such advantages and dedicate the golden hours of her youth to the task of raising a name by working in wet clay, plaster of Paris, stubborn marble, and still more intractable bronze."[45]

Her decision to become a professional sculptor was precipitated by a caustic remark from David Hume. Young Anne had been critical of the Scottish philosopher's taste in art after he had admired the figurines being sold by an Italian street urchin; Hume intimated that "no woman could display as much science and genius as had entered into the makings of the plaster casts she so scorned." Anne immediately obtained wax and tools and modeled a head, said to be his. Reluctantly, Hume admired the work, claiming, however, that wax was a far simpler medium to master than marble. Again accepting his challenge, she reproduced the wax head in marble and continued to work with immense dedication in an area where few women had tread—certainly none

of her social class (painting had become a fad and many "lady" water colorists were having their work hung at the Royal Academy's annual exhibitions).

Anne Seymour Damer was considered an eccentric by her friends and was the only woman sculptor of note in England until the 20th century. She studied anatomy with Cruikshanks, clay and wax modeling with Cerrachi, and marble chiseling with Baron. She was exceptionally well-read in literature and history, and was especially fond of the artists of antiquity. When she was nineteen she married John Damer, "a fop and spendthrift," who, after dissipating his inheritance, committed suicide nine years after their marriage. She worked little during the marriage, but upon Damer's death, traveled throughout Europe, continuing her studies. In Florence she was asked to add her self-portrait to the collection at the Uffizi. She also did portrait busts in bronze, marble, and terra cotta of her famous friends and relatives; her full-length marble of King George III was placed in the Edinburgh Register Office and the bust of Countess Elizabeth Derby (Fig. 4-9) is today in the National Portrait Gallery, London. After receiving several commissions from Napoleon, she became his supporter and was said to have sent him a note of friendship before the battle of Waterloo. (A political activist, she also supported Charles Fox, the statesman and orator who opposed George III's colonial policies, and loudly expressed her sympathy for the American colonists' struggle for independence.)

Walpole, who later willed her his famed villa, Strawberry Hill (where she became a hostess), and a yearly stipend of £. 2000 for its maintenance, praised her extravagantly: "Mrs. Damer's busts from life are not inferior to the antique. Her shock dog, large as life and only not alive, rivals the marble one of Bernini in the Royal Collections." Her critics, however claimed that she lacked originality and had too many assistants in her studio. In her own will she asked that she be buried with her sculptural tools and that her correspondence be burned. It is because of the last request that more is not known about this fascinating woman.[46]

MARIE COSWAY (1759-1838)

Clayton, in 1876, began her essay on Maria Cecilia Louisa Hadfield Cosway by assuming that "Few people are, perhaps, unfamiliar with the truly remarkable figures of that much envied and bitterly laughed at pair, Mr. and Mrs. Cosway—the observed of all ovservers in fashionable society as the radiant

FIG. 4-9. Anne Seymour Damer, *Elizabeth, Countess of Derby as Thalia* (c. 1789). Marble. National Portrait Gallery, London.

18th century was waning. The one, a preposterous little Dresden china maniken, with a face like a monkey, trying to assume the airs of a prince of the blood royal, . . . the other, a golden-haired, languishing Anglo-Italian, graceful to affectation, endeavoring to play the fairy princess, to take rank among the most exclusive queens of the salon."[47] However, one hundred years later, few indeed are familiar with the Cosways. Richard usually receives a few lines in histories of English art relating to the revival of miniature painting in the late 18th century; of Maria we read even less, although her reputation seemed still to be secure at the beginning of this century (an engraving after her self-portrait sold at a London auction for $1,000 in 1901).

After having made a small fortune as innkeepers in Leghorn, Italy, where she was born, Maria Hadfield's parents decided to open a pensione in Florence in order that their talented convent-bred child could study the old masters. In Florence Maria proceeded to win drawing medals and was elected to the Florentine Academy of Fine Arts when she was only nineteen. There she met Angelica Kauffmann who was

FIG. 4-10. Maria Cosway, *Georgiana, Duchess of Devonshire as Diana*. Devonshire Collection, Chatsworth. Reproduced by Permission of the Trustees of the Chatsworth Settlement.

FIG. 4-11. Maria Cosway, *Self-Portrait* (c. 1786). From the Mezzotint by Valentine Green. Present location unknown.

enchanted by the young girl who reminded her so much of herself as a child. During a visit to Rome the Hadfields made the acquaintance of the ubiquitous Fuseli and the English colony of artists, as well as Anton Raffael Mengs, the German Neoclassicist. After meeting the precocious Maria Hadfield, James Northcate, Reynolds' subsequent biographer, wrote to his friend in London (1778): "We have now in Rome a Miss Hadfield who studies painting. She plays fairly on the Harpsichord, and sings and composes music very finely, and will be another Angelica."[48]

The sudden death of her father left Maria and her mother penniless. In desperation Maria wanted to join a convent; a distraught Mrs. Hadfield wrote Angelica Kauffmann, by then successfully established in London. Kauffmann persuaded mother and daughter to come to London, and not only financed their trip but introduced Maria to prospective patrons. By the time the forty-year old Angelica left London, she had almost been replaced by Maria Cosway as the reigning young beauty of the art world.

It was during a visit with Angelica to the home of Charles Townley, one of the most avid art collectors of the period, that Maria met Richard Cosway. At the time of their meeting, Richard Cosway was gaining fame and wealth from his miniatures. Maria continued her art training after their marriage (1781), probably under her husband's tutelage. Although she had been painting large canvases based on themes in English literature and Greek mythology, she was urged by Richard to do miniatures. Cosway kept his shy, retiring wife in virtual seclusion after their marriage while training her in the dignity and grace necessary to be a brilliant hostess. Evidently she was, because poets, writers, orators, diplomats, lords and ladies, and even the Prince of Wales flocked to their Sunday evening musicales, where Maria entertained. The Cosway's popularity dropped, however, when Richard expressed support for the French Revolution; his aristocratic patrons deserted him in droves. On a trip to Paris in 1786, the couple met Thomas Jefferson, who praised Maria's "beauty and that softness of disposition which is the ornament of her sex." They later traveled together; Jefferson wrote poems in her honor and preserved the correspondence they carried on until 1824.

Depressed after the birth of her only child (named after Angelica Kauffmann), Maria Cosway left the three-month-old infant with her husband to travel and paint on the Continent, returning for a brief visit in 1794 when her daughter was ill and again in 1796, when the child died. She was back in London in 1800 and at this time did a series of drawings that were later published as etchings. Entitled "The Progress of Female Dissipation" and "The Progress of Female Virtue," they were most likely based on William Hogarth's successful series, "The Rake's Progress" (c. 1734). In 1802 Maria began traveling again, spending much of her time with a married sister in Lodi in northern Italy. In 1812 she founded the Collegio delle Grazie on the estate of the Duke of Lodi. In 1821 she returned to London to care for her dying husband. Her last years were spent administering the college at Lodi, which in 1830 became part of the Dame Inglesi, a convent based in Austria. In 1834 she was made a Baroness by the Emperor of Austria because of her work at the school.[49]

Cosway began exhibiting regularly at the Royal Academy in 1781, when she showed three works: *Rinaldo, Creusa Appearing to Aneas* (which was engraved by V. Green), and *Like Patience on a Monument Smiling at Grief.* Her debut was favorably received, one critic writing: "She was poetic in feeling, facile in execution, and drew artistic inspiration from Spenser, Shakespeare, Virgil and Homer."[50] Her interest in literary subjects continued: *Lodona,* based on Pope's *Windsor Forest,* is typical of the paintings popular in France and England in the early 19th century. A large melancholy female is draped in Grecian clothing. Her weary body rests in a romantic landscape, with the dramatic sweep of the feathery trees on the right creating an aura of mystery. This work was engraved by Bartolozzi and is illustrated in Sparrow. A certain fantastic element stemming from Fuseli sometimes appeared in her work.

Cosway was best known for her portraits. She painted Vigée-Lebrun, Madame Récamier (as a guardian angel), and Georgiana, Duchess of Devonshire, as the moon goddess Diana emerging from a flurry of clouds, her diaphanous gown floating in the winds (Fig. 4-10). In her *Self-Portrait* of 1786 (Fig. 4-11), engraved by Green, she presented herself as a cool, self-assured, and determined woman, which is quite at variance with the softly feminine "pretty toy" that Richard portrayed in his likeness of her. Ironically, judging by the hair style and dress, they were painted within only a few years of each other.[51]

MARGARET CARPENTER (1793–1872)

Born Margaret Sarah Geddes into a family of considerable literary reputation, Carpenter was acknowledged as one of the leading portrait painters of the

FIG. 4-12. Margaret Carpenter, *Portrait of John Gibson, R.A., Sculptor* (c. 1857). National Portrait Gallery, London.

allowed her to copy the pictures in his gallery. Following his suggestion, she sent three pictures in three successive years to the Society of Arts, receiving an award for each. For a drawing of a boy's head she won a gold medal. Again, following Lord Radnor's advice, she went to London in 1814 and immediately had a portrait accepted for exhibition at the Royal Academy, where she exhibited regularly until six years before her death. In 1817 she married W. H. Carpenter, who later was appointed Keeper of the Prints and Drawings at the British Museum. The couple had two sons, one of whom, William, also became a successful painter. When her husband died in 1866, Margaret was awarded an annual pension of £.100 in recognition of her achievements and of her husband's service to the Crown.

At least a half-dozen of Carpenter's portraits are in the National Portrait Gallery, London; the others are most likely still in the homes of the descendants of her patrons. *John Gibson, R.A. Sculptor* (Fig. 4-12) and *R.F. Bonington, Painter* are both romantic and aristocratic, in the best tradition of English portraiture that began with the elegant conceptions of Van Dyck. In the Gibson likeness, in which the sculptor is shown holding a tool of his trade, there is great virtuosity of brushwork; the painter Bonington is portrayed as a dark and brooding figure.

BARBARA LEIGH SMITH BODICHON (1827–1891)

"Not only as a finished artist is Madame Bodichon well known, but also as a philanthropist, one of those brave and noble women who make strenuous efforts to stem the tide of vice and misery, and to right the wrongs under which so many helpless sisters suffer." Indeed, this formidable and accomplished woman was renowned both as an artist and as a feminist activist, a combination not to be repeated again until the resurgence of feminism in the arts in the 1970s. She was a friend of Mrs. Jameson, a founder of *The English Woman's Journal*, and the model for the heroine in George Eliot's *Romola*.

Educated along with her brother under the guidance of her father, a Unitarian and a radical member of Parliament, she was admitted to the company of his friends and so became aware of the social problems of her time. Her father also took a keen interest in her development as an artist and arranged for her to study with John Varley, the water colorist, and William Holman Hunt, Sr; she also was an early

19th century. Engravings were made after the portraits of the famous people who sat for her; "her portraits were considered as excellent likenesses; her touch was firm, her color brilliant." In fact, it was difficult for many sympathetic critics to understand why she was not received into the Royal Academy. Clayton quotes a writer in the *Art Journal* who was extremely critical of Carpenter's neglect: "Had the Royal Academy abrogated the law which denies a female admission to its ranks, Mrs. Carpenter would most assuredly have gained, as she merited, a place in them; but we despair of ever living to see the rights of women vindicated in this respect; the doors of the institution are yet too narrow for such to find entrance."[52]

Carpenter's earliest training was from a local artist in Salisbury, her place of birth. It was there, too, that she attracted the attention of Lord Radnor, who

graduate of Bedford College. One of the fortunate few, Barbara Leigh Smith had a guaranteed income of £.300 a year (as did her brothers), which allowed her to pursue her destiny independent of men. However, she did eventually marry a French physician, Eugene Bodichon, equally interested in social reform and as indifferent to social convention as she. The couple traveled a great deal. In 1857 they visited America for a year and Barbara painted wherever they went. Her *Falls of Niagara* was well received and exhibited in Philadelphia and Washington; after she returned to England her American scenes found immediate buyers when shown at the Dudley Gallery. During their visits to Brittany, Spain, and Algiers, she preserved "vivid recollections of the spots wandered through." She was acclaimed as "one of the few artists who can paint moving masses of water, her waves dance and leap as if they were really moving." Between 1869 and 1872 Bodichon exhibited a series of coastal scenes, including *The Sea at Hastings* (Fig. 4-13), at the Royal Academy. She was influenced by the Barbizon School, especially Corot and Daubigny. French critics described her as the "Rosa Bonheur of Landscape"—"she does not merely reproduce the outward features of her scenes, but brings a strong intellectual force to give vitality," wrote one.[53] A friend of the Pre-Raphaelites, she was described by Rossetti as being "blessed with large rations of tin, fat, enthusiasm and golden hair."

After her visit to the United States, Bodichon became an abolitionist and wrote a series called "Slavery in the South." She also wrote extensively on the political, educational, and legal disabilities of women. With the assistance of a friend, Elizabeth Whitehead, who was to be responsible for most of the teaching, Bodichon founded the Portman Hall School, a most unconventional institution in that it was nondenominational, coeducational, and without class distinction. She was later to assist in the founding of Girton College for Women (1869); their museum houses the bulk of the artist's work. Although she and her husband traveled extensively, Barbara Bodichon periodically returned to England to stoke the fires of the women's movement.[54]

LUCY MADDOX BROWN ROSSETTI

To write of women artists in England and bypass so illustrious a name as Lucy Maddox Brown Rossetti would be unforgivable. Her name quickly brings to mind the Pre-Raphaelite Brotherhood, the mid-19th century group of militant painters who organized the first revolt against the Royal Academy by attacking the Academy's emphasis on dark, pretentious history paintings, trivial anecdotal themes, and what they termed "monkeyana," after the popular animal paintings of Landseer. In their search for an art that was "true to nature," they advocated a return to the purity of art before the High Renaissance.

Lucy was the oldest daughter of Ford Maddox Brown (1821–1893), a latecomer to the Pre-Raphaelites. Her early art training was casual: at eight or nine she had a few drawing lessons, but her abilities were not recognized until 1868, when one of her father's assistants failed to arrive to do some routine work. Lucy volunteered to assist and did so well that her

FIG. 4-13. Barbara Leigh Smith Bodichon, *The Sea at Hastings.* Girton College, Cambridge, England.

FIG. 4-14. Lucy Maddox Brown Rossetti, *The Fugitive.* 22½" × 16". Present location unknown.

father encouraged her to study seriously. At first she worked under his direction and then, along with a brother and sister, was enrolled at the Branch Government School of Art. In 1869 she exhibited a water color at the Dudley Gallery which was praised by critics for its harmony, "quiet unity and solidity of tone," and "unquestionably true feeling." Entitled *Painting*, it showed a young woman sitting at an easel painting an older woman holding a bouquet of flowers.

After a tour of Europe in 1874, she married William Michael Rossetti. He was Assistant Secretary to the Board of Inland Revenues, an art critic and poet, and brother of Dante Gabriel Rosetti, a founder of the Pre-Raphaelite movement. The couple had a daughter. Lucy then produced a series of history paintings,

including *Margaret Roper Receiving the Head of Her Father, Sir Thomas More, from London Bridge.* "Her pictures are simple and direct in handling," wrote Ellen Clayton, and "full and harmonious in tone of color . . . The subject, indeed, always presents itself to this artist in a clear, concrete form."[55] The influence of her father and brother-in-law can be seen in *Romeo and Juliet*, a charming and tender rendition of the legend. Juliet is shown hovering over the dead body of her lover, the sun pouring over their faces from an open door. It has been described as "full of thought, full of the young soul of the artist."[56] In *The Fugitive* (Fig. 4-14), Lucy has captured the spirit but not the elegance of the paintings of her famous brother-in-law. There is a similar intensity in the woman's eyes, the pursed lips, elon-

gated nose and abundance of hair. Lost in a delicate-
ly etched woodland, the fugitive is dressed in a
medieval costume of the artist's invention; her captor
stares at her ominously from behind the tree she has
chosen as her resting place.

ELIZABETH THOMPSON (Lady Butler) (1850–1933)

Her sudden and dazzling success at the Royal Aca-
demy in 1874 for a stunning picture of miltary life
painted when she was barely out of school threw
Elizabeth Thompson "into a fever." She was regard-
ed as a "youthful conquerer" and was "admired,
envied, and extolled." Indeed, not since the days of
Angelica Kauffmann had a woman artist created
such a stir. Extra police had to be hired to control the
crowds lined up to view *Calling the Roll After an
Engagement: Crimea* (also known as *Roll Call*), the
first in her series of military pictures. After purchas-
ing the painting for £126, the buyer presented it to
Queen Victoria. Prints after the painting made the
artist famous throughout the country and each new
work was greeted with anticipation. In 1875 the
caustic art critic, John Ruskin, commented on her
celebrity in his *Notes of the Academy*. That year she
had exhibited *Quatre Bras, 1815* (Fig. 4-15)—now in
the Melbourne National Gallery. Wrote Ruskin:

I never approached a picture with more iniquitous preju-
dice against it than I did Miss Thompson's—"Quatre
Bras"—partly because I have always said that no woman
could paint, and secondly because I thought what the
public made such a fuss about must be good for nothing. . . .
But it is Amazon's work, this, no doubt of it, and the first
fine Pre-Raphaelite picture of battle we have had; pro-
foundly interesting, and showing all manner of illustrative
and realistic faculty. . . . The sky is most tenderly painted,
and with the truest piece of cloud of all in the Exhibition;
and the terrific piece of gallant wrath and ruin on the
extreme left, when the cuirassier is catching round the neck
of his horse as he falls, and the convulsed fallen horse, seen
through the smoke below, is wrought through all the truth
of its frantic passion with gradations of color and shade
which I have not seen the life of since Turner's death.[57]

Born in Lausanne, Switzerland, of English par-
ents, Thompson's mother was a landscape painter;
her father was an independently wealthy man edu-
cated at Oxford, and saw that his two daughters
(Elizabeth's sister was the poet and writer Alice
Meynell) had vigorous athletic as well as intellectual
training. They freely roamed the countryside in both
England and Italy, where the Thompsons spent their
winters. Elizabeth began drawing horses and soldiers
in her school books as her father recounted the
glories of England's past during history readings; in
1866 she began her serious study of art at the South
Kensington School of Art, where she was the recipi-

FIG. 4-15. Elizabeth Thompson (Lady Butler), *Quatre Bras, 1815.* 38½″ × 85⅛″. Purchased 1884, National
Gallery of Victoria, Melbourne.

FIG. 4-16. Elizabeth Thompson (Lady Butler), *The Remnants of an Army*. The Tate Gallery, London.

ent of the prizes the school had to offer. She later studied at the school attached to the Society of Lady Artists and, not wanting to snub the group that gave her her initial encouragement, showed at their exhibitions after her first success at the Royal Academy. There was, in addition, travel and study in Florence and Rome, and private study from the female nude.

Missing!, a water color of 1873, shows a turbaned black man on a charging, silky, black horse, a long bamboo-like spear in his hand. There followed *Balaclava*, depicting the return of the Light Brigade of the famous charge (1876), *The Remnants of an Army* (1879) (Fig. 4-16), *After the Battle, Tel el Kebir* (1885), and the huge anecdotal *Steady the Drums and Fifes* (1897). Composed like an ellipse, from the central group of disheveled and animated drummers, the composition of thousands decreases in size on either side. There is a large sky, the wreckage of the regiment is strewn carelessly about, and in the distance, men are still marching. Typically, the artist avoids showing the bloodshed of battle.

In 1877, Thompson married a military man, the Rt. Hon. Sir William Francis Butler, with whom she traveled to the far outposts of the British Empire,

sketchbook and notebook in hand. Her accurate descriptions of military life came from direct observations of miltary manoeuvers and from interviews with military experts and veterans of various campaigns. For *Quatre Bras*, she gained permission to have three hundred men from the Royal Engineers pose in full dress in battle formation, and then fire their ammunition to secure the requisite effect. The clarity and glossiness of the figures contrasts with the more textural brushstroke used to depict the grass—an almost Impressionist handling of light and color. Nochlin suggests that in her later works Lady Butler referred to photographs, "a practice current among her French contemporaries."[58]

GWEN JOHN (1876–1938)

Gwendolen Mary John's lifestyle and personality seemed to be quite at variance with that of her more famous brother, Augustus. While he was an expansive, explosive, bohemian character, she was devout and subdued. So unobtrusive was her life, in fact, that no critical articles were written about her impor-

tant stay in France, where she lived most of her life. A memorial exhibit was held for her seven years after her death, and the 217 works in a variety of media were greeted with respect, but again she faded from critical consciousness. That her work went almost unnoticed is partially the artist's own fault: in her later years she deliberately chose to isolate herself, rarely leaving her "little shack on a piece of waste land" that she shared with her cats. Many personal letters were found in her room after her death, but since in life she was a very private person, her heirs have chosen to respect that privacy. Today her work is being reevaluated. Her paintings have an energy, a solemn dignity, and a complexity of feeling that have endured, and she is gradually being recognized as one of the finest English painters of the late 19th and early 20th centuries. Exhibits of her work were held in England in 1961, 1964, 1968, 1970 and 1976; in America, where the large John Quinn reservoir of her paintings remains, she was given a retrospective at the Davis and Long Gallery in New York in 1975.

Born in Wales, the second of four children of Edwin John, a solicitor, and his wife Augusta, an amateur artist who encouraged her children's early interest in art, Gwen moved with her family to Tenby, a seaside resort, after the death of Mrs. John in 1884. There the children were invariably found watching the artists at work; and as their father wrote later, "Wherever they went their sketchbooks went with them. In their walks along the beach, on excursions into the country . . . and when they were a little older, in London . . ."[59] Augustus and Gwen were given an attic room in which to work and Gwen brought neighborhood children in to pose. She also attended a small private academy in Tenby, where, judging by the atrocious grammar and spelling in her letters, she learned very little. In 1895 she followed Augustus to the University of London's Slade School of Art, where they shared rooms and subsisted, wrote Augustus, "like monkeys, on a diet of fruit and nuts." Her talent and originality did not go unnoticed at the Slade: she won a prize for figure drawing and one for composition during her three years of study there.[60]

Augustus took issue with those who claimed he and his sister were opposites in personality: "Gwen and I are not opposite but much the same really, but we took a different attitude. I am rarely exuberant. She was always so; latterly in a tragic way. She wasn't chaste or subdued, but amorous and proud. She didn't steal through life but preserved a haughty independence which people mistook for humility. Her passions for both men and women were outrageous and irrational. She was never unnoticed by those who had access to her."[61] Indeed, she had a series of convoluted relationships with both men and women which usually ended in their withdrawal from her because she was unable to moderate her feelings. One attachment, with a fellow painter from the Slade, Ambrose McEvoy, was fruitful in that he shared with her the results of his studies of the techniques of the old masters. The influence of his research is evident in one of her loveliest paintings, the haunting *Self-Portrait* (Fig. 4-17) of about 1900. A delicate and beautiful portrayal, the sense of isolation that is a central theme in her work is clearly defined here.[62]

After completing her formal studies in London, Gwen made the obligatory trip to Paris, enrolling in the Académie Carmen, a school run by a former Whistler model where the master himself appeared twice weekly to give critiques. When Augustus inquired of his sister's progress, adding that he thought her drawings "showed a feeling for character," Whis-

FIG. 4-17. Gwen John, *Self-Portrait* (1900). The Tate Gallery, London.

FIG. 4-18. Gwen John, *Woman Reading at a Window* (1900). Museum of Modern Art, New York. Mary Anderson Conroy Bequest in Memory of her Mother, Julia Quinn Anderson.

tler replied: "Character? What's that? It's tone that matters. Your sister has a fine sense of tone."[63]

John's works of the 1895–1900 period show the influence of the Slade faculty, the Nabis, and Whistler; those of the early 20th century show her debt to Picasso's "blue period." *Young Woman with a Violin* (c. 1895–1900), although showing a customary solitary figure, has more interior detailing and is set further back in the picture plane than her later work. In *Woman Reading at a Window* (1911; Fig. 4-18)—which was shown in 1913 at the Armory Show in New York and is almost certainly a self-portrait—an elongated silhouette of a woman appears near a window. Here also is the distinction between figure and ground that disappears in the later work. John's subject matter was limited and rarely varied: she painted a handful of her women friends, some nuns she befriended after becoming part of the Catholic revival in early 20th-century France under the influence of her friend, the neo-Thomist philosopher Jacques Maritain; a few orphans taught by the nuns; some cats; almost bare rooms; and some self-portraits. Her sitters are usually shown alone and in simple poses. The heads and hands are expressive of the character, while the body becomes almost pure abstraction. In her later paintings there is less attention paid to the glazing and underpainting she learned from McEvoy, the paint being applied spontaneously in thick, broad strokes. She used a limited palette and close spatial relationships. The artist rarely dated or signed her work.

While working as an artist's model during her first years in Paris, John met Rodin, who claimed she had not only "un corps admirable," but that she was also "un bel artiste." Although at first she disliked the old sculptor, she maintained a long and complex relationship with him; many of his letters to her were found after her death. She also formed a close friendship with the poet Rilke, who was then acting as Rodin's secretary. Rilke sent her books to read and supported her during some difficult times.[64]

When her brother recommended her in 1910 to the American collector John Quinn, the result was both productive and profitable. Although they did not meet until 1921, three years before Quinn's death, they corresponded frequently. He became Gwen's chief patron: for an annual stipend that allowed her to paint without resorting to menial employment, she sent him all the work she could part with. She also reported to him the latest news of the Parisian art world and recommended works for him to add to his collection. After her patron's death, she seems to have worked less and become more withdrawn.

Although not actively involved in any of the theoretical battles raging in the art world prior to World War I, Gwen John was aware of them. There is an occasional glimpse of Cézanne in some of her portraits, while a still-life of the 1920s evokes Matisse. Her self-sufficiency and independence, however, created a consistently personal oeuvre. She once wrote: "A beautiful life is one led, perhaps, in the shadow, but ordered, regular, harmonious."[65]

NOTES

1. Quoted in W. Lyon Blease, *The Emancipation of English Women* (London, 1910), 2.

2. Quoted in Janet Dunbar, *The Early Victorian Woman* (London: George G. Harrap & Co., Ltd., 1953), 25. Women were granted custody of their children under seven in 1837 and could file for divorce after 1857, but were not considered separate legal entities until 1891.

3. Blease, *The Emancipation*, 10–11.

4. Lady Montagu (1739), quoted in M. Philips and W. S. Tomkinson, *English Women in Life and Letters* (Oxford University Press, 1926), 186.

5. Blease, *The Emancipation*, 29.

6. Quoted in *Ibid.*, 66–67.

7. Quoted in Gladys M. Cuddeford, *Women and Society* (London: Hamish Hamilton, 1967), 43.

8. Quoted in Blease, *The Emancipation*, 36–37.

9. Blease, writing in 1910, found this latter idea preposterous.

10. Quoted in Philips and Tomkinson, *Life and Letters*, 184; Blease, *The Emancipation*, 44–45.

11. Mrs. Barbauld, *Legacy to Young Ladies*, quoted in Blease, *The Emancipation*, 56, 61.

12. Blease, *The Emancipation*, 40–44.

13. Dr. Johnson paid her the ultimate compliment when he wrote that she "can make a pudding as well as translate Epictetus and work a handkerchief as well as compose a poem . . ."; Cuddeford, *Women and Society*, 15.

14. Blease, *The Emancipation*, 94–95, 104; Cuddeford, *Women and Society*, 23.

15. Philips and Tomkinson, *Life and Letters*, 366–76; 383–98; Blease, *The Emancipation*, 92.

16. Dunbar, *Victorian Woman*, 86–88, 117–19; Blease, *The Emancipation*, 102.

17. Since she could not be given a diplomatic, academic, or ministerial post, as went to her celebrated male colleagues, the appointment to court was devised. The experience proved debilitating, and she left after five years. See Ellen Moers, *Literary Women: The Great Writers* (New York: Doubleday & Co., Inc., 1976), 179.

18. F. B. Pinion, *A Jane Austen Companion* (London: Macmillan, 1973), 49.

19. Dunbar, *Victorian Woman*, 118-32; Philips and Tomkinson, *Life and Letters*, 344-60. Currer, Ellis, and Acton Bell were the pen names used by Charlotte, Emily, and Anne Bronte.

20. From *The Subjection of Women*, reprinted in Rossi, *Feminist Papers*, 196.

21. Ernest Short, *A History of British Painting* (London: Eyre & Spottiswoode, 1953), 209-10; Adeline Hartcup, *Angelica* (London: William Heinemann, Ltd., 1954), 10.

22. Quoted in Ellet, *Women Artists*, 169.

23. Clement, *Women in the Fine Arts*, 159; Ellen C. Clayton, *English Female Artists*, 2 vols. (London: Tinsley Brothers, 1876), Vol. 1, 301.

24. Josephine Kamm, *Rapiers and Battleaxes* (London: George Allen & Unwin Ltd., 1966), 42-46.

25. Clayton, *English Female Artists*, 20; Clement, *Women in the Fine Arts*, 72.

26. Elizabeth Walsh and Robert Jefferies, "The Excellent Mrs. Mary Beale" (Jeffrye Museum, London, Oct. 13-Dec. 21, 1975), 9.

27. Clayton, *English Female Artists*, 45, 51.

28. Elizabeth Walsh, "Mrs. Beale, Paintress," *Connoisseur* (1955), 3-8; Clayton, *English Female Artists*, 42-44; Walsh and Jefferies, "The Excellent Mrs. Mary Beale," 11-15; Sparrow, *Women Painters*, 58.

29. Clement, *Women in the Fine Arts*, 192-93; Clayton, *English Female Artists*, 59-68.

30. Sparrow, *Women Painters*, 58; Clayton, *English Female Artists*, 58.

31. Quoted in Lady Victoria Manners, "Catherine Read: 'The English Rosalba,'" *Connoisseur*, 88 (1931), 380.

32. Quoted in Hartcup, *Angelica*, 9.

33. Clayton, *English Female Artists*, 148-230.

34. Quoted in Blease, *The Emancipation*, 59.

35. Interestingly, Reynolds did a similar "decision painting" at this time depicting David Garrick hesitating between the muses Tragedy and Comedy. Both are probably based on earlier works that each had viewed independently; Hartcup, *Angelica*, 26.

36. Quoted in Clement, *Women in the Fine Arts*, 345.

37. Quoted in Hartcup, *Angelica*, 31-32.

38. Quoted in Clement, *Women in the Fine Arts*, 345.

39. Hartcup, *Angelica*, 169-82.

40. Quoted in Ellet, *Women Artists*, 166.

41. Clement, *Women in the Fine Arts*, 249.

42. Quoted in Clayton, *English Female Artists*, 302.

43. *Ibid.*, 295-97.

44. Quoted in *Ibid.*, 305.

45. Quoted in Clement, *Women in the Fine Arts*, 96.

46. Ellet, *Women Artists*, 177; Clement, *Women in the Fine Arts*, 96-100.

47. Clayton, *English Female Artists*, 314.

48. Quoted in Dorothy Moulton Mayer, *Angelica Kauffmann, R.A. 1741-1807* (London: Colin Smythe, 1972), 95. Much of the biographical information on Kauffmann is culled from this book.

49. Constance Scheerer, "Maria Cosway: Larger-Than-Life Miniaturist," *Feminist Art Journal* (Spring 1976), 13.

50. Quoted in Clayton, *English Female Artists*, 321.

51. Richard Cosway's portrait of Maria appears in *Time* magazine's Bicentennial issue of July 4, 1975.

52. Quoted in Clayton, *English Female Artists*, 388.

53. Quoted in *Ibid.*, 176.

54. Kamm, *Rapiers and Battleaxes*, 46-47.

55. Clayton, *English Female Artists*, 124.

56. Percy Bate, *The English Pre-Raphaelite Painters: Their Associates and Successors* (London: George Bell Sons, 1901), 23, 112.

57. Quoted in Clement, *Women in the Fine Arts*, 69-70.

58. Nochlin, "Lady Elizabeth Butler," in "Women Artists," 249.

59. Edwin John, quoted in Cecily Langdale, "Introduction," "Gwen John: A Retrospective Exhibition", (Davis & Long Company, New York, October 14-November 1, 1975), 5.

60. Augustus John, *Chiaroscuro* (New York: Pellegrini & Cudahy, 1952), 49.

61. Quoted in Langdale, "Introduction," 5.

62. Sir John Rothenstein, *Modern English Painters from Sickert to Smith* (London: Eyre & Spottieswoode, 1952), 163.

63. John, *Chiaroscuro*, 66.

64. *Ibid.*, 249, 251.

65. Quoted in Rothenstein, *Modern English Painters*, 170.

The American Experience

THE CHANGING ROLES OF WOMEN

The first explorers came to the New World without women, but for settlements to develop the second sex was needed. Women brought with them knowledge, skills, and a cultural heritage. They were the civilizers and community builders of the new nation who raised money for churches, saw to the welfare of their neighbors, educated the children, and during their husbands' long absences for hunting and scouting expeditions managed household and farm and fought Indians. The so-called masculine characteristics of self-reliance, courage, and resourcefulness were necessary for survival on the frontier, and since much of the New World was wilderness, there was no room for the delicate "lady" in early colonial life. Depending on the values brought from the mother country, the colonies varied in their treatment of women, the Moravians and Quakers being more liberal in their attitudes than the Puritans.[1]

Essentially, marriage was the only "career choice" for a woman, and there were few spinsters in the new colonies. Because of the shortage of women their status was enhanced. Dowries became unnecessary, and marriages were made across class lines. Status was no longer fixed by birth or work: just as a man brought to this country as a servant could acquire land and through personal initiative secure a respectable place in the community, so too a poor girl could marry well. Although their legal status was limited, women were granted rights and privileges denied them in England and on the Continent: the wife was allowed an interest in her husband's property and ownership of her personal wardrobe; she could make contracts, enter business and sue in his behalf. Widows were recognized as legal heads of households, and many women were listed as property holders. In most of the colonies both widows and single women were given land grants as heads of households, having the legal right to own and operate their own business and keep their profits. Women were often named executors of their husband's estates, and as property owners voted and were eligible to hold the power of attorney in court cases. They served on juries in cases involving women and held minor community offices such as interpreter, tax-treasurer, state printer, and post-mistress. Within the home, however, male privilege still prevailed. The father was sole guardian of the children; the wife had no recourse if abused, except to run away and disappear into the new territories. Judging from the quantity of newspaper advertisements concerning runaway wives, this was a frequent occurrence, but since married women were not allowed to keep the monies they earned, few had funds to support such an adventure in freedom.[2]

With the constant shortage of labor during the colonial period, it was necessary for everyone to work—men, women, children, and the aged. In all social classes, the work of women was essentially the same: the bearing and raising of children, the management of the household, and the processing of the raw materials which the sons and husbands produced in the fields. One authority on American women wrote: "Frontier conditions created a spirit of comradeship and mutual help, and men and women worked together on a basis of equality, even though law and custom decreed otherwise."[3] In addition, colonial women acted as physicians, midwives, and nurses; kept inns and taverns; raised sheep and flax, wove, dyed and printed cloth, and supervised the production of clothing for home use and sale. Some did fine needlework, made lace, or were milliners; others were printers and publishers of newspapers; still others owned stores where they sold their own products as well as those of their neighbors; a few dabbled in law and real estate and were notaries. Indeed, women were an integral and vital part of the commercial life of the colonies before the Revolution set men free.[4]

Reacting to the injustices of the British as did their men-folk, as early as 1766 a group of women calling

themselves the Daughters of Liberty met to spin all day; they vowed to wear nothing but homespun clothing and signed compacts to drink no more British tea and to boycott British-made goods. The idea of women banding together for anything but church work was in itself revolutionary, and it was soon considered patriotic to imitate their actions. When war began, a network of relief organizations clothed and fed the soldiers and provided medical supplies and care for the wounded. Like their sisters in the French Revolution, women donated their jewelry to amortize the war debt. Taking over jobs previously held by men, they worked in munitions factories and did the heavy farming. Yet the politics of war were considered beyond their sphere. In France on the eve of its revolution, Thomas Jefferson wrote home to a female friend describing the politicized atmosphere: "Men, women, children talk of nothing else. . . . But our good ladies, I trust, have been too wise to wrinkle their foreheads with politics. They are contented to soothe and calm the minds of their husbands returning ruffled from political debate. They have the good sense to value domestic happiness above all others."[5]

Women shared in the sense of a new beginning after the Revolution. Fearing that the men at the Second Constitutional Congress would, by custom, ignore her sex, Abigail Adams (1744–1818) wrote her husband: ". . . I desire you would Remember the Ladies, and be more generous and favourable to them than your ancestors. Do not put such unlimited power into the hands of Husbands. Remember all men would be tyrants if they could. If particular care and attention are not paid the Ladies we are determined to foment a Rebellion, and will not hold ourselves bound by any Laws in which we have no voice, or Representation."

Indeed, a conflict existed as to the role of women in a democracy: young girls needed training in order to be independent and intelligent citizens, but since marriage was the ultimate goal, they were counseled to be fashion-conscious and "accomplished." With increased wealth and industrialization, a large urban middle-class developed in the new republic. There was more leisure for middle-class women: they became "ladies," mimicking the manners and mores of the local gentry. The new ideal of womanhood became the "lady of the house"—a luxury no Puritan or pioneer man had ever afforded. Mass-circulation magazines emerged to meet their needs, to inform them about fashion, entertainment, interior decoration, morality, and child rearing. With a circulation of 150,000 by 1860, *Godey's Lady's Book* (edited for

forty years by the redoubtable Sara Josepha Hale) was the most influential of the 19th-century journals catering to women. Hale frequently reminded her readers that "The station of women as the companion of free, independent, civilized and Christian man is the most important she can sustain on earth—the most honorable, useful and happy."[6]

No longer viewed as a partner as in colonial times, this new woman was ignorant of her husband's work and isolated from the world outside the home. In fact, as her sphere of activity narrowed, the American Victorian woman became enshrined in her home. Virtues were made of her "piety, purity, submissiveness, and domesticity," and women were said to be "morally and spiritually superior to men." Since these ideals were reinforced in the popular novels and paintings of the period, most women believed them and behaved accordingly.[7] In *Society in America* (1837), Harriet Martineau wrote of her fear that America's growing prosperity would arrest the development of American women: "It will be long before they are put to proof as to what they are capable of thinking and doing: a proof [to] which . . . English women have been put by adversity, and the result is a remarkable improvement in their social condition." She further observed that "While woman's intellect is confined, her morals crushed, her health ruined, her weakness encouraged, and her strength punished, she is told that her lot is cast in the paradise of women: and there is no country in the world where there is so much boasting of the 'chivalrous' treatment she enjoys. . . . In short, indulgence is given her as a substitute for justice."[8]

The Industrial Revolution changed the conditions under which women worked: while previously their labor was done in the home or in an adjacent building that permitted the combination of production of goods with domestic duties, this became difficult when work was done far from home in large factories. In the New England mills the earliest workers were the daughters of respectable farm families, but after the first wave of immigrants began working for lower wages, the children of "old families" were withdrawn from factory work, reinforcing old class distinctions.[9] And as professional training became more institutionalized, women—who were denied higher education—were thereby denied admittance to the professions.[10]

When one examines the role of women in 19th-century France and England, it becomes obvious that in those countries too a step backward had been taken. Whereas women achieved some degree of independence and autonomy in 18th-century France,

England, and America, it was back to hearth and home and to the cult of domesticity in the beginning years of the 19th century. The influence of Rousseau was transmitted to England, from which the Victorian family ideal was then exported to America.

The Civil War awakened American women from their lethargy. Again they were called upon to care for their wounded. Dr. Elizabeth Blackwell (1821–1910), the first woman to receive an American medical degree, organized the Woman's Central Association for Relief which trained nurses; the prison and mental hospital reformer, Dorothea Dix (1802–1887), was appointed Superintendent of Nurses and thereby created a profession, despite the interference of physicians who resented women invading their sphere. Women arranged fairs to raise money for the Sanitary Commission, and the work of women artists was to be found in the art department. In the South, where the ideal of delicate femininity continued to prevail, women suffered the most because the war was fought on their soil, but they managed the plantations and kept the soldiers fed and clothed. In the North, women went to work in munitions plants and mills—and, for the first time, in government offices. They again entered the retail trades and monopolized the teaching profession. Many of these women did not return home after the war, since new areas of work had become permanently open to them.

EDUCATION

In the 17th century, almost everyone in the American colonies was illiterate: at mid-century only about half the women in Massachusetts could sign their names; by the end of the century the illiteracy rate among women had dropped to 38 percent. In New England the wealthier girls went to private school or to the public "dame schools," started in 1635 and modeled after the English boarding schools. Headed by "spinsters or poverty stricken widows," their curricula included reading, writing, and simple arithmetic, as well as sewing, embroidery, music, and a little dancing. Although Benjamin Franklin was proud of his daughter Sarah's needlework and dancing ability, he urged her "to acquire those useful accomplishments, arithmetic and bookkeeping." In addition, he recommended "that brand of education for young females as likely to be of more use to them and their children in case of widowhood than either music or dancing. by preserving them from losses by

imposition of crafty men, and enabling them to continue perhaps a profitable mercantile house . . . til a son is grown up fit to undertake and go on with it."[11]

In Southern plantation society, education followed the pattern established by the English aristocracy; until the late 18th century it was mostly tutorial. Thomas Jefferson devised a plan for his daughter's day which was probably not atypical: it included music practice; dancing; drawing; letter writing; reading from the French; and reading in English. He was interested in the books she read and in the drawings she produced, and was most concerned about her spelling, as "it produces great praise to a lady to spell well . . ."[12] By the end of the 18th century, boarding schools were found everywhere. Although the curriculum varied little from that of the dame schools, there was a renewed emphasis on submissiveness, etiquette, and the art of being a charming hostess—probably designed to give security to those just entering the middle classes.

In the publicly supported schools (by 1647, each community in Massachusetts was required to have a school), girls attended after the boys' lessons were finished or, in the summer, when the boys were working in the fields. Only among the Quakers was there parity of education between the sexes, and, as in England, it is from this group that many of the early reformers emerged. By sitting in on their brothers' tutorial sessions, or with the aid of an indulgent father, some girls were given the tools with which to educate themselves. In an exchange with her husband, Abigail Adams expressed both the frustrations and longings of the women of her class:

If you complain of education in sons what shall I say of daughters who every day experience the want of it? . . . If we mean to have heroes, statesmen, and philosophers, we must have learned women. The world perhaps would laugh at me, but you, I know, have a mind too enlarged and liberal to disregard sentiment. If as much depends as is allowed upon the early education of youth and the first principles which are instilled take the deepest root great benefit must arise from the literary accomplishments in women.[13]

It was to this end that post-Revolutionary educators directed their efforts. Women were educated to better fill the roles to which they were assigned by men: to be more interesting companions, economical housekeepers, and intelligent mothers. As Benjamin Rush, a leading educator and advocate of female education, explained: "Let the ladies of a country be educated properly and they will not only make and administer

its laws, but form its manners and character."[14] A generation later Catherine Beecher (1800–1878) and her younger sister Harriet Beecher Stowe (1811–1896) wrote a home economics text—*Treatise on Domestic Economy*—that in its scientific approach to "hygiene, medicine, diet and plumbing," reinforced the argument that "intelligent household management" was women's noblest achievement.

Inevitably, there were women who felt restricted by this limited view of female education. Those who had to earn their living turned to teaching, because, as in England, it was one of the few occupations open to middle-class women. Since the field was male-dominated, women faced frustration at every turn, and when they were allowed into the profession, they immediately recognized their inadequate preparation. After being denied permission to take the state teachers' examination in Vermont, Emma Hart Willard (1787–1870) began her own school, teaching such "masculine" subjects as trigonometry, algebra, history, and geography. Using textbooks she had written and methods she had devised, she trained her own teachers. Convinced that women's education would not prosper until it received public support, Willard, in 1821, persuaded the city of Troy, New York, to sponsor the Troy Female Seminar. Later known as the Emma Willard School, it was the first school to offer a secondary education to girls and remains the oldest continuing educational institution for women in America.

Also concerned with the inadequate education of teachers, her own included, Mary Lyon (1791–1839) spent two years raising the funds that finally enabled Mount Holyoke College in South Hadley, Massachusetts, to open its doors to young women in 1837. With a curriculum comparable to that offered at the best men's colleges, the school stressed "academic excellence" combined with a "practical orientation." Ohio's Oberlin College and the land grant colleges in the Western states had already begun matriculating women; during the last quarter of the 19th century, the elite Eastern women's colleges known as the "Seven Sisters" graduated several classes of women ready to pursue professional training.

Recognizing the critical need for adequately trained teachers after Connecticut began its public school system in 1842—the first state to do so—Catherine Beecher sought funds in Hartford to build a model school building with the latest equipment in which to train teachers. Her rigorously trained former students went on to staff schools in the West, and she herself later opened teacher training institutions in the new territories. Despite her strong intellect and

determined will, Beecher, who had raised her eight orphaned younger siblings, subscribed to the 19th-century idea that teaching was simply an extension of the maternal role, and that women's education should be directed to upgrading the skills women needed to perform in their limited sphere.[15]

The young Quaker Susan B. Anthony (1820–1906) was a more radical thinker than Beecher. The product of a warm family devoted to reform, she was encouraged as a child to seek the skills to make her independent. By mid-century, America was committed to educating its young, as cheaply as possible, which meant hiring women as teachers. Like many of her contemporaries, Anthony became a teacher. With Elizabeth Cady Stanton (1815–1902), she crusaded for adequate pay for "the women engaged in the noble work of educating our future Presidents, Senators and Congressmen."[16]

SOME "SCRIBBLING WOMEN"

Most of the women described by novelist Nathaniel Hawthorne as "that mob of scribbling women" had the advantage of a good education and chose writing, rather than teaching, to support themselves. Writing remained the only career throughout the period under consideration in which women were not only well paid, but to some extent respected. Plays, poems, and novels flowed plentifully from women's pens; those rare women who ventured into scholarly or philosophical areas, the "masculine" fields, were ridiculed for their unfeminine behavior. Hannah Adams (1775–1832), the author of several books on history and religion and the first colonial woman to support herself through her writings, was one of these:

Innumerable stories were told to show how she had unsexed herself by her learning. She was said not only to be unconscious of a hole in her stocking, but to be absolutely unable to recognize her own face in the glass . . .[17]

Anne Bradstreet (1612–1672), the first American poet, came to the New World as a young bride with her husband Simon, who later became governor of the Massachusetts colony. Her poems were published by her brother-in-law after her death; the discreet Bradstreet, mother of eight, wrote only for herself and a few of her friends. Although she accepted man's preeminence in this world, this early feminist asked only for "some small acknowledgement of ours." She expressed her feelings in these lines:

I am obnoxious to each carping tongue
Who says my hand a needle better fits,
A poet's pen all scorn I should thus wrong;
For such despite they cast on female wits,
If what I do prove well, it won't advance—
They'll say it's stolen, or else it was by chance.[18]

Born in Africa around 1755 and sold as a slave in Boston in 1761, Phillis Wheatley was the most unusual woman poet of the 18th century. Her mistress, Mrs. John Wheatley, saw to it that the bright young woman had an excellent education that included Latin and astronomy; before she was twenty she had a local reputation as a poet. Her first book of poems, with a frontispiece likeness engraved by the early black artist Scipio Moorehead, was published in England and dedicated to her friend, the Countess of Huntingdon.[19]

The earliest narrative writer in America was Mary Rowlandson, who, around 1675, wrote a widely read account of her family's capture by the Indians. The first American novel was written by Sarah Wentworth in 1781, and the first American "best-seller" came from the pen of a woman. Susanna Rowson's *Charlotte Temple* (1797), a "vice-does-not-pay" morality tale, went through 200 editions and was widely imitated. Mercy Otis Warren (1728-1814) shared in her brothers' early educational experiences, and is believed to have been as active as her brother James in creating the Committees of Correspondence that organized the revolutionary forces before the war for independence. A poet and a playwright—she wrote successful satirical sketches ridiculing the British and the Tories—as well as the mother of five, she kept a diary during the war that became the basis of her three-volume history of the American Revolution.

Judith Sargent Murray (1751-1820) shared in her brother's lessons while he was preparing for Harvard. Born into a family that held liberal views in both politics and religion, Judith had already begun her career as a writer when she married the Universalist minister John Murray. She published a book of verse in 1784 and was the first American-born woman dramatist to have her plays performed. Her essay "On the Equality of the Sexes" first appeared in the *Massachusetts Magazine* in 1790: Murray attacked not only the traditional notion of training women for marriage and dependency, but also the elitist practice of forcing sons into a "genteel and impractical" education when what the new republic needed was good manual laborers. As for girls, she urged an education that would enable them to "procure for themselves the necessaries of life; independence

should be placed within their grasp." At a time when reformers thought only of educating women to better serve others, Murray claimed a woman should feel competent at some occupation and "should reverence herself."[20]

Lydia Maria Child (1802-1880) began a children's magazine in 1827 and wrote a popular book, *The Frugal Housewife*, that went through twenty editions in seven years. Her encyclopedia on child care was followed in 1835 by a massive three-volume *History of the Condition of Women, in Various Ages and Nations*, a compendium of biographical data designed to inspire incipient feminists. Child believed in the moral superiority of women and urged men to attain "similar excellence." After she published *An Appeal for the Class of Americans Called Africans* she was identified with the radical abolitionists and never again enjoyed her earlier popularity.[21]

While many women contributed to or edited temperance and abolitionist publications (Child edited *The Anti-Slavery Standard*), there was no tradition for the novel of social protest in America as there was in 19th-century England. Although her personal knowledge of slavery was slight, Harriet Beecher Stowe created a vivid novel about the horrors of slavery in *Uncle Tom's Cabin*. The book was first published serially in a Washington anti-slavery journal. When it appeared in novel form in 1851, it sold more than 2,500,000 copies in a single year. Stowe was attacked by pro-slavery forces for her lack of "integrity and gentility"—no lady, it was said, would write that way.

Bronson Alcott was an idealistic but penniless educator, and his daughters found it necessary to support themselves. Louisa May (1832-1888) first tried teaching, but the pay was poor. With writing she could support herself and gain the independence she so desired. She wrote from her own experience; her family achieved immortality through her novels. Her realism, skill at developing characters, and her warmth and humor have ensured her popularity with each new generation of readers. Her sister May, the prototype for "Amy" in *Little Women*, was a painter and in 1879 wrote a charming book of advice to young women artists entitled *Studying Art Abroad*.[22]

Margaret Fuller (1810-1850) defies classification: in her short life she was educator, reformer, writer, and radical thinker. Her father set an exacting regime for her early education and she was a brilliant student, but when he died she was unprepared to assume financial support of her mother and younger

siblings. She first taught at Bronson Alcott's school, and later started a series of "Conversations" through which she shared her unusual education with women from Boston's social and intellectual elite, charging twenty dollars for a series of ten talks. She became a friend of the Boston Transcendentalists, and co-editor, with Ralph Waldo Emerson, of a journal, *The Dial*. In *Woman in the Nineteenth Century* (1845) she enjoined her sisters to seek within themselves their identity and "explore the groundwork of being until they find their peculiar secret . . . woman, self-centered, would never be absorbed by any relation; it would only be an experience to her as to a man. It is a vulgar error that love, a love to woman is her whole existence; she is also born for Truth . . ."[23]

THE REFORMERS

Thomas Paine was the only male radical of the Revolutionary period to question the restraints society forced on women. In an article entitled "An Occasional letter on the Female Sex," he had a woman write a letter addressed to all men in which she asks: "If we have an equal right with you to virtue, why should we not have an equal right to praise? The public esteem ought to wait upon merit. Our duties are different from yours, but they are not therefore less difficult to fulfill, or of less consequence to society." In "Reflections on Unhappy Marriages," Paine, a victim of two unsuccessful unions, questioned whether marriage was indeed a "natural" institution.

The novelist Charles Brockden Brown also questioned the status of women. In *Alcuin: A Dialogue of the Rights of Women* (1796-97), he has the schoolmaster Alcuin engage in lengthy conversations with Mrs. Carter, a socially prominent Philadelphian. Describing women as equal to men in all aspects except morality, where they are superior, he envisions a utopia in which "women wear the same clothes as men and enter the same occupations, in which marriage is based on reason rather than emotion, and in which divorce is easy."

Outraged by the results of the Revolution and the wording of the Constitution, Abigail Adams wrote her husband that "whilst you are proclaiming peace and good will to Men, Emancipating all Nations, you insist upon retaining an absolute power over Wives."[24] Indeed, the document that purportedly insured equality of opportunity for all and set the nation on a course of egalitarianism, in reality granted equality only to white male property owners. The leaders of the first women's rights convention in Seneca Falls, New York (1848), in preparing their statement of principles, paraphrased the Declaration of Independence with mocking alterations:

We hold these truths to be self-evident: that all men and women are created equal . . . The history of mankind is a history of repeated injuries and usurpations on the part of man toward woman, having in direct object the establishment of an absolute tyranny over her.[25]

The full impetus of the women's movement began to be felt with the general spirit of reform and evangelism during the Jacksonian era. Women were encouraged to speak out at revival meetings; thus, by the late 1820s Protestant women other than Quakers were gaining experience in public speaking. It was in the rural towns of western New York where Theodore Weld, abolitionist and revivalist leader, held his most successful meetings, and it was in this same area that the women's movement took root. The temperance and abolitionist movements also grew out of this "Second Great Awakening" that placed man, rather than God, at the center of the universe. Women were active in the reform movements along with their husbands. When they were denied leadership and a public platform, they at first organized their own reform societies and then directed their energies to improving their own lot. This step toward independence was seen as a threat to the teachings of the church and the status of the family, yet 19th-century American feminists were middle-class conservatives whose impetus for reform was moral and religious rather than radical. Most, except for Stanton, ignored the issue of sexual fulfillment and were involved primarily with the temperance and/or abolitionist cause. They believed that by moral persuasion men would recognize the wrong in keeping slaves and women subjugated and would therefore set both free. By contrast, the English feminists (and their American counterpart Margaret Fuller) were solitary thinkers, urban intellectuals, and political radicals. Skeptical of all institutions—including the church—they related their oppression through that of the working classes rather than the slaves.[26]

The American women's movement brought together an unusual pair: the Quaker teacher, abolitionist, and temperance leader, Susan B. Anthony, who never married and was critical of motherhood for the time it took away from the feminist struggle; and Elizabeth Cady Stanton, the robust, erratic,

creative mother of seven. Fast friends from the start, Stanton wrote that they "exactly complimented each other. . . . I am the better writer, she the better critic. She supplied the facts and statistics, I the philosophy and rhetoric, and together we have made arguments that have stood unshaken by the storms of thirty long years. . . ."[27]

Stanton was the progenitor of many of the ideas upheld by feminists in the 1970s. As early as 1847, she complained of the legal use of the husband's name to identify his wife: "I cannot acknowledge this principle as just," she wrote a friend, "therefore I cannot bear the name of another."[28] She was also one of the few to realize that "woman's chief discontent is not with her political, but with her social, and particularly her marital bondage. The solemn and profound question of marriage . . . is of more vital consequence to woman's welfare, reaches down to a deeper depth in woman's heart, and more thoroughly constitutes the core of the woman's movement, than any such superficial and fragmentary question as woman's suffrage." Stanton insisted that she was not against marriage itself, but "against the present form that makes man master, woman slave. The only revolution that we would inaugurate is to make woman a self-supporting, dignified, independent, equal partner with man in the state, the church, the home."[29]

THE STATE OF THE ARTS AND WOMEN ARTISTS

Although there were artists working in the colonies during the 18th century, there was no place for them to study or to view the work of their predecessors. Information on techniques and glimpses of style could be gleaned from the "copy books" printed in England, or from prints after paintings of the royal family. Occasionally, a second- or third-rate portrait painter migrating from Europe would accept a student, and if he brought copies of old masters with him the student could gain some knowledge of the history of art. By and large, however, there were few artists of any significance practicing their trade in colonial America.

In 1795 Charles Willson Peale founded the "Columbianum or Art Academy of Painting, Sculpture, Architecture, etc." in Philadelphia. Because of political divisiveness within the group, it closed after the first exhibit. Seven years later a group of New York professional men, considering themselves connois-

seurs of the arts, banded together to form the American Academy of Fine Arts (only two or three of the founders were actually artists). A similar institution, the Pennsylvania Academy of the Fine Arts, was founded in Philadelphia in 1805. Both institutions sought to perpetuate the taste of their founders, and while they exhibited old masters and contemporary Europeans and Americans working in Europe, they failed to encourage younger American artists or art students. In New York the National Academy of Design was established in 1825, modeled after the English Royal Academy. Artists themselves managed the new Academy, and under the directorship of Samuel F.B. Morse it became an extremely influential group, eclipsing the power of the American Academy of Fine Arts.

Sensing the need for an institution committed to both exhibition and sale, a group of artists and financiers organized the American Art-Union. From 1839 to its demise in 1852, the New York Art-Union and its Western outlet in Cincinnati, encouraged artists and sought wider distribution for their work. For five dollars a year, family memberships were available; publications and engravings after award-winning paintings were mailed to members all over the country. Unsold paintings were purchased by the management and distributed through lotteries (in 1849, 1,100 art works found homes in this manner). In addition, countless visitors viewed the free public galleries of the Art-Union's building in New York. The Art-Union leaders hoped to break American artists' dependency on European models: painters were urged to seek subject matter in the American landscape and from the American experience, thereby creating an indigenous American school of art.

Among the women exhibitors at the Art-Union were Sarah Cole (active 1848–52), a landscapist and sister of Thomas Cole; Herminia Dassel; and Lilly Martin Spencer. In New York, women exhibitors at the Academy of Fine Arts included the miniaturists Sarah Goodridge and Ann Hall, Emma Peale (a grand-daughter of Charles Willson Peale), Jane Stuart, and Sarah Hope Harvey, wife of the history painter John Trumbull. Between 1826 and 1860 approximately 1,300 artists exhibited at the National Academy of Design, about eighty of whom were women. (Many of the anonymous exhibitors identified themselves as "A Lady.") A few women were admitted to the Academy as students in 1831, but they were not admitted on a regular basis until 1846; by 1871, when a life class for women was permitted, about one-third of the student body were women. (Coeducational life classes were not instituted until

1930.) Emily and Maria Maverick, Emma Stebbins, Margaret Bogardus, and Eliza Greatorex became Associate Members, Herminia Dassel an Honorary Member, and Julia Fulton and Ann Hall full Members. The National Academy of Design eventually grew staid and conservative, sparking the founding of the Art Students League (which since its inception in 1875 has continued to be responsive to women's needs) and the Society of American Artists.[30]

Several women were included in the first exhibit of the Pennsylvania Academy in 1811, and in 1824 Anna and Sarah Peale were elected Academicians; seven years later Jane Sully, daughter of the fashionable portrait painter Thomas Sully, was similarly honored. In 1811 too a "ladies' day" was established to enable women to view partially draped or nude antique casts, but not in the company of men. By 1844 women were enrolled at the Academy on a regular basis, and in 1860 they were allowed to attend anatomy lectures. Frustrated by their inability to study from the live model, women students organized informal sessions at which they posed for each other. At long last, in 1868, a woman was hired to pose in the nude for the female life class. In 1877 a nude male model was allowed. As a gesture to its women students, the Academy hired Catherine Drinker as a part-time lecturer in perspective in 1878, and in 1895 her niece and former student, Cecilia Beaux, became the first full-time female professional artist associated with the Pennsylvania Academy. Only one other, Violet Oakley taught there (1913–17) before the 1950s.

During the 19th century women were amply employed in the burgeoning craft industries as patternmakers, china-painters, and rug and textile designers. To meet the need for trained craftswomen, the Philadelphia School of Design for Women was inaugurated in 1844. Within the next decade similar institutions were founded in Chicago, Cincinnati, and New York. In order to better promote the work of women, a Ladies Art Association was founded in New York in 1867 by the wood engraver Alice Donlevy.

Women were well represented at Philadelphia's Centennial Exposition of 1876; approximately one-tenth of the works in the art gallery were by women, among them the sculptors Emma Stebbins, Edmonia Lewis, and Elisabet Ney; Margaret Foley designed a fountain for the center of the Horticultural Hall. The Woman's Pavilion, funded by women themselves, featured over 600 exhibits of women's contributions to the arts, crafts, medicine, journalism, science, education, business, and literature; a library of books by women and a model kindergarten were also exhibited. Especially fascinating was the display of inventions patented by women. The radical feminists, however, led by Stanton and Anthony, boycotted the Woman's Pavilion, claiming the displays "only hinted at the injustices against women, instead of displaying them as an incentive to change."[31]

The World's Columbian Exposition in Chicago (1893) boasted a Board of Lady Managers chaired by the wealthy art patron Berthe Honoré Palmer, as well as a building designed by a woman—Sarah Hayden, a recent graduate of the Massachusetts Institute of Technology, and one of thirteen female architects to submit designs for the Woman's Building. In describing the Venetian Renaissance structure, Maud Howe Elliot wrote: "Our building is essentially feminine in character, it has the qualities of reserve, delicacy, and refinement. . . . None of the critics thought to praise it by saying it looks like a man's work. . . . Today we recognize that the more womanly a woman's work is the stronger it is." An astonishing variety of art and handicraft products from all over the world were on display. The goal was to "direct attention to women's progress and development, and her increased usefulness in the arts, sciences, manufacturing, and industries of the world during the past 400 years and present a complete picture of the condition of women in every country of the world, and more particularly of those women who are the breadwinners."[32] Mary Fairchild MacMonnies and Mary Cassatt were commissioned respectively to design murals depicting primitive and modern women for the north and south tympanums in the Hall of Honor.

Although America's women reformers at first judged artists as no better than gamblers, dancers, or actors, the Seneca Falls Convention and its aftermath had a positive effect on the status of the female artist. While at the beginning of the century she was essentially an amateur, a "primitive," or a social dilettante practicing the water-color technique and "correct drawing" she had learned at boarding school, by century's end she could gain entry to most art schools, had probably studied in Paris, and was the recipient of most of the available art awards.

HENRIETTA JOHNSTON (d. 1728/29)

Henrietta Johnston brought with her to the New World the rural English version of the fashionable Rococo pastel portraits popularized by Rosalba Carriera in Europe's courtly circles. Although she was

one of the first professional artists in colonial America, she worked in isolation in the Charleston, South Carolina, area (she made one trip to New York in 1725), and her influence on other artists was minimal. Little is known of her family background or art training, but she may have been familiar with prints after the portraits of Kneller and Lely. The prints, popular in England, were beginning to enter this country and served as compositional and stylistic sources for colonial artists throughout the century.

Henrietta was the wife of the minister Gideon Johnston, and the couple, continually in debt, left England in 1706 to seek a better life in the New World. It was most likely to alleviate their financial condition that she began her professional career, and after her husband's death by drowning in 1716 it was probably her only means of support. Most of the work attributed to Johnston was done between 1707 and 1725; the subjects of her small portraits were the "rich planters, colonial officials, military men, their wives and daughters, and the belles and beaux of the day," all elegantly attired. An itinerant artist, she traveled from home to home, residing in the house of her sitter until the commission was completed; most of her paintings still belong to the families of her patrons. There is no record of her having had a studio.[33]

Johnston's work must be classified as primitive. Its charm, directness, and innocence have great appeal. The gentle and delicately painted portrait of Frances Moore (1725) reveals a delightful young girl flirtatiously eyeing the viewer. Her equally charming brother Thomas (Fig. 5-1) was captured as a bright-eyed five-year-old. As with many primitive paintings, the hands are awkwardly drawn and the heads are too large for the bodies.

FIG. 5-1. Henrietta Johnston, *Portrait of Thomas Moore as a Child* (c. 1725). Pastel. 11⁶/₁₆″ × 8⅝″. Virginia Museum of Fine Arts, Richmond.

PATIENCE LOVELL WRIGHT (1725–1786)

Although most of her extant sculptural busts—for example, that of Admiral Howe—are related more in size and conception to miniature painting than to monumental sculpture, Patience Lovell Wright has the distinction of being the first professional sculptor in the New World. Born to New Jersey Quakers, she modeled her family in bread dough and clay as a child. At twenty-three she married Joseph Wright and worked continuously through nineteen years of marriage and the raising of three children. After her husband died, she went to New York City to open a waxworks, but in 1772, reputation and children in hand, she sailed for London in search of a wider

clientele. In her London studio she displayed historical groups in addition to life-sized busts and full-length figures of celebrities of the day. Royalty and nobility came to her studio to watch her work. Impressed by her charm and "brilliant conversation," the King and Queen saw that she was a frequent guest at Buckingham Palace, an honor not afforded untitled Englishwomen. One of her few works surviving in its original form, the full-length figure of William Pitt, Earl of Chatham (wearing the robes from his last oration) (Fig. 5-2), which was placed in Westminster Abbey after his death, dates from this period (1779). In 1775 she was featured in *The London Magazine*; describing her as "the Promethean modeller," the writer claimed that the self-



FIG. 5-2. Patience Lovell Wright, *William Pitt, Earl of Chatham* (war effigy, 1779). By courtesy of the Dean and Chapter of Westminster, Westminster Abbey, London.

taught sculptor "would have been a miracle if the advantages of a liberal education had fallen to her lot."

Wright remained a patriot during the war with the American colonies, and there is evidence that because she was a confidante of members of the British nobility she was able to pass on valuable information to her American friends. Evidently she remained in Europe after the war. In 1781 she was in Paris, where she was commissioned to do a bust of Benjamin Franklin. In 1785 she wrote to George Washington, who responded by saying he "should think himself happy to have his bust done by Mrs. Wright." Indeed, Patience Wright wanted to model all the heroes of the Revolution: "To shame the English King," she wrote Jefferson in 1785, "I would go to any trouble and expense to add my mite to the stock of honor due to Adams, Jefferson and others, to send to America." But this dream was never fulfilled; she died in London shortly thereafter.[34] Her son, Joseph Wright, established himself in the United States and painted a well-received portrait of the first President. Her daughter married the English portrait painter John Hoppner.

EUNICE GRISWOLD PINNEY (1770–1849)

Eunice Griswold Pinney represents the countless women, many of them anonymous, who filled the demand for wall decorations in 18th- and 19th-century America. Their untrained eye—with its distorted perspective, its attention to detail, bold patterns, and brilliant colors—produced paintings of infinite charm. Many of their paintings were discarded during the "sophisticated" Gilded Age but gained new respect among the 20th-century avant-garde who sought the abstract forms and freshness of such innocent visions.

Born in Simsbury, Connecticut, where her parents were prosperous community leaders, Eunice was the fifth of eight children, all of whom were taught the "habits of persevering industry" by their mother in their strictly disciplined home. In her early twenties she married Oliver Holcombe, by whom she had two children. Widowed at twenty-seven, she soon married again: she had three children by Butler Pinney.

Unlike many of the women amateurs, Pinney was entirely self-taught. Her distinct style evolved from many long hours of experimentation. Between her fortieth and fiftieth years, she painted about fifty water colors that described her literary and familial interests.[35] The elegantly dressed figures in her two-dimensional designs have expressionless faces and long, thin arms with small, stylized hands. Her color is fresh and vigorous, and the patterning and con-

struction bolder than is usual with the typical female amateur. Among the most charming of her water colors is *Two Women* (Fig. 5-3) at the New York State Historical Association. With almost perfect symmetry, two women sit in profile facing each other. Between them is an oval tilt-top table on which, miraculously, a candle sits. On either side of the candle are almost identically treated windows. The floor is boldly patterned, and the entire scene is framed with drapery.

SARAH GOODRIDGE (1788–1853)

Although Sarah Goodridge's talent manifested itself early—she drew her first portraits on birch bark as a child—there was little opportunity for art training in rural Massachusetts in the late 18th century. After briefly attending the district school, she was sent to a boarding school in Milton, and then, with one of her brothers, made a trip to Boston where she received a few drawing lessons. Returning home, she taught school for two summers, but by 1820 was back in Boston ready to begin her professional career. She experimented with oils, then took a few lessons from an ivory painter, and thus found her metier.

During her first year in Boston, Goodridge met the portraitist Gilbert Stuart, who invited her to bring her miniatures to his studio for informal criticism. Under his tutelage she gained "sureness and delicacy." Stuart's daughter, Jane, also a painter, described how her father came to sit for Goodridge:

My mother, being very much dissatisfied with the portraits painted of Stuart, implored him to sit for Miss Goodridge, the miniature artist; and, as she was a great favorite of his, she would frequently invite her to the house, hoping he would be induced to sit for her. One afternoon he said, "Goode, I intend to let you paint me." She seemed to be quite overcome at the idea, as she worshipped his genius. She then came prepared, when he gave her every ad-

FIG. 5-3. Eunice Griswold Pinney, *Two Women*. Watercolor. 11″ × 14⅜″. Courtesy New York State Historical Association, Cooperstown.

vantage, considering he disliked what he called "having his effigy made."[36]

So impressed was Stuart with the results (Fig. 5-4) that he had the miniature preserved in a bracelet along with locks of his own and his wife's hair. Asher B. Durand did an engraving after the portrait for the National Portrait Gallery of Distinguished Americans (a print of which was hung in the Academy of Fine Arts' 1833 exhibition), and Goodridge made two additional miniature copies of the Stuart visage for interested patrons.

Many of the leading citizens of Boston came to her studio, where she painted about two miniatures a week while supporting and caring for her aged mother, paralytic brother, and orphaned niece. She made a few trips to Washington to portray the giants of government in miniature. While ivory painting is usually delicate and flattering, Goodridge's work was forceful, honest, and simple. Her best work was done before 1840, yet she continued working until a few years before her death, stopping only as her eyesight began to fail.[37]

FIG. 5-4. Sarah Goodridge, *Portrait of Gilbert Stuart*. Miniature. Metropolitan Museum of Art, New York. The Moses Lazarus Collection, Gift of Sarah and Josephine Lazarus, 1888.

ANN HALL (1792–1863)

From 1827 until her retirement in 1858, Ann Hall was a frequent exhibitor at the National Academy of Design and, in 1829, became the first woman to be elected to full membership. Nevertheless, her participation in the business of the Academy seems to have been limited to token attendance at a meeting at which a quorum was needed. Although she took a few lessons in oil, Hall was essentially a miniaturist, painting exquisite compositions of socially prominent women and children (Fig. 5-5) that were described as "marked with the beautiful simplicity of some of Reynolds' or Lawrence's portraits of children, evincing a masterly touch and glowing in admirable coloring." Her miniature groups sold for as much as $500; a portrait of a Greek girl exhibited at the Academy in 1829 was engraved, copied, and "universally acknowledged."

Born in Connecticut, the third daughter of a distinguished physician and amateur artist, Ann was encouraged by her family to develop her gift for reproducing nature. She took a few lessons from Samuel King (also an early teacher of Washington Alston) while on a visit to Rhode Island. Essentially self-taught, she gained additional skills by copying in miniature from prints of old masters that her brother sent home from Europe. Several of her copies were later reproduced in enamel in France. Although miniature painters never enjoyed the reputation in 19th-century America that they had earlier abroad, Hall's acceptance by and continued association with the National Academy of Design attests to her skill and popularity. Her miniatures are at once sweeter and more flattering than those of Goodridge, and Ellet considered her the best of the American miniaturists.[38]

ANNA CLAYPOOLE PEALE (1791–1878) and SARAH MIRIAM PEALE (1800–1885)

Anna and Sarah, respectively, were the fourth and last of the six children of James and Mary Claypoole Peale. Their maternal grandfather was James Claypoole, the first native-born Pennsylvanian to become a professional artist. Their uncle was the famed Charles Willson Peale—painter, artisan, taxidermist, inventor, museum innovator, abolitionist, supporter of women's rights. Since he believed that "women had a special sensitivity which particularly suited them to be artists, he taught both his daugh-

ters and encouraged his nieces Anna and Sarah to paint.

Surrounded thus by art and artists, and born during the period after the Revolution when Philadelphia was the most cultivated of American cities, the Peale girls had a very favorable environment in which to develop their talents. Anna's first lessons were from her father, a miniaturist, who taught her the technique of painting on ivory, claiming that miniature painting was a "most suitable employment for a lady." He also taught her the technique of oil painting; as a result, her minatures, with their complexity of brushstroke and sublety of modeling, often resemble tiny oils. Anna copied her father's miniatures and those of other celebrated artists. After two of her miniatures from life were hung at the annual exhibit of the Pennsylvania Academy of the Fine Arts, her work was in such demand that she raised her fees.

Until joined by Sarah, Anna was the only professional woman artist in Philadelphia. Anna shared a studio in Washington with her uncle Charles in the winter of 1819, when they both painted portraits of General Jackson, President Monroe, and various members of Congress and the military; they were also frequent guests at the White House. In order to expand her clientele in the Baltimore area, Anna placed this advertisement in the *Baltimore American Commercial Daily Advertiser* in 1822: "Miss Anna C. Peale, paints miniatures on ivory. Application made at the [Peale's Baltimore] Museum, where specimens of [her] painting may be seen."

In 1829 Anna married the Rev. Dr. William Staughton, a Baptist minister recently elected president of the Theological College at Georgetown, Kentucky. While enroute to his mission and after only three months of marriage, he died. Returning to Philadelphia, Anna resumed her career with renewed intensity, but after succumbing to matrimony for a second time—to General William Duncan, "a gentleman highly esteemed in social life"—she retired temporarily. Believing this connubial state to be a permanent one, Ellet wrote of her in 1859: "In her happy home, surrounded by accomplished relatives, and beloved by a large circle of friends, she looks back with pride to the days when she toiled to woo the Muse of Painting." But Anna outlived this spouse too and continued her career, developing a

FIG. 5-5. Ann Hall, *Ann Hall, Mrs. Henry Ward, and Henry Hall Ward* (1818). Courtesy of the New York Historical Society, New York City.

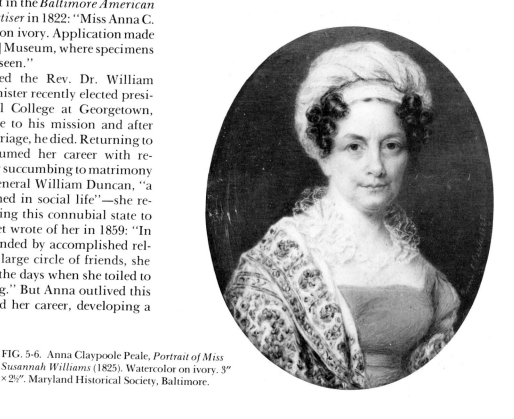

FIG. 5-6. Anna Claypoole Peale, *Portrait of Miss Susannah Williams* (1825). Watercolor on ivory. 3" × 2½". Maryland Historical Society, Baltimore.

style in her maturity that departed from her earlier dependency on her father. Her miniatures were usually "sprightly and pleasing," and her technique "detailed and careful."[39] Her portraits of young women can be recognized by the widely placed and fully opened eyes, the rather long noses, and the pursed lips that turn up at the edges. *Miss Susannah Williams* (1825; Fig. 5-6) varies from her typical production in that the subject was over sixty when she sat for Anna, and the artist captured some of the weariness of old age.

Sarah Miriam was the most successful and most professional of all the Peale women, and one of the few women producing full-sized portraits in early 19th century America. After several years of assisting her father with the background details of his paintings, she made her debut in 1818 with a self-portrait that won the praises of her uncle Charles, who encouraged her but also commented "that her talent was good [yet] she didn't seem fond of painting and only worked hard when promised a profit." That same year she showed two portraits at the Pennsyl-

vania Academy's annual exhibition and the following year, two more portraits and four still-lifes. In 1819 she wrote her cousin Titian that she had been "very busy for a week past finishing my pictures for the Academy . . . today I have been assisting papa with one of his which tired me much." A visit to cousin Rembrandt in 1820 proved quite fruitful: from him Sarah learned how to produce a "creamy, almost translucent skin tone by means of superimposing delicate glazes over the base paint," and how to handle the delicate details of lace and pattern on a sitter's costume.

Settled in Baltimore by 1825, Sarah painted and sold from a studio in "Peale's Baltimore Museum" (modeled after the Philadelphia example and managed by Rembrandt and Rubens Peale) until its demise in 1829, taking as her clientele the city's "substantial class." By so doing she was in competition with Thomas Sully, John Vanderlyn, John Wesley Jarvis, and Chester Harding—the leading male practitioners of the art form in that area. When the Marquis de Lafayette made his triumphant tour

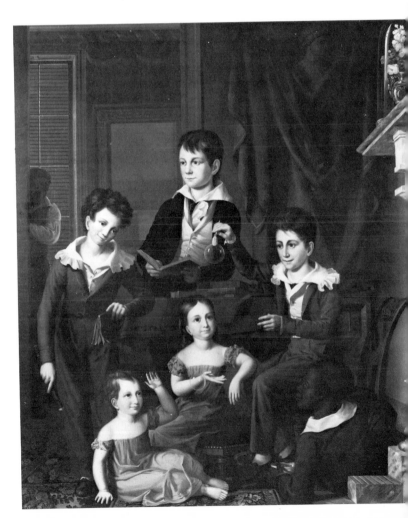

FIG. 5-7. Sarah Miriam Peale, *Children of Commodore John Daniel Danels* (c. 1826). 29½″ × 59¾″. Maryland Historical Society, Baltimore.

of the United States in 1825, he sat for Sarah four times, and the finished portrait was "highly praised as a faithful likeness." One of her best paintings of this period, and one of her more complex compositions, is the *Children of Commodore John Daniel Danels* (1825–26; Fig. 5-7). Its rich detailing of the interior of an upper-middle class home renders it a valuable document of life in the early 19th century. The five children are variously posed around a central table; two black child-servants are in the shadows. Attention is paid to every detail: the Oriental rug, the marble mantelpiece topped with a bouquet of flowers, the draperies, and the blinds.

In need of rest, Sarah accompanied some friends to St. Louis in 1847; she stayed in that city thirty years. Although she set up a studio there, only about twenty of her paintings from that period have been identified, and she sent none home for exhibition. When she returned to Philadelphia at the age of seventy-seven to be with her sisters Margaretta and Anna, she found that Anna's reputation had eclipsed her own.[40]

HERMINIA BORCHARD DASSEL (d. 1858)

A frequent exhibitor at the New York Art-Union and the National Academy of Design, Herminia Borchard Dassel was the daughter of a German banker from Königsberg, Prussia. After her father's bankruptcy in 1839, the Borchards migrated to America, and it was then that the young Herminia decided to contribute to the support of her family through the sale of her paintings. Mornings and evenings were spent in domestic activity, but during her free afternoons, she wandered the countryside in search of subject matter. Her first commission was for a full-sized portrait of a clergyman at his pulpit, surrounded by his congregation. In 1846 she returned to Europe, this time for study in Düsseldorf, the center of the anecdotal school of painting that was attracting many American artists of her generation. After four years, she returned to America, devoting herself almost exclusively to painting elegant portraits of New York's aristocracy (Fig. 5-8) in order to finance her next trip to the Continent. This time her destination was Italy, where she absorbed enough local color to provide material for at least a dozen canvases before being forced to leave during the Revolution of 1848. At the Art-Union exhibit of 1849 she showed *An Italian Flower Girl, Italian Peasant Mother,* and *Peasant Girls from Neptuno.* The following year she exhibited *The Shepherd Boy* and *Girls at the Fountain.* In the latter a girl carries a water jug on her

FIG. 5-8. Herminia Borchard Dassel, *Portrait of Ann Saltonstall Seabury (Mrs. William Walton).* Courtesy of the Frick Art Reference Library, New York.

head, while a friend rests her weary head on her shoulder; a monk stands beside the fountain in the distance. Later paintings concentrated on the exotica of the North American continent.

Even after she married, Herminia Dassel supported herself and her family as a professional artist. Evidently she had the respect of her colleagues, since her several trips abroad were reported in the Art-Union's publications.[41]

JANE STUART (1812–1886)

There were twelve children born into the Gilbert Stuart family, and Jane, born when her father was fifty-seven, was the youngest. Although the illustrious Stuart accepted students, unlike Peale, he refused to instruct his own children. When asked why, he replied that he thought it best to let "young artists find a road for themselves." Jane assisted her father

FIG. 5-9. Jane Stuart, *A Literary Subject* (1834). 36″ × 26″. Collection of Victor D. Spark, New York.

in grinding colors and filling in the backgrounds of his paintings, but he never encouraged her to seek formal instruction. She complained to her friend and subsequent biographer, Mary E. Powell, "that he had kept her too busy, while he should have been teaching her to draw." She did pick up his methods surreptitiously, however, later writing: "When I was a child I was often in the room when my father was instructing artists, and remember many things that were said to them when no one thought that I had two ideas on art, or anything else."

When her father died penniless in 1828, Jane opened a studio in Boston and began her professional career as an artist in order to support her mother and three sisters. Her first commissions were for copies after her father's paintings—the Frick Collection in New York owns the last copy she made of the famous George Washington Atheneum portrait. Other commissions followed; in a review of the 1833 exhibit at the Academy of Fine Arts, the critic for the *American Monthly Magazine* wrote that "Miss Stuart is among the best portrait painters in our city, so far as coloring and keeping go." A portrait of her father with the famous Atheneum portrait in the background is today at Brown University in Providence, Rhode Island. Jane Stuart was one of the few American artists painting Biblical scenes. The *Columbian Centinel* published the following verse in praise of *The Magdalen Forgiven* (c. 1825):

> There's something Raphael vainly sought
> That flows in every line
> A something that he never caught,
> A something that he never taught,
> A something all divine.[42]

The romantically evocative *A Literary Subject* (Fig. 5-9) is an example of her later narrative style.

In the 1850s, after a fire in her studio that destroyed all that the family owned of their famous father's oeuvre, Jane moved to Newport, where she remained until her death. Known affectionately as "Miss Jane," she gained a local reputation as a fortuneteller and matchmaker. Claiming that since she looked like her father and was therefore too plain for marriage, she never made a match for herself. A good deal of time and energy in her later years was spent writing about her father and upholding his reputation.

LILLY MARTIN SPENCER (1822–1902)

As followers of the French social critic Charles Fourier, Lilly Martin's parents came to New York in 1830, via England where she was born, in search of a self-contained communal society based on "moral harmony." The venture never materialized, but throughout their lives Gilles and Angelique Martin were closely associated with both cooperative societies and the reform movements. In fact, Lilly's mother carried on an extensive correspondence with women activists in Ohio, as well as with Elizabeth Cady Stanton, whose portrait Lilly was to paint in 1902. A letter exists from October 1850, in which Angelique urges her daughter to become more of a feminist activist. Lilly's reply needs no elaboration:

My time dear mother to enable me to succeed in my painting is so entirely engrossed by it, that I am not able to give my attention to anything else. . . You know dear Mother that that is your point of exertions and attention and study like my painting is mine, and you know dear Mother as you have told me many times that if we wish to become great in any one thing we must condense our powers to one point.[43]

A few years after their arrival in New York, the Martins were forced to leave because of a cholera epidemic. They bought a farm outside Marietta, Ohio, where Mr. Martin resumed his career as a French instructor in a local teacher's seminary. Hardly the typical frontier family, the couple brought with them a library consisting of works by Shakespeare, Locke, Rousseau, Voltaire, Molière, Pope, and Gibbons, which were used in the education of the four young Martins and which most certainly inspired Lilly's early literary and allegorical paintings.

Lilly's first major art project was to decorate the plaster walls in her home with portraits of her family. Reported in the local paper, the home became a tourist attraction and led to her first exhibit in Marietta. So impressed was the editor of the Cincinnati *Chronicle* that he arranged for her to meet Nicholas Longworth, the art patron, whose home is now the Taft Museum. Longworth offered to send her East to study with Washington Allston or John Trumbull, and later to Europe, but she refused. With the exception of a few lessons with former students of Thomas Sully in the Cincinnati area, the young artist's training was minimal; her figures, with their over-large heads, were always out of proportion.

Leaving her mother on the farm with the younger children, Lilly and her father moved to Cincinnati in 1841 when that city was going through a cultural renaissance and overflowing with former itinerant artists seeking fame and fortune in the growing metropolis. Within a month after her arrival she had her first exhibit, and within three years she married Benjamin Rush Spencer, an Englishman who even-

FIG. 5-10. Lilly Martin Spencer, *Peeling Onions* (c. 1852). 36″ × 29″. Collection of William Postar, Boston.

domestic situation as subject matter in humorous, sentimental, and anecdotal works showing the influence of the Düsseldorf School. Paralleling the Victorian literary tradition, she even contrived to introduce a moral lesson into each painting, thereby gaining the approval of the new middle class art patrons, who, like their counterparts in 17th-century Holland, demanded an easily accessible art that supported their value systems.

One of Spencer's best genre paintings is *Peeling Onions* (c. 1852; Fig. 5-10). While Vermeer would have objectified his image by having the housewife peel apples or potatoes, the choice of this peculiar moment of culinary preparation is what amused and enchanted American audiences. The apples, pears, grapes, and kitchen utensils, easily identified as objects from the artist's own kitchen, are remarkably well painted.

In 1858, their finances dwindling, the growing Spencer family moved to Newark, New Jersey. In partial payment for the home they purchased, Spencer painted a fine portrait of the children of the owner, Marcus L. Ward, grouped around a Gothic Revival chair. Even during this period before the Civil War when her reputation was greatest, the family had continuous financial difficulties. Spencer received little money from the hundreds of thousands of prints made after her paintings by the French firm of Goupil—she was paid only for the original painting—and was forced to do illustrations for *Godey's Lady's Book* and to add color to lithographs, some after her own paintings. In a letter of 1859 she philosophized on the disparity between fame and fortune: "You may think . . . that my fame does me a great deal of good, but . . . fame is as hollow and brilliant as a soap bubble, it is all colors outside, and nothing worth kicking at inside."[46]

In order to compete with French Salon paintings that were being imported by the nouveau riche after the Civil War, Spencer created what she thought would be her masterpiece, an allegory of *Truth Unveiling Falsehood*. An inelegant figure of Truth shelters a youthful Confidence nursing the baby Innocence, while a ragged Ignorance is shielding her eyes from the monster Falsehood who is in the process of devouring her infant. The philosophic message was discussed in journals; poets wrote odes to the work; ministers discussed it from the pulpit; she was compared to the French academics Bouguereau and Gérôme. Photographs from the work enjoyed a brisk sale, but the canvas itself, after being exhibited in the Woman's Pavilion at the Centennial with several of her portraits, was in her studio when

tually abandoned his own work to assist his wife in her professional career. He stretched her canvases, built her frames, managed her business affairs, shared in the housework, and assisted in the care of their seven children. When the demand for her work was greatest, he assisted by filling in background and drapery details. (During the first years of their marriage, he was among her students.)[44] Although this marital arrangement was rare, it was not unprecedented—as we have already seen in this survey of women artists. However, it is difficult for the conventional observer to accept; Flexner refers to Benjamin Rush as "the no good husband she subsequently supported."[45]

Spencer's first successes after her marriage were with the still-lifes, genre, and exotic anecdotal pieces that were shown at the initial exhibit of the Western Art-Union in 1847. One of the paintings was engraved for mass distribution, and her reputation preceded her subsequent arrival in New York. She became a student at the National Academy of Design, where she was soon awarded honorary membership. She continued to paint literary and allegorical themes, but increasingly she began using her family and

she died. However, as a result of the publicity surrounding the allegory, Martin received one of her major commissions: Richard B. Connally, comptroller-general of New York, asked her to paint full-length portraits of four members of his family. Also shown at the Woman's Pavilion, the paintings exhibited her ability to handle the details of satin, lace, and jewelry, as well as the virtuosity of her brushwork. The only surviving work—*We Both Must Fade* (Fig. 5-11)—shows the Victorian concern with the transience of youth and beauty.

In 1880, the family moved to upstate New York, and in 1890, the year her husband died, Spencer offered fourteen of her paintings for sale at auction. The highest bid for a painting was ten dollars. However, in 1900 she sent three paintings to the National Academy of Design show and was again ensconced in a New York studio. After a career

FIG. 5-11. Lilly Martin Spencer, *We Both Must Fade* (1869). 71⅜″ × 53¾″. Courtesy of National Collection of Fine Arts, Smithsonian Institution, Washington, D.C.

spanning more than sixty years, the relentless artist died in 1902, having spent the morning at her easel.[47]

ELISABET NEY (1833–1907)

It was a long way from the studios in the palace of the art-loving "mad king" of Bavaria, Ludwig II, to a plantation near Hempstead, Texas, but that was the path traversed by Franzisca Bernadina Wilhelmina Elisabet Ney, the daughter of Johann Adam Ney, a well-known sculptor of ecclesiastical subjects from Mönster, Westphalia. Her choice of residence was seen as fortuitous by at least one native, who proclaimed that the "day she entered the capital city of Texas marked a new era in the development of the state. . . . [She was] the pioneer in the art development of Texas."

After attending the local schools and working in

FIG. 5-12. Elisabet Ney, *Portrait Bust of Arthur Schopenhauer* (1859). Marble. 19½″ × 18½″ × 11″. Elisabet Ney Museum, Austin.

her father's studio, the seventeen-year-old Elisabet was determined to go to Berlin to study with Christian Daniel Rauch. Her parents objected and after two years of pleading, a compromise was reached: she was allowed to matriculate at the Academy of Fine Arts in Munich. An exceptionally talented student, she left after two years to study with Rauch; following his death she was entrusted with the completion of his commissions. Ney was acclaimed at the 1856 Berlin Exposition, charmed the philosopher Arthur Schopenhauer into sitting for her (Fig. 5-12), and was commissioned to carve busts of King George V, Bismarck, Garibaldi, and scores of other historical personages, past and present.

In 1863 she secretly married Edmund Montgomery, a Scottish physician, scientist, philosopher, and author whom she had met in her student days in Munich. In spite of her two subsequent pregnancies, the free-spirited Ney denied her marriage, even to her parents and close friends, which resulted in social ostracism in Europe and in America, to which they migrated after the outbreak of the Franco-Prussian War in 1870. The couple first settled in a colony of similarly liberated souls in Thomasville, Georgia, where they lived until the community's demise two years later. Ney worked for twenty years in veritable isolation from both the art world and civilized society before she built a studio in Austin with the proceeds from the sale of her Munich studio. Texans had their first glimpse of the antique when she had her plaster casts shipped to the Austin studio, which is now the Elisabet Ney Museum. Commissions began to arrive: she did statues of Stephen Austin and Sam Houston for the Texas Building at the World's Columbian Exposition in Chicago. Cut off as she was from developments in the art world, she continued to work in the now outdated Neoclassical idiom she had learned as a student.[48]

Lorado Taft called Ney "one of the best equipped of women sculptors." While he considered her full-length male figures "unmasculine as such interpretations of women always have been," he declared that her busts of the leading scions of Texas were "virile" and "strangely alive."[49]

HARRIET HOSMER (1830–1908)

Henry James labeled them the "white, marmorean flock"—the large number of American sculptors who descended on Rome in the mid-19th century to take advantage of the Carrara marble and the trained artisans there. Among them were a group of women, who, defying Victorian tradition, remained unmar-

ried and led independent, productive lives. They had international reputations and their Neo-classical pieces helped create the first American school of sculpture. One of the most successful was Harriet Hosmer, whose career is well documented.

Born in Watertown, Massachusetts, the daughter of a physician, she lost her mother and siblings at an early age and was left in her father's care. She led an outdoor life of hunting, fishing, and roaming the countryside. At sixteen she was sent to the liberal Mrs. Sedgwick's boarding school in Lenox. After three years of further study in Boston, she enrolled in the Medical School of St. Louis, one of the few places that allowed women to study the human body. Her host and sponsor was Dr. Wayman Crow, father of a close friend from Mrs. Sedgwick's, who gave her her first commission and remained her most consistent patron (his daughter Cornelia Crow Carr later edited Hosmer's letters and memoirs). Hosmer's first piece was an idealized bust of *Hesper* (1852). After describing the beauty and grace of the sleeping maiden, the critic in the New York *Tribune* added that "The poetic conception of the subject is the creation of her own mind, and the embodiment of it is all done by her own hands."[50]

Armed with her diploma in anatomy and daguerreotypes of *Hesper*, Harriet and her father, accompanied by the actress and singer Charlotte Cushman, friend and catalyst to numerous women sculptors, sailed for Rome in 1852. John Gibson, a leading English sculptor then resident in Rome, accepted her as a student; she occupied a small studio in his garden that had once belonged to Antonio Canova. She also shocked the local citizenry by riding her horse unaccompanied in the street, an "unladylike" practice that was soon halted by the authorities. The actress Fanny Kemble, whom she had met while at Mrs. Sedgwick's, is quoted as saying that "Hatty's peculiarities will stand in her way of success with people of society and the fashionable world." But Kemble was wrong: Harriet's patrons were among the nobility of France and England, and her "eccentricities" became part of her charm. The poet Elizabeth Barrett Browning later wrote that Hosmer was "a great pet of mine and Robert's." One of Hosmer's most moving pieces is the *Clasped Hands of the Brownings* (1853), cast by the sculptor from the hands of the poets. The embodiment of the Romantic spirit epitomized by the Brownings, the hands are imbued with intimacy and affection.

A demanding worker, Hosmer set for herself a rigorous schedule and most of her significant work was executed during her first decade in Rome. Her most popular piece was *Puck* (1856; Fig. 5-13), copies

FIG. 5-13. Harriet Hosmer, *Puck on a Toadstool* (1856). Marble. Height 30″. Courtesy Wadsworth Atheneum, Hartford. Gift of A. C. and S. G. Dunham.

of which can be found from Connecticut to Australia. A deliberately commercial piece created at a time when her father suffered financial reverses, this "fancy piece" of a "bat-winged elf astride a mushroom, a beetle in one hand, a lizard in the other," was purchased by the Prince of Wales, and proved so popular that she had it reproduced thirty times, selling each edition for a thousand dollars, thus ensuring her economic independence. The companion piece, *Will O' the Wisp*, was only slightly less successful.

The work that established Hosmer's reputation among her peers was the large *Zenobia in Chains* of 1859 (Fig. 5-14). After having captured Egypt and most of Asia Minor, the captive Queen of Palmyra was forced to join a procession in Rome in her chains. Hosmer chose to show the Queen, "noble in

FIG. 5-14. Harriet Hosmer, *Zenobia in Chains* (1859). Marble. Height 49″. Courtesy Wadsworth Atheneum, Hartford.

defeat, walking with stately pride in her captivity." Her choice of subject matter expressed her feminist concerns, and according to Lydia Maria Child, "It was her womanly modesty, her manly courage, and her intellectual tastes, which first attracted Miss Hosmer toward [Zenobia]."[51] While working on the *Zenobia*, Hosmer sent photographs of it to Anna Jameson, whom she had met through the Brownings while the latter was working in Rome on her book *Sacred and Legendary Art*. As both friend and critic, Mrs. Jameson replied in October of 1859:

I have embarked so much pride and hope in you as an artist, that I should be in despair of you if you fall into the error of your countrymen and sacrifice what alone can be permanent in style and taste, to a vulgar ambition of self-sufficing, so-called originality, which is as far from what is truly poetic and original as possible . . . your statue has many indications of being most beautiful and fulfilling all my ambition for you, which is saying much, but now for criticism. The diadem is too low on the brow, thus taking from the value and dignity of the face and that intellectual look which Zenobia had. . . .[52]

Although Hosmer failed to win several prestigious commissions in the United States—her invited competition piece of Lincoln for Springfield, Illinois, was rejected—she was commissioned in 1860 to create a standing figure of Senator Thomas Hart Benton, now in Lafayette Park in St. Louis. The work is impressive because of its massive size, but she draped the figure in a pseudo-classical toga—which seems highly inappropriate for a frontiersman. A photograph exists of Hosmer mounted on a ladder near the colossal bronze (which was cast in Munich); it is at least three times her height. The tiny sculptor is unconventionally attired in a skirt that reaches only to her calves. "Tomorrow I mount a Zouave costume," she had written a friend, "not intending to break my neck upon the scaffolding, by remaining in petticoats." She was also known to wear a Bloomer costume on occasion.[53]

In her later years Hosmer made lecture tours in the United States and, as the "most famous woman sculptor" of her day, she enjoyed large responsive audiences. Her career began to wane in the 1870s along with the nation's flagging interest in the Neoclassical ideal.

EDMONIA LEWIS (1843–1900)

Henry James wrote that "One of the sisterhood, if I am not mistaken, was a negress, whose colour, picturesquely contrasted with that of her plastic material, was the pleading agent of her fame." But she was also a sculptor of great technical facility, and no less imaginative than her contemporaries in Rome.

Lewis was born near Albany, New York, of a Chippewa Indian mother and a free black father. Orphaned while still an infant, she was raised in the tribal tradition of her mother and was later adopted by abolitionists who sent her to Oberlin College in 1862. From Oberlin she went to Boston with a letter of introduction to the abolitionist William Lloyd Garrison, who arranged for her to study with the sculptor Edmund Brackett. Her first success was a medallion of Colonel Robert Gould Shaw, the leader of the black regiment that attacked Fort Wagner in Charleston, South Carolina; it was exhibited at a Soldiers' Relief Fair in Boston.

With proceeds from the sale of one hundred replicas of the medallion, and with the assistance of her patrons—the Story family of Boston—Edmonia Lewis sailed for Rome in 1865. Through a letter of introduction to Harriet Hosmer, she found her way to the "white, marmorean flock" and the circle around Nathaniel Hawthorne, the Brownings, and Charlotte Cushman. Impressed by her talent, courage, and independence, Hosmer arranged for her to study with John Gibson, whose Neoclassical style she adopted.[54]

Lewis' subject matter reflected her dual heritage: her first Roman piece, *Freedwoman* (now lost), was described by Lorado Taft as a depiction of a newly emancipated slave "overcome by a conflict of emotions on receiving tidings of her liberation."[55] *Forever Free* (Fig. 5-15) completed two years later in celebration of the passage of the Thirteenth Amendment to the Constitution which forbade slavery, represents her conversion to Neoclassicism. It lacks the vigor that the earlier piece purportedly possessed. *Old Indian Arrow Maker and His Daughter* (Fig. 5-16) is a small anecdotal marble with ethnologically detailed accuracy. Of Lewis' two small groups illustrating Longfellow's "Hiawatha," a reviewer in the abolitionist newspaper *Revolution* wrote in 1871: "In both, the Indian type of feature is carefully preserved, and every detail of dress, etc., is true to nature. The sentiment equals the execution. They are charming bits, poetic, simple, and natural, and no happier illustrations of Longfellow's most original poem were ever made than these by the Indian sculptor."[56]

The piece that ensured Lewis' reputation in the United States is also lost. First exhibited in Rome and other American cities before being shown at the Philadelphia Centennial, her conception of the dy-

FIG. 5-15. Edmonia Lewis, *Forever Free* (1867). Marble. Howard University, James A. Porter Gallery of Afro-American Art, Washington, D.C.

FIG. 5-16. Edmonia Lewis, *Old Indian Arrowmaker and His Daughter* (1872). Marble. Height 27". Carver Museum, Tuskegee Institute, Alabama.

ing Cleopatra was considered very original and striking, quite unlike the idealized interpretations of the Egyptian queen produced by her colleagues. "The effects of death are represented with such skill as to be absolutely repellant," wrote Taft. "Apart from matters of taste, however, the striking qualities of the work are undeniable, and it could only have been produced by a sculptor of very genuine endowments."[57]

Accompanied by five of her marble pieces, Lewis returned to the United States in 1873 for a short time. She traveled to San Francisco and San José, exhibiting and then selling her work. The San José Library Association raised funds to purchase a bust of Lincoln and a pair of "fancy pieces"—*Asleep* and *Awake*. Again in America in 1875, she was feted in Philadelphia, Boston, and St. Paul, Minnesota. Little is known of her life after the Centennial, however. There was a notice of her appearance in Boston in 1885 when *Forever Free* was presented to the Rev. M. Grimes, and the following year she was back in Rome where she met with the abolitionist Frederick Douglass. Although Lewis was almost as well known as Hosmer during their most productive years, no biographer has recorded her last days and it is not certain when and where she died.[58]

The oldest female member of the "white, marmorean flock" was Emma Stebbins (1815–1882). She had already established a reputation as a painter and had been elected an associate of the National Academy of Design when she went to Rome in 1857 to study with John Gibson. One of the few surviving American Neoclassical fountains is her *Angel of the Waters* (c. 1862) at the Bethesda Pool in Central Park, New York. In 1878 Stebbins published *Charlotte Cushman: Her Letters and Memories of Her Life.*

Margaret Foley (1820–1877), a cameo portraitist in Boston before sailing for Rome in 1861, was praised by Tuckerman for a head of Senator Sumner: ". . . unsurpassable and beyond praise . . . simple, absolute truth embodied in marble."

The subject matter chosen by Anne Whitney (1821–1915) attests to her feminist and abolitionist concerns: she created a figure of a freed slave entitled *The Liberator*, modeled the figure of the Haitian revolutionary Toussaint L'Ouverture, and did busts of Harriet Martineau and Harriet Beecher Stowe. Of her full-length marble of Samuel Adams (1876) in the Statuary Hall of the Capitol in Washington, D.C., Taft wrote: "Although no woman sculptor has succeeded as yet in making a male figure look convincingly like a man, this statue has a certain feminine

power and is among the most interesting works in the collection." Whitney was also an instructor in art at Wellesley College for many years.

Louisa Lander (1826–1923) was a model for one of the free-spirited women artists in Hawthorne's *The Marble Faun*. He wrote of her in his *Notebooks*: "There are very admirable points about her and her position: a young woman, living in almost perfect independence, thousands of miles from her New England home, going fearlessly about these mysterious streets. . . ." Her portrait of Hawthorne at the Essex House in Salem, Massachusetts, and *Virginia Dare* at Roanoke Island, Virginia, are her only extant works.

Vinnie Ream Hoxie (1847–1914) achieved notoriety when she was only fifteen—she was commissioned to create a statue of Lincoln for the Rotunda in the Capitol at Washington, D.C. Because of her youth and her sex, a storm of criticism ensued, yet the final figure won the approval of both her peers and the politicians, who were thankful that the national hero was not depicted semi-nude and draped in a toga. This work and its favorable reception marked the waning of the Neoclassical tradition—after the Civil War the country had lost its innocence and idealism—and represented a victory for the proponents of realism.[59]

Hoxie was the only woman in the "white, marmorean flock" to marry. The others, perhaps, agreed with Hosmer's definition of purpose, as explained in a letter of 1854 to her patron, Dr. Crow:

Even if so inclined, an artist has no business to marry. For a man, it may be well enough, but for a woman, on whom matrimonial duties and cares weigh more heavily, it is a moral wrong, I think, for she must either neglect her profession or her family, becoming neither a good wife and mother nor a good artist. My ambition is to become the latter, so I wage an eternal feud with the consolidating knot.[60]

SUSAN MACDOWELL EAKINS (1851–1938)

Susan Macdowell Eakins' first one-woman show was held at the Pennsylvania Academy of Fine Arts in 1973, thirty-five years after her death. Although she exhibited intermittently at the Academy from 1876 through 1882, and was the first recipient (1879) of the Mary Smith Award for the best work exhibited by a woman living in Philadelphia, as well as the winner of the Charles Toppan Prize for the "most accurate drawing" three years later, after her marriage to Thomas Eakins in 1884, her primary concern was to

FIG. 5-17. Susan Macdowell Eakins, *Two Sisters* (1879). Collection of Mary "Peggy" Macdowell Walters, Roanoke.

free her husband to paint. In the privately printed *Thomas Eakins Who Painted* (1946), Margaret McHenry explained that although Susan loved to paint, she "had given it up for herself because she believed that there wasn't room for two artists in one family." Charles Bregler, a close friend of both Eakinses, claimed that: "Mrs. Eakins was kinda killed when she married. . . . She would have been a great painter if she hadn't married." But Susan Casteras, in her introductory essay to the 1973 Academy exhibit, takes issue with this viewpoint: although Susan did nurture and support her husband during the period of his neglect, she did not submerge her own talent. With capable household help she still had the time and freedom to paint—an activity she continued during their thirty years together. According to the artist's nephew, Walter G. Macdowell, Thomas Eakins was equally supportive of his wife and thought "She was as good a woman painter as he had ever seen and she knew more about color than he did."[61]

One of seven children of William H. Macdowell, a successful engraver, Susan grew up in a liberal and aesthetic environment. She and her sister Elizabeth were encouraged in their pursuit of art; a room was provided for them at home to use as a studio. After painting on her own for many years, Susan, at age twenty-five entered the painting and drawing class of Christian Schussle at the Pennsylvania Academy. For six years she studied there (later under Eakins), a dedicated student and frequent exhibitor.

The influence of her husband-to-be is already strong in *Two Sisters* (1879; Fig. 5-17), one of her best paintings. Her sisters Dolly and Elizabeth are shown sitting in the family parlor, one sewing while the other reads. The forms that emerge from the shadows are rich in color; the figures are solid masses, while the background is thinly brushed in. Another powerful painting of this period is the *Portrait of a Lady* (1880; Fig. 5-18). While the attention to detail in the woman's costume shows the influence of Schussle, the strong characterization of personality is reminiscent of Eakins. Her paintings of the late 1870s and early 1880s are strong and direct, showing none of the sentimentality typical of contemporary portraits.[62]

Rarely leaving the confines of her home in search of subject matter, she often took her family and friends as models. Her work was personal and private, based on what she saw and what she knew. Like so many of her circle, Susan Eakins was a photographer and, although she preferred to work directly from nature, she frequently used the untouched photograph as a pictorial aid. After her husband's death, and perhaps because of the influence of the Impressionists, her brushwork became looser and her color lighter. These late works, however, lack the strength of the earlier paintings.[63] Like the wives of many male artists who achieved fame, Susan Macdowell Eakins was not interested in promoting herself. As with most artistic partnerships, the conundrum remains: would she have been a better painter if she had not been associated with Eakins, or did her talent grow and mature because of their relationship?

CECILIA BEAUX (1855–1942)

Perhaps Cecilia Beaux would object to being included in a book like this, for she did not like to be identified as a "woman" artist and objected to a newspaper item that suggested she was the "best

female Portrait Painter in Philadelphia." Indeed, she looked forward to the time "when the term 'Women in Art' will be as strange sounding a topic, as the title 'Men in Art' would be now."[64]

Beaux was the second of two daughters born to Frenchman Jean Adolph Beaux and Cecilia Kent Leavitt, a Connecticut Yankee of Puritan stock. Her mother died twelve days after her birth, and the despairing father returned to his native Provence, leaving his daughters to live in Philadelphia with their maternal grandmother and two aunts. Educated in a home where culture was valued, she learned from her grandmother that "everything undertaken must be completely conquered," and that "no kind of Art, music or other, should be treated as a toy or plaything to be taken up, trifled with, and perhaps abandoned."[65] Allowing nothing to distract her energies from painting for very long, Beaux was an indefatigable worker all her life.

For two years, beginning in 1869, she was enrolled in the exclusive Miss Lyman's school in Philadelphia. Her talent in drawing was recognized, and her Uncle Will Biddle sent her to the studio of his cousin, Catherine Drinker, the first woman lecturer at the Pennsylvania Academy and painter of well researched historical and Biblical pictures. Although fascinated by the studio atmosphere, young Cecilia was less than pleased with the lessons—copying lithographic reproductions of plaster casts of antique sculptures. She moved on to Adolf van der Whelen's Art School for Women, where after much of the same tedium she was allowed to draw geometric forms in plaster—a chore so abhorrent to her that she credited her subsequent distaste for any paintings related to Cubism to these early lessons. Promoted next to working on plaster casts and paleontological specimens, she was able to put the latter experience to good use when she was commissioned by a lithographer to do a series of drawings for a government geological survey. In her desire to become independent, Beaux took a course in china-painting and began making children's portraits on plaques: she was so successful that commissions arrived from all over the country. She later wrote that "this was the lowest depth I reached in commercial art . . . [and] I remember it with gloom and record it with shame."[66]

Although the records of the Pennsylvania Academy indicate that Cecilia Beaux was a student there from 1877 to 1879, she denied ever having matriculated at the institution. Since she was expected to marry soon, as had her sister, Uncle Will saw no point in her being "thrown into a rabble of untidy and indiscriminate art students and no one knew what influence." In addition, her protective uncle, who at first objected to her leaving the genteel tradition behind by becoming a professional, refused to let her attend the life class there. Beaux did attend the critiques offered twice monthly by William Sartain, a New York artist who had studied in Munich. Afraid of the charismatic appeal Eakins had for his students, the independent Beaux refused to enter his class; nevertheless, his forthright approach to painting is felt in her early works. She had no mentor, nor was she the disciple of any particular school of painting or theory of art since, she claimed, "All special direction and theory are liable—almost certain—to be in error sooner or later."[67]

Improbable as it may seem, Beaux's first major composition, *Les Derniers Jours d'Enfance* (1883–85), remains among her finest achievements. The portrait of Whistler's mother had been exhibited at the Pennsylvania Academy in 1861, and its influence is obvious. Beaux's work, however, is a portrait of a young mother (her sister) who sits in semi-profile

FIG. 5-18. Susan Macdowell Eakins, *Portrait of a Lady* (1880). Collection of Mr. and Mrs. John D. Rockefeller III, New York.

holding her child. Using furnishings from the family home, the artist created the background of the painting in her studio. To Beaux, "the highest point of interest lay in the group of four hands which occupied the very center of the painting." The work was an immediate success when exhibited at the Academy and won for her the Mary Smith Award. It was also well received at the Paris Salon in 1887.[68]

Another major painting of this period is *Fanny Travis Cochran* (1887; Fig. 5-19). The child is shown in semi-profile sitting on a mahogany chair that turns slightly inward, in contrast to the figure that turns gently in the other direction. It is the first of an important series of "white paintings"—the others being *Sita and Sarita* (1893–94), *Ernesta with Nurse* (1894), and *New England Women* (1895)—in which she experiments with the effect of color on form (Whistler was working on similar problems). In the Cochran portrait the composition is simplified to heighten the effect of the sensuous colors and brushwork. Referring to a later painting, a critic in *Century Magazine* wrote in 1894 of her uncanny ability to capture children in paint: "Few artists have the fresh touch which the child needs and the firm

FIG. 5-19. Cecilia Beaux, *Portrait of Fanny Travis Cochran* (1887). 35½" × 28½". Courtesy of the Pennsylvania Academy of Fine Arts, Philadelphia.

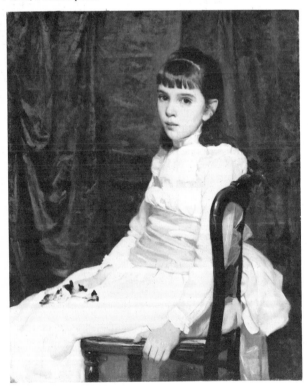

and rapid execution which allows the painter to catch the fleeting expression and the half-forms which make child portraits at once the longing and the despair of portrait painters."[69]

In 1888, at age thirty-two, Cecilia Beaux made the first of several trips to Europe, where she enrolled at the Académie Julien, receiving criticism from Fleury and Bouguereau. The following year she attended Colarossi's evening classes; much of her time was spent studying the old masters at the Louvre. During a later trip to France (1896) with artist Lilla Cabot Perry (1848?–1933), of the prominent Boston Cabots, Beaux visited Monet at Giverny. The only painting that suggests a flirtation with Impressionism is *Dorothea in the Woods*, painted shortly after their meeting. In this canvas, the schematically handled landscape dominates the figure, a rare occurrence in her oeuvre.[70]

In the 1890s Beaux moved her studio to New York. A series of monumental double portraits added to her national and international celebrity, and heralded her entrance into an intellectual and socially elite world. *Mother and Daughter* (1898; Fig. 5-20), an over life-sized double portrait in the manner of John Singer Sargent, is an aesthetic and psychological triumph; it won for the artist more awards than any other piece. The haughty pair are shown before making their entrance into the ballroom, thus marking the daughter's debut into society. The mother's dark silhouetted cape contrasts with the elaborately textured fur of her daughter's frock. A major triumph in the early years of the twentieth century was *After the Meeting* (1914; Fig. 5-21). The animated figure of Dorothy Gilder is at variance with the artist's usually composed portrayals of her friends. Spatially, too, it is unusual. The large, important form of the chair is cropped on the right; the gesturing right hand of the seated woman leads the eye to the group partially hidden by the geometric forms of the folded screen. In its linearity and bold patterning it is reminiscent of Matisse and more daring on every level than her other work of the period.

After World War I Beaux was commissioned to execute portraits of Cardinal Mercier, Admiral Beatty, and Georges Clemenceau by the United States Portraits Commission. Although the likenesses were well received as they traveled throughout the country (they now hang in the National Portrait Gallery in Washington, D.C.), they lack the structure and vigor of her early works. Indeed many of her portraits in the teens and twenties, including a self-portrait (Uffizi, Florence), became quite superficial.

FIG. 5-20. Cecilia Beaux, *Mother and Daughter* (1898). 83″ × 44″. Courtesy of the Pennsylvania Academy of Fine Arts, Philadelphia.

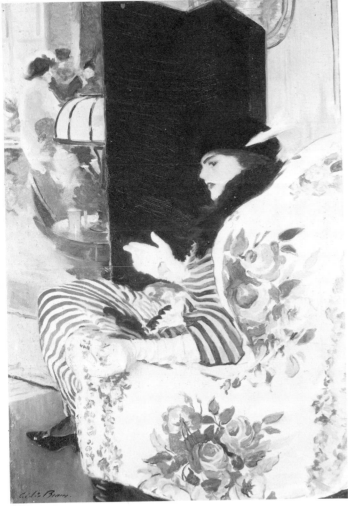

FIG. 5-21. Cecilia Beaux, *After the Meeting* (1914). 40″ × 28″. Toledo Museum of Art, Toledo, Ohio.

That, however, should not detract from the fact that she was a brilliant painter who from 1888 to 1908 created work that at the very least fulfilled her definition of the "function of Plastic Art," which was "to develop its special Power so that it can reach farther and farther, deeper and deeper, into what the mind of man can grasp and enjoy through SIGHT."[71]

ANNA ELIZABETH KLUMPKE (1856–1942)

When Anna Elizabeth Klumpke was a little girl growing up in San Francisco, her mother bought her a Rosa Bonheur doll dressed in a costume consisting of a blue smock over a finely embroidered peasant blouse, black velvet pants, and patent-leather shoes. Thus, Anna was very young when the French artist became part of her life.

Dorothea Tolle Klumpke, "delicately educated" in New York, had separated from John Gerard Klumpke, a Dutch immigrant who had made a fortune in San Francisco real estate, because of the religious fanaticism of her husband's instrusive stepsister. With funds provided by her husband, Mrs. Klumpke took her brood to Switzerland, where they were privately tutored in French, Latin, German, drawing, and music.

Dorothea encouraged her children and stimulated their efforts to achieve in their chosen fields. In her memoirs, Anna wrote of the moment that she and her mother first saw Bonheur's *Plowing in Nivernais* when they visited Luxembourg: "For a long time we stood before those six oxen, so imposing in their massive strength. The intense energy of the artist's execution impressed me even then."[72] She then requested permission to work as a copyist in the Luxembourg Museum; while reproducing the painting that had so captivated her, she was offered $200 for the finished product. With tuition thus in hand, Klumpke enrolled at the Académie Julien in Paris. An attentive and conscientious student, she won a medal in the first student competition.[73] Anna later recalled M. Julien's encouragement of his female charges: "Prepare yourselves to compete favorably with my men students. There is no reason why you should not succeed, as did . . . Vigée-Lebrun, or even Rosa Bonheur."[74] At the Salon of 1885 Klumpke received an honorable mention for a portrait of her sister Augusta.

When, in 1889, Anna finally met her heroine Rosa Bonheur, the older artist was aware of the achievements of the Klumpke sisters: she admired Anna's portrait of her mother in the current Salon; Augusta, the first woman intern at a Paris hospital, had discovered a nerve that caused paralysis of the arm; Dorothea, with a Doctor of Mathematical Science degree from the Sorbonne, had distinguished herself as an astronomer; and Julia, the youngest, was a composer and violinist who had studied in Boston and Paris. Klumpke's reputation as an artist had by this time also spread to the United States. When Elizabeth Cady Stanton was vacationing in the south of France, she invited the artist to be a houseguest. The portrait that Klumpke did of Stanton (Fig. 5-22) captures the intensity and dignity of the great feminist at seventy-one; it had a prominent place in the Salon of 1887 and received an honorable mention.

A large painting of peasant women cheerfully

doing their laundry, *In the Wash House*, was shown in the spring Salon of 1888 before being brought to the Art Institute of Chicago that autumn. From there the painting traveled to the Pennsylvania Academy, where it won for the artist the Temple Gold Medal. The first woman so honored, Klumpke donated the painting to the Academy. Between 1889 and 1898, she made several trips to Boston, where she established a studio, taught, accepted commissions, and exhibited her work.

From the United States Klumpke wrote Bonheur requesting that she sit for her. More than a year passed before she received a reply: "I am at your disposal, dear Mademoiselle, in regard to the portrait you desire to paint of me. The sittings do not amuse me much, but for the esteem in which I hold you I shall do my best, only I cannot restore to youth the model which has become very spongy; but this does not matter, and I offer the hospitality of my house for the time necessary, whenever you wish to come."[75] Working side by side in the large studio at By, their friendship deepened; Bonheur asked Klumpke to remain with her and become her biographer: "I feel

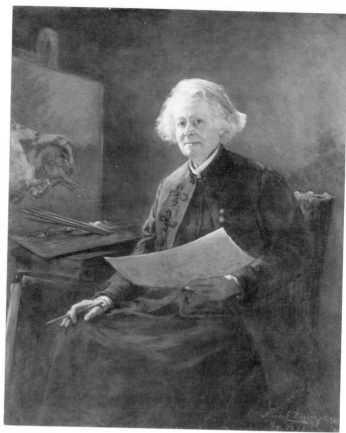

FIG. 5-23. Anna Elizabeth Klumpke, *Portrait of Rosa Bonheur* (1898). 46⅛ × 38½". Metropolitan Museum of Art, New York. Gift of the Artist in Memory of Rosa Bonheur, 1922.

maternally ambitious for you, for I feel you will understand and continue my art, my intelligence, my life."[76] Completed in 1898, the portrait remains Klumpke's finest (Fig. 5-23). The relaxed figure of the aged artist at her easel shows a greater understanding of human form than Klumpke had heretofore exhibited. (Klumpke donated the portrait to the Metropolitan Museum of Art in memory of Bonheur in 1922.) Bonheur died in her protégé's arms in 1899; the Bonheur estate at By was left to Klumpke, who for the next dozen years was preoccupied with arranging memorial exhibits, creating awards in Bonheur's honor, and establishing the Rosa Bonheur Museum at the Château in Fontainebleau. In 1908 her offical biography of Bonheur was published in French.

The last years of Klumpke's life were spent in her native San Francisco, Boston, and By. A small exhibit at the Doll and Richards Gallery in Boston prompted this response from a critic:

It is a rather choice group of small paintings which Miss Klumpke is exhibiting—nearly all of them little pictures

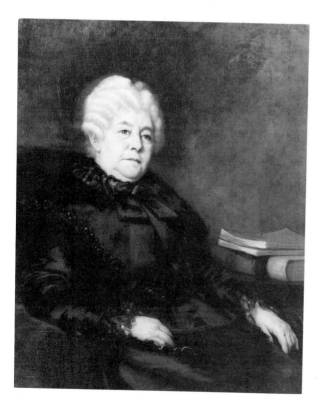

FIG. 5-22. Anna Elizabeth Klumpke *Portrait of Elizabeth Cady Stanton* (1887). 39¾" × 32½". National Portrait Gallery, Smithsonian Institution, Washington, D.C.

painted in and around her estate at Fontainebleau. . . .
There is a nice sense of atmosphere and luminosity in all of
Miss Klumpke's paintings and a delicate color harmony.
While studying with Rosa Bonheur, [she] caught that
sense of poetry of nature which the eminent French woman
scintillated. But on top of that Miss Klumpke had a fine
technique of her own.[77]

NOTES

1. Gerda Lerner, *The Woman in American History* (Menlo Park, Calif.: Addison-Wesley Publishing Co., 1971), 23; Eugenie A. Leonard, Sophie H. Drinker, Miriam Y. Holden, *The American Woman in Colonial and Revolutionary Times, 1565-1800* (Philadelphia: University of Pennsylvania Press, 1962), 26, 33.

2. *Ibid.*, 14; *Ibid.*, 30.

3. Lerner, *American History*, 9.

4. Leonard, *Colonial and Revolutionary Times*, 76.

5. Quoted in Carl Holliday, *Woman's Life in Colonial Days* (New York: Frederick Ungar, 1922), 143.

6. June Sochen, *Herstory: A Women's View of American History* (New York: Alfred Publishing Co., Inc., 1974), 119. Hale also supported women's education and their right to enter the professions.

7. Lerner, *American History*, 29; William O'Neill, *Everyone was Brave* (Chicago: Quadrangle Books, 1969), 5-7.

8. These quotes are taken from *Society in America*, part of which is reprinted in Rossi, *Feminist Papers*, 125-43.

9. Although conditions in the New England mills were never as harsh as those experienced by English workers, women joined men in a strike in 1824. In 1834 they formed their own union, the Lowell Female Labor Reform Association, and struck, demanding an end to wage cuts, increased production, and long hours. By the 1840s the Irish immigrant was the chief mill worker.

10. Elizabeth Anthony Dexter, *Colonial Women of Affairs* (Boston: Houghton Mifflin Co., 1931), 141.

11. Quoted in Holliday, *Woman's Life in Colonial Days*, 74, 85.

12. Quoted in *Ibid.*, 74-75.

13. Quoted in *Ibid.*, 92.

14. Quoted in Linda K. Kerber, "Daughters of Columbia: Educating Women for the Republic, 1787-1805," in *The Hofstadter Aegis*, Stanley Elkins and Eric McKitrick, eds. (New York: Alfred A. Knopf, 1974), 58.

15. Lerner, *American History*, 40-45.

16. Quoted in Rossi, *Feminist Papers*, 391.

17. Quoted in Inez Haynes Irwin, *Angels and Amazons* (New York: Doubleday, Doran & Co., Inc., 1933), 22. This remark was made by the 19th-century writer Lydia Maria Child.

18. Quoted in Dexter, *Colonial Women of Affairs*, 126.

19. Sochen, *Herstory*, 69.

20. Kerber, "Daughters of Columbia," 40; Rossi, *Feminist Papers*, 19.

21. Robert E. Riegel, *American Feminists* (Lawrence, Kansas: University of Kansas Press, 1963), 99; Lerner, *American History*, 35.

22. Sochen, *Herstory*, 146; Lerner, *American History*, 35-36, 38.

23. Quoted in Rossi, *Feminist Papers*, 182; Bell Gale Cherigny, *The Women and the Myth: Margaret Fuller's Life and Writings* (Old Westbury, N.Y.: The Feminist Press, 1977). By interpreting her life from a feminist perspective, Cherigny destroys many of the myths surrounding this remarkable woman.

24. Quoted in Rossi, *Feminist Papers*, 13.

25. From Stanton and Anthony, *History of Woman Suffrage*, Vol. 1, 116, quoted in Lerner, *American History*, 83.

26. Rossi, *Feminist Papers*, 248, 254-58.

27. From *History of Woman Suffrage* Vol. 1, 431, quoted in Lerner, *American History*, 88-89.

28. Rossi, *Feminist Papers*, 390-91, 244-46.

29. Quoted in O'Neill, *Everyone Was Brave*, 19-20, 21.

30. Most of the above information was culled from Mary Bartlett Cowdrey, *American Academy of Fine Arts and Art Union* (New York Historical Society, 1953) and Cowdrey, *National Academy of Design Exhibition Record 1826-1860* (New York Historical Society, 1943).

31. For a more detailed survey of women's participation in the Centennial Exposition see Judith Paine, "The Women's Pavilion of 1876," *Feminist Art Journal* (Winter 1975-76), 5-12.

32. Maude Howe Elliot, *Art and Handicraft in the Woman's Building of the World's Columbian Exposition, Chicago, 1893* (Chicago: Rand, McNally & Co., 1894), 35-38; Joslyn Snyder-Ott, "Woman's Place in the Home (that she built)," *Feminist Art Journal* (Fall 1974), 7.

33. "Women Artists of America, 1707-1964" (The Newark Museum, New Jersey, April 2-May 16, 1905), 8, catalogue essay by William H. Gerdts; *Dictionary of American Biography* (New York: Charles Scribner's Sons, 1934), Vol. 10, 741-42.

34. Gerdts, "Women Artists," 8; Ellet, *Women Artists*, 182-85; *Dictionary of American Biography*, Vol. 20, 562-63.

35. Mary Black and Jean Lipman, *American Folk Painting* (New York: Bramhall House, 1966), 98-100.

36. Quoted in John Hill Morgan, *Gilbert Stuart and His Pupils* (New York Historical Society, 1939), 61.

37. *Dictionary of American Biography*, Vol. 7, 404-5.

38. Ellet, *Women Artists*, 300.

39. *Ibid.*, 290-93; "Four Generations of Commissions, The Peale Collection" (Maryland Historical Society, March 3, 1975-June 29, 1975), 88; *Dictionary of American Biography*, Vol. 14, 344.

40. "Four Generations of Commissions," 97-98; *Dictionary of American Biography*, Vol. 14, 350.

41. Ellet, *Women Artists*, 312-15; Cowdrey, *Art Union*, 101-2.

42. Quoted in Virgil Barker, *American Painting* (New York: The Macmillan Co., 1950), 379.

43. Quoted in Elsie F. Freivogel, "Lilly Martin Spencer," *Archives of American Art Journal*, Vol. 12 (1972), 9.

44. Catalogue essay by Robin Bolton-Smith and William H. Truettner, "Lilly Martin Spencer: The Joys of Sentiment" (National Collection of Fine Arts, Washington, D.C., June 15-September 3, 1973), 11-27; Ellet, *Women Artists*, 317-26.

45. James Thomas Flexner, *First Flowers of Our Wilderness* (New York: Dover Publications, Inc., 1947), 193.

46. Bolton-Smith and Truettner, "Lilly Martin Spencer," 55.

47. *Ibid.*, 63-74.

48. *Dictionary of American Biography*, Vol. 14, 350; "Elisabet

Ney; Texas' First Sculptor," a release from the Elisabet Ney Museum, Austin, Texas.

49. Lorado Taft, *The History of American Sculpture* (New York: The Macmillan Co., 1903), 214-15.

50. Ellet, *Women Artists*, 362.

51. From a letter to the Boston *Transcript*, in Cornelia Carr, ed., *Harriet Hosmer: Letters and Memoirs* (New York: Moffat, Yard & Co., 1912), 192.

52. Quoted in *Ibid.*, 149-51.

53. *Dictionary of American Biography*, Vol. 9, 342-43; William H. Gerdts, Jr. catalogue essay in "The White, Marmorean Flock," (Vassar College Art Gallery, April 4-30, 1972); Russell Lynes, *Art Makers of the Nineteenth Century* (New York: Atheneum, 1970), 130-32.

54. Elsa Honig Fine, *The Afro-American Artist* (New York: Holt, Rinehart & Winston, Inc., 1973), 63; Lynes, *Art Makers*, 134-35.

55. Taft, *American Sculpture*, 212.

56. Quoted in Clement, *Women in the Fine Arts*, 211.

57. Quoted in Fine, *Afro-American Artist*, 66.

58. Fine, *Afro-American Artist*, 66-67; Gerdts, "White, Marmorean Flock."

59. Gerdts, "White, Marmorean Flock·" Clement, *Women in the Fine Arts*, 127-65; Ellet, *Women Artists*, 346-49; Taft, *American Sculpture*, 214.

60. Quoted in Carr, *Harriet Hosmer*, 35.

61. Quoted in "Susan Macdowell Eakins: 1851-1938," (Pennsylvania Academy of the Fine Arts, Philadelphia, May 4-June 10, 1973), catalogue essays by Seymour Adelman and Susan P. Casteras, 24.

62. Casteras, "Susan Macdowell Eakins," 15; Douglas Davis, "The Unknown Eakins," *Newsweek* (May 28, 1973), 10.

63. *Ibid.*, 30-31; *Ibid.*, 10.

64. Virgilia Sapieha, Ruth Neely, Mary Love Collins, *Eminent Women: Recipients of the National Achievement* (Menosha, Wisconsin: George Bank Publishing Co., 1948), 19; "Cecilia Beaux: Portrait of an Artist" (Pennsylvania Academy of the Fine Arts, Philadelphia, September 6-October 20, 1974), catalogue essay by Frank H. Goodyear, Jr.

65. Goodyear, "Cecilia Beaux," 14; Cecilia Beaux, *Background with Figures* (Cambridge, Mass.: Riverside Press, 1930), 87.

66. Goodyear, "Cecilia Beaux," 20; Beaux, *Background with Figures*, 60, 64, 80-85.

67. Goodyear, "Cecilia Beaux," 21; Beaux, *Background with Figures*, 87, 98, 173.

68. Goodyear, "Cecilia Beaux," 22; Beaux, *Background with Figures*, 93.

69. Quoted in Clement, *Women in the Fine Arts*, 36.

70. Beaux, *Background with Figures*, 127; Goodyear, "Cecilia Beaux," 86.

71. From a 1907 lecture given at Simmons College, Boston, on "Portraiture."

72. Anna Elizabeth Klumpke, *Memoirs of an Artist*, ed. by Lillian Whiting (Boston: Wright & Potter Printing Co., 1940), 14.

73. During this period—1883-84—the Julien had segregated life classes: the nude model posed all day for men, while the women drew from a draped model in the morning and from the nude in the afternoon. The women protested, and thereafter both groups had nude models at their disposal all day, although classes continued to be conducted separately.

74. Klumpke, *Memoirs*, 20.

75. Quoted in Klumpke, *Memoirs*, 38.

76. *Ibid.*, 45.

77. *Ibid.*, 86.

CHAPTER SIX

The Impressionist Period

THE STATUS OF WOMEN IN 19TH-CENTURY FRANCE

In France, as elsewhere, large-scale changes occurred in the lives of women because of the Industrial Revolution. The goods that were traditionally produced at home as part of a family industry were now manufactured in distant factories. Poor women were exploited by factory owners while their wealthy counterparts were encouraged to become conspicuous consumers. Many women of the bourgeoisie, now released from the bondage of work, began to examine the conditions of their existence: their education, their relationships to the men in their lives, and their legal, economic, and political status. Some identified with the plight of the working classes and became socialists; others, believing that nothing would change without female enfranchisement, focused their energies on the women's suffrage movement and spread their message through the printed word.

During the reign of Napoleon III, (1852–70) censorship of the press brought with it a concomitant suppression of feminism. At the end of his reign, censorship was relaxed and shortly thereafter a few feminist-oriented journals appeared, the first of which was the weekly *Le Droit des Femmes*, co-edited by Léon Richer and Maria Deraismes (1828–1894), a member of the haute bourgeoisie. First published in 1869, the journal supported civil and political rights for women, divorce, the right to file paternity suits, and higher education and salary equalization for women. A collection of Deraismes' articles, "Ève dans l'humanité," was published in book form at the end of 1869. In them she attacked the left for their lack of interest in female enfranchisement and refuted their belief that women would be influenced by the clergy in their voting habits. She also mourned the loss to posterity of that half of the population that was deliberately kept semi-literate and isolated within their homes. Ever the iconoclast, Deraismes was a leader in the battle against the Victorian moral codes that denied women their sexuality. Before embarking on their joint enterprise, Richer had published *La Femme Libre* (1867), in which he demonstrated that in addition to debilitating women, the French system of education for females worked against men's interests: "Women need to know because they need to judge . . . women need to know because they have a mission to teach."[1]

During the period between 1883 and 1900, Caroline Remy, the "grand old lady of French journalism," was probably the best known of all French women. Under the pen name Severine she wrote that "wherever and whenever one of my sisters cried out for help, I noted the complaint and tracked down the causes of evil, pointing out the injustice of our fate." Always the champion of the poor and downtrodden, she was one of Dreyfus' staunchest defenders.[2]

Many feminist socialists were active during the Commune of 1871 after the Franco-Prussian War. Through the Union des Femmes, they organized cooperatives and child-care centers and campaigned for educational reforms. Few documents exist of women's participation in the Commune, but as active supporters of the socialist takeover of the French government, they were also victims of the resultant massacre when the Communards' brief period of glory ended.

Regrettably, one of socialism's leading theorists, Pierre Joseph Proudhon, was an unremitting misogynist. In his *Amour et marriage* and other writings, he told of the natural inferiority of women, who, without the guidance of men, would never have left the bestial state. Woman was incapable of understanding truth; she lacked initiative and the power of abstraction and generalization; and, along with children and eunuchs, she lacked the capacity for genius. She was granted the virtues of beauty and tenderness, but that tenderness, according to Proudhon, should be used in support of man, who, with her love and

devotion, would bring honor to all "mankind." Juliette Lamber (1836–1936), also a socialist, saw as one of her missions the rebuttal of Proudhon's statements on women. In 1861 she wrote a long attack on the philosopher entitled "Idées anti-proudhonniennes sur l'amour, la femme et le mariage," wherein she carefully analyzed and then attacked each of his theories relating to women. For example, where Proudhon claimed that shame and misfortune would befall the man who allowed his wife to work, Lamber stated that "work alone has emancipated men, and work alone will emancipate women."[3]

The first exclusively suffragist newspaper published in France was La Citoyenne, founded by Hubertine Auclert in 1881 with the motto: "To dare, to resist." It was violently anti-clerical, as were most of the suffragist journals, because the women believed that the Church and its teachings were responsible for the centuries-long efforts to limit women's sphere.[4] Auclert was convinced that civil rights would be granted to women only after they had the vote. In an article on "Le Vote des Femmes," she used the career of Madame Curie to make her point: the eminent scientist had won a Nobel Prize and was a respected scholar and teacher, but politically she was powerless since she could not vote nor enact any legislation. Although La Citoyenne was published for ten years, its impact was minimal.[5]

Through their fiction, Dumas, Flaubert, Zola, and De Maupassant all demonstrated that they were not without sympathy for the plight of women in late 19th-century France. Frequently accused of being a misogynist, Dumas in fact supported women's suffrage and predicted that one day they would hold political office. He was also an advocate of marriage and divorce reforms, but believed that custom rather than law impeded women's development, and that change could not be legislated. In La Dame aux camélias (1851), he was critical of the bourgeois values that prevented the lovers from marrying, stating that God perhaps would pardon the "kept woman," but not the man. In Madame Bovary (1857), Flaubert shows how Emma, a romantic young girl, is unprepared for the realities of marriage and the demands of a boorish, insensitive husband.

Zola, a socialist, indicated his sympathy for the oppressive conditions under which the working-class woman struggled to survive and keep her family fed and clothed. A scene in a wash-house in L'Assommoir (1877) describes the horrors attached to even the simplest of chores; another scene demonstrates how enslaved the female mentality has become: although Gervaise is in labor, she feels compelled to prepare her husband's dinner. In Au Bonheur des dames (1883), he describes how the capitalist economy exploits women of all classes, the poor by forcing them to work for starvation wages to produce goods, and the wealthy by the deceptive advertising designed to seduce them into purchasing goods for which they have no need.[6]

De Maupassant wrote in L'Inutile Beauté (1890) of an upper-class woman's attempt to escape her destiny as a perpetual bearer of children. Gabrielle was considered one of the most beautiful women in Paris; to keep her unattractive to other men and to control her, her husband impregnated her seven times by the time she was thirty. Her cry: "I want no longer to be victim of the loathsome torture of maternity, which you have imposed upon me for eleven years! I want to live at last like a woman of the world, like I have a right to do, like all women have a right." His reply: "You are mine. I am your master. I can demand of you what I want. The law is with me!" And he was correct.[7]

THE IMPRESSIONIST MOVEMENT

Monet, Renoir, Pissarro, Sisley, Degas, and Berthe Morisot formed the nucleus of the initial group of Impressionists, who first exhibited together as the Société Anonyme in April of 1874. (Mary Cassatt did not join the group until 1879, and Eva Gonzalès —along with her mentor, Manet—never actually joined them.) They were dissident pupils from the studio of Gleyre, from the Académie Suisse, and from the École des Beaux-Arts who left the academic art world to study light and color in the forest of Fontainebleau, on the banks of the Oise, and in the province of Normandy. Socially and intellectually they were a diverse group, yet they shared a need for liberation from the rigidities of the Salon system. They ignored the hierarchy of subject matter and refused to paint historical or mythological subjects, insisting that content was secondary to color and light; they ignored the rules of perspective, the formulas for creating shadow, and the finish that barely hinted at brushwork; they made no moral judgements, anecdotal comments, or sentimental gestures.[8]

Although their vision appeared new, the Impressionists were hardly revolutionaries. Rather than identifying with one particular aesthetic philosophy, they incorporated those aspects of the art of the past which they felt to be important. They looked

to Ingres' control, to Delacroix's innovative color theories (which in turn had been influenced by the English landscapist Constable), to Courbet's use of nature, to the Barbizon School's *plein air* paintings, and to the colors of the Venetian Renaissance. They also adopted "modern" trends—recently discovered Japanese prints and even the cropped vision and chance gestures of photographs. They eliminated earth colors and black from their palette and created shadow by juxtaposing pure colors, thereby creating vibrant surfaces shimmering with light.[9]

WOMEN ARTISTS OF THE IMPRESSIONIST ERA

Mary Cassatt and Berthe Morisot were never patronized by their male colleagues because of their sex. They partook in every decision concerning the planning of Impressionist exhibitions, and were respected for their talents and intelligence as well as their charm, graciousness, and hospitality. They were both thoroughly professional, indefatigable workers, their oeuvre cut short only by Morisot's series of illnesses and Cassatt's demanding family responsibilities. While driven to paint by the same "inner necessity" and compulsion that motivated their colleagues, they were circumscribed by the mores that governed women of the haute bourgeoisie.

According to Ellen Wilson, one of Cassatt's biographers, the two women first met while both were copying paintings at the Louvre. Impressed by Morisot's talent and commitment, which she found rare among the "lady copyists," Cassatt wanted to become better acquainted, but the natural reserve of both young artists prevented them from becoming more than nodding acquaintances at this time. They eventually became friends, but not intimates. Needless to say, their work was frequently compared. Gauguin's comment on viewing their work together in 1879 gives an indication of the differences in their style: "Miss Cassatt has as much charm, but she has more power."[10]

Exacerbated by the machinations of Manet, who enjoyed toying with the affections of bright, pretty young women, a heightened spirit of competition existed between Morisot and Eva Gonzalès. When Manet met the twenty-year-old Gonzalès in 1869, he was so impressed with her dark beauty that he asked her to come to his studio and pose. Morisot often worked alongside Manet, and she came to resent the newcomer's presence in the studio and wrote her sister Edma: "Manet lectures me, and holds up that eternal Mademoiselle Gonzalès as an example; she has poise, perseverence, she is able to carry an undertaking to a successful issue, whereas I am not capable of anything. In the meantime he has begun her portrait over again for the twenty-fifth time. She poses every day, and every night the head is washed out with soft soap."[11] For Manet's portrait of Gonzalès, exhibited at the Salon of 1870, Morisot had little praise. She thought the colors washed out and "the head weak and not pretty." She described the painting by Gonzalès in the same Salon as "passable and nothing more."[12]

Although Suzanne Valadon is not traditionally identified with the Impressionists (she never exhibited with the group), her indoctrination into the mysteries of the art world came initially from men, many of whom were connected with that group: Puvis de Chavannes, Renoir, Degas, and Toulouse-Lautrec. With the exception of Lautrec, these artists were also colleagues of Cassatt and Morisot; yet because of the differences in class—Valadon was a Montmartre street urchin—their relationships with them differed. Valadon claimed at various times to have been mistress to Puvis de Chavannes, Renoir, and Toulouse-Lautrec; she also suggested that Renoir might be the father of her son, Maurice. In the last years of Degas' life, Valadon was the cantankerous artist's only contact with the outside world. Cassatt and Degas had drifted apart after vehement arguments concerning the Dreyfus case, and Valadon became his "terrible Maria." There is no record of any meeting between the two women, and in all probability they were unaware of each other's existence. Valadon was ten years old when Cassatt first met Degas, and the older artist would most likely have snubbed the youthful gamine. The differences in social background are also reflected in their art: Valadon's work is full of raw energy and primitive vitality, while Morisot's paintings are gentle and delicate and Cassatt's cool and controlled.

BERTHE MORISOT (1841–1895)

. . . the interesting thing about Berthe Morisot was that she lived her painting, and painted her life, as if it were some natural function, part of her vital being to translate into painting what she saw: to turn light into creative art. She would take up or put down her brush as though it were a passing thought and that was what gave her work its special charm, for it expressed the artist's ideal in the closest relationship to the intimate feelings of life. As a

girl, wife or mother, her sketches and paintings follow her own existence closely. I am tempted to say that to see her work all together reminds one of a woman's diary in colour and line.[13]

Thus the poet Paul Valéry who had married Morisot's niece, described the artist's work. Yet hers was not a provincial art, although it glorified the homely, the commonplace, and domestic life, as indeed did most of Impressionism. Her aesthetic was a revolutionary one.

Art was a tradition in the Morisot family. Berthe's granduncle was Fragonard, her grandfather was a well-known architect, and her father had studied at the École des Beaux-Arts before becoming a government functionary. When Berthe and her sister Edma showed an interest in painting, their parents sought instruction for them; they also built them a studio on the grounds of their rented home and began entertaining poets and artists. Their first teacher was Geoffroy Alphonse Chocarne, an uninspiring artist whose initial lessons consisted of drawing "straight strokes for flat surfaces, strokes which were closely massed in the shadows, more open in half-tones, and scantly as they approached the lights." Rather than submit to this pedantry, the sisters were almost ready to give up painting when the family met Joseph Guichard, who had been a student of both Ingres and Delacroix. Impressed with the work of both Edma and Berthe, Guichard warned Mme. Morisot: "With natures like those of your daughters, my teaching won't end with giving them pretty little drawing-room accomplishments. They will become painters. Have you really considered what that means? In your well-to-do society that would be a revolution, almost a catastrophe."[14] Forewarned, Mme. Morisot contracted Guichard to teach her daughters, and in 1858 they began their lessons at the Louvre, studying the old masters under Guichard's watchful eye.

In 1860, tired of working only in their studio and at the Louvre, the Morisot sisters expressed a desire to paint in the open air. This was anathema to Guichard, who believed that painting from nature thwarted the "free flight of imagination." However, he introduced them to Camille Corot, dean of the "plein-air" painters. Enchanted by the young sisters, the usually reclusive artist became a weekly dinner guest at the Morisots'; he gave them his paintings to copy, which he then faithfully criticized. Following the master's advice, they painted in the early morning hours and after sunset, when the light was diffuse and details disappeared, when forms could be more easily reduced to planes. The silvery quality of morning light reappears in many of Berthe's subsequent paintings. Since Corot disdained teaching, he introduced his young disciples to a former student, Achille François Oudinet, who became their next teacher. At his suggestion, the Morisots took a house on the banks of the Oise, a favorite locale for the Barbizon painters. It was there that they met landscapist Charles Daubigny and Honoré Daumier, the political caricaturist and draftsman whose vigorous drawings may have influenced Berthe's own. So impressed was Oudinet with their progress that he urged them to submit work to the Salon of 1864. Berthe was represented with two landscapes—*Souvenir of the Banks of the Oise* and *Old Roadway at Auvers*. She described herself as a pupil of Guichard and Oudinet, but not of Corot.[15]

Berthe and Edma exhibited together in four successive Salons, but in 1868 Berthe showed alone. Edma had married a naval officer, and although she never submitted work to the Salons nor partook in the Impressionist exhibits, the exchange of letters between the two sisters suggests that she continued to paint. Isolated in the provinces, Edma was envious of her sister's fascinating life spent "chatting with Degas, laughing with Manet, and philosophizing with Puvis." Responding to a letter from Edma, who was depressed by her separation from her sister and the art world, Berthe wrote (1869): "... this painting, this work that you mourn for, is the cause of many griefs and many troubles. You know it as well as I do, and yet, child that you are, you are already lamenting that which was depressing you only a little while ago."[16] In August of 1870, Edma wrote of an attempt to paint in which she "completely ruined a still life on a white canvas," and the following month of her frustration in trying to paint outdoors. "However, I reproach myself for having done nothing this season," she concluded. "My passion for painting has not yet left me." In a later note (1872) to Edma, Berthe chided her sister for tormenting herself over her work. She was almost envious of Edma's choice—to paint or not to paint—since her own agony in responding to that "inner necessity" often filled her with despair. "You are far more fortunate than I am: you work when you feel like it, and that is the only way in which one can do good work," she wrote. "As for me, I work hard without respite or rest, and it's pure waste...."[17] It is from this almost thirty-year exchange of letters that we learn of Berthe's pain and insecurity and of the darker side of her life not revealed in the sunny, spontaneous paintings. Although she sold few paintings during her lifetime, and then mostly to her colleagues, she had their

respect and continued support, being considered "an artist of real accomplishment" by Théodore Duret, one of the earliest chroniclers and supporters of Impressionism.

Morisot's first mature painting was *A View of Paris from the Trocadéro*, exhibited in the Salon of 1867. Although Corot's influence is still apparent, especially in the painting's delicate harmonies, the execution is bolder and broader than that of her former teacher. The surprising perspective and quality of light and atmosphere reveal a "sensitivity that lacked neither confidence nor temerity." So impressed was Manet with the painting that he proceded to paint the same view. Although they were aware of each other's work, Manet and Morisot had not yet met. They were introduced by Henri Fantin-Latour in the winter of 1868 while all were copying paintings at the Louvre. Their attraction for each other was immediate. As Rewald explained: "She was deeply impressed by Manet's talent; he in turn was fascinated by her feminine charm and natural distinction."[18] Shortly thereafter he asked her to pose for one of the figures in *The Balcony*, a painting he was planning based loosely on Goya's *Majas on a Balcony*. She accepted, and during her daily visits to his studio (accompanied by her mother), she studied his work. The Morisot and Manet families became close friends; the Morisots attended the Manets' Thursday evenings, where Baudelaire, Degas, Zola, and Alfred Stevens (who introduced Berthe to Puvis de Chavannes) gathered. The two families began to spend summers together.

Morisot produced several remarkable paintings in 1869. One, the *View of the Little Harbor of Lorient*, shows her sister Edma clad in white and sitting on a low wall that overlooks the harbor. The broad diagonal planes are interrupted only by the verticality of the boat masts and the texture created by the lively handling of the brush. Puvis de Chavannes had found the painting "not too bad," but Manet was so impressed with the work that the delighted Morisot gave it to him.

Much has been written about the relationship between Manet and Morisot. When they met, Morisot was already a mature painter and not in need of a mentor. (Indeed, the influence of the older artist is more apparent in Morisot's early work, done prior to their long association.) One must conclude that the relationship was mutually beneficial: her work became bolder and freer; his palette lightened and he began to work in the open air. Morisot's paintings were always smaller, less structured, and more spontaneous than Manet's; in addition, while under the influence of Corot and Oudinet, she painted mostly landscapes, but after meeting Manet—who was primarily concerned with the figure—she experimented with the effects of light on the figure in a landscape, a subsequent Impressionist preoccupation. Morisot was aware of Manet's powerful influence and worked diligently to maintain her independence. She wrote Edma (1871) concerning a portrait she was doing of their older sister, Yves: "The work is losing all its freshness. Moreover, as a compostion it resembles a Manet. I realize this and am annoyed."[19]

Another significant painting of 1869 was the double portrait of her mother and sister (Fig. 6-1); like a symphony of light and dark passages, it is quite classical in composition. The dominant form is the darkly silhouetted Mme. Morisot to the right. The light is focused on the figure of her expectant sister set further back in the picture plane and seated on a patterned couch, her head framed by a painting. Completing the triangular composition is a table on which a small bouquet rests.

The Franco-Prussian War dispersed the Impressionist group. Illness and devastation finally forced the Morisots to leave Paris and join Puvis de Chavannes at Saint-Germain. The deprivations she suffered during the war left Morisot's health permanently

FIG. 6-1. Berthe Morisot, *The Mother and Sister of the Artist* (1869). 39½″ × 32¼″. National Gallery of Art, Washington, D.C. Chester Dale Collection.

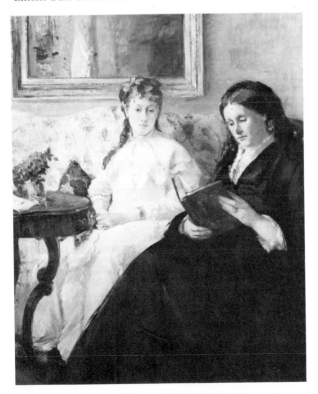

impaired, and she had "come out of this siege absolutely disgusted with my fellow men, even with my best friends," as she confided to her sister. "Selfishness, indifference, prejudice—that is what one finds in nearly everyone."[20] Although she had a painting in the first post-war Salon, most of her friends' works were rejected. Depressed by the general atmosphere in France, Morisot made her first trip to Spain to study the paintings of Goya and Velásquez in the Prado at Madrid.

An 1873 canvas, *The Cradle* (Fig. 6-2), a portrait of Edma watching her sleeping infant, is imbued with both intimacy and monumentality. There is a delicacy in the handling of fabric—the transparent muslin draping the cradle, the blue-white of the curtains, and the gentle ruffles around the collar and cuffs of the dress—combined with boldness of composition. Shown at the first Impressionist exhibition, it received mildly favorable reviews perhaps because of its appealing subject matter. Jean Provane of *Le Rappel* wrote: "Nothing could be truer or at the same time more touching than this young mother, who, although dressed in a shoddy way, bends over a cradle into which our view of a pink child is muted by a pale cloud of muslin."[21] Also shown was a painting of two figures in a landscape engaged in the game of "hide-and-seek." In composition and color, it is quite at variance with *The Cradle*: here form and local color are subordinated to light—an early revelation of both the charms and weaknesses of the Impressionist aesthetic. After viewing his former pupil's work, the shocked Guichard wrote Mme. Morisot: "When I entered, dear Madam, and saw your daughter's works in this pernicious milieu, my heart sank. I said to myself: 'One does not associate with madmen except at some peril.' "[22]

After the second Impressionist exhibit in 1875, the critics were extremely hostile to Morisot. Albert Wolf of *Le Figaro* began his review of the show by describing the artists as "five or six lunatics, one of whom is a woman . . . as is the case with all famous gangs. Her name is Berthe Morisot, and she is interesting to behold. In her, feminine grace is preserved amidst the frenzy of a mind in delirium."[23]

By 1886 criticism of her work began to be more sympathetic. In *Les Impressionistes en 1886*, Felix Feneon wrote:

Mlle. Berthe Morisot is all elegance: bold, clear, and nimble technique, and feminine charm without affectation. In spite of a tendency toward improvisation her values are rigorously accurate. Those young girls sitting on the grass, at their toilette, or combing their hair (all

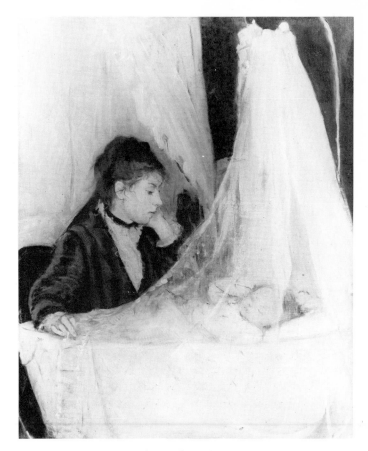

FIG. 6-2. Berthe Morisot, *The Cradle* (1873). 21⅝″ × 18⅛″. Jeu de Paume Galerie, Musée du Louvre, Paris.

paintings) are exquisite works; her rapid drawings and swiftly delineated watercolors are a joy.[24]

Her work at this time is characterized by a spontaneous, dancing brushstroke that creates a dazzling surface. The strokes are long and fluid rather than short and choppy, and follow the direction of the form so that form is never dissolved. There is always a contrast in direction, and often just at the point where diffusion seems imminent, the artist adds a line for definition. In *In The Dining Room* (1886; Fig. 6-3) the central figure of the woman pausing with her cup of tea almost merges into the background; there is minimal definition of space or architecture.

Around 1890 Morisot's technique began to change. Like Renoir, she became disillusioned with where Impressionism had led her, and introduced more structure into her compositions. Her color also became more brilliant. Following the example of Corot and Cézanne, she never drew before starting to paint, but in the last few years of her life began making many preliminary sketches before working on can-

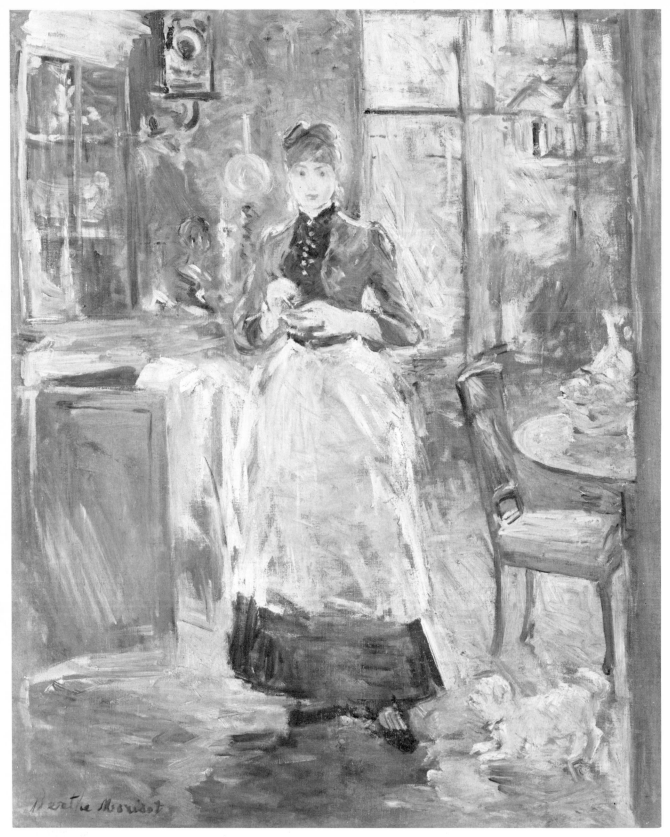

FIG. 6-3. Berthe Morisot, *In the Dining Room* (1886). 24⅛″ × 19¾″. National Gallery of Art, Washington, D.C. Chester Dale Collection.

vas. In fact, few drawings of hers exist dating from before the late 1880s.

While preparing for her first one-woman exhibit at the Boussard and Valadon Gallery (May 25–June 18, 1893), her husband died. Morisot retreated to her studio and painted assiduously in order to forestall depression. She did not attend the opening, but heard of its success from Renoir, who wrote: "Your colleague is happy to tell you that your dread of a fiasco is itself a fiasco . . . Everybody is satisfied and I compliment you." Puvis de Chavannes was charmed by her efforts and told her that he "left these modest rooms absolutely enraptured."[25] Through the efforts of Stéphane Mallarmé, the Symbolist poet and a long-time friend and admirer, the Luxembourg purchased *Femme au Bal*—a painting that had been in the fifth Impressionist exhibit (1880),—for a price well above her current market value. Occurring only one year before her death, the event signified to Morisot a recognition of her achievement and her professional status.[26] A retrospective exhibition was held at Durand-Ruel's after her death in 1895, at which most of the buyers were her former friends and colleagues.

Mme. Morisot's tolerance of her daughter's search for truth through art had its limitations. Since Berthe had not yet made a spectacular success, her mother was far less supportive than she had been in her earlier years and questioned whether her "spinster" daughter's pursuit was worth the sacrifice. Shortly after the Franco-Prussian War Mme. Morisot wrote Edma: "Everyone thinks that it is better to marry, even making some concessions, than to remain independent in a position that is not really one." In a letter of 1872 she further explained:

She has perhaps the necessary talent—I shall be delighted if such is the case—but she has not the kind of talent that has commercial value or wins public recognition; she will never sell anything done in her present manner, and she is incapable of painting differently. . . . When a few artists compliment her, it goes to her head. . . . I am therefore a bit disappointed to see that Berthe won't settle down like everybody else. It is like her painting—she will get compliments, since she seems to be eager to receive them, but she will be held at arms length when it comes to serious commitment.[27]

Morisot's marriage in 1874 to Eugène Manet, Édouard's younger brother, was a happy one. Unlike Mme. Morisot, he supported her in her work and helped organize and hang the Impressionist exhibits. An amateur artist himself, he often accompanied his wife on painting expeditions. They were devoted to their daughter Julie and were never away from her long.[28] Since Eugène never secured a permanent position, he became Julie's tutor, and both frequently served as Berthe's models. In Paris they led a restricted social life, exchanging visits or dining with Degas, Monet, Renoir, Cassatt, Fantin-Latour, and Puvis de Chavannes. At their country home a permanent room was reserved for Renoir; the two artists often shared the same models and painted the same landscapes.[29]

Morisot worked assiduously throughout her married life, during which the love of art and the habit of work never diminished. She had written Edma shortly after the latter's marriage that men were apt to "believe that they fill all of one's life, but as for me, I think that no matter how much affection a woman has for her husband, it is not easy for her to break with a life of work. Affection is a very fine thing, on condition that there is something besides with which to fill one's days."[30] Although she rarely theorized about art, she once commented on the role of the woman artist: "The truth is that our value lies in feeling, in intention, in our vision that is subtler than that of men, and we can accomplish a great deal provided that affectation, pedantry, and sentimentalism do not come to spoil everything."[31]

MARY CASSATT (1844–1926)

The irony of Mary Cassatt's existence was that she lived the gracious life of a well-to-do American, devoted to her parents and family, while never ceasing to work assiduously as a professional artist. Except for her career, she was the compleat Victorian lady, a model of propriety. "She drew that almost impossible line between her social life and her art, and never sacrificed an iota to either," wrote her friend George Biddle, the young Philadelphia artist. "Socially and emotionally she remained the prim Philadelphia spinster of her generation."[32] Her association with the rebellious Impressionists seems unlikely at first, but she was an independent person making explorations on her own, and did not compromise her work. Somehow she managed to reconcile two worlds: she aided her poverty-stricken colleagues by advising her wealthy friends to buy their works. Her friends, in turn, amassed great fortunes as they sold their holdings, or gained reputations as generous benefactors when they donated them to museums. The Metropolitan Museum of Art, the Philadelphia Museum, and the Art Institute of Chicago owe their fine Impressionist collections to Cassatt's tireless proselytizing. Cassatt also advised

her American friends to buy the works of old masters when they became available, and it is testimony to her impeccable taste that these same museums have many El Grecos, Correggios, and Raphaels. Well aware of the inadequacies of American museums because of her own experience as a young student, she made it her mission to see that great art became available to the American public.[33]

Cassatt is included among the Impressionists rather than in the preceding chapter because it is with them that she identified, and it is from them that she received her artistic freedom.

Born in 1844 in Allegheny City, Pennsylvania, now a part of Pittsburgh, Mary was the fifth of seven children of Robert and Katherine Kelso Cassatt. Her peripatetic father changed residences as frequently as he fathered children, and by 1849 the Cassatts were living in Philadelphia. But not for long. Restless again, Robert Cassatt packed his family belongings and began what was to be the first in a series of extended visits to Europe. After a brief stay in Paris, the family moved to Heidelberg and later Darmstadt, Germany, to facilitate the technical education of their eldest son, Alexander, who was later to become president of the Pennsylvania Railroad. They were back in Paris for the Exposition Universelle in 1855 and returned to the United States at the end of the year. They settled first in West Chester, but were established again in Philadelphia by 1861, when Mary enrolled in the Pennsylvania Academy of the Fine Arts. After four years of tedious study "drawing from dull, lifeless casts" and copying fourth-rate paintings, Mary persuaded her father to let her go to Europe for further study. For a young girl of her social position, the study of art and other "accomplishments" was an acceptable way to pass the time before being presented to society; some girls, properly chaperoned, went to Paris, Rome, Düsseldorf, or Munich to study, but rarely with the idea of becoming a professional artist. A reluctant Mr. Cassatt made arrangements for his persistent daughter to live with family friends in Paris and to begin the serious study of art in the atelier of the fashionable academic, Charles Chaplin. Mary's parents eventually came to believe they had made the correct decision. As Mrs. Cassatt later wrote her son Aleck: "After all a woman who is not married is lucky if she has a decided love for work of any kind and the more absorbing it is the better."[34]

With the outbreak of the Franco-Prussian War in 1870, Cassatt was forced to return home. There she painted a full-length portrait of her two-year-old nephew with all the lush colors and texture of an 18th-century royal portrait. Before the year was out, she sailed for Italy to begin a serious study of the old masters. She spent eight months in Parma studying the work of Parmigianino and Correggio, whose unsentimental "mother and child" presentations had a profound effect on her secular interpretations of the theme. She also studied in Rome with Carlo Raimondi, the painter and engraver who headed the engraving department at the Art Academy. From Rome, in 1872, Cassatt sent her first work to the Paris Salon, *A Balcony in Seville,* signed "Mary Stevenson." It was accepted, as was her second Salon entry, *Madame Cortier* (1874), a straightforward and boldly modeled portrayal of an older woman that contrasted sharply with the sentimentality of the typical Salon renditions of such a theme. When Degas saw the painting, he purportedly remarked: "It is true. There is someone who feels as I do."[35] When a portrait of her sister was rejected in 1875 for being too bright (it was accepted the following year after she toned down the background to conform to Salon standards), and after a rejection the following year, Cassatt vowed never again to submit to the Salon. (Although she had been accepted for five successive Salons, she disapproved of the jury system.)

By this time she was aware of and exhilarated by the small group of rebel artists who had begun to exhibit independently in defiance of Salon dictates. Therefore, when Degas invited her to join the Indépendents, she was overjoyed. After perusing the work in her studio, the caustic Degas remarked: "These are real. Most women paint pictures as though they were trimming hats. No you."[36] An enduring professional and personal relationship developed between the two. They shared the attitudes of the class to which they both belonged and were fastidious to the point of snobbery. Both witty and acerbic, they respected each other's talent and intelligence and shared a common aesthetic: both were passionately committed to drawing. Degas' biting sarcasm would often cause her to withdraw from him: "Sometimes it made him furious that he could not find a chink in my armour and there would be months when we just could not see each other, and then something I painted would bring us together again and he would go to Durand-Ruel's and say something nice about me, or come to see me himself."[37] After one such separation, Degas saw her painting *Boy Before a Mirror* (1901) at Durand-Ruel's and heralded it as "the picture of the century." Immediately, he sought out Cassatt to praise the work, but he also added: "It has all of your qualities and all of your faults. It is the Baby Jesus with his

English nurse."[38] During her frustrations while painting the large mural for the Woman's Pavilion at the World's Columbian Exposition in Chicago, Cassatt had been a "half dozen times at the point of asking Degas to come see my work, but if he happens to be in the mood he would demolish me so completely that I could never pick up in time to finish for the exposition."[39] Yet his was the only opinion she respected. When they were separated, he often wrote her letters and poems. Unfortunately for scholars, the very private and unsentimental Cassatt burned them all. There has always been speculation about the degree of their intimacy. When later in life a young relative asked her if she had ever had an affair with Degas, she replied indignantly: "What, with that common little man; what a repulsive idea."[40]

After 1900, mainly as a result of their differences over the Dreyfus affair—she sided with the pro-Dreyfus forces and Degas with the government—their relationship began to deteriorate. In addition, because of his impending blindness he had become increasingly irritable and reclusive; by 1908 he could no longer paint. She still felt an affection for him and arranged for his niece to come to Paris to care for him, and despite her own infirmities was at his funeral in 1917. She wrote George Biddle afterward: "His death is a deliverance but I am sad. He was my oldest friend here and the last great artist of the 19th century. I see no one to replace him."[41]

Soon after Cassatt met Degas, her mother, father, and older sister Lydia joined her as permanent residents of Paris. Abandoning his brokerage firm in Philadelphia—he never enjoyed business— Mr. Cassatt chose to live in Paris, the city he loved, on a modest income which was eventually supplemented by Mary's sales and Alexander's generous gifts. Mary was never as wealthy as her colleagues thought; she was merely well-bred. As her father explained in a letter to one of his sons in 1878: "Mame [his pet name for Mary] is working away as diligently as ever but she has sold nothing lately and her studio expenses with models from one to two francs an hour are heavy. Moreover, I have said that the studio must at least support itself. This makes Mame very uneasy as she must either make sale of the pictures she has on hand or else take to painting pot-boilers as the artists say, a thing that she has never yet done and cannot bear the idea of being obliged to do."[42] By combining their incomes, they were able to lead a comfortable, though not luxurious, existence in the various apartments and summer villas that Mary was always seeking. (She purchased the Château de Beaufresne

in 1892 from sales of her paintings, and lived in it until her death.) Although her family, especially Lydia, served as models for many of her paintings, as did her brothers' children on their many extended visits to Paris, for eighteen years Mary was burdened with their various ailments. Many precious painting hours were devoted to their care; she produced only about 617 oils and pastels compared to Degas' 1,466 and there are only 64 known works from the decade of the 1880s, when the artist was at the height of her creative powers but felt her family responsibilities most overwhelming.[43]

Cassatt's first significant painting after her meeting with Degas was *Little Girls in Blue* (1878), now in the Mellon Collection at the National Gallery, Washington, D.C. The unusual asymmetrical composition—with four large, seemingly arbitrarily placed over-sized blue chairs on which rests a little girl and one of Cassatt's pet Belgian griffons—shows the influence of Degas. She had sent it to the American section of the 1878 Exposition, and it was refused. Cassatt was indignant, since Degas had found the painting quite good. At her first appearance with the Impressionists (1879) she showed *La Loge*, which remains one of the finest achievements of her "Impressionist" period. The red-headed Lydia, with pearl necklace and pink gown, is seated in a red opera box; she is leaning against a mirror in which is reflected the curve of her back and the audience in the curved loge. The dynamic thrust of her body and the unexpected cropping of an arm, as well as the interest in theatrical light, show the influence of Degas, but the color shows an affinity for Renoir. Ultimately, however, the painting is pure Cassatt: like her other sitters, Lydia is a healthy-looking American beauty bearing no resemblance to the types painted by her French colleagues.

The avant-garde writer and critic Huysmans had high praise for Cassatt's paintings in the fifth Impressionist exhibition the following year. Huysmans found one of her entries, *A Cup of Tea* (Fig. 6-4), reminiscent of contemporary English painting: "In spite of her personality, which is still not completely free, Miss Cassatt has nevertheless a curiosity, a special attraction, for a flutter of feminine nerves passes through her painting which is more poised, more calm, more able than that of Mme. Morizot [sic]."[44] A more carefully composed painting than any she had done previously, its strong diagonals (the table and the figure on the left) are contrasted with the bold vertical striping of the wallpaper. On the silver tea service to the right there rests a single cup which repeats the form and color of the cup

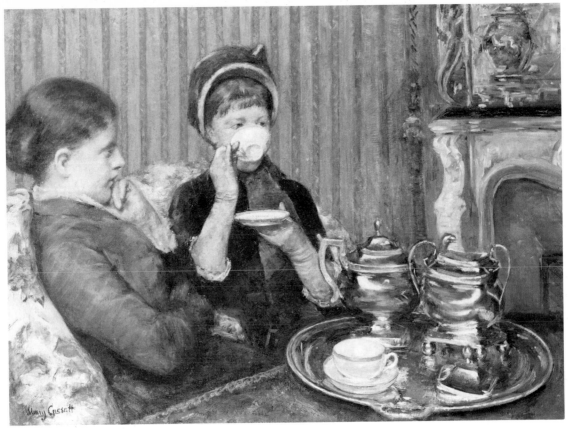

FIG. 6-4. Mary Cassatt, *A Cup of Tea* (c. 1880). 25½″ × 36½″. Courtesy Museum of Fine Arts, Boston. Maria Hopkins Fund.

partially shielding one of the women's faces, creating a tension between the two forms.

Cassatt's first paintings on the theme of mother and child were done in 1880. Degas had suggested the theme as an unworked area in contemporary art, and the subject came to dominate her work in the 1880s and 1890s. Many male art historians have read into this preoccupation her maternal frustration (although Canaday grants her happiness and fulfillment without the impediments of husband and children), but when her entire oeuvre is examined, the importance of this single theme is diminished. Indeed both Degas and Cassatt limited their subject matter, exploring the varieties of possibilities within a narrow range. Cassatt explored the areas of activity available to the Victorian female, which was mostly the life centered around home and family, with an occasional trip to the opera.

After the 1881 Impressionist exhibit Huysmans wrote that Cassatt was now an artist who owed nothing to anyone, "an artist wholly impressive and personal." Her section included portraits of children and women in interior and garden settings, all painted without the sentimentality "on which most [Salon painters] have foundered." Even *Le Figaro* and the usually indifferent American press commented favorably. Her reputation thus insured, artists and patrons began seeking her out. Although she wanted recognition, success bored her. "Too much pudding," she called it.[45] Like many women artists (including contemporary women), Mary Cassatt did not promote herself; she did not have her first one-woman show (at Durand-Ruel's) until 1891.

In 1883 Cassatt painted one of her finest portraits—one of her mother, entitled *Reading Le Figaro*. It is one of her last Impressionist paintings; afterward she paid more attention to line and design, and was less concerned with the painterly quality of the canvas. Several devices she frequently used are present: the curvilinear chair contrasting with the verticality of the picture frame and diagonal of the newspaper; and the use of the mirror, which not only extends the picture space but affords another view of the subject.

FIG. 6-5. Mary Cassatt, *The Bath* (1891). 39″ × 26″. Courtesy of the Art Institute of Chicago.

FIG. 6-6. Mary Cassatt, *La Toilette* (1891). Drypoint and aquatint. Metropolitan Museum of Art, New York. Gift of Paul J. Sachs, 1916.

The Japanese influence is apparent in much of Cassatt's oeuvre during the 1890s. In *The Bath* (Fig. 6-5), the outstanding work in her second one-woman show at Durand-Ruel's (1893), there is bold patterning in the wallpaper, dress, and rug, an emphasis on line with minimal modeling and texture, and "bird's-eye" perspective. The abrupt cropping of form and distorted perspective were also devices favored by Degas. The asymmetrical composition also has her typically extended verticality emphasized by the stripes of the wallpaper. The figures of mother and child constitute a tightly unified pair, the two heads forming an oval which is repeated in the bowl in the lower part of the painting. There is no sentimentality in Cassatt's vision. While the relationship between mother and child may have appeared cold to Victorian sensibilities, to modern eyes she has struck the right chord. It remains one of her finest paintings.

Like all the Impressionists, Cassatt had been fa-miliar with Japanese woodcuts before the large Ukiyo-e exhibit at the École des Beaux-Arts in 1890. After visiting the display twice, once with Degas and again with Morisot, she based a series of prints on particular Ukiyo-e woodcuts, especially those of Utamaro. As early as 1879 Cassatt had been drawing on copper to perfect her line. From Degas she learned the technique of soft-ground etching and aquatint. Nonetheless, the set of ten color aquatints designed as "an imitation of the Japanese methods" were an original contribution to printmaking, "adding a new chapter to the history of the graphic arts" and, according to Adelyn Breeskin, the foremost Cassatt authority, "as color prints, have never since been surpassed."[46] Degas was extravagant in his praise. However, after examining the elegant drawing in *La Toilette* (Fig. 6-6), where with a single sinuous line Cassatt captured the grace and beauty of a woman's back, he felt compelled to add: "I will not admit that a woman can draw so well."[47] (Cassatt devoted herself to printmaking because she thought it a good way to bring art to the general public at reasonable prices. She urged her colleagues to do the same.)

At the end of 1904, Cassatt was singularly honored by the French government by being made a Chevalier of the Legion of Honor. She was especially pleased because she thought that at last she would have some influence with American museum directors. But she was still a prophet without honor in her own country; when in 1898 she made her first trip home since the Franco-Prussian War, the Philadelphia *Ledger* noted tersely: "Mary Cassatt, sister of Mr. Cassatt, president of the Pennsylvania Railroad, returned from Europe yesterday. She has been studying painting in France and owns the smallest Pekingese dog in the world."[48] By contrast, the American colony in Paris was impressed, and as a result she was made the honorary president of the Paris Art League, a school for American women students. Besides lecturing at the school, she financed two scholarships which carried the stipulation that the girls must study, for at least one year, the French 17th- and 18th-century pastellists that both she and Degas admired.

Cassatt was a supporter of women's suffrage. She became especially committed to the vote for women during World War I. In a letter written to her friend Louisine Havemayer, irrepressible suffragette and wife of the "sugar king" Henry O. Havemeyer, she wrote that ". . . woman must be up and doing, let them league themselves to put down war." She also wrote Mrs. Havemeyer in 1914 that any exhibit of hers in New York must be in support of suffrage. The

following year, using paintings from her vast collection, Mrs. Havemeyer organized a joint Degas-Cassatt show at the Knoedler Galleries to raise funds for the movement. Few people attended because "their principles forbade their going."[49] Also involved in the politics of Le Mesnit, the village in which the Château de Beaufresne was located, Cassatt is remembered for her efforts on behalf of the young girls exploited for centuries by the local button factory.

In her later years Cassatt confided to her friend, Forbes Watson, that "A woman artist must be . . . capable of making the primary sacrifices." (To an interviewer who asked her if she regretted not having married, she replied: "There's only one thing in life for a woman; it's to be a mother.")[50]

Cassatt never accepted the works produced by the radical artists of the early 20th century. She had utter disdain for Gertrude Stein and her circle, and after a brief visit to the Stein apartment in 1908 remarked to a friend that she had never in her life seen so many "dreadful paintings and people gathered together in one place." The once radical artist had lived long enough to become a conservative. By the time she was in her late sixties her best painting years were past; her eyesight began to deteriorate and she was forced to have several cataract operations. Irrational, opinionated, embittered and lonely in her old age—she even alienated Mrs. Havemeyer—Cassatt died of diabetes in 1926.

EVA GONZALÈS (1849–1883)

Eva Gonzalès was a young and impressionable twenty-year-old when she first met Édouard Manet, sixteen years her senior. So impressed was he with her "dark beauty" that he requested permission from her family to paint her portrait. Aware of the artist's reputation as a revolutionary, the protective parents were at first hesitant. Only after the intervention of Phillipe Jourde, Eva's godfather and a friend of Manet's, was permission granted. The portrait on which Manet worked so assiduously (see section on Women Artists of the Impressionist Era) shows the delicate Gonzalès perched on the edge of a chair painting a floral still-life. One of the large white flowers from the bouquet has conveniently fallen to the lower right corner of the painting, creating a counterpoint with her finished canvas. The girl's long diaphanous white gown, slashed with a touch of black at the waist, and the pale skin and black hair against a somber background create a muted symphony in black, greys, and white. Her Spanish beauty was exactly what Manet required in his models, and he was to paint her many more times.

Gonzalès' father, Emmanuel, though a French citizen, was of Spanish extraction; her mother, an accomplished musician, was from Flanders. As members of the haute bourgeoisie, Eva and her older sister were strictly reared in "customs which were codified by immutable rules of decorum."[51] They were properly "finished" young ladies: charming, accomplished, and reserved. In fact, so reserved was Eva, that if the Louvre were crowded on the days she spent copying there, she was forced to "take to her bed" when she returned home. Emmanuel Gonzalès was an author of best-selling adventure novels whose creative vision had once been compared with that of Cervantes and Goya: his imaginative tales were often first tested out on his family and friends. As founding president of the Society of the People of Letters, Emmanuel frequently entertained members of the Parisian literary and artistic elite. Eva was thus exposed early to the ideas flourishing in the arts of mid-19th century Paris. As she matured, she became the "jewel" of these paternal salons.

Like so many potential artists, Gonzalès filled her school notebooks with drawings "from nature." She took her first lessons from Charles Chaplin, the fashionable academic who often attended her father's salon (he was also Cassatt's teacher). After meeting Manet, she left Chaplin's atelier and became not only Manet's model, but his student as well—and, much to the chagrin of Berthe Morisot, the only artist he allowed to sign "pupil of Manet" to Salon entries. He helped her overcome her paralyzing timidity and enthusiastically encouraged her painting, which became at once more bold and decisive.

One of Gonzalès' entries for the Salon of 1870 was *L'Enfant de Troupe*, a full-length portrait of a child in military dress holding a musical instrument. Although the poses are quite different, the subject and treatment were most likely derived from Manet's *The Fifer* of 1866. Through her father's connections, the painting was purchased by the government, where it was assigned to a provincial museum in Villeneuve-sur-Lot; it was not well hung until 1970. Her work in this Salon (her first) was well received. She was praised in the press for possessing "the intuition which must be art"; she was also applauded for "her temperament, her masculine masterliness, her elegance, her spirit."[52] Another painting of those early years is *Girl with Cherries* (Fig. 6-7) in the Art Institute of Chicago. It is a tightly composed canvas painted with a confidence

unusual for one so young. The palette is subdued—mostly greys, blacks, and greens—with a touch of red in the cherries and in the model's cheeks.

It was a more mature, self-assured Gonzalès who exhibited in the first Salon after the Franco-Prussian War (1872). Zola compared the face of the woman in *La Plante Favorite* with that of a medieval madonna. *Indolence*, a portrait of her sister in which the colors were compared to Corot, also was favorably received. When *Les Oseraies*, a plein-air painting of "seductive freshness" was rejected for the Salon of 1873, her supporters were indignant. The following year, however, she was successful again with *La Nichée*. It even disarmed that old Salon apologist, Leroy, who, in the tradition of the gracious gentleman, praised her thus: "The canvas is nearly as pretty as its author, which is not saying little." The painting was purchased by the state. Of *Le Petit Lever*, shown at the Salon of 1876, Castagnary wrote: "Never could a woman artist do better."[53] Gonzalès continued to have Salon successes. Although her subject matter

FIG. 6-7. Eva Gonzalès, *Girl with Cherries* (c. 1870). 21⅞″ ×18¼″ Courtesy of the Art Institute of Chicago.

and her technique have much in common with Impressionism, ind she is included in the chapter on Impressionist women, she, like Manet, refused to exhibit with that group, both continuing to seek recognition via the official Salon system.

In 1876, after a three-year engagement, Gonzalès married the engraver Henri Guérard, a habitué of the Impressionist table at the Café Guerbois. According to Borty, a friend of the artist, her work became more serious and complex after her marriage. In *Reading in the Forest* (1879; Fig. 6-8) the artist has successfully handled one of the Impressionist preoccupations: figures in the open air. While the composition is reminiscent of Courbet, the figures of Manet, and the woodland settings of Corot, the synthesis is a personal statement.

Gonzalès gave birth to her first child, a son, in 1883, and died of an embolism five days later while making a funeral wreath for Manet, who had died the day before. Mme. Auguste Manet, Édouard's mother, paid her respects to the family and vividly described the scene:

Poor Eva was covered with flowers. She had them in her hair, in her hands, and on her poor face, which had become the colour of wax, and was still beautiful despite this change.[54]

It is difficult to speculate as to what Eva Gonzalès would have accomplished artistically if she had lived a longer life. Her oeuvre clearly shows her debt to Manet, yet when examining her work, one is struck by the authority of her drawing, composition, and brushwork. By contrast, when Mary Cassatt was thirty-four (the age at which Gonzalès died), she had just met Degas and had not yet joined the Impressionists or come into her own as a painter.

SUZANNE VALADON (1865–1938)

The myth of Suzanne Valadon has often overshadowed her art. Indeed, in her case it is difficult to separate her life from her art, to examine her oeuvre without understanding the soil in which it was rooted. The raw energy of her drawings grew out of the vitality of her childhood as a street urchin in Montmartre and as a habitué of its cafés and bars when she was barely into her teens. While the reputation of her son, Maurice Utrillo, overshadowed her own during her lifetime, it is now difficult to attribute any originality to his repetitive street scenes of Montmartre.

Valadon was not a literate person. She kept no

FIG. 6-8. Eva Gonzales, *Reading in the Forest* (1879). 41¾″ × 54″. Brandeis University Art Collection, Rose Art Museum, Waltham. Gift of Mr. and Mrs. Abraham M. Sonnabend, Brookline, Massachusetts.

diary, nor did she write letters. To communicate as a child, she drew. Her memories of her early years cannot be corroborated and there are many inconsistencies in her narrative. Nevertheless, though the details of her life may never be verified, its spirit remains. She never intellectualized nor theorized about art, and when speaking of her own work once said: "I don't understand the experts, neither their explanations nor their comparisons. When they speak of technique, balance and values they simply make me dizzy. Only two things exist for me and all others who paint: good pictures and bad pictures, that's all."[55] Never having taken an art lesson, she did not recognize the need for formal training. While modeling, she was able to gain intimate knowledge of the techniques of some of the most celebrated artists of her time, but claimed not to have been influenced by any of them in her own work. What she did learn, she claimed, was "the art of dedication." To her, painting was an extension of life itself: "I paint with the stubbornness I need for living, and

I've found that all painters who love their art do the same."[56] Essentially, her education came from the streets of Montmartre, where she was taken by her mother Madeleine as a very young child.

Madeleine's accounts of her own early years were equally unreliable, but it is known that she had a miserable marriage to a man named Courlaud by whom she had several children. After his death she left the children with her family and became a prized seamstress in the Guimbaud household in Limousin. Much to everyone's surprise, the reclusive and devoted Madeleine was "seduced in a very cold part of January," by a miller. When Marie-Clémentine (renamed Suzanne by Toulouse-Lautrec nineteen years later) was born, the disgraced Madeleine fled to Montmartre in Paris. It was a world of artists, musicians, writers, philosophers, and politicians that the young Suzanne met there. Completely demoralized by the Franco-Prussian War, Madeleine took to drink, working only sporadically at her various cleaning jobs; Suzanne was enrolled at the

Convent of St. Vincent de Paul, but her truancy was legend, and before she was ten she was apprenticed to an *atelier de couture*, where she stayed for four years. A succession of odd jobs followed: waitress, dishwasher, groom, pushcart vendor, and—at sixteen—a trapeze artist. After a fall, Suzanne turned to modeling; her lovely face and voluptuous body made her an instant attraction, while her capacity for work and her sense of mission—she viewed her role as integral to the creative process—made her a very desired model. She later recalled: ". . . I knew I was somewhere at last and that I should never leave."[57]

Hearing of Valadon's charm as a model, Puvis de Chavannes summoned her to his studio to pose in 1882. For six months she worked diligently for him (she appears as both the male and female figures in *The Woods Sacred to the Arts and to the Muses*). Puvis introduced her to the world of luxury; she became the fifty-seven-year-old artist's mistress. The following year she posed for Renoir's *Le Bal à Bougival*—either at Bougival, according to Valadon, or in his Montmartre studio, as Renoir suggested. She accompanied him to Guernsey, posing for several of the nude figures in *The Bathers*.

Shortly after her separation from Puvis, Valadon met Miguel Utrillo, a wealthy young Catalan engineering student and amateur artist; they became inseparable and when Maurice was born, it was assumed Utrillo was the father. Despite his signing an act of recognition seven years later in which he claimed paternity, and despite the young boy's growing resemblance to the Catalan, Valadon continued to insist that the father was a drunken accountant who had seduced her and died shortly thereafter. Since Maurice had become an alcoholic while still in his teens, Valadon could thereby blame her son's dissipated existence on his "father's" genes rather than her own neglect.

While working as an artist's model Valadon began drawing again with renewed enthusiasm (she had abandoned this "childish" activity during her adolescence); she wanted "to work like mad, not to produce beautiful drawings to be framed and hung, but good drawings which capture a moment of life-in-movement in all its intensity."[58] Once, in 1884, when Renoir paid her a surprise visit, he found her at work and purportedly exclaimed: "Ah, you too, and you hide this talent." He offered her no further assistance, however, but she continued to draw nevertheless; it was her secret life, her private world divorced from the raucous bohemian life she lived outside her studio.

The first artist to express interest in her work—and

her first customer—was Toulouse-Lautrec. After renting a studio on the floor above hers, he quickly became part of the Montmartre scene; his parties were legendary and Valadon frequently acted as his hostess. He counseled her on her dress, her table, her health, and her son's education. Between 1887 and 1890, she posed for him many times. From this period dates the gentle, tender portrait that Lautrec did of Valadon; it demonstrated an affection for a woman he was rarely to exhibit again.[59]

As an admirer of Degas, Lautrec had often heard the older artist claim that great draftsmanship can only evolve from a laborious study of the old masters. Seeking to refute that opinion, Lautrec offered to introduce Degas to a "natural artist"—Suzanne Valadon. To her, the meeting was "the wonderful moment of my life." Degas perused her work and proclaimed: "Yes. It is true. You are indeed one of

FIG. 6-9. Suzanne Valadon, *Seated Nude* (1893). Drawing. Metropolitan Museum of Art, New York. Robert Lehman Collection, 1975.

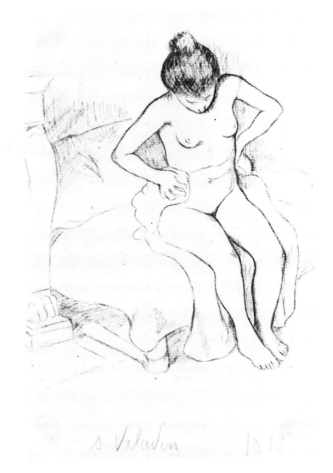

us."[60] He coached her and encouraged her, but fundamentally she followed no teacher. Some of Degas' surviving letters indicate his respect and affection for his "terrible Maria": "I send you my best and beg of you again, if you are well, not to abandon drawing. You have a genius for it . . ."[61] What he admired most in her work was its boldness and economy of line, its certainty and savagery, its honesty and lack of pretense. Valadon's models were working-class women—short, plump, and earthy. They are shown preoccupied with the task at hand—bathing or dressing—and do not attempt to communicate with the viewer (Fig. 6-9). They can perhaps be compared to Degas' late series of nudes at their ablutions, often referred to as his "keyhole" drawings. Degas also directed her while she produced her first etchings, which he described as "supple and hard." In 1895, after the dealer Vollard exhibited, at Degas' suggestion, a series of twelve etchings showing women in various phases of their toilette, several other galleries began bidding for her work. Vollard himself ordered 100 editions of *Two Girls Drying Themselves*. That same year, Valadon showed a group of nude drawings of Maurice at the Impressionist and Symbolist exhibition. All the drawings were sold. The critic Francis Jourdain wrote: "Suzanne Valadon's line was crude and firm, executed with undaunted courage which gave her studies unexpected character and revealed a mania for truth." He also added: "Very gifted, isn't she? One would hardly think they are drawn by a woman."[62]

Valadon first saw the work of Gauguin at the Exposition Universelle of 1889, and at once recognized a kindred spirit. A devotee of the primitive and the savage in art, the sophisticated Parisian Gauguin had, ironically, left Paris in search of what was natural to Valadon. She later spoke of how she was "impressed by the techniques of Pont-Aven," the group of artists centered around Gauguin, and of how she had decided "to pursue them, but without the vestiges of aestheticism or artiness."[63] Indeed, if there is any artist with whom her work can be identified, it is Gauguin.

In 1894, after a brief *ménage à trois* with the avant-garde composer Erik Satie and Paul Mousis, a well-to-do-banker, Valadon was convinced by the latter that her erratic life in Montmartre was detrimental to her art and both her own and her son's health. She was soon ensconced in an elaborate mansion in the Parisian suburbs, where she reigned as Mousis' wife for fourteen years (they were never legally married), until she met and fell in love with the handsome young painter André Utter, a friend of Maurice, and

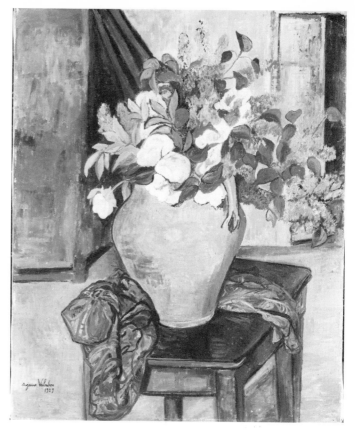

FIG. 6-10. Suzanne Valadon, *Lilacs and Peonies* (1929). 39⅝" × 32". Metropolitan Museum of Art, New York. Bequest of Miss Adelaide Milton de Groot (1876-1967), 9967.

the leader of the new generation of artists and intellectuals. She left her life of stagnating security to live with this man, twenty-one years her junior. (They married several years later before he left for active duty during World War I.) Utter taught her to paint and began to promote the work of both mother and son.

In 1915 Berthe Weill gave Valadon her first one-woman show. There were many viewers but few buyers during those war years. Nevertheless, reviews were favorable: "At the point of her brush, everything comes to life, lives and breathes," wrote the critic Clarensol. "This extraordinary woman is passion itself, and one seeks in vain for anyone to compare her with. . . . She paints solidly."[64] In 1917 a joint exhibition was held at the Bernheim Jeune Gallery of work by the "wicked trinity," as Valadon, Utter, and Utrillo were known. Viewers came to glare at the scandalous trio, and few paintings were sold. One of the buyers was Paul Poiret, the fashion designer, who purchased a Valadon nude and a

landscape by her son. When in 1923 he showed their paintings at his salon, it became chic to own their work. Dealers began vying for their paintings, and the Bernheim Jeune Gallery put them on an annual stipend of $60,000 in exchange for their yearly output. The bills were all paid; money for food, rent, and paints was no longer a problem, but Valadon had the bohemian's disdain for money and spent it impulsively, often bestowing unexpected bounty on the street artists and urchins of the Butte. When she was elected an associate of the Société des Artistes Indépendents, the party she threw to celebrate the event ended three days later.

By the 1920s, Maurice's paintings commanded higher prices than her own, but Valadon was proud of him—she had been his teacher. She still painted prodigiously—smaller, more compact still-life and floral compositions (Fig. 6-10) and sensuous nudes. The colors were raw and vibrant, the old certainty in drawing continued. Indeed, some of her best paintings were done in the twenties. In *The Blue Room* (1923), the reclining figure has the toughness of a Lautrec and the voluptuousness of a Renoir, while the boldness of pattern and the color is reminiscent of Matisse. In *Reclining Nude* (1928; Plate 2), now in the Lehman Wing of the Metropolitan Museum of Art, the artist has again combined bold color and patterning with strong linear movement. The contours of the nude woman's body fit snugly into those of the love seat in which she rests with abandon.

In 1929, Valadon was invited to participate in an "Exhibition of Contemporary Art—Women and Flowers" as well as in "Painters, Self-Portraits."

Three years later she had another solo exhibition of paintings, prints, and drawings. Of this exhibit, Édouard Herriot, a friend and twice Premier of France, wrote:

To us who admire and love her art, Suzanne Valadon is springtime—a creature in whose sharp, incisive forms we find the fountains of life, the spontaneity of renewed day-to-day living. And before this very great and dedicated artist, the heir of those masters of the 19th century whose names we now revere, I marvel that so scrupulous a respect for the truth of form is able to achieve such a fete of color and movement.[65]

She also exhibited with the Salon des Femmes Artistes Modernes from 1933 until 1938.

In her last years, the aged street urchin-turned-artist wandered through Montmartre, regaling all those who would listen with tales of the Butte's former glories. Her work became more somber and more intimate, her subject matter the cats and flowers with which she surrounded herself. Many of these were shown at the "Exhibition of Women Painters" at the Petit Palais in 1937, a show that also included works by Vigée-Lebrun, Morisot, Gonzalès, Marie Laurencin, and Sonia Delaunay. Honored, but again impoverished, Valadon died in 1938 of a stroke while at her easel painting a bowl of flowers. Her funeral was in the best Montmartre tradition: Picasso, Rouault, Derain—the entire Parisian art community was there. Thus, even at the end, she was among great artists. As she was wont to say: "When you judge me, don't forget that I lived among giants."[66]

NOTES

1. Marie Collins and Sylvia Weil Sayre, eds., *Les Femmes en France* (New York: Charles Scribner's Sons, 1974), 153–54, 175–76.

2. Beatrice Braude, "Severine: An Ambivalent Feminist," *Feminist Art Journal* (Fall 1973), 14–15.

3. Collins and Sayre, *Les Femmes en France*, 160–65.

4. In actuality, most of the women's journals in France stressed the traditional female role and supported Catholic moral values.

5. Collins and Sayre, *Les Femmes en France*, 181.

6. *Ibid.*, 205–13.

7. *Ibid.*, 217.

8. François Mathey, *The Impressionists* (New York: Frederick A. Praeger, 1961), 2.

9. Mathey, *The Impressionists*, 55, 107; John Canaday, *Mainstreams of Modern Art*, 155, 157.

10. Quoted in Frederick A. Sweet, *Miss Mary Cassatt: Impressionist from Pennsylvania* (Norman, Okla.: University of Oklahoma Press, 1966), 41.

11. Quoted in Denis Rouart, ed., *Correspondence of Berthe Morisot* (London: Lund Humphries, 1957), 38.

12. *Ibid.*, 43, 44. Interestingly enough, Mme. Morisot had designs on Gonzalès for her son Tiburce. He was planning to marry someone else when she wrote Berthe (1872) that "he would do much better to marry Mlle. Gonzalès—there is a woman who is ravishing in every respect, and so intelligent and such good manners!" *Ibid.*, 73.

13. Quoted in Phillips Huisman, *Morisot: Enchantment* (New York: French and European Publications, Inc., 1963), 62–63.

14. Quoted in Armand Fourreau, *Berthe Morisot* (London: John Lane the Bodley Head Ltd., 1925), 12–13.

15. In *Lives of the Painters*, 919, Canaday suggests that the Morisot's family connections may have been responsible for the sisters' quick acceptance into the Salon.

16. Quoted in Rouart, *Correspondence of Morisot*, 28.

17. *Ibid.*, 38–39, 78.

18. John Rewald, *History of Impressionism* (New York: Museum of Modern Art, 1946), 164.

19. Quoted in Rouart, *Correspondence of Morisot*, 11.

20. *Ibid.*, 51.

21. Quoted in Fourreau, *Berthe Morisot*, 168.

22. Quoted in Rouart, *Correspondence of Morisot*, 80.

23. *Ibid.*, 98.

24. Quoted in Gerd Muehsam, ed., *French Painters and Paintings from the Fourteenth Century to Post-Impressionism* (New York: Frederick Ungar Publishing Co., 1970), 523.

25. Quoted in Rouart, *Correspondence of Morisot*, 170-71.

26. Théodore Duret, *Manet and the French Impressionists* (Freeport, N.Y.: Books for Libraries Press, 1971), 187. Duret's book was originally published in 1910.

27. Quoted in Rouart, *Correspondence of Morisot*, 65-66, 72.

28. After the baby's birth she wrote her sister Yves: "Well, I am just like everybody else! I regret that Bibi is not a boy . . . she would perpetuate a famous name, and mostly for the simple reason that each and every one of us, men and women, are in love with the male sex." *Ibid.*, 101.

29. Renoir did not bring his wife to meet Morisot until 1891. Morisot was not impressed and wrote Mallarmé: "I shall never succeed in describing to you my astonishment at the sight of this ungainly woman whom, I don't know why, I had imagined to be like her husband's paintings." *Ibid.*, 165. In fact, none of the Impressionist men married women with heightened aesthetic sensibilities.

30. *Ibid.*, 29.

31. *Ibid.*, 158.

32. Quoted in Sweet, *Miss Mary Cassatt*, 146.

33. Some of the people whose collections she helped develop were Louisine Havemeyer, Carroll Tyson, Mrs. Potter Palmer, and James Stillman.

34. Quoted in Nancy Hale, *Mary Cassatt* (Garden City, N.Y.: Doubleday & Co., Inc., 1975), 156.

35. Quoted in Sweet, *Miss Mary Cassatt*, 31.

36. Quoted in Ellen Wilson, *An American Painter in Paris: A Life of Mary Cassatt* (New York: Farrar, Straus & Giroux, 1971), 72.

37. From a letter to Mrs. Havemeyer, quoted in John Bullard, *Mary Cassatt: Oils and Pastels* (Washington, D.C.: National Gallery of Art, 1972), 14.

38. Quoted in Wilson, *An American Painter in Paris*, 169.

39. Quoted in Sweet, *Miss Mary Cassatt*, 132.

40. *Ibid.*, 182.

41. Quoted in Bullard, *Mary Cassatt*, 20.

42. Quoted in Sweet, *Miss Mary Cassatt*, 36.

43. Bullard, *Mary Cassatt*, 10.

44. Quoted in Sweet, *Miss Mary Cassatt*, 51.

45. *Ibid.*, 45, 60-61.

46. Quoted in Hale, *Mary Cassat*, 155.

47. Quoted in Wilson, *An American Painter in Paris*, 140.

48. Quoted in Sweet, *Miss Mary Cassatt*, 150. The dog was actually one of her prize toy griffons.

49. Hale, *Mary Cassatt*, 257-59.

50. *Ibid.*, 150.

51. P. Bayles, "Eva Gonzalès," in *Renaissance*, Vol. 5 (June 1932), iii. This is one of the few articles about Gonzalès.

52. *Ibid.*, 113.

53. *Ibid.*, 114.

54. Quoted in Rouart, *Correspondence of Morisot*, 117.

55. Quoted in Peter de Polnay, *Enfant Terrible: The Life and Work of Maurice Utrillo* (New York: William Morrow & Co., Inc., 1969), 190.

56. *Ibid.*, 55.

57. John Storm, *The Valadon Drama: The Life of Suzanne Valadon* (New York: E. P. Dutton & Co., Inc., 1959), 19-51.

58. *Ibid.*, 54.

59. *Ibid.*, 70-79.

60. *Ibid.*, 87-89.

61. Quoted in Robert Coughlan, *The Wine of Genius* (New York: Harper Bros., 1957), 29.

62. Storm, *Valadon Drama*, 114; de Polnay, *Enfant Terrible*, 57.

63. Storm, *Valadon Drama*, 111-14.

64. *Ibid.*, 192.

65. Quoted in *Ibid.*, 234.

66. De Polnay, *Enfant Terrible*, 198.

20TH Century: An Overview

MULTITUDE OF MOVEMENTS

The only constant in the art of the 20th century has been change. Groups formed, published manifestoes and journals, and were themselves soon replaced by yet other "avant-garde" groups claiming to reject the past, yet still chained to history. The center of the art world at the beginning of the 20th century was Paris (Fauvism, Cubism), but revolutionary ideas were also fomenting in Italy (Futurism), Germany (Expressionism), and Russia (Rayonism, Constructivism, Suprematism), and America (Ash Can School). Artists traveled from one center to another, exchanging new ideas and carrying with them the sense of vitality engendered by such visits. Thus, art prior to World War I was international rather than provincial. To be sure, unique national sensibilities were evident; essentially, however, the various movements of the pre-World War I avant-garde were all seeking to come to terms with the formal elements of art in an increasingly industrialized and dehumanized society in which the need for art was being questioned. This was a time of experimentation, challenge, and optimism. The questions explored by the revolutionary artists in the first decade of the century are those still being explored in the late 1970s.

With the advent of World War I, the artists dispersed and former colleagues found themselves fighting in opposing armies; those with no stomach for politics sought refuge in neutral countries. The spirit of optimism and comradeship was dissipated during those years of bloodshed, and a sense of nihilistic individualism became the dominant theme of the post-war period in all countries save Russia, where for a brief and glorious moment the artist became an integral part of the new and revolutionary society.

Few women were associated with the early 20th-century movements. While Apollinaire labeled

Marie Laurencin a "scientific Cubist," she was more muse than colleague to the group that surrounded Braque and Picasso. Working in collaboration, Sonia Terk-Delaunay and her husband Robert developed the theory of Simultaneity, a system that incorporated the structural elements of Cubism with the expressive color of the Fauves. The latter group had no female members. Similarly, there were no women associated with Die Brücke (The Bridge), a German Expressionist group, and those who exhibited with Der Blaue Reiter (The Blue Rider)— Gabriele Münter, Marianne von Werefkin, Elisabeth Epstein, Erma Barrera-Bossi (1885–1960), and Maria Franck-Marc—were there in connection with men. Nevertheless, two women working in isolation are considered the precursors of German Expressionism: Paula Modersohn-Becker and Käthe Kollwitz. Modersohn-Becker was aware of the works of Cézanne, Gauguin, and Van Gogh while a student in Paris and incorporated their expressive means in her work at the turn of the century. The Dresden (Bridge) and Munich (Blue Rider) groups were unaware of her existence before her death in 1907, as she was of theirs. Kollwitz, although she has frequently been pigeonholed by art historians within the German Expressionist category, dismissed their work as "pure studio art" and completely irrelevant to the needs of the people to whom she devoted her life. She did, however, share in their graphic tradition, their continued use of human form, and their rejection of establishment values.

Many of the artists in Russia's pre-World War I avant-garde were women. They organized exhibitions, issued manifestoes, influenced lifestyles, and, with the coming of the Revolution, took an active part in bringing art to the service of the new regime. Because of the vastness of the country, there were

many art centers; the proliferation of art societies and exhibitions in Russia was astounding, and women played significant roles in them all.

Stemming from a new-found pride in the traditional art of its rural areas, a neo-primitive movement took hold in Russia between 1909 and 1912 with Natalya Goncharova as one of the leaders. In fact, this interest in naive art led to the advocacy of a Russian national art separate from Western values, and by 1910 there was an extreme reaction against European domination of Russian art. Goncharova denounced the "Munich decadence" and the "cheap Orientalism" of the School of Paris. The Italian Futurists, however, had a profound effect in Russia (Marinetti's manifesto was published in Russian in 1913), especially on Goncharova. Rayonism became the Russian counterpart of the Italian movement: "Rayonism is concerned with spatial forms that can arise from the intersection of the reflected rays of different objects, forms chosen by the artist's will."[1] Opposed to the Western idea of individual expression, the Rayonists believed that anyone who studied the laws of refracted color could produce a painting. Like their Italian colleagues, the Russian Futurists were concerned with the reality of urbanization and mechanization and the forces of speed and dynamism. To the Russians the machine was seen as a new liberating element that man would eventually control.

In the years prior to World War I, most American artists were by contrast still entrenched in a 19th-century aesthetic. The renegades who organized "The Eight" (Henri, Sloan, Luks, etc.) were radical only in their choice of subject matter—the poor, the urban enviroment. A few artists who had studied abroad, among them Marguerite Thompson Zorach, were aware of the turmoil that was occurring in European art circles, and, in fact, the photographer Alfred Stieglitz had sponsored small exhibits of works by the European and American avant-garde at his 291 Gallery in New York City. Still, the American public was largely unaware of the new aesthetic until the Armory Show in 1913. Sponsored by the Association of American Painters and Sculptors, it opened in New York and traveled later to Chicago and Boston. Attendance was beyond all expectations. The international section created an uproar, yet despite the scorn of the critics and the general public, the innovations presented challenged the complacency of the most American artists and changed the direction of their work.

Approximately 41 of the 300 exhibitors at the Armory Show were women. Among them were the painters Marie Laurencin, Mary Cassatt, Gwen John, and Marguerite Zorach; and the sculptors Enid Yandell, who had modeled the caryatids that supported the roof garden of the Women's Building at Chicago's World Columbian Exposition, Bessie Potter Vonnah (1872–1955), whose *The Young Mother* (1896) was exhibited in 1976 at the Whitney Museum of American Art's Bicentennial sculpture exhibit, and Ethel Meyers (b. 1881), who did genre pieces. It was in the studio that she shared with her husband, Jerome Meyers, that the men who organized the exhibit gathered to discuss their ideas.

During and immediately after World War I, in neutral Zurich, there came together a band of exiled artists recoiling from and reacting to what they felt to be the madness of society and the arbitrariness of human experience. At once anarchic, negative, and destructive, they created an art of the absurd throughout which, however, ran a seriousness of purpose: the reexamination of the traditional functions of art and of the basic foundations of society. Known initially as the Dada movement and later as Surrealism, it produced many styles, all of which were more or less concerned with the illustration of dreams as interpreted by Freudian psychology. The Surrealists had a dual and conflicting view of woman. She was either the "woman-child," the incarnation of innocence, purity, and naïveté, more intuitive and spontaneous than the mature and intellectually developed man, and therefore closer to her unconscious (which was prized), or she was a sorceress, seer, or divine. It was within these ideological confines that the women artists of Surrealism sought to define their roles. Among them were Sophie Taeuber-Arp, Meret Oppenheim, Leonora Carrington, Dorothea Tanning, and Kay Sage; all were closely associated with the men of Dada and Surrealism.[2]

During the 1920s and 1930s, many American artists, having become disenchanted with European art styles, went back to their roots to create an art that glorified the best of an American past that was slowly disappearing. This movement, known as Regionalism, along with the politically motivated "social protest" art, dominated the American art scene during the Depression years. Artists were included in the various New Deal programs implemented to find work for the unemployed; the programs reflected the fiercely egalitarian spirit of the Roosevelt years, and among the artists receiving aid, 41% were women. They included Louise Nevelson, Alice Neel, Lee Krasner, and Isabel Bishop.

Among the other women artists of professional status who were supported by the WPA/FAP were

Marion Greenwood (1909–1970), Gwendolyn Bennet (b.1907), Elizabeth Olds (b. 1919), Loren MacIver (b. 1909), Irene Rice Pereira (1901–1971), Minna Citron (b. 1896), Doris Lee (b. 1901), and Concetta Scaravaglione (1900–1975). Greenwood was a muralist who had previously worked with Orozco and Rivera in Mexico. During World War II she was the only woman appointed as an official artist-correspondent. Bennet, from Texas, headed the Harlem Community Art Center from 1937 to 1940, and Olds, the first woman to be awarded a Guggenheim Fellowship (1926–27), worked in the graphics division developing serigraphy as a fine art. Concerned with social issues, she sought to create fine prints for mass production. From 1936 to 1940, MacIver worked in the easel division, which Pereira also joined. Pereira experimented in an abstract style with various materials, including parchment, plastic, and glass. In her several books and articles she tried to verbalize the mathematical and philosophical principles she used in her paintings. MacIver went on to create lyrical abstractions based on her poetic visions of the mundane world. Citron first taught painting and then worked as a muralist, as did Doris Lee, who was active in the Artists Congress. Scaravaglione's massive sculptures can still be seen in various Federal buildings around the country.[3]

The upheaval created by World War II caused many leading European artists to emigrate to the United States, thereby enabling young American artists to study with and observe the great modern masters at work. Most influential of all the teachers was Hans Hofmann, who taught Nevelson, Krasner, and Marisol. With both Paris and Rome torn by war, New York became the center of the art world. From this confluence of innovative Europeans (mostly Surrealists) and the younger, well-trained American painters already sophisticated in the history of modern art emerged a new school of painting—Abstract Expressionism. The Abstract Expressionists were part of the existential movement that swept Europe after the holocaust of war; the disaffection with public institutions and public solutions to world problems caused a general turning inward to personal expression in art and other media. Among the founders of Abstract Expressionism were Willem de Kooning and Jackson Pollock, assisted by their painter-wives, Elaine Fried de Kooning and Lee Krasner. Women artists have responded ever since to the ferment and challenge of American art, participating in all the important movements of the later 20th century.

THE STATUS OF WOMEN ARTISTS

From all over Europe and America, the "ladies" flocked to Paris to study art in the beginning of the 20th century. They came from Russia, Germany, Italy, and the United States to absorb the excitement of the Parisian art scene. Some women merely continued in the academic tradition within which they were trained; others, more adventurous, shed both their academic background and their Victorian upbringing to become part of the radical art movements and bohemian lifestyle in Paris, or in their native cities to which they eventually returned. Art magazines of the period offered abundant advice to these women. In 1904, Clive Holland wrote sympathetically of the English female art student's desire to study abroad: "English schools of painting (with few exceptions) do not appear to encourage individuality, and more particularly the individuality of women . . ." Although life for the woman art student was not as free or strenuous as that of her male counterpart, Holland reassured her that it was "sufficiently Bohemian for the most enterprising feminine searcher after novelty." He advised on housing, amusements ("when an escort is available"), housekeeping, entertaining friends ("if she be emancipated these will be of both sexes"), where and how to obtain models (at the model market on the Place Pigalle), and what schools to attend, including details of curriculum and fees of the various academies open to women. Most attended the Academie Julien or the Academie Colarossi (formerly Suisse), where women had the choice of working alongside their male colleagues, drawing from the clothed or nude model "in a common spirit of studenthood." At the monthly exhibitions, the work of the men and women was shown together and they competed on an equal basis for medals and diplomas.[4]

Even after the prerequisite study in Paris, the woman artist was not reviewed very favorably. After a 1931 exhibition at the Women's International Art Club in London, where the National Association of Women Artists of New York contributed a section, the critic of the London *Observer*, H. Wilenski, attacked women's art in general as having a "kind of tentative stickiness, an indecision, a species of faltering in the attack. When this is found in women's pictures it is generally evidence of immaturity, and 90 per cent of women exhibitors are always immature; when it is found in the pictures by men," he continued, "it is usually the result not of immaturity, but of senility or fatigue." Wilenski particularly

attacked the American women, whom he accused of "resting content with a form of dreary studio painting that became obsolete in Europe fifty years ago."[5]

Founded by five women artists in 1889 to counteract the discrimination in American art schools and galleries, the National Association of Women Artists currently has a membership of 700 professional artists in 39 states. Wilenski's appraisal of the Association's conservatism at the Loudon exhibition may have had some validity, and in 1925 an alternative women's group, the New York Society of Women Artists, was formed. With Marguerite Zorach as president, the group held its initial exhibit in 1926. It was hailed as "an outstanding art event"; the work was said to have "freshness and vitality" and an "astonishing versatility." They became known as the "women radicals," and after the second exhibit they were labeled "the left wing of the feminine artistic movement." After their 1929 exhibit a New York *Post* critic noted that "the particular significance of this exhibition lies in the fact that it indicates the trend of thought of the more modern element among women." Before moving their annual exhibitions to the art galleries in the Squibb Building in 1932, the Society showed with the Swedish Society of Women Artists at the Brooklyn Museum.[6] For that occasion, and for the first time in the United States, the history of women in art was lent the prestige of institutional interest: the museum sponsored a radio talk on women artists which was edited into an article for the *Brooklyn Museum Quarterly* (January 1932). The questions of sex discrimination and the necessity for separate exhibitions were raised but not explored.

After the large and "very exciting" 1936 exhibit of the San Francisco Society of Women Artists at the San Francisco Museum of Art, the critic of the San Francisco *News*, Emilia Hodel, found it timely to introduce her readers to women artists of the past. After quoting the industrialist Charles Francis Adams as stating that he had "never heard a single [king of industry] say anything worthwhile," Hodel concluded that those positions admired by the masses require little intelligence. "That is why women never try to be 'queens of industry.' Women are too clever." She also added that "Women are personal and subjective. They are not detached, abstract creatures. That is why they are such strong competitors in any creative work, where individuality counts."[7]

While American men were trained most often for business and the professions, women of the middle and upper classes continued to be educated in the arts. Indeed, since art was of so little importance in early 20th-century industrialized society, it entered the women's sphere. (When art became big business, to be sure, men took over.) Woman, the eternal civilizer, supported projects such as the Central Art Association, which, before the turn of the century, brought art to the rural masses in America. As supporters of the arts and crafts movement, women artists worked with feminist reformers and introduced the pride of craftsmanship to the children of the poor in urban settlement houses. The wives and daughters of the wealthy became patrons of the arts and amassed the great collections that now fill America's museums. Women founded the Yaddo and MacDowell artists' colonies, and when professionals were needed to manage the New Deal art projects, women's expertise was tapped. Audrey McMahon, a director of the College Art Association and managing editor of the *Art Bulletin*, and Juliana Force of the Whitney Museum of American Art led the list of professional women administrators.[8]

Before the Depression, the opportunities for American women to succeed in art-related fields were relatively good, and judged by the literature of the period, artistic work was considered respectable. Seventy per cent of the art students in the Boston area were women, and the jobs available to them were varied: museum work, portrait painting, industrial design, advertising, illustrating for publishing houses, and interior design. A report in the *Christian Science Monitor* concluded optimistically: "Women are welcomed in the field of art, and there they have an opportunity to show their talents."[9]

In 1927, Helen Ferris and Virginia Moore surveyed the condition of women in the arts for their book *Girls Who Did*. (The chapter on "The Fine Arts" was written by Mary Fenton Roberts.) They found that while women were welcomed in the lower ranks of the art profession, they represented only 15% of the solo exhibitions at the New York galleries and were the recipients of only 20% of the awards and commissions granted to professional artists. The situation improved during the thirties and forties when women comprised between 25 and 30% of the exhibitors in the large artist-juried group shows.

Women's exhibitions continued, of course, and in 1947 Ralph Pearson, in his *Art Digest* column "A Modern Viewpoint," questioned their validity. The tone of his article reveals the continuing paternalism with which the woman artist was treated, even by a man writing from a supposedly "modern" point of view. His comments were occasioned by two simultaneous exhibitions, one of Canadian women artists and the other of the National Association of Women

Artists. He began: "Our women who paint and sculpt, God bless them (as women), have called attention to their sex . . ." Pearson found both exhibitions wanting; he searched for an "essentially feminine expression" in their work but could find none and could not understand why. Thus, as late as 1947 American art magazines were propagating the idea of a peculiar "feminine sensibility" that derived from the nature of women. In Pearson's words:

Women are sensitive souls highly keyed to the valleys and mountaintops of life and alert to the varied stimuli around them, they should give themselves easily and completely to the language of spirit and be willing to develop power over aesthetic means.[10]

In 1943, the Richard Feigen Gallery in New York had its opening exhibit "Famous Women Artists" from the past 300 years. Included were Rosa Bonheur, Mary Cassatt, Marie Laurencin (her three "pale pink, blue and white canvases of sloe-eyed boys and girls" were described as the "only feminine note" in the show), and Paula Modersohn-Becker, whose work was little known in this country at the time—a fact that the reviewer noted and lamented.[11]

The Sidney Janis Gallery held a particularly provocative exhibition in 1949 entitled "Artists: Man and Wife." Exhibiting were Robert and Sonia Terk-Delaunay, Dorothea Tanning and Max Ernst, Elaine (Fried) and Willem de Kooning, Jean and Sophie Taeuber-Arp, Lee Krasner and Jackson Pollock, Helen Phillips and William Stanley Hayter, and Françoise Gilot and Pablo Picasso (the latter couple without benefit of license). With the exception of the Delaunays, each spouse worked in a different style; Picasso, but none of the women, showed a preoccupation with domestic themes; and the most "lyrical" work was that of a man, Hayter. Typical of the woman critic who patronizes other women, Marynell Sharp concluded: "Surprisingly enough the current exhibition quenches the ancient argument that a woman is more at home in front of a stove than an easel."[12]

America's political and social upheavals of the 1960s gave impetus to the feminist art movement. There was first the black revolution, then the student revolution, and when—as in the French Revolution—women found that the men with whom they shared revolutionary rhetoric were concerned only with their own liberation, the women's revolution began. Beginning as an arm of the politically active Art Workers' Coalition, Women Artists in Revolution (WAR) sought funds for a center from which to direct their activities. With a grant from the New York State Council on the Arts (received after much picketing), they opened the Women's Interart Center, which, as the name implies, incorporates women's films, dance, and theatre activities, as well as art exhibitions and workshops, under one roof. A women's Ad Hoc Committee was formed in 1970 to protest the low representation of women in the Whitney Museum's Annuals: only 5% of the works were by women in the 1969 painting Annual. Although there are more women painters than sculptors, 20% of the works in the sculptural annual the following year were by women, and in 1973, 23%. In addition, due to the efforts of its women curators, an increasing number of one-woman shows have been held at the Whitney. The protests of women artists spread to other museums in New York, and did not go unnoticed in other areas of the country and Europe.[13]

Suddenly, in the 1970s, the "invisible" woman had become visible. Popular magazines wrote about the "new" woman and women artists. Art journals devoted entire issues to the historical and contemporary condi-

FIG. 7-1. Hannah Wilke, *Untitled* (1974). Terra cotta and pink liquitex. ½" × 4¾" × 3¾". Ronald Feldman Fine Arts Inc., New York.

tion of the woman artist. *Art News* led the way in its January, 1971, issue on "Women's Liberation, Women Artists, and Art History," edited by Thomas B. Hess and Elizabeth C. Baker. Linda Nochlin's controversial essay, "Why Have There Been No Great Women Artists?", appeared in that issue, and the ideas she presented are still the subject of debate. Not content with the single issue of an art journal devoted to their work or with the occasional reference to women artists of the past, some women have created their own journals. Among the best is the *Feminist Art Journal*, edited by Cindy and Chuck Nemser, which in its search for a meaningful art historical past and a significant present, has published essays on women artists from the cloistered collectives of medieval times to the feminist collectives of the 1970s.

In 1972, women composed 75% of the art school population in the United States. Little had changed in the last five centuries: women are still encouraged to study art in order to have a meaningful way to spend their time before and after the "important" work of their lives is done. Those who do not see the pursuit of art as a mere "accomplishment" are hampered at every turn when they decide to become professionals. A national survey of commercial galleries in 1972 showed that only 18% exhibited the work of women; among museums that collect contemporary work, only 6 to 10% of their purchases were from women artists. Tired of being token representatives in male-dominated institutions, many women began seeking alternative exhibition spaces and cooperative galleries in New York (Women's Interart Center, Inc., Soho 20), Chicago (Artemisia, Inc.), Providence (Hera), Montreal (Powerhouse Gallery), London and Paris. To communicate with women artists all over the world the West East Bag (WEB) was formed, with contacts in most major art centers.

In answer to the criticism that sexual segregation in art is arbitrary, since art has no sex or color, the feminist art critic Lucy Lippard claims that sex is no more arbitrary than age, subject matter, or place of national origin categorizations for choosing works of art to be exhibited. Ultimately, of course, it is the individual work of art one responds to, not the sex of its creator. Some feminists hope that the separatist women's art movement is temporary, and that eventually all art will be judged by aesthetic rather than political standards. Others, having established their own institutions, are content to create their own audience and to perpetuate their own institutions outside the male-dominated art distribution system.

Many women artists are also seeking a feminist

FIG. 7-2. Faith Ringgold, *Ms. Jones, Andrew, Barbara, and Faye* (1973). From Family of Women Series. Mixed media. Collection of the artist, New York.

symbolism and iconography within this separatist system. Others see as their mission the elevation of traditional women's crafts—needlework, quilting, weaving, appliqué, pottery—to the status of "fine" arts. Yet another group is creating a body of erotic art designed to stimulate and reflect female sexual fantasies. Hannah Wilke is involved with "vaginal iconology" (Fig. 7-1); her work reflects her feelings about her own body. In the early 1960s she was afraid to show her work, but now poses with it. Her "vulva icons" are made from lint, poured latex, and clay. The folds in her small latex hangings are held together with metal snappers. In this way she combines toughness and softness, which may be read, according to the artist, as maleness and femaleness.[14] Wilke has removed the female sexual organ from its hidden recesses and displayed it openly, like a powerful male organ, thereby inviting "vagina envy."

FIG. 7-3. Judith Bernstein, *Horizontal Plus #3* (1975). Charcoal on paper. 9' x 28'. Collection of the artist, New York.

Faith Ringgold, a black artist, claims that she has been discriminated against more because of her sex than her color. Her politically motivated work of the late sixties and early seventies was linked with the black art movement;[15] she now works in a style that reflects her African heritage and feminist concerns. Using the mask-like faces of African sculpture and African fabrics, as well as quilting, needlework, appliqué, weaving, braiding, and beading, Ringgold creates soft sculptural forms. Since, according to the artist, most college and regional art galleries do not want to invest in women's exhibitions, her work is designed to travel easily. An entire exhibit can be packed in a few suitcases and rehung in a series of new environments according to themes created by the artist. The *Wedding Party* is a cross-cultural interpretation of the ultimate woman's fantasy. *Ms. Jones, Andrew, Barbara and Faye* (1973; Fig. 7-2) is a family portrait that is part of her "Family of Women" series.

The expressionistically rendered giant charcoal drawings (Fig. 7-3) of phallic screws by Judith Bernstein, a Yale University art graduate, are both erotic and political—her attack on a patriarchal society. They are so controversial, their imagery so disturbing, that even in this permissive age they have been censored. Bernstein describes her work thus: "Each drawing contains a massive force of energy that creates its individual icon. These architectural scale charcoal drawings are fetishistic in character. My work is an image of the 70's . . . an image reflecting a sexually aware age on a wide spread basis . . . an age where women are demanding equality on all levels. The phallus and all it stands for is not exclusively a male image."[16] Other artists, such as Sylvia Sleigh, in parody of the erotic art created for centuries for men, are creating male "odalisques" with emphasis on the genital area.

Some women artists insist that since women have different social and biological experiences than men, there is an essentially "female" quality in women's art. Lucy Lippard, in her catalogue essay, "The Women Artists Movement, What Next?" for the 1975 Paris Biennale, believes she has identified it, and has suggested the following: "a central focus (often "empty," often circular or oval), parabolic bag-like forms, obsessive line and detail, veiled strata, tactile or sensuous surfaces and forms, associative fragmentation, autobiographical emphasis."[17] According to Lippard and her supporters, "biology determines iconography," to paraphrase Freud. Yet being female, like being black, is merely one aspect of what makes an artist.[18] Equally important are time and place of birth, genetic heritage, education and training, and the artist's unique life experiences. All these factors are, to be sure, influenced by the fact that an individual is female, but they would also pertain if the artist were rich rather than poor, rural rather than urban, black rather than white. The question "What is woman's art?" is thus political rather than aesthetic. In the broadest sense, any art created by a woman may be termed woman's art, just as any art done by a black can be labeled black art. Nevertheless, any narrowing of the definition restricts the creative process and results in a constricting rather than an expanding aesthetic.

NOTES

1. Quoted in John E. Bowlt, ed., *Russian Art of the Avant-Garde: Theory and Criticism* (New York: The Viking Press, 1976), 93.

2. For an excellent article on the women surrealists, see Gloria Feman Orenstein, "Women of Surrealism," *Feminist Art Journal* (Spring 1973), 1, 15–21.

3. For an in-depth study of the WPA/FAP, including its women participants, see Francis V. O'Connor, ed., *Art for the*

Millions (Greenwich, Conn: New York Graphic Society), 1973; and "7 American Women: The Depression Decade" (Vassar College Art Gallery, January 19–March 5, 1976).

4. Clive Holland, "Lady Art Students' Life in Paris," *International Studio*, Vol. 21 (1904), 225–31.

5. Quoted in "Women's Art," *Art Digest* (April 1, 1931), 7.

6. "Women Radicals," *Art Digest* (February 1, 1935), 21.

7. "An Exhibit, and a Defense of Women," *Art Digest* (November 1936), 17, 23.

8. Karal Ann Marling, "American Art and the American Woman," in "7 American Women: The Depression Decade," 8–13.

9. "Women's Chance," *Art Digest* (May 15, 1932), 26.

10. Ralph Pearson, "A Modern Viewpoint: Women as Artists," *Art Digest* (May 15, 1947), 23.

11. "Famous Women Artists," *Art Digest* (November 15, 1943), 6.

12. Marynell Sharp, "Man and Wife," *Art Digest* (October 1949), 12.

13. "A Documentary Herstory of Women Artists in Revolution" with facsimiles of the letters that changed hands and the ensuing newspaper publicity was published by the Women's Interart Center in 1973. For a study of the women artists' movement in France, see Aline Dallier, "Fear of Feminism in France," *Feminist Art Journal* (Spring 1975), 15–18, 30.

14. Dorothy Seiberling, "The Female View of Erotica," *New York Magazine* (February 1974), 58.

15. See Fine, *The Afro-American Artist*, 209–10.

16. Quoted in *Art: A Woman's Sensibility* (Feminist Art Program, California Institute of the Arts, 1975), 8.

17. Quoted in Lawrence Alloway, "Women's Art in the 70's," *Art in America* (May–June 1976), 64–72.

18. Since the author believes there is a similarity between the black artists' search and the women's, she has adapted the last paragraph from her book, *The Afro-American Artist*.

The European Moderns

KÄTHE KOLLWITZ (1867–1945)

The three things that meant the most to Käthe Kollwitz were her children, her husband, and her work. A socialist, a feminist, and a pacifist, she lived through two bitter world wars and the unconscionable poverty and despair before and after each. She saw mothers and their children as the most helpless victims of war, poverty, and starvation, and made them the subjects of much of her graphic work. So strong was her identification with the women she drew, that she unwittingly gave them her own features. Kollwitz was a private person and spoke little of herself. Beginning in 1908, she kept a journal, and it is from these daily writings that we learn of the quotidian aspects of her life, her pain, the cyclical depressions that prevented her from working, her fears and anxieties for her children and grandchildren, and her love for her husband Karl. A beautiful and compassionate woman emerges from her writing, which has the simplicity, clarity, poetry, and humility of her finest work.

Käthe Schmidt was born in Königsberg, East Prussia, the fifth child of Katherina Rupp and Karl Schmidt. Her mother was the well-educated daughter of Julius Rupp, the nonconformist minister and founder of the Free Congregational Church, and her father, Karl Schmidt, was a lawyer, radical socialist, and activist in the Social Democratic Worker's Party. As a follower of Karl Marx, Schmidt was unwilling to practice law under the repressive regime of Bismarck, becoming instead a master mason and then a successful builder. Indeed, he was rather unusual for a Prussian father in refusing to send his children to the authoritarian Prussian schools and having them educated privately. In addition, he encouraged his daughters to develop their individual talents and to seek goals beyond the traditional ones of wife and mother.

When Käthe showed artistic talent, her parents provided her with the best lessons Königsberg had to offer, because, as Käthe later wrote, they did not believe she would be distracted by men since she was "not a pretty girl." Denied admission to the Königsberg Academy of Art because of her sex, she began private studies with the engraver Rudolf Maurer, and later with Emile Neide, a painter of local repute. Her younger sister Lisa was also talented, but never developed her skills and was content later to enter a conventional marriage. When, in 1941, Kollwitz reflected on this, she concluded: "I was keenly ambitious and Lisa was not. I wanted to and Lisa did not." Although equally gifted, Lisa lacked the total concentration necessary to develop great art.[1]

With few restrictions, the two sisters were permitted to roam the streets of Königsberg. Käthe's favorite spot was the waterfront, where she was fascinated by the movements of the Russian and Lithuanian workers. She was obsessed by their grandness and dignity, and later wrote: "All this apparently aimless loafing undoubtedly contributed to my artistic growth." For a long period her work dealt with the world of the workers and she became known as a "socialist" artist. In a 1941 diary entry she explained her choice of subject matter and why she felt compelled to deviate from contemporary aesthetic standards:

. . . my real motive for choosing my subjects almost exclusively from the life of the workers was that only such subjects gave me in a simple and unqualified way what I felt to be beautiful. For me the Königsberg longshoremen had beauty; the Polish Jimkes on their grainships had beauty; the broad freedom of movement in the gestures of the common people had beauty. Middle-class people held no appeal for me at all. Bourgeois life as a whole seemed to me pedantic. The proletariat, on the other hand, had a grandness of manner, a breadth to their lives. Much later on, when I became acquainted with the difficulties and tragedies underlying proletarian life, when I met the women who came to my husband for help, and so, incidentally, came to me, I was gripped by the full face of

the proletarian's fate. . . . And portraying them again and again opened a safety valve for me; it made life bearable.[2]

Käthe's older brother, Konrad, was a political and social activist and a member of the Social Democratic Worker's Party. He introduced her to the writings of Ibsen, Zola, Tolstoy, Dostoevsky, Marx, Goethe, and August Bebel, the latter a cofounder of the Party and author of *Women and Socialism*. Bebel's call for a new society where "women will be entirely independent, both socially and economically" intrigued Käthe. He also claimed that "the development of our social life . . . demands the release of woman from her narrow sphere of domestic life, and her full participation in public life and the missions of civilization."[3] Through her brother she met the equally socially committed Karl Kollwitz; they were engaged in 1884.

Fearing that her relationship with Karl would interfere with her studies, Käthe's father sent her to Berlin, where she enrolled in the Women's School of the Berlin Academy. Her first instructor, the Swiss artist Karl Stauffer-Bern, recognized her talent as a graphic artist and introduced her to the works of Max Klinger, Prussia's leading graphic artist, who worked in a naturalistic style. His portrayal of the workers as victims of social forces beyond their control, and his claim that certain subjects were more suitable to black-and-white than to color, convinced the young artist that she had found a kindred spirit. She was also fascinated by the engravings of Hogarth, Rembrandt, and Goya (her anti-war series have been compared to the latter's *Disasters of War*); the only contemporary German artist for whom she felt an affinity was the independent Expressionist Ernst Barlach, a sculptor and graphic artist who later inspired her to attempt wood engraving.[4]

Käthe studied for a year at the Women's School of Art of the Munich Academy. As a center of German cultural and intellectual life, Munich attracted serious and committed students. Most of Käthe's colleagues at the Women's School considered marriage an "act of betrayal" and were committed to a life of celibacy. Therefore, they viewed Käthe's engagement ring with hostility, which reinforced her own ambivalence; her engagement to Karl was a long one. When Karl finished his medical studies he joined the experimental health insurance plan for workers organized by Bismarck, and was stationed in Berlin. He finally suggested marriage, and after examining the choices available to women in 1890, Käthe correctly perceived that she would have more freedom as the wife of a physician in Berlin than under the watchful

eyes of her intrusive father in provincial Königsberg. Her father's final message to her before her marriage was: "You have made your choice now. You will scarcely be able to do both things. So be wholly what you have chosen to be."[5]

The couple married in 1891 and had their first child, Hans, in 1892. Although she was with Hans daily, "Karl did everything possible so that [she] would have time to work."[6] In the midst of work on her first great cycle, *The Revolt of the Weavers*, their second son, Peter, was born (1896). Although his arrival created additional responsibilities for the artist, it also stimulated her creativity. (Her family took from her, but also gave to her. Reflecting on this period, she later wrote about how she became more productive because she became more sensual. "I lived as a human being must live, passionately interested in everything."[7])

Inspired by the opening performance of Gerhart Hauptmann's play, "The Weavers," the cycle described the 1844 rebellion of a group of linen hand weavers caught between a dying feudalism and an emerging and aggressive capitalism. Her work on this project was "slow and painful" and took five years to complete. Although she had originally planned to etch the entire series, her dissatisfaction with her etching technique resulted in three lithographs and three etchings. Plate One describes "Poverty," Two "Death," and Three "Conspiracy." They are dark and brooding lithographs, fully realized political and aesthetic statements; the light is often used symbolically, yet the settings are quite realistic. The most exciting composition is Plate Five, "Attack." Here is the essence of the artist's revolutionary statement. Stooped from years of labor, her men and women together stone the elegantly delineated iron gates surrounding the home of a mill owner. Kollwitz was capable of drawing decorative details if she chose; however, after this series, in her search for a clarity and simplicity of statement, she eliminated all such distracting indications of time and place from her work.

The series created a sensation when exhibited in the Great Berlin exhibit of 1898. A gold medal was suggested, but Kaiser Wilhelm II refused to honor the "gutter artist." When it was shown two years later in Dresden, Max Lehrs, the Gemäldgalerie's curator of prints and drawings, prevailed upon the King of Saxony to award Kollwitz a gold medal. From that time hence, she was considered "among the foremost artists of the country." As a result of the success of *The Revolt of the Weavers*, Kollwitz was asked to teach at the Women's School of Art, where

FIG. 8-1. Käthe Kollwitz, "Outbreak" (1903). Etching. 19⅞" × 23". Plate 5 from *Peasants' War* series. Staatliche Museen Preussischer Kulturbesitz, Berlin-Dahlem.

she stayed for two years. In 1918 she became the first woman elected to a professorship at the Prussian Academy of Arts, and in 1928 the first female to head a department there. She taught the master class in graphics and received a stipend of about $200 a month, her first real income. Even at the height of her fame, she rarely earned more than $500 a year from her work.[8]

Kollwitz had begun exhibiting with the dissident and socialist Secessionists in 1893; at that time she was the only female member of the group. When the group split in 1910 because of the growing conservatism among some of its members, Kollwitz joined the more radical New Secessionists (whose members included Gabriele Münter, Wassily Kandinsky, Alexei von Jawlensky, and Marianne von Werefkin). Reluc-

tantly, Kollwitz became secretary to the group, but in 1916 she happily became its first woman juror. Mindful of the difficulties faced by women artists, she was responsive to the work submitted by women, but also wrote of her "unpleasant position on the jury":

I always find myself forced to defend the cause of a woman. But because I can never really do that with conviction, since most of the work in question is mediocre (if the works are better than that the other jury members will agree), I always become involved in equivocations.[9]

Her growing concern with women artists led her, in 1926, to help found the Society for Women Artists and Friends of Art. Composed of a group of German and Austrian artists, the Society sought, through its own organizational efforts, to bring the work of women before the public.

Kollwitz's second great series was inspired by Zimmermann's *The Great German Peasants' War*, a chronicle of the 16th-century German peasant uprising. She was especially intrigued by the idea of women as revolutionaries and had just completed an etching describing female participation in the French Revolution entitled *Dance Around the Guillotine*, (1901); therefore the character of Black Anna inciting the peasants to rebel fascinated her. What was to become the fifth sequence in the series, *Outbreak*, (1903; Fig. 8-1), was completed first, and on the basis of this plate she was awarded a commission to execute the entire series by the Association for Historical Art. Black Anna, her back bent, her arms upraised, is an earthy force as she summons her people to fight in a battle in which she too will participate. The powerful thrust of the body embodies the spirit of the artist, who at this period of her life was imbued with an ardent revolutionary spirit. The artist did no less than eleven states of this intense work before she was satisfied with the final print. The second plate, "Raped" (Fig. 8-2), is unusual in Kollwitz's oeuvre, and certainly rare in the history of Western art—the violation of the female is interpreted from a woman's point of view. It is a study in contrasts: the diagonal figure of the ravaged woman is extremely foreshortened; she lies in a bed of delicate, but wilted flowers, the only known depiction

FIG. 8-2. Käthe Kollwitz, "Raped" (1907). Etching and soft ground. 12¼″ × 20¾″. Plate 2 from *Peasants' War* series.

FIG. 8-3. Käthe Kollwitz, *Seeds for the Planting Shall Not Be Ground Up* (1942). Lithograph. 14⅜″ × 15½″.

of vegetation in the artist's entire oeuvre. Indeed, this is war seen from a woman's perspective. In the final print, "The Prisoners," the huddled mass is defeated, but not broken. There is no descriptive background; the timelessness of the scene became apparent when sixty-four years later, in 1972, the Irish Republican Army used it for a poster on which they affixed their own slogan: "No More Internment."[10]

From 1902 through 1908, Kollwitz worked on the *Peasants' War.* In the interim she made her first extended visit to Paris, where she enrolled briefly in the sculpture class at the Académie Julien and visited Rodin at his studio in Meudon (1904); in 1907, as the recipient of the Villa Romana Prize sponsored by Max Klinger, she was able to spend a year at a Florentine villa, all expenses paid. Her other cycles were *War* (1922–23), comprising seven woodcuts, and *Death* (1934–35) with eight lithographs. The three woodcuts from the 1925 *Proletariat* series resulted in an invitation to visit Russia.

By 1913 war seemed inevitable, and after the assassination of Archduke Ferdinand in 1914, Germany united to fight for the fatherland. Her son

Peter was one of the first to be killed; she never fully recovered from this loss, but characteristically "she responded to Peter's death with life." The following year she began the large sculptural monument to her son that was to obsess her for the next fifteen years. In reality, it is less a monument to a slain son than to the surviving parents. A massive, mourning father, on his knees, his arms tightly clasped, his face strong and stoic, a crouching mother, her robe in massive folds—Karl and Käthe, cast in granite, hover over the graves in the soldiers' cemetery near Roggevelt, Belgium, where Peter was buried. The figures possess the power and strength of her greatest drawings and have the added monumentality of the sculptural medium. Kollwitz achieved what she had sought—"Simplicity in feeling, but expressing the totality of grief." When they were finally set in place, she was at last able to "give up her sorrow."[11]

Her first major work after the war was the lithograph "Mothers," a theme that was to occur with variations in countless later drawings, etchings, woodcuts, and sculptures. Here the mothers and children are the abandoned victims of war. The

mothers enfold their children in an effort to protect them from famine, war, death; the theme is treated again in the woodcut "The Mothers" from her War series of 1922. In stark black-and-white forms from the woodblock to create a single unit. In the lithograph "The Survivors," created as an anti-war poster for Anti-War Day, September 21, 1924, she added the slogan "War Against War." Here the central Madonna-like figure clasps three young children to her bosom with her massive hands while the blindfolded warmongers peer over her shoulder.

Several sculptures repeat the theme. In *Protecting Mother* of the early thirties a single, crouching nude woman envelops her children, and in *Tower of Mothers*, a bronze of 1937–1938, a pyramid of mothers builds a protective tower to restrain the children, to see that the "seeds for the planting shall not be ground up." The forms have been simplified for maximum power, and as always it is the expressive face and hands of the artist herself that protect the young. The artist's last lithograph has as its title the above line from Goethe's novel *Wilhelm Meister*:

FIG. 8-4. Käthe Kollwitz, *Self-Portrait* (1936). Bronze. 15¼" × 8⅝". Courtesy Hirshorn Museum and Sculpture Garden, Smithsonian Institution, Washington, D.C.

Seeds for the Planting Shall Not Be Ground Up (Fig. 8-3). It was completed in 1942, three years before her death and two years after her husband's, while war was again destroying Germany. (Before the year was out, her grandson Peter, like his uncle and namesake before him, was "ground up.") As Kollwitz described the work to a friend: "This time the seeds for the planting . . . are all around the mother . . . wanting to break loose." The mother restrains them, saying: "For the time being you must play rough and tumble with one another. But when you are grown you must get ready for life, not for war again."[12] The powerful pyramid-shaped composition shows that the artist, at seventy-four, had lost none of her powers of perception.

Kollwitz's most lasting contribution to the history of art may be the approximately ninety-one self-portraits which she began when still in her teens and continued until two years before her death. Not since Rembrandt had an artist so consistently bared her soul through her face. Whether a charcoal drawing, an etching, a lithograph, woodcut, or sculpture (Fig. 8-4), the artist reveals her moods, her pains, and the psychological depths she has explored. They are extraordinary creations showing her development as an artist and as a woman. The earliest portraits are set in lovingly detailed backgrounds, but as she sought greater simplicity in her work, these particulars disappear; what remains is the powerful force of her personality produced with only essential lines and planes.

PAULA MODERSOHN-BECKER (1876–1907)

While Cassatt was concerned with the formal elements in her mother and child compositions, and Käthe Kollwitz embodied the mother as protector, Paula Modersohn-Becker portrayed the earth mother who is in tune with the animal kingdom. The image she projects in so many of her works is powerful, and hardly like the sentimental portrayals of the subject found in the popular art of the period. In a *Mother and Child* of 1906 (Fig. 8-5) she shows us the primitive and instinctual aspects of the relationship; she tells us that we are part of the continuum of nature. The monumental mother lying on the floor nursing her child envelops the infant in her arms; the infant, enveloped in its mother's arms, is caught in the linear rhythms of her body. The artist's color during

FIG. 8-5. Paula Modersohn-Becker, *Mother and Child* (1906). 32½″ × 49″. From the holdings of the Ludwig-Roselius Collection, Bremen.

the period ran to pinks, ochres, yellow-greens, and violets applied in large flat areas.

In a short, productive life, Paula Modersohn-Becker produced over 400 paintings, and more than twice that many drawings and etchings. Her last words before she died from a heart attack at thirty-one, three weeks after the birth of her daughter, were "What a pity!" Indeed, when one examines her extensive oeuvre, one is impressed by its power and maturity of vision. She died at an age when most artists are still searching for their style. Yet, she would not have us mourn her premature death. The year before her marriage in 1901 she wrote in her diary:

I know I shall not live very long. But why should this be sad? Is a festival more beautiful for lasting longer? For my life is a festival. My sensual perceptions grow sharper, as though I were supposed to take in everything within the few years that will be offered me . . .[13]

Paula Becker was born in Dresden, her mother of aristocratic lineage and her father a railroad administrator. Their home was a gathering place for artists and writers. When she was twelve, the family moved to Bremen, where Paula took her first art lessons. While still in her teens, she was shipped off to London for further study. Like countless daughters before and after her, she was also advised to become qualified as a teacher in the event she had to earn a living. She later enrolled in the Women's School of the Berlin Academy (where Kollwitz studied and later taught) and after visiting the Worpswede art colony during the summer of 1897, vowed to return upon completing her studies in Berlin.

Founded in 1889 by Fritz Mackensen and Otto

Modersohn, two Düsseldorf-trained artists, Worp-
swede was one of the series of "back to nature"
colonies that flourished in the German countryside
before the turn of the century. Poets, novelists,
artists, and other intellectuals were attracted to the
beauty and tranquility of this village near the Baltic
Sea. "Deeply sensitive to the emotional elements in
the landscape, which create a link between man and
things," the Worpswede painters perceived nature as
a "poetic reality."[14] Although she painted the same
subject matter as the other Worpswede artists—
landscape, peasants, and still-life—Modersohn-
Becker never conformed to their "lyric naturalism."
Her forms became flat, she ignored conventional
perspective and "local color," and chose colors and
forms for their expressive qualities. Stripped of all
anecdotal detail, her paintings often appear crude
and primitive. She was not concerned with imitating
nature, but sought to give "figurative expression" to
her unconscious feelings. In a 1902 diary entry she
elaborated on her search:

There is no need to be too much concerned with nature in
painting. The color sketch should exactly reflect some-
thing you have felt in nature. But personal feeling is the
main thing. After I have set it down in form and color, I
must introduce those elements from nature that will make
my pictures look natural.[15]

After two productive years under the tutelage of
Mackensen, she was ready to exhibit at the Bremen
Kunsthalle (1899). Critical and public reception was
negative. (Modersohn-Becker sold only two paint-
ings during her lifetime, and in fact had difficulty
even giving them away. The winner of one of her
works at a charity raffle in Worpswede chose to
exchange his prize for other merchandise.) Accord-
ing to Ellen Oppler, the "devastating" criticism the
young artist received from the conservative critic
Arthur Fitger was directed at the new curator, Gustav
Pauli (the author in 1919 of the first monograph on
the artist), for desecrating the sacred walls of the
museum with the work of three unknown women.
(The others were Clara Westhoff and Maria Bock.)
Fitger described their work as "things that the primi-
tive beginner, blushing modestly, might show her
teacher or advisor."[16]
Depressed by the failure of her show, Paula Becker
took the first of her four trips to Paris, where she
enrolled at the Académie Colarossi and the École des
Beaux-Arts; she also studied the paintings in the
Louvre and frequented Vollard's, where she discov-
ered Cézanne. The young artist immediately under-
stood his work and began incorporating his formal

discoveries into her own still-life paintings. In *Still-
Life with Apples* (1903) and *Still-Life with Melon*
(1905), there is the same tilted perspective and monu-
mentality of form.
After several months in Paris, she returned to
Worpswede with renewed confidence, but her family
urged her to abandon her career as an artist and
accept a position as a governess. She took the only
other alternative available to her at the time—mar-
riage to Otto Modersohn (1901). Although Moder-
sohn recognized his wife's genius—he considered her
a "genuine artist, such as there are few in the world"
and predicted that she would someday be known
throughout the world—the alliance was not a partic-
ularly fulfilling experience for his wife. A diary entry
of 1902 is particularly revealing:

In my first year of marriage I have cried a lot. I live as lonely
as in my childhood. It is my experience that marriage does
not make one happy. Marriage takes away the illusion that
previously bore upon one's entire life—that there is a soul-
mate.[17]

Modersohn recognized his wife's need to work
apart from him, and again, in 1903, feeling strangled
by the provincialism of Worpswede, she headed for
Paris. Her feeling of independence was fostered by
her friendship with the sculptor Bernhard Hoetger
and his wife, two of the few people who openly
encouraged her. After he visited her studio, she sent
him the following note: "You have given me the
most wonderful thing in the world: faith in myself."[18]
During her stay in Paris she discovered the arts of
Japan, India, and Persia; the decorative elements of
these arts were incorporated into many of her figure
paintings. She also discovered Coptic mummy paint-
ings. When she saw the work of Van Gogh and
Gauguin, she felt an immediate kinship with these
artists, identifying especially with their depiction of
workers and people of the earth, and with their
distortion of form and color for expressive reasons.
Indeed, she was the first German artist to incorporate
post-Impressionist ideas and styles into her work: a
similarity exists in the pose, linearity, and use of
floral patterning between Van Gogh's *La Berceuse*
and Modersohn-Becker's *Old Peasant Women in the
Garden* (1905). Conceived as a series of verticals,
horizontals, and oval shapes, the Modersohn-Becker
is a more stolid painting than the Van Gogh. Like
Kollwitz, Modersohn-Becker was an admirer of
Klinger, and most of her subjects came from the
poorer classes. The brooding, square-jawed peasants
of Lower Saxony appear over and over again in her
paintings; they are never portrayed in their individ-

FIG. 8-6. Paula Modersohn-Becker, *Self-Portrait on Sixth Wedding Anniversary* (1906). 41⅜" × 27⅞". From the holdings of the Ludwig-Roselius Collection, Bremen.

her use of color, sense of form, and decorative tendencies, he concluded sadly that "even now, her serious and strong talent will not win over many friends among the public at large."[19]

The *Self-Portrait on Sixth Wedding Anniversary* (Fig. 8-6), painted in 1906 before Otto's arrival in Paris, may reflect her ambivalence about their reunion. As Oppler aptly phrased it, "her maternal potential is confronting her artistic self." She portrays herself nude and pregnant with a firm, round belly; the positioning of the arms emphasizes the body's roundness. The three-quarter length and three-quarter view figure, partially draped in Polynesian style, is one of the rare views of a pregnant nude in Western art.

Among the residents of Worpswede was the poet Rainer Maria Rilke. Rilke respected Modersohn-Becker's intellect, and they enjoyed many hours of philosophical discussions together, but when he wrote a monograph on the community in 1902, he neglected to mention her presence there. Her genius slowly became apparent to Rilke, who three years later was to write that she was "painting things that are very Worpswede-like, yet which nobody has yet been able to see and paint, and in this quite individual way, strangely approaching Van Gogh and his tendency." After her death he described her as "an artist who exposed herself to the Paris of Van Gogh, Gauguin and Cézanne, to the presence of Maillol, and probably even Matisse and Henri Rousseau, and who at times went even beyond the German successors of these artists."[20] In addition, Rilke recommended to his patron that he become a collector of her work, which included a 1906 portrait of Rilke.

Paula Modersohn-Becker was an independent and determined young woman who was convinced that she would "be something," as she wrote to her sister Milly in 1906, or "amount to something," as she wrote to her mother before leaving for her last trip to Paris.[21] When her letters and diaries were published a decade after her death, her name began to be known in Germany. During the Nazi regime her paintings were removed from museum walls and exhibited in the infamous degenerate art show of 1936–37. Today she is again being honored in her native Germany; record-breaking crowds have attended her various retrospectives and critical attention has been overwhelmingly favorable. According to Alfred Werner, the artist would have objected to being included in this survey: "Aloof as she was from the Feminist Movement, she would have resented putting too much emphasis on her sex in connection with her profession."[22]

uality, but are prototypes of sufferers. This depersonalization was, fortunately, achieved without a concomitant loss of feeling and tenderness toward her subjects.

During her third visit to Paris in 1905, Modersohn-Becker enrolled at the Académie Julien and discovered the works of the Nabis—Vuillard, Denis, and Bonnard—among the avant-garde dealers along the Rue Lafitte. She immediately made plans to visit their studios, an audacious act for a woman alone. Within a year after her return to Worpswede, she was back in Paris again. Although she loved her husband, she urged him to try to get used to living without her. Since his constant flow of letters could not persuade her to return, Otto joined his wife in Paris. His presence must have disarmed her, because she returned with him to Worpswede and joined the group for another exhibit, her second and last. Pauli reviewed the exhibit and praised "this highly gifted woman artist." However, after attempting to explain

MARIANNE VON WEREFKIN (1870-1938)

According to Juliane Roh, the history of the Blue Rider cannot be completely written until the diaries of Marianne von Werefkin are published. Kept from 1898 until her death, and written in French, they record the quotidian aspects of her life as well as her musings about art. As early as 1900, she wrote of "literally being obsessed by abstraction," which she seems to have understood as a "distance from reality, that which is wonderful and dreamlike."[23] She recorded her conversations with Kandinsky, and it is generally agreed by historians of the period that Kandinsky's rejection of the concrete world in his paintings was related to the mystical speculations of Von Werefkin.[24]

Born in Russia of aristocratic parents, she had studied for ten years with the realist Ilya Repin in St. Petersburg, and became known as the "Russian Rembrandt" for her paintings of the old Jewish men in the village near her father's family estate. When her father, a general in the Russian army, died in 1896, she left for Munich with a friend from Repin's

studio, Alexei von Jawlensky. In Munich, Jawlensky entered the school run by Anton Azbe, where he met Kandinsky. For the first several years in Munich Von Werefkin painted very little; most of her energies were devoted to nurturing Jawlensky's talent. Described by her friends as a "strangely dynamic woman" and a "female devil," she was also the focal point of a salon in which all facets of art were discussed, from painting and sculpture to music and dance. Van Werefkin was in her late thirties when she started painting seriously again, and by then all traces of her Russian training had vanished.

Because of their admiration for Gauguin and Van Gogh and for the French Fauves—Jawlensky had worked with Matisse—Jawlensky and Werefkina (as she was affectionately called) spent more time in Paris than in Munich and became involved with the politics of modern art. While Jawlensky incorporated many of the advanced art styles in his work, Von Werefkin was not as open to other influences and worked in a highly personal style. Kandinsky described her work as "confessions in a diary." Peter Selz, an authority on German Expressionism, wrote

FIG. 8-7. Marianne von Werefkin, *Sunday in Spring* (1910). 22″ × 28¾″.

that "she catches quick, transitory moods, but beyond mere narrative she creates rhythmic arrangements by large, strongly outlined color planes that cut into each other."[25] Summers between 1908 and 1912 were spent at Murnau in Southern Bavaria, with Gabriele Münter and Wassily Kandinsky, as well as Auguste Macke, Franz Marc, Paul Klee, and other members of the pre-World War I German avant-garde. Von Werefkin worked only briefly in the so-called Murnau style; she was more of a Symbolist and returned again to producing paintings that embodied a "genuine, visionary power."

Since the artist did not date her paintings, their chronology must be developed according to stylistic changes. *Young Ladies' Boarding School* (c. 1910) is one of the broad-stroked, sketchy representations of anonymous groups of people that she produced after a trip to Paris. A painting such as *Sunday Afternoon* recalls the loneliness and anxiety of works by Edvard Munch.[27] The long line of empty tables at which a man and woman sit stretches into bleak infinity. The silhouettes of the figures and the trees suggest that Von Werefkin was familiar with Art Nouveau forms. *The Country Road* (1909; Plate 3) has the same haunting quality as Munch's *The Scream* (1893). The flat, anonymous, isolated figures of the three women in the foreground of the painting are dwarfed by the swirling lines, intense colors, and broad brush strokes of the background. All the artist's sources—Gauguin, Munch, the Nabis—seem to coalesce in *Sunday in Spring* (Fig. 8-7; 1910). The large green expanses of grass, sinuous blue river and band of red buildings in the background, contrast with the tiny black, white and grey silhouettes of the anonymous strollers. The artist seems more at peace with herself in this painting.

Most of her work disappeared after her death, to be rediscovered again in the 1950s in Rome and Basel by Dr. Clemens Weiler, curator of the Wiesbaden Museum of Art. When, in 1958, the City Museum of Munich held a joint exhibition of works by Jawlensky and Von Werefkin, it marked the first such comprehensive showing of her oeuvre. There is now a Von Werefkin Museum in Ascona, Switzerland.

GABRIELE MÜNTER (1877–1962)

Gabriele Münter was the daughter of German-born immigrants to the United States who had met and married in Tennessee, but who had returned to their native Germany after the outbreak of the American Civil War. Gabriele, the youngest of several children,

visited her American relatives after her mother died in 1898, and with her older sister traveled throughout the American South. She stopped first in St. Louis, Missouri, and then in Moorfield, Arkansas, and Plainview, Texas, sketching family and scenery during two years of travel.

Before her American trip, Gabriele had taken some drawing lessons, "as many girls did in those days," and had studied briefly at the Women's Art School in Düsseldorf. She found the instruction there "very uninspiring, still dominated by the ideas and tastes of the later Romantics." In addition, neither she nor any of the other female students were taken seriously. After her return from the United States, she first lived with a sister in Bonn, and then in 1901 went to Munich in order to enroll at the Academy, where she was denied admission because she was a woman. "In those days," recalled Münter, "a woman could study art in Munich only privately, or in the studios of the Künstlerinnenverein, the association of women artists."[28] When she enrolled in Kandinsky's class at the Phalanx School, she was at last treated seriously as

FIG. 8-8. Gabriele Münter, *Portrait of Marianne von Werefkin* (1909). Städtische Galerie im Lenbachhaus, Munich.

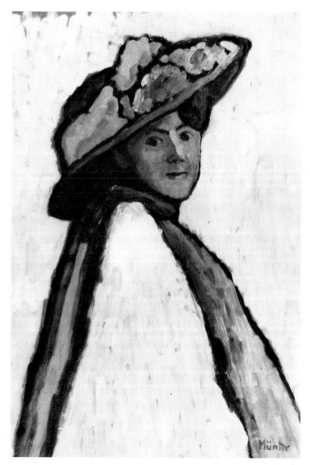

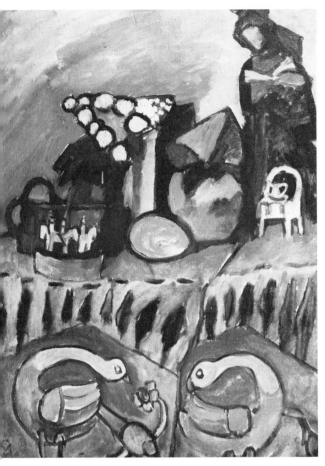

FIG. 8-9. Gabriele Münter, *Still Life with Russian Tablecloth* (cloth). 27″ × 19¾″. Courtesy Leonard Hutton Galleries, New York.

however, seek her out at home, and in defiance of the contemporary social code, they openly declared their love, exchanged rings, and for five years traveled throughout Europe and North Africa. Their families accepted the relationship, and Kandinsky frequently introduced her as his wife. When Münter was having difficulty with the effects she wanted with her brush, Kandinsky taught her to first use her palette knife and then her brush: "My main difficulty was that I could not paint fast enough. My pictures are all moments of my life, I mean instantaneous visual experiences, generally noted very rapidly and spontaneously . . . It was Kandinsky who taught me to achieve this kind of rapid and spontaneous recording of moments of life."[30] By the time they settled in Murnau, Münter was working independently; there was a change in her style "from realistic copying of nature—more or less impressionistic—to the feeling of content, to abstraction, to the extracting of essence"[31]

Both Kandinsky and Münter were deeply moved by a Gauguin retrospective they had seen in Paris and by an exhibit of the Fauves. The influence of Matisse can be seen in Münter's 1909 portrait of Marianne von Werefkin (Fig. 8-8). It is remarkably like Jawlensky's *Portrait of a Girl* of the same year. However, their portraits lack the exuberance of the French painter's work: they are heavier, and despite the bold use of color, more somber. In the Münter portrait, the orange, blues, and ochres of the large oval-shaped hat are repeated in the planes of the face; the large purple scarf surrounds the white dress form, and each shape in turn is surrounded by a heavy, non-continuous black line. The background is flat, the only texture coming from the heavy impasto of the yellow and ochre paint. While Jawlensky's portraits became more aggressively primitive, Münter's, in her quest for ever greater simplicity, became child-like and wispy.

Her use of flat areas of bright color surrounded by dark heavy outlines was learned from Bavarian *Hinterglasmalerei* ("behind-the-glass" painting), which she collected. The religious purity and extreme simplification of this centuries-old folk art had great appeal for Münter, and beginning in 1910 she produced a series of works in this style that included not only religious paintings (*Madonna and Child*, 1910), but icons to the changing seasons in the Bavarian countryside, sophisticated interiors, seascapes, and circus scenes. Her collection of folk art became the subject matter for some of her most delightful still-life compositions (Fig. 8-9).

During their first summer at Murnau (1908), the

an artist. The Phalanx group, of which the school was a part, attempted—with little success—to introduce the Impressionists and post-Impressionists to Munich and to provide a place for young artists to exhibit. Kandinsky's life class opened up new experiences for young artists, because, as she wrote, he "explained things in depth and looked at me as if I was a human being, consciously striving, a being capable of setting tasks and goals." Kandinsky was impressed by the ease with which Münter worked. "Everything was given to you by nature," he told his pupil. "What I can do for you is merely to guide your talent, to nurse it, and to make sure that nothing false touches it."[29]

But Kandinsky also fell in love with her. She joined his summer sketching classes in the Bavarian mountains and cycled with him on his rounds of criticisms. However, when his wife arrived, he refused to let Münter return to the school. He did,

landscapes of Kandinsky and Münter were quite similar, but by the following year Kandinsky's were bursting with the restless energy and emotional violence that led him increasingly toward abstraction. In *Cottage in the Snow* (1908–9) Münter has applied her color with slab-like strokes outlined in darker colors to create grid-like forms and a scintillating surface. In her later landscapes there is a deliberate primitivization: all objects are reduced to their essential forms and each color is contained in a clearly outlined form. When seeking an "inner reality," Kandinsky began his first experiments in abstraction; Münter dabbled only briefly with these new ideas.

With the outbreak of World War I, Kandinsky left for Russia, entrusting his entire oeuvre to Münter, who, although she refused to look at the paintings, protected them (in a specially built storage unit in the basement of the Murnau house) through two world wars and various political upheavals. They met for the last time in 1916 in Stockholm, where each had an exhibit; Kandinsky wrote the prefaces for both catalogues. In hers, he defended her objective paintings by comparing them to vocal music, which, "although it no longer attracts the composer, retains in its retrospective form, the capacity to arouse emotions."[32] The effect of their separation was said to be "psychologically inhibiting" for both artists. Although Münter did exhibit during this period—she had a one-woman show entitled "50 Paintings of 25 Years"—she later wrote: "In the decade between 1920–1930 I had a period of sterility in painting. I lived restlessly here and there, sometimes in my Murnau house, at times in some boarding house, sometimes as a guest with friends or relatives. For years I had no studio."[33]

New inspiration came in the late 1920's, when Münter met Johannes Eichner, a man versed in art history, psychology, and philosophy, and author of a book about the couple—*Kandinsky und Gabriele Münter vom Ursprüngen und Moderner Kunst* (Munich, 1957); he was her companion until his death, a few years before her own. During the Nazi takeover, her paintings were removed from museum walls and condemned as "degenerate." She escaped the horrors of World War II by secluding herself in Murnau. It was in connection with Eichner's book that the hidden Kandinsky canvases became known. On her eightieth birthday, in 1957, Münter donated them to the city of Munich, where they were hung in the Municipal Gallery along with some of her own early work. She refused to attend a showing of the paintings which now form part of the Gabriele Münter Foundation in Munich.

NATALYA GONCHAROVA (1881–1962)

In the catalogue of her second one-woman exhibit in 1913 (in which she showed 768 works covering the period from 1900 to 1913), Natalya Goncharova explained her artistic development and her aesthetic creed:

I fathomed the art of painting myself, step by step, without learning it in any art school. (I studied sculpture for three years at the Moscow Institute of Painting, Sculpture and Architecture and left when I received a small medal.) At the beginning of my development I learned most of all from my French contemporaries. They stimulated my awareness and I realized the great significance and value of the art of my country—and through it the great value of the art of the East. . . . Now I shake the dust from my feet and leave the West, considering its vulgarizing significance trivial and insignificant—my path is toward the source of all arts, the East . . . Contemporary Western ideas (mainly of France; it is not worth talking about the others) can no longer be of any use to us. And the time is not far off when the West will be learning openly from us. . . . Similarly, I find those people ridiculous who advocate individuality and assume there is some value in their "I". . . . Untalented individuality is as useless as bad imitation. . . .[34]

Goncharova was born into a family of ancient nobility near the village of Tula. One of her father's ancestors had been architect to Peter the Great and her father continued the tradition; her mother was a member of the Belyav family, prominent patrons of Russian music. Through her father she was also a great-granddaughter of the poet Alexander Pushkin. At ten years of age, Natalya was sent to school in Moscow, and at seventeen she began her studies at the Moscow Institute of Painting, Sculpture and Architecture with Prince Paul Trubetskoi, a "World of Art" sculptor who had studied with Rodin. Another student at the college was Mikhail Larinov, the son of a military physician from the Ukraine; their lives and their art were to be closely intertwined for over sixty years, although they refused to marry until 1955 when both were seventy-four. Soon after their meeting Goncharova gave up sculpture for painting. When asked if this was at Larinov's insistence, she replied, in a 1937 interview, that sculpture was "too limited." "Sculpture cannot translate the emotion that comes from landscape, the moving fragility of a flower, the sweetness of a spring sky."[35]

Goncharova and Larinov first showed their works at the "World of Art" exhibition in 1906,[36] and in the same year were part of the Russian section of the Salon d'Automne organized by Diaghilev to introduce the younger generation of Russian artists to Paris. Neo-Primitivism was first introduced at the

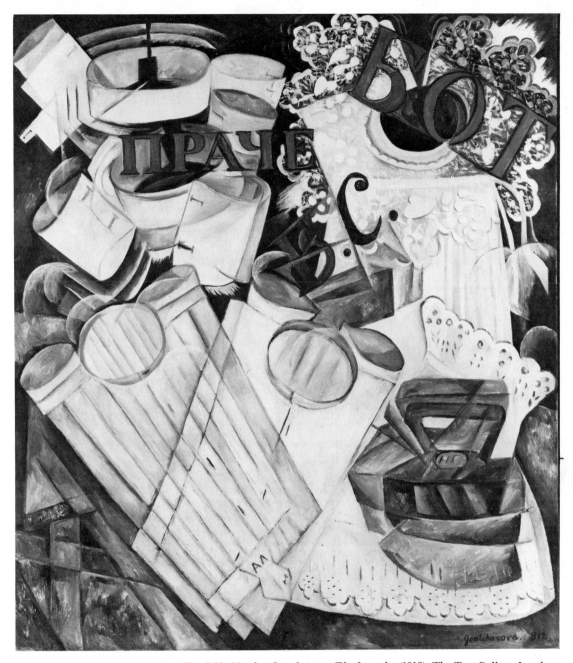

Fig. 8-10. Natalya Goncharova, *The Laundry* (1912). The Tate Gallery, London.

last of the three "Golden Fleece" exhibitions in 1909. The short-lived movement (1906–9) declared its aims in the journal it published: "We intend to propagate Russian art beyond the country of its birth, to represent it in Europe in a whole and integrated fashion in the very process of its development."[37] Besides the obvious Fauvist influences, Goncharova and the Neo-Primitives drew their in-

spiration from Siberian embroidery, peasant pastry forms, toys and woodcuts, and icon paintings. Most of her Neo-Primitive paintings were of peasant themes, while many of her religious paintings were directly influenced by icons.

Goncharova's Rayonist paintings date from about 1911 to 1914 (when she left Russia to work with Diaghilev's Ballets Russes in Paris). Although it too

was a short-lived movement, Rayonism was most important in that it "rationalized the contemporary ideas in Russia, carrying to their logical conclusion Fauvism, Cubism and the indigenous Russian Decorative-Primitive movement."[38] *The Laundry* (1912; Fig. 8-10) shows the artist in transition from Neo-Primitivism to the more abstract Rayonism. The dynamics of futurism and the machine aesthetic are revealed, even though most of the tools—iron, washboard, wringer—are meant to be used by women. A more complete Rayonist work is *Cats* (1912; Fig. 8-11) now in the Guggenheim Museum, New York. Small, angular shapes sparkle throughout the bold and dynamic canvas. The colors are black, yellows, ochres, and a touch of red.

Goncharova was considered by many to be a better painter than Larinov. Diaghilev called her "the most famous" of all the radical Russian painters, claiming that artists imitated her work, while fashionable Moscow and St. Petersburg society imitated her lifestyle: ". . . she painted flowers on her face. And soon nobility and bohemia alike were going out . . . drawn and painted in rainbow colors on their cheeks . . ."[39] In 1914 Diaghilev invited Goncharova to design the sets for his productions of Rimsky-Korsakov's opera "Le Coq d'Or," which he was presenting in Paris. Her theatrical designs became a natural extension of her aesthetic ideas. Indeed, the similarity between the 1914 painting *Espagnole* and the stenciled costume design for a Spanish dancer done that same year (Fig. 8-12) is remarkable. Both

FIG. 8-12. Natalya Goncharova, *Costume for a Spanish Dancer* (1914). Stencil. Collection D. Lobanov.

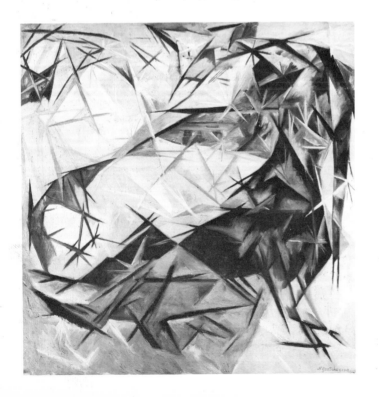

have heightened color, overlapping planes, and bold floral patterning, the only difference being the suggestion of bodily movement in the costume rendering. In 1916, she went to Spain to prepare designs for ballets by Ravel and Albeniz. Finally settled in Paris in 1917, Goncharova continued her association with Diaghilev until his death in 1920, after which she continued to design productions for other ballet companies. Her most memorable work may have been for Igor Stravinsky's "Firebird," which the Ballets Russes presented in 1926. Her involvement with the theater left little time for painting.

Goncharova's interest in icon paintings was carried into the rich patterning and strong linear designs of her late theater pieces. According to Camilla Gray, "this flair for ornament became almost a scientific investigation for Goncharova, and together with her use of icon painting as a source of

FIG. 8-11. Natalya Goncharova, *Cats* (1913). 33¼″ × 33″. The Solomon R. Guggenheim Museum, New York.

pictorial composition is her chief independent contribution to the modern movement in Russia."[40]

In 1950, when Larinov suffered a stroke, Goncharova sold some of her paintings to pay for his medical expenses. Although herself suffering from crippling arthritis and barely able to work, she painted a series of strong abstractions based on the theme of "outer space" when the Russians launched the first Sputnik in 1958. A visitor to the couple's Paris apartment a few years before their deaths described how they were living. After forty years, they still thought of themselves as Russian exiles and seemed to have "allowed themselves to be slowly submerged under an accumulation of old newspapers, art magazines and exhibition catalogues proliferating around them as the years went byThey were like nomads who had been forced to become sedentary because they had accumulated in their camp too many possessions to be able to move any longer."[41]

ALEXANDRA EXTER (1882–1949)

The Constructivists' desire to create a public art was most effectively implemented in their works for the theater, a vital aspect of Russian culture. One of the most successful artists in creating this synthesis was Alexandra Grigorevich Exter, a native of Kiev, who through her tireless teaching in Kiev, Odessa, and Moscow, saw her ideas spread to all areas of Russian theater before she was forced into exile in 1924 (her bold and revolutionary conceptions were greeted with hostility when the Kremlin took a hard line on the arts). When a collection of her scenic and costume designs went on view at the New York Public Library in 1974, she was again recognized as a "veritable Amazon . . . a scythian rider" in the front ranks of the Russian avant-garde.[42]

In 1908, Exter, at age twenty-six, arrived in Paris to study at the Académie de la Grande Chaumière, where she stayed for six years. She was aware of every new current in the avant-garde and was quick to incorporate each into her own work. In Paris she met Léger, Braque, and Picasso, and in Milan the Futurists Marinetti and Boccioni; along with Olga Rozanova, she showed at Milan's "Free Futurist Exhibition" in 1914. The differences between Russian and French Cubism are evident in one of Exter's typical works of this period, *Wine* (1914; Fig. 8-13 Rather than the French predilection for subdued colors and overlapping planes, she uses bold, almost crude colors, with interlocking planes: the wine

FIG. 8-13. Alexandra Exter, *Wine* (1914). Oil and collage. 25⅜″ x 31⅜″. Courtesy Leonard Hutton Gallery, New York.

glasses, fruit, and stenciled letters are all of equal importance. *Venice* (1915) shows the influence of French Cubism, the Delaunays' Simultaneity, and Italian Futurism; these are combined with Exter's own brilliant sense of color and bold patterns and rhythms, which create a dynamic unity.[43]

Back in Moscow in 1914, Exter began her association with Alexander Tairov, the founder of the Moscow Kamerny Theater, whose audiences were largely students and intellectuals. She was free to experiment with Cubist and Futurist ideas and with Tairov developed a system of "Synthetic theater" in which "set, costume, actor and gesture were to be integrated to form a dynamic whole."[44] In their first production, "Famira Kifared," the costumes and sets were conceived as nonobjective forms in space; they revealed "the same passion for movement and the same desire to articulate different planes, stratified and disposed in a spiral and centrifugal movement" as did her paintings. In an extension of the most absurd behavior of the Futurists, the actors were painted to emphasize their movements. They became colored, textured surfaces creating dynamic changes in space; they were "living nonobjective constructions in motion."[45]

When Exter began her exile in Paris in 1924, she taught theatrical design at Léger's Académie d'Art Moderne, where she helped revolutionize French theater, cinema, and puppetry. Her scenic designs are in themselves abstract works of art. The gouache for *Boats* (1930; Fig. 8-14) is composed of verticals and diagonals in various shades of blue and blue-grey. The severe forms are relieved by the black, magenta, and oranges of the oarsmen and the linear diagonals of the oars. Her interest in human form and movement led her to costume design. She also designed chandeliers, rugs, embroideries, furniture, and porcelain. Like many artists of her generation, she viewed art as part of a total environment and strove for the interdependence and interrelatedness of all the arts.

In Paris, Exter lived modestly with her second husband, George Nekrasov, an actor and the son of wealthy Russian tea merchants. He managed the household, delivered her work to exhibitions, and in deference to his more famous wife, frequently introduced himself as "George Exter." During the war years, while living in poverty and suffering from angina pectoris, Alexandra Exter sculpted an angel that now marks her grave. In spite of her illness, she wrote a friend in 1947: "I worked every day; the time passes quickly that way. . . ."[46]

FIG. 8-14. Alexandra Exter, *Boats* (1930). Gouache. 19⅜″ × 26¼″. M. Knoedler & Co., New York, and Fisher Fine Art Ltd., London.

FIG. 8-15. Olga Rozanova, *The Factory and the Bridge* (1913). 32¾″ × 24¼″. McCrory Corporation, New York.

OLGA ROZANOVA (1886-1918)

In 1917, the year before her death, Olga Vladimirov-na Rozanova created a painting with a dark green stripe placed slightly off-center on a scrubbed canvas of a much lighter green—a painting that predates American minimalist conceptions by more than thir-ty years. A devotee of nonobjective art, she wrote in "The Bases of the New Creation and the Reasons Why it is Misunderstood" (1913): "We propose to liberate painting from its subservience to the ready-made forms of reality and to make it first and foremost a creative, not a reproductive, art."[47]

Born in a small village in Vladimir province, Rozanova went to Moscow in 1904. She first studied at the Bolshatov Art College, and then at the Stroganov School of Applied Art, where her interests ranged from poetry to painting and sculpture. An early Futurist, she gained recognition as both poet and painter, and contributed to Futurist publications in both capacities. In 1912 she married Alex Kruche-nikh, a painter and leading Futurist poet.

The Factory and the Bridge (1913; Fig. 8-15) is typical of Rozanova's Futurist paintings. The forms are identifiable, but the slight shifting of planes enhances the dynamism and tension of the urban environment. *Workbox* (1915), an oil and collage at the Tretyakov Gallery, Moscow, shows her analytic

approach to the picture surface, which in turn reflects her interest in both Cubism and Futurism, and eventually Suprematism. Like Goncharova's *The Laundry*, it is an abstraction of objects culled from woman's domestic sphere. On several large, dark areas of color, Rozanova has created a dynamic composition with items from a sewing box.

After the Russian Revolution, as head of the Industrial Art Faculty of IZO Art College, Rozanova began a restructuring of the country's industrial arts education programs. Her attempts to merge art and industry were later realized by the Constructivists. At the time of her death (from diptheria), she was at work decorating an airport to commemorate the first anniversary of the October Revolution. The first exhibit organized by Inkhuk (Institute of Artistic Culture) was a memorial retrospective of her works, featuring 250 paintings in styles ranging from Im-pressionism to Suprematism.

LIUBOV POPOVA (1889-1924)

After Goncharova and Larinov left for exile in Paris, the leadership of the Russian avant-garde fell to Tatlin, Malevich, and Liubov Serbeevna Popova. But few collectors became interested in Popova's work. During and after World War II, her paintings were being used to cover open windows.[48]

Born into an educated and sophisticated family living in suburban Moscow, Popova began her seri-ous study of art in 1909 when she enrolled at the Stroganov School of Applied Art in Moscow. After a year's study she toured Italy, being much impressed by the art of the Renaissance, and by 1912 was at work in the Paris studio of the Cubist painter Jean Met-zinger. As with many Russian artists studying a-broad, she returned home when war began. Popova became closely associated with Tatlin and, along with the other members of the avant-garde, took part in the series of revolutionary art exhibits held in Moscow and St. Petersburg beginning with the famous "Knave of Diamonds" show in 1914.

She soon developed a personal style of abstraction: in *Architectonic Painting* (1917; Fig. 8-16) the jut-ting angular shapes are conceived as layers of planes; the movement is swift and the colors—red and red-orange clashing with pink, grey, black and white— brilliant. Her later work was often done on rough board, the crudely brushed paint helping to create movement. "Texture is the content of painterly surface," she wrote in her essay on Constructivism in the catalogue for the "Tenth State Exhibition."

FIG. 8-16. Liubov Popova, *Architectonic Painting* (1917). 31½" × 38⅝". Museum of Modern Art, New York. Philip Johnson Fund.

"The artistic consciousness must select those elements indispensable to painterly content, in which case all that is superfluous and of no artistic value must be omitted. Hence depiction of the concrete cannot be a subject of painting."[49]

With Varvara Stepanova (1894–1958), Popova eventually worked for the stage director Vsoelod Meyerhold. His theory of bio-mechanics was an application of Constructivist theory to the theater. Like the other Constructivists, she abandoned easel painting for production art, and, in addition to designing revolutionary posters and theater pieces, worked for a time in a textile factory. A member of Inkhuk and later Proletcult (the proletarian cultural organization), she was quoted as saying: "No artistic success has given me such satisfaction as the sight of a peasant or a worker buying a length of material designed by me."[50]

SONIA TERK-DELAUNAY (b. 1885)

Unlike many artists who become anachronisms in their old age despite their youthful radicalism, Sonia Terk-Delaunay continues to be avant-garde in her work. Although she deliberately limited her search to a narrow area, her influence has been universal. Through her fabric and poster designs, costume and fashion creations, book illustrations, playing cards, stained-glass windows, and automobile interiors, she surreptitiously introduced modern art to an unsuspecting public. Among the artists indebted to her are Paul Klee, Franz Marc, Ellsworth Kelly, and Bridget Riley.

Terk-Delaunay began to be known as an artist only after her husband's death. Although both worked on the theory of Simultaneity together, Robert was the public theorist and exhibitor. Sonia rarely spoke of her art, and believed a dealer would have limited her freedom. Since she never created a "product" but rather responded to an "inner necessity," she cared little for public or critical acclaim.[51]

Sonia Terk was born in the Ukrainian village of Gradizhsk. The unusual circumstances of the artist's early childhood do not seem to have affected her psychological development adversely. The youngest of three children, she was adopted at the age of five by her maternal uncle, Henry Terk, a wealthy Jew whose townhouse in St. Petersburg was filled with an extensive collection of Barbizon art. Although her father visited her once in Paris, she never saw her mother again. Educated at home by three governesses

concurrently until she was fourteen, Sonia learned German, English, and French, and in 1903 left for Germany to study with the respected academician Ludwig Schmid-Reutte. Since she never entered any of the Russian academies, she had no contact with the young Russian avant-garde, many of whom were her contemporaries, and because of her long association with the French iconoclasts, she is usually considered a French artist.

After two years in Germany, Sonia left for Paris to enroll in the Académie de la Palette. In a 1965 interview she described her first few months in Paris: "I'd bought three books on Impressionism in Germany. I wanted to live near it, near Sisley and Monet, near their airiness and lightness. I began in a horrible school where five teachers took turns. In the evenings we broke out and went to see Bonnards and Vuillards [we] found Matisse too timid, too bourgeois. We wanted to go further. . . ."[52] She also discovered Van Gogh and Gauguin, and her first important painting of the early Parisian years, *Philomene* (1907), is a synthesis of Gauguin, Matisse, Van Gogh, and Russian peasant art.

In Paris she met Kandinsky, and probably Münter, Jawlensky, and Von Werefkin. A neighbor was the German art critic, collector, and gallery owner Wilhelm Uhde, to whom she turned when her family began pressuring her to return home. Their marriage of convenience, which took place in London, lasted for one year. It was at Uhde's gallery that she had her first one-woman show (she did not have another for fifty years), and through Uhde that she met the Cubists, the Fauves, and Robert Delaunay. "I was carried away by the poet in him, the visionary, the fighter," she later recalled.[53] There was a civil divorce from Uhde, and Robert and Sonia Terk-Delaunay, in 1910, began an extraordinary collaboration of life and art that was to produce one son, Charles (1911), and several grandchildren. They were supportive rather than competitive, were each other's best critics, and were able to build two separate oeuvres based on mutual dependency, mutual respect, and shared theories.

The birth of her son was the occasion of Terk-Delaunay's first experiment with complete abstraction. She described the project, created for the baby:

. . . I had the idea of making . . . a blanket composed of bits of fabrics like those I had seen in the homes of Russian peasants. When it was finished the arrangements of the pieces of material seemed to me to evoke Cubist conceptions and we tried then to apply the same process to other objects and paintings.[54]

FIG. 8-17. Sonia Delaunay, *Electric Prisms* (1914). 93¾″ × 98¾″. Musée National d'art moderne, Paris.

FIG. 8-18. Sonia Delaunay, *Portuguese Market* (1915). 35⅝″ × 35⅝″. Museum of Modern Art, New York. Gift of Theodore R. Racoosin.

With the blanket came not only more serious experiments with collage, but a complete redecoration of their apartment.

During the period in which the Delaunays were experimenting with the relationship between color and light, the night lights of Paris had changed from illumination by gas to that of the electric lamp. They were fascinated by the "multi-colored haloes" created by the light's reflection, and by the rings encircling the moon, that other source of night light. Terk-Delaunay's most significant painting after these discoveries was *Electric Prisms* (1914; Fig. 8-17, which in reality is an analysis of decomposed light. In it can be seen the source of much of her subsequent work. (The printed words on the left, added as an afterthought at the suggestion of Robert, act as an advertisement for her collaborative simultaneous work with the poet Blaise Cendrars.) Approximately eight feet square, the painting is dominated by two interlacing circular prisms of brilliant, sensuous color that expand into increasingly larger arcs. Light was a recurrent theme in avant-garde poetry of the period; Apollinaire speaks of a "world revived, bathed, transformed by natural and artificial light." Essentially, this was also the theme of the Delaunays' paintings. The Delaunays' discs are meant to be cosmic and mystical; the artists seized upon them as the "form that least restricts color, and at the same time contributes a maximum of dynamism to a composition."[55]

Another of Sonia's significant paintings of the pre-war period was *Le Bal Bullier* (1913), developed from a series of studies made at the notorious dance hall of that name in Montmartre, where the tango was all the rage. The Delaunays dressed for such occasions in "simultaneous" clothes designed by Sonia that, according to Apollinaire, "transformed fantasy into elegance." Three other versions of the painting were made: the figures of the dancers eventually disappeared, leaving only movement and light.

When World War I broke out the Delaunays were in Spain. They spent six years on the Iberian peninsula continuing their researches into light and color. Perhaps under the influence of the "intimate sunshine of Portugal," the exotic marketplaces with their rich variety of vegetables, and the brilliantly colored and patterned costumes of the peasants, or because of their fear of becoming too intellectual and remote, there was a brief return to figuration on the part of both Delaunays. In *Portuguese Market* (1915; Fig. 8-18) Sonia has captured the bright colors and forms of the marketplace. Although most of the

FIG. 8-19. Sonia Delaunay, *Poster for International Women's Year, 1975.* 22½″ × 30¼″. UNESCO, Paris.

"fame and fortune," has diminished her reputation as a serious artist. The separation of artist from craftsperson dates from the Renaissance notion of individual creative genius. (Michelangelo would dine with kings, not artisans). Although there have been exceptions, the dichotomy persists: Terk-Delaunay's attempt to redesign the objects of daily life, while paving the way for the acceptance of modern art and design by the masses, has relegated her to a secondary status in the history of art. This assessment tends to be reinforced by the fact that crafts and design have traditionally been patronized as "woman's work."

From about 1931 to 1935 Terk-Delaunay again concentrated mostly on painting. During the first years of World War II the Delaunays were in Meudon in unoccupied territory sharing a house with the Arps. Despite the horrors of the war, it was a productive period for all of them. After Robert's death in 1941, Sonia occupied herself for a decade with making inventories of his documents, arranging exhibitions, and assisting Pierre Francastel in preparing a definitive study of her husband's work.

Today, after more than seventy years of painting, Sonia Terk-Delaunay still expresses a *joie de vivre,* a lyricism, and a dynamic tension in her work. Art is still part of her total pattern of living: she continues to create fashion as well as furniture, prints for fabrics, and painting—all equally important in her estimation. As she put it in a recent interview: "One day you make paintings and one day you make clothing."[56] In 1975 she was commissioned by UNESCO to create the poster that came to symbolize the International Women's Year (Fig. 8-19).

MARIE LAURENCIN (1885–1956)

Marie Laurencin's work has always drawn praise for its essentially "feminine" quality. Approvingingly, Rodin noted that "here is one who is satisfied to be a 'fauvette;' she knows what grace is; she's serpentine." Apollinaire declared that she had brought "feminine art to major status."[57] Her thin, sloe-eyed female figures (all self-portraits) exist in a rarified atmosphere; even her attempts at nature do not explore the natural world. "Everywhere today one sees her blue and grey rose confections, flat decorations of fluttering, wraith-like women whose ancestors are the ladies in Persian miniatures, 18th-century prints, and even the profile pastels of Manet," wrote a critic in 1932.[58]

While most men found her charming, she seemed

forms in the tightly structured painting are still derived from the disc, the gaiety and spontaneity of the people and products at the colorful gathering are also evident. (Sonia returned to abstraction with her fabrics in the 1920s, but Robert did not entirely abandon nature again until after 1930.) It was in Madrid in 1917 that the Delaunays met Diaghilev, who asked Robert to do the sets and Sonia the costumes for his new production of "Cleopatra."

A commission from the Lyon silk manufacturers in 1922 for Sonia to create fifty designs came at a fortuitous time; she had lost her income from home after the Revolution, as had Robert several years before. Her "simultaneous fabrics" were an extension of her paintings: each assignment presented a new problem in design and color and an opportunity to continue her research into color. Unfortunately, Terk-Delaunay's association with fashion and fabric design, while bringing her the proverbial

FIG. 8-20. Marie Laurencin, *Group of Artists* (1908). 24¾″ × 31⅛″. Baltimore Museum of Art, Cone Collection.

to have irritated the women in her circle. Sonia Terk-Delaunay considered her a "social butterfly" who could paint only at Apollinaire's suggestion. When asked recently to evaluate Laurencin's work, Terk-Delaunay replied: "I hate it."[59] In a 1945 interview, Fernande Olivier, companion to Picasso during his Cubist period, stated: "In spite of Apollinaire, who was very much infatuated, and wanted to impress her upon us, she did not immediately penetrate into our intimate circle. Not particularly natural, she seemed

to us to be putting on airs, to be a little stupid, very affected, concerned above all about the effect she had produced."[60]

Marie Laurencin was born in Paris, the illegitimate child of an unknown father. She lived with her mother, a virtual recluse who earned her living embroidering designs created by her daughter. Although always interested in art, Marie received little encouragement from her drawing teachers at the Lycée Lamartine, which she attended until she was

twenty. Nevertheless, she continued her studies in evening classes at the Académie Humbert (Braque was a fellow student) and made her professional debut at the 1902 Salon des Indépendents. When Laurencin first met Apollinaire (through an art dealer), she was earning her living as a porcelain painter. Enchanted by her naïveté, the poet introduced her to his circle of friends who frequented the Bateau-Lavoir, the café in Montmartre where radical artists and poets could be found at almost any time of the day debating the merits of Cubism and other affairs of taste. Although she rarely participated in these theoretical exchanges, Laurencin—unlike the women of Impressionism—was actually there to witness the excitement. Apollinaire was delighted with her: "She is gay, she is kind, she is witty, and so talented. She is like a sun. She is myself, in the form of a woman."[61] He became her constant champion, defending her from all those who accused her of being superficial; he linked her with Picasso, Braque, Derain, and Matisse, and categorized her work as a type of "scientific Cubism." When Gertrude Stein purchased Marie's group portrait of the artist with Apollinaire, Picasso, Fernande Olivier, and Picasso's dog Frika, Laurencin was at last taken seriously as an artist. Organized around the central figure of Apollinaire, the painting is composed of sweeping arabesques and flat patterns of color. Picasso is painted in the Egyptian manner—in profile, with a frontal view of the eye, and the angularity of Olivier's face is emphasized by the use of Cubist structuring. The delicately etched features suggest the contemporary vogue for orientalism. All in all, it is a decorative and pleasing painting with, however, none of the intellectual discipline of Cubist art (Fig. 8-20).

Laurencin and Apollinaire were inseparable; she became his muse, he her Pygmalion. Before their relationship he was known as an intellectual and a critic; with her support, he became a poet again. Their friend Henri Rousseau painted them together as Le Poète et sa Muse. She acted as the hostess for his famous soirees, and her own home in Auteuil soon became the gathering place for the Cubists and other habitués of Montmartre. Laurencin reigned like a queen, with her cat, whom she said was the model for all her female faces. As she became popular, her influence was felt in the world of fashion and interior design. With this blossoming into independent womanhood came violent quarrels with Apollinaire, who could not tolerate her new strength; their relationship ended after five years. In 1914 Laurencin married the aristocratic German painter Otto von Waetgen, and subsequently found herself an enemy of France when war broke out. She and her husband spent the war years in Barcelona. There she met Francis Picabia and contributed both poems and drawings to "391," his Dada review. After divorcing Von Waetgen in 1920, she returned to Paris.

In addition to her paintings, Marie Laurencin worked extensively in etching and lithography. She illustrated Edgar Allan Poe's "The Raven," a version of Alice in Wonderland, and works by Apollinaire and Gide. She also designed sets for Diaghilev's Ballets Russes and for the Comédie Française. In 1937 she was invited to show her paintings in the Historic Masters of Independent Art exhibit at the Petit Palais. Her waning years were spent in isolation among her books, many of which were authored by her friends. At one point the artist succinctly described herself: "Loves luxury. Very proud of having been born in Paris. Likes neither long speeches nor reproaches nor advice, nor even compliments. Eats quickly, walks quickly, lives quickly. Paints very slowly."[62]

SOPHIE TAEUBER-ARP (1889–1943)

Sophie Taeuber was born in Davos, Switzerland, and studied at the St. Gall School of Applied Arts and the Debschitz School in Munich from 1909 to 1912. When she met Jean Arp at the Tanner Gallery in 1915, she was teaching weaving and textile design at the Zurich School of Arts and Crafts. Like many wives of famous artists, she chose not to publicize herself. Yet Jean credits his success to her inspiration: "It was Sophie Taeuber who, through the example of her clear work and her clear life, showed me the right way, the way of beauty. . . . the limpid serenity that emanated from the vertical and horizontal compositions of Sophie Taeuber . . . influenced the baroque treatment, the diagonal structure of my abstract 'configurations.' "[63]

The couple did not marry until 1921, but their artistic collaboration began almost immediately. Of their first work together in 1915, Jean wrote: "[We worked with] the simplest forms, using painting, embroidery and pasted paper. They were probably the first manifestations of their kind, pictures that were their own reality, without meaning or cerebral intentions. We rejected everything in the nature of a copy or a description, in order to give free flow to what was elemental and spontaneous."[64] Both were

FIG. 8-21. Sophie Taeuber-Arp, *Parasols* (1938). 35″ × 25″. Rijksmuseum Kröller Müller, Otterlo, The Netherlands.

active in the Dada movement, and some of Sophie's most inventive pieces were inspired by it. These included a series of mechanical puppets and a *Dada Head* (1920), a painted wood sculpture made from a hat stand decorated with geometric forms and including the letters DADA and the numbers 1920.

Taeuber-Arp is among the pioneers of geometric abstraction. A duo-collage of 1918 constructed of rectangular-shaped luminous colors attached vertically and horizontally like so many bricks is credited to her initial invention. Sophie successfully transformed some of Jean's paintings into tapestries (*Pathetic Symmetry*, 1916–17) and taught him to embroider so he could do the same. A continual exchange of ideas took place between the two artists throughout their lives. At times their work is quite similar, but there remained an essential difference: Sophie's work always retained a "certain craftlike quality," and was "delicate but precise." While her ideal was always "clarity," Jean was more concerned with the unconscious and the "law of chance."

After 1920, Jean abandoned geometry to explore

the world of amorphous, curvilinear shapes, while Sophie's work became increasingly rectilinear. The pulsating rhythms and movements of the "taches quadrangulaires" of the 1920s anticipate Mondrian's *Broadway Boogie-Woogie* (1942) by almost twenty years. In 1926–27, along with the De Stijl painter Theo van Doesburg, she designed the boldly geometric interior of the Café L'Aubetter in Strasbourg.

Taeuber-Arp's most inspired work may be the wood polychrome reliefs she created between 1935 and 1938. These are flawlessly executed works without "artifice or affectation."[65] *Shells and Flowers* (1938) is a painted circular relief with precisely excised geometric forms suggestive of the title. *Parasols* of the same year is composed of nonobjective geometrical forms mounted on a rectangular board (Fig. 8-21). Taeuber-Arp was a member of the Abstraction-Création group—she did lithographs for their publications—and participated in the Cercle et Carré exhibitions. By 1942, when it was no longer safe to remain in France, the Arps again exiled themselves in Zurich, where in the following year Sophie died suddenly of accidental gas poisoning in the home of the sculptor Max Bill.

A joint Arp exhibition was held at the Sidney Janis Gallery in New York in 1950. On display were both their individual works as well as their collaborations. As the reviewer in *Art Digest* wrote: ". . . she chose the straight line, the deliberate form; her husband chose the curve, the chance shape."[66] Sophie also took greater liberties with color. Their collages, tapestries, and reliefs were frequently attacked by critics for being mere "applied art" or "craft." In the privately printed *Jalons* (1951), Jean wrote in defense of Sophie:

Sometimes her work has been described as applied art. Stupidity as well as malice inspire such a remark. Art can be expressed just as well by means of wool, paper, ivory, ceramics, glass as by painting, stone, wood, clay . . . Art is always free and liberates the objects to which it applies itself.[67]

GERMAINE RICHIER (1904–1959)

When, shortly before her death, Germaine Richier explained the meaning of her art, she became very uncomfortable: "It's not easy to say all that. If I had the words, I'd be a writer." Nevertheless, her explanation was poignant and succinct: "Our age, when you consider it, is full of talons. People bristle, as they do after long wars. It seems to me that in violent works there is just as much sensibility as in poetic

ones. There can be just as much wisdom in violence as in gentleness."[68] Richier's sculpture has sometimes been compared to that of Giacometti, to the grotesqueries of the Gothic style, and to the distortions in African primitive sculpture. Her work has been described as both surrealistic and expressionistic; indeed, some works often combine both spirits. There is also a feeling for the organic—she frequently cast directly from nature (the legs and face of one of her figures of Don Quixote were cast from rotting tree limbs; the skin of the tall female figure in *The Leaf* (c. 1955) is composed of leaf imprints).

Germaine Richier was born in the Arles region of France, where her father was a wheat and grape farmer; when she was old enough to go to school the family moved to Montpellier. Since she refused to take exams, her formal education was minimal. What excited her most during her childhood was nature: "The animals, the insects! I kept cocoons, in order to watch the silkworms. Oh, the praying mantises, the ants and grasshoppers! I had whole regiments of grasshoppers!" she told an interviewer in 1958.[69] Essentially, Richier's work is concerned with the life cycles in nature—birth, growth, and decay. Although in her maturity she resisted the "lure of nature," this early interest pervades her work. Unlike most successful painters, she did not fill up her notebooks with drawings. In fact, she rarely drew as a child. What intrigued her was building and playing with cement and creating figures with stones.

Against her parents' wishes—her father claimed "Women aren't made for art"—Germaine enrolled at the Montpellier École des Beaux-Arts in 1922. But the teaching was uninspiring, and since there was no sculpture to be seen in Montpellier, she went to Paris in 1925 to enter the atelier of Antoine Bourdelle, a former student of Rodin. (Giacometti was also a student of Bourdelle.) "Everything I know I learned from him," claimed the artist. "He taught me to read a form, to see forms."[70] After leaving Bourdelle's studio in 1929, Richier took students and did portrait busts, which are sensitive analyses of form and personality, much in the tradition of Rodin. But she sold little and was supported by her older brother, a businessman in Marseilles. In 1929 she married a fellow student, the Swiss sculptor Otto Bänninger.

Richier's first Paris exhibit was at the Gallery Max Kaganovich in 1934. In 1937 she received several awards, including the Blumenthal Prize for Sculpture for work exhibited at the Petit Palais, and the Diploma of Honor for work shown at the International Exhibition in Paris. She also was invited to show at the Women Artists of Europe exhibition

FIG. 8-22. Germaine Richier, *Hurricane* (1948–1949). Bronze. Musée National d'art moderne, Paris.

(along with Valadon and Laurencin), held at the Musée du Jeu de Paume. During World War II the Bänningers exiled themselves in Zurich, where both

maintained studios and Richier continued to teach. After the war she returned to France alone (the couple had divorced) and was invited to exhibit at the 1947 International Exhibition of Surrealism; in 1948 she had her first one-woman show. Her post-war works show her reaction to the violence and decay of the war years. In 1955 she married the writer René de Solier.

The rooms at the Martha Jackson Gallery, where in 1957 Richier had her first one-woman show in New York, looked "like a jungle in an advanced state of decrepitude."[71] Included was *The Batman* (1946–56), the wings of which are delicate, spidery filigrees of bronze webbing that defy the properties of the material. Indeed, the delicacy of some of the casting in her work is miraculous, and the patinas a combination of science and mystery. Using a series of acids, the patina-maker first brushes on the bronze and then burns it with a blow-pipe—his methods remain his secret. In the small *Horse with Six Heads* (1953), also in the exhibit, the galloping horse's body and legs are pierced to near transparency. The heads are ravaged and rotted but still animated in a macabre dance of death. *Storm* and *Hurricane* (Fig. 8-22), life-sized bronzes of the late 1940s, are menacing and threatening figures: two decomposing human beings, their flesh "pitted, torn and lacerated," stand as male and female metaphors for the turbulent natural disasters implied by their titles. Their partially fragmented faces are filled with the terror of the battle-scarred; their sinewy arms extend to spidery hands and their thin legs support expansive bodies. Richier's series of praying mantises are both sinister and menacing; again they explore the theme of nature in the process of decomposition.

In the 1950s Richier began experimenting with environments for her pieces. The small bronze *Sculpture with Background* (1955–56) is more abstract than her earlier work and is set on a rectangular bronze sheet, the back of which is a small pitted bronze rectangle. Her collaborations with Maria Elena Vieira da Silva resulted in what have been described as "curious works," some relief sculpture, and experimentation with paint on plaster surfaces. Unfortunately for Richier, life duplicated art: the decay of flesh portrayed in her work was now occurring within her own body; she died of cancer in 1959, optimistic and productive until the end.

MARIA ELENA VIEIRA DA SILVA (b. 1908)

Maria Elena Vieira da Silva has traditionally been identified with the School of Paris, the loosely linked group of abstract painters whose work evolved from the explorations of the Cubists and their followers that flourished in France after World War II with the return from exile of the masters of the avant-garde.

Born in Lisbon, Portugal, she had the good fortune of having her entire family support her desire to pursue a career as an artist. Vieira da Silva first went to Paris in 1928 to study sculpture with Bourdelle (where she most likely met Richier) and Charles Despiau. When she decided to concentrate on painting, she entered the studios of the Fauvist painter Othon Friesz and later the Cubist Leger. She became a French citizen in the 1950s and has since then lived in a small house in a remote section of Paris that she and her husband, the painter Arpad Szenes, built after World War II.

Her work in the 1930s was more abstract than that of the succeeding decade, when, as she described it, she began "painting landscapes from nature."[72] Her inspiration comes from cities, from electric railways, steel scaffolding, bridges, and cloudy skies and rocky landscapes (Fig. 8-23). "The space of her cities and the architecture of her landscapes are translated in terms of a natural, spontaneous geometry. Form is neither compressed nor silhouetted and there are no flat elements in her constructions."[73] constructions."[73]

Vieira da Silva does not explain the meaning of her art, but she has frequently described the method by which she works. It is not the actual painting that takes time, but the waiting in front of the canvas for something to occur. "There are times," she said in a 1961 interview, "when I start off aimlessly making tiny squares and lines out of which hundreds of things might, or might not, evolve. But it is a means of passing the time while seeking a way of getting to grips with the canvas and making some sense out of it. . . ." A slow, painstaking worker, the artist works directly on the canvas without making any preliminary sketches. If inspiration comes quickly, she will work boldly; otherwise, a dot, or a square, or a few lines added together begin to take shape and construction begins.[74]

Vieira da Silva's cityscapes are a strange combination of perspective and lack of it, a fusion of Renaissance space and the Cubist grid. *The Invisible Strollers* (1951) captures the spirit of the city—a city where confusion reigns and nerves jangle, but devoid of people. In *Iron Bridges* (1954), the tension and thrust of the structures are rendered through forms (mostly rectangles or squares slashed by diagonals) that are static yet clashing. By contrast, *Aerial Metro* (1955) has delicately sweeping curves and a lighter palette. There is the feeling of flight; the "perspective" is that which can only be seen from an airplane window. In

FIG. 8-23. Elena Vieira da Silva, *Stones* (1950). 19¾″ × 25½″. The Phillips Collection, Washington, D.C.

works of the late 1950s, such as *Enchantment* (1958), the grid is less obvious and space is even more compressed. Inspiration must have come quickly in this painting, for the brushwork seems as spontaneous as that used by the Abstract Expressionists. Vieira da Silva's color is often subdued, with pale greys and white predominating.

MERET OPPENHEIM (b. 1913)

Meret Oppenheim's famous "fur-covered tea cup" has become a metaphor for the audacity of· the modern artist. Ironically, however, most students of art have until recently assumed that its creator was a man.

Meret Oppenheim was born in Berlin of a German father and a Swiss mother. Her maternal grandmother was a writer and an activist in the Swiss League for Women's Rights. When World War I began the family returned to neutral Switzerland. Meret studied in both Basel and Germany, and in

1932 left for Paris to enroll in the Académie de la Grande Chaumière. When she first saw the works of the Surrealist Max Ernst, she was impressed and inspired by his vision; in Paris she also met Giacometti and the Arps, who introduced her to André Breton and invited her to show with the Surrealists. She exhibited with them for the first time in 1933 and was a regular at the Surrealist meetings, ceasing to attend shortly before Breton's death in 1966 only because the gatherings began to bore her. An attractive and lively eighteen when she first encountered the Surrealists, Oppenheim became their "fairy princess" and "mascot," and the model for many of Man Ray's most compelling photographs. According to one contemporary, "Her uninhibited behavior and inventive grace made her the perfect example, both in her life and her art, of the Surrealist woman."[75] At seventeen, she had decided either not to marry or to wait until she was mature and sure of her own identity. She did eventually marry—at thirty-five—and remained happily wed until 1968, when her husband of twenty years died.

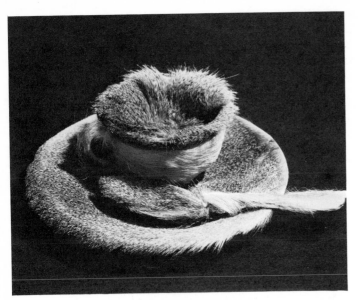

FIG. 8-24. Meret Oppenheim, *Object (Le Dejeuner en fourrure)* (1936). Fur-covered cup, saucer, and spoon. Cup 4⅜″ diameter, saucer 9⅜″ diameter, spoon 8″ long, over-all height 2⅞″. Museum of Modern Art, New York.

Max Ernst wrote the preface for the catalogue to Oppenheim's first one-woman show held in 1936 in Basel. That same year Breton organized the first large-scale Surrealist exhibit, "Crise de l'object." The sensation of the exhibit was Oppenheim's *Object (Le Déjeuner en Sourrure* (Fig. 8-24). When, also in 1936, the Museum of Modern Art in New York mounted an exhibition on "Fantastic Art, Dada, Surrealism," Oppenheim's "fur-lined teacup" was chosen by visitors from among the approximately 700 items on view as the symbol of the entire show; it soon became the symbol for the seven-year-old museum itself.[76] This was not in keeping with Oppenheim's intent, however. To the artist, the *Object* was a joke, a product of her youthful rebellious spirit.[77]

The ensuing publicity depressed her. In fact, Oppenheim never cared for publicity, or actual approbation, nor did she ever promote herself or her work—"the work has to speak for itself." Annoyed at the constant requests to repeat her earlier triumph, the artist in 1972 decided to satirize her original satire by making an edition of 120 fur-lined teacups and saucers, with spoons, and placing them under glass.

After her initial success, little was heard from the artist. Exiled in Switzerland during World War II, she was cut off from the avant-garde; a period of self-doubt between 1944 and 1956 yielded very little work. After Jungian analysis, the artist's self-confidence returned, and at the International Surrealist Exhibi-

tion held in Paris in 1959 she created another sensation: In the "object porteur d'idée" (object bearing an idea) entitled *Woman as Banquet*, three men and two women are shown feasting at a banquet where a nude woman is the centerpiece. According to the artist, the work has been misinterpreted. It is not woman as a delectable feast, "an object of beauty to be consumed," or a protest against sexism, but a fertility rite for woman as nurturer in which both men and women partake.[78]

Although Oppenheim has always felt part of the "very enlarged woman's movement," she refuses to exhibit in sexually segregated exhibitions. She has written eloquently about the problems of being a woman and the need for attitudinal changes on the part of both men and women:

It is important to know that the impediment is in our mind We cannot ask men to change their attitude towards us. . . It is much more than only an old prejudice to fight against. . . . We, men and women, must become conscious that we are on the point of leaving a state, the patriarchal, which was very important for humanity to pass through. It does not, of course, treat of a return to the matriarchy . . . both together have to develop the qualities which have been neglected—to develop intellect—which is intuition, sensibility, and real wisdom.[79]

LEONORA CARRINGTON (b. 1917)

Leonora Carrington is a writer as well as a painter; the themes of her paintings and stories are interchangeable. Whatever the displacements, incongruities, or unexpected juxtapositions, all her works display the artist's peculiar sense of humor. A line from "The Oval Lady," 1939, reveals her vision: "I saw her wave her hand above the balustrade, and while she was waving it, her fingers became detached and fell to the ground like shooting stars."[80] In order to put us "in contact with the multiple realms and levels of our experience," Carrington, in both her painting and her writing "delves into the unexplored and unchartered vistas of the imagination, searching for the new horizons that we discover when we are in touch with our psychic powers. . . ." Her search has led her to explore alchemy, the Cabala, the occult, and Zen Buddhism.[81]

Born near Lancashire, England, she was the daughter of a "self-made" president of the Imperial Chemical Industries conglomerate. For two years, from 1932 to 1934, she attended schools in Paris and Rome, and at nineteen (1936) became the first student at Amédée Ozenfant's "Purist" academy in London.

There she met Max Ernst, who reinforced the direction of her work. She returned with him to Paris, where he introduced her to Breton and the Surrealist poet Paul Eluard. With Ernst's support and encouragement, she won the respect of the Surrealists and immediately began exhibiting with them. Her early paintings were done in egg-tempera on wood panels which she polished with pristine, enamel-like finishes; her later works are more somber in tone, with hazy atmospheric effects replacing the former jewel-like clarity.[82]

Carrington's 1937 *Self-Portrait* (Fig. 8-25) reveals the peculiar juxtapositions of the Surrealist imagination. The wild-eyed, wild-haired artist has seated herself—rather uncomfortably—in a delicate, blue Victorian chair. The animals with which she surrounds herself exist on various levels of reality: suspended in space behind her head is a white hobbyhorse, while a realistic white horse prances off into the extended vista seen through an opening in the rear wall on the left half of the canvas; a strange-looking beast with three bulging teats and an anthropomorphic face stands at her knee.

With the advent of World War II, Ernst, a German citizen, was incarcerated by the French authorities before being permitted to emigrate to America. Distraught by these events, Carrington fled to Spain, where because of her emotional state she was committed to a mental hospital. Realizing that their patient was "more inspired than mad" and a casualty of the war, her doctors released her. In 1943 she retold the tale of her anguish, and of the inability of the hospital staff to reach her, in a poetic little book entitled *En Bas*, which was published the following years in English translation in the American Surrealist journal *VVV*. A sympathetic Mexican diplomat offered to marry her in order that she might leave the country. She accepted, and after a brief period in New York, where many of the original Surrealists were living in exile, the couple moved to Mexico, where Carrington still lives. Her first marriage was brief, and in 1946 she married the Hungarian photographer Emerico Weisz, by whom she had two sons.

The only painting by Carrington that seems to have been inspired by the myths and legends of the ancient Mexicans is *El Mundo Mágico de los Mayas*, a mural commissioned by the Museum of Anthro-

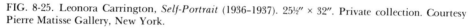

FIG. 8-25. Leonora Carrington, *Self-Portrait* (1936–1937). 25½″ × 32″. Private collection. Courtesy Pierre Matisse Gallery, New York.

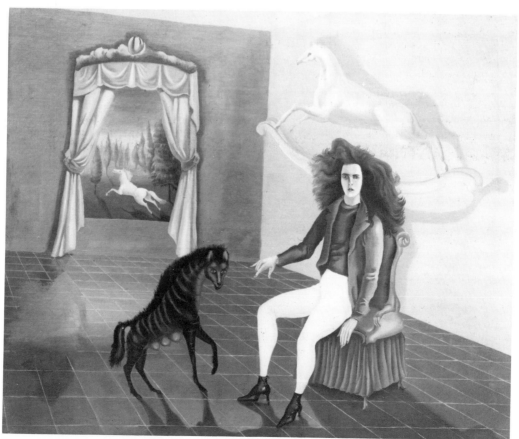

pology in Mexico City and dedicated to the State of Chiapas. Her largest painting to date, it incorporates the legends, symbols, customs, and mythology of the xenophobic Chamula Indians.

In 1946–47 a film company sponsored a competition for a painting of "The Temptation of St. Anthony" to be used in a filmed version of De Maupassant's story. Eleven artists, including Dorothea Tanning and Max Ernst (whose entry won), submitted works; each was invited to describe their painting in the catalogue for a subsequent group exhibit of all the entries. Carrington described hers as follows:

The picture seems pretty clear to me, being a more or less literal rendering of St. Anthony complete with pig, desert and temptation. Naturally one could ask why the venerable old man has three heads—to which one could always reply, why not?

You will notice the veteran's suit to be whitish and of an umbrelloid form which would lead one to believe that the original color had been washed or bleached out by the vagaries of the weather or that the monkish apparel had been cleverly constructed out of used mummy wrappings in umbrella or sunshade form as a protection from sand storms and sun, practical for someone leading an open air life and given to contemplation. . . .

The Saint's traditional pet pig who lies across the nether half of the picture and reviews the observer out of its kindly blue eye is adequately accounted for in the myth and likewise the continually flowing water and the ravine.

The bald-headed girl in the red dress combines female charm and the delights of the table—you will notice that she is engaged in making an unctuous broth . . .[which] has overflowed and taken on a greenish and sickly hue. . . .

And last to the ram with the earthenware jar—one could only quote the words of Friar Bacon's brazen head: Time was—Time is—Time is past. I was always pleased with the simple idiocy of these words.[83]

In satirical paintings such as *Edwardian Hunt Breakfast* (1956), *Professional Ethics* (1955), and *Litany of the Philosophers* (1959), the artist has used her peculiar vision to mock our social, political, and educational institutions. Her work in the 1970s at the Brewster Gallery, New York, is as cryptic as ever. She now uses acrylics on her small, exquisitely detailed canvases.

Carrington's "Commentary" in the catalogue to her 1976 retrospective exhibition organized by the Center for Inter-American Relations, New York, touched briefly and mystically upon the problems of being female:

The furies, who have a sanctuary buried many fathoms under education and brain washing, have told Females they will return, return from under the fear, shame, and finally through the crack in the prison door, Fury. I do not know of any religion that does not declare women to be feebleminded, unclean, generally inferior creatures to males, although most Humans assume that we are the cream of all species. Women, alas; but thank God, Homo Sapiens . . .! Most of us, I hope, are now aware that a woman should not have to demand Rights. The Rights were there from the beginning; they must be Taken Back Again, including the mysteries which were ours and which were violated, stolen or destroyed, leaving us with the thankless hope of pleasing a male animal, probably of one's own species.[84]

BARBARA HEPWORTH (1903–1975)

Barbara Hepworth's earliest memories are of the shapes, textures, and forms of the Yorkshire landscape. From the beginning she saw nature with the eye of a sculptor. Riding with her father, an impoverished engineer, the youngster was aware of the "sensation of moving physically over the contours of fullnesses and concavities, through hollows and over peaks," a sensation that never left her. "I, the sculptor, am the landscape," she wrote in her spare and moving pictorial autobiography. "I am the form and I am the hollow, the thrust and the contour."[85]

There was a strange combination of discipline and liberalism in her home: through her mother's frugality she was able to study music and dance, and her father fulfilled his promise to his three daughters and saw that they received an education equal to that of their brother. At the Wakefield Girls' High School, the perceptive headmistress arranged for Barbara to sit for a scholarship to the Leeds School of Art, where she first met Henry Moore, the sculptor whose work has been most closely associated with her own. After only nine months at Leeds, and then not quite sixteen, she left to begin the three-year course of study at London's Royal College of Art. Moore joined her in this venture, and after receiving their diplomas, they were each awarded traveling scholarships to Italy. For two years Barbara Hepworth wandered through Italy, observing and absorbing the "new bright light and the new idea of form in the sun." She produced little work, but learned carving from the Italian master Ardini. She also married the sculptor John Skeaping, with whom she lived at the British School in Rome. Hepworth's carvings of the late 1920s—*Seated Figure* and *Torso* of 1927, *Infant* of 1929—were naturalistic in conception, but also showed her respect for the carvings of primitive peoples.

Shortly after the Skeapings returned to England their son Paul was born and their relationship began to deteriorate. "I had an obsession for my work and my child and my home. John wanted to go free."[86] Friends had warned her that her family would interfere with her art, and that it was impossible to devote herself to both. Like Morisot, Kollwitz, Terk-Delaunay, and many other women artists before her, Hepworth believed this to be untrue: "I had nearly thirty years of wonderful family life; but I will confess that the dictates of work are as compelling for a woman as for a man. Not competitively, but as complimentary, and this is only being realized." She worked every day, even if for just an hour, or at midnight, when her children were small. When they fell ill, or there was a family crisis, she found that the only way she could work through her anxiety was to create a new form, a beautiful object. "Having children suited me well as an artist," she told an interviewer in 1959, "and I always felt that the time which is given up by a woman artist flows back into this relationship. It is something which nourishes art."[87] (When Paul, who became an R.A.F. pilot, was shot down over Thailand in 1953, Hepworth responded with one of her few religious expressions—a *Madonna and Child* for the St. Ives Parish Church. It is a closed form, the silhouette not unlike her other works of the period. Only in details does it differ: the features are coolly geometricized like Egyptian carvings, but the tenderness between mother and child bears witness to the mother's suffering.)

In 1931 Hepworth met and married the painter Ben Nicholson; their union lasted twenty years. This close association was mutually beneficial: he introduced her to the world of color and she in turn sharpened his sense of form; each was the other's most respected critic. Through their travels to the Continent and their contacts with the European avant-garde, Hepworth and Nicholson introduced modern art to England; they were part of the first generation of English artists to attempt to break with England's academic tradition.

In 1934 Hepworth gave birth to triplets—two girls and a boy. With only the income from Nicholson's white reliefs and Hepworth's carvings, the family's situation was precarious. They survived however, the children intensifying their sense of purpose.

When Hepworth returned to her studio after the birth of her children, her work changed. All direct references to nature disappeared and she became more involved in the formal aspects of the work—the "relationships in space, in size and texture and weight, as well as in the tensions between forms"—

explorations which continued to occupy her throughout her life. While Hepworth was associated with the English Constructivists of the 1930s, she never acquiesced to their strictly formalist perceptions. Her art, although abstract, was always organic, rooted in nature and the human form. Even her largest pieces are conceived on a hman scale, and are related to the people who walk through and around them, rather than to the architectural or landscape setting.

FIG. 8-26. Barbara Hepworth, *Nanjizal* (1958). Wood. Height 98". The Tate Gallery, London.

FIG. 8-27. Barbara Hepworth, *Single Form* (1964). Bronze with granite base. Height 21'. United Nations, New York, through a grant by the Jacob and Hilda Blaustein Foundation.

Essentially a carver rather than a modeler because she liked the resistance to hard material, Hepworth knew intimately the stones, marbles, and woods in her studio, and each was treated "according to its own nature." The image was almost always complete in her mind before she began to chip away—"almost," because, as the artist explained, "the really important thing seems to be the sculptor's ability to let his intuition guide him over the gap between conception and realization without compromising the integrity of the original idea."[88] Since Hepworth preferred to work directly with the material for the "physical pleasure of direct contact with every part of the form," she never used mechanical devices or automatic tools. Only in the last decade and a half of her life did she employ assistants.

The forms that had intrigued Hepworth since childhood were the single standing form (the figure in a landscape), the double form (the relationship of one living thing to another), and the oval, spherical, or pierced form (sometimes painted white, black, or blue-grey to heighten the inner mystery). Carved from a yew tree, the elegant *Nanjizal* (1958; Fig. 8-26) stands "like a symphonic creation of genius [combining] strength, subtlety and the utmost simplicity. . . . It evokes a feeling of sophistication, it commands respect, it forces the mind to recognize the great in the natural."[89] Now confined to an interior setting (at the Tate Gallery), this ultimate "figure in a landscape," when frontally viewed, suggests two figures in close harmony. It is abstract and organic as it swells and sweeps to its 98-inch height, a fully realized masterpiece showing the artist at the peak of her technical skills.

In 1939–40, Hepworth began to introduce string for contrast, for transparent effects, and to create tension. (See *Wood and Strings*, 1944, and *Stringed Form (Gothic)*, 1954.) Before 1955, she worked mostly in hard woods and stones—living materials. When in 1956 the artist found a way to personalize a method of working in bronze—she had large bronze sheets cut to shape and then textured them with files and abrasives—she created large linear constructions that literally soar into space, and that are more akin to her drawings than her carvings. In *Winged Figures I and II* (1957) she combined string with brass, creating works that combine lightness and elegance with power and dignity.

Dag Hammarskjöld, late Secretary-General of the U.N., was a collector of Hepworth sculpture. The piece he commissioned for the United Nations Plaza in New York City eventually became his own memorial: *Single Form* (1964; Fig. 8-27). Hepworth used her "artist's instinct" to overcome the engineering problems of stress and wind velocity, an intuitive capacity she claims she inherited from her father. Since the 21-foot work had to be cast in seven pieces, Hepworth decided to use the joints as part of the composition. The linear diagonal of the casting seam creates a dramatic contrast with the thrust of the large single form.

Hepworth's greatest public honor came in 1959 when she won the first prize at the Sao Paulo Biennial in Brazil, where she showed twenty works spanning a twenty-year period. The internationally respected artist died tragically in a studio fire in 1975. The following year, the Trewyn Studio at St. Ives, which she had occupied almost continually since evacuating London during World War II, opened as

a small museum dedicated to her memory. Following the instructions in her will, it was left "as closely as possible as it has been in my lifetime."

BRIDGET RILEY (b. 1931)

Bridget Riley's paintings directly challenge our vision; they affect our equilibrium and are discomforting; there is no respite from the energy they release. Her paintings are all about contrasts in movement and psychic states: states of tension and release, repose and dislocation, order and disruption. Ultimately, however, they are about the release and eventual taming of energy. According to Riley, "There are vast reserves of energy in everything and if you allow them to operate freely, relieved of pressures, concepts, malfunctions, distortions or perversities, or remove them from the burden of carrying or embodying a projected character, you are nearer to stimulating or unleashing a truly creative power."[90]

Bridget Riley was born in London, the elder of two daughters of John Fisher Riley, a paper manufacturer, and Bessie Gladstone, a descendant of the Victorian prime minister. The Gladstones were So-

cialists and their children were educated to be liberals. Riley described her mother as "optimistic, positive in views and sense of emancipation, well read, unconventional, very much a product of the new world for women of the nineteen twenties, and willing to rethink attitudes to orthodox or accepted issues."[91] Bridget's earliest encouragement in art came from her aunt, a graduate of Goldsmith College of Art, London. The young artist enrolled there in 1949 and for three years worked with Sam Rabin, a teacher, who, using Ingres drawings for examples, heightened her awareness of the balance between "perceptual accuracy and abstract formal values."

In 1952 Riley enrolled in the Royal College of Art, where she began to paint. A student painting was exhibited in the 1955 "Young Contemporaries" exhibit. The artists with whom she most identified were Van Gogh, Monet, Mondrian, and especially Seurat; *Blue Landscape* and *Pink Landscape*, both of 1959, explode with pointillist dots so large that they can almost be read as individual forms. During a trip to Italy, Riley was especially impressed by the speed, dynamism, and energy of Italian Futurist paintings. At Harry Thurbon's summer art school in Norfolk, she met the artist-teacher Maurice de Sausmarez, with whom she discussed the optics of the pointil-

FIG. 8-28. Bridget Riley, *Hero (Ascending and Descending)* (1965). 72″ × 108″. Courtesy of the Art Institute of Chicago.

lists; he expanded her cultural horizons, guided her growth as an artist, and wrote the catalogue essay for her first one-woman show in 1962. That same year, Anton Ehrenzweig, author of *The Hidden Order of Art* and an authority on the psychoanalysis of visual and aural perception, became interested in her work and wrote the first essay on the artist to appear in a major art publication.[92]

The stimulus for Riley's compositions comes from the world of nature and from feelings. It is not the description or analysis of a phenomenon, but the sensation or psychic feel of it that preoccupies her: the movement or stillness of a summer day, forces and progressions of flight, the sensation of breathing or touching, the mood or color of a time or place. The titles are carefully chosen and are meant to communicate the idea behind the painting. In *Kiss* (1961), two large sensuous black shapes touch and part, leaving a white shape on either side of the point of contact. *Uneasy Centre* (1963), part of her circle series—her work shows a constant progression with each succeeding piece—has individual circles that contact sequentially in three different directions as they spiral into a circular form pulsating off the center of the canvas. *Breathe* (1966) suggests the in-and-out quality of the inhalation process; there is a swift downward thrust in *Fall*. In *Hero (Ascending and Descending)* 1963; Fig. 8–28) the thick, central part of the horizontally drawn elongated triangles rise when read from below and descend when the eye moves down from the top of the painting. This movement is created by the change in scale, by the spacing between triangles that creates the rhythm, and by the change in direction or thrust at the apex of the triangles. The sequences in Riley's work are arrived at intuitively; the subtle shifts in the units

make computers or the silk-screen process useless. While the surfaces of her completed paintings are anonymous and lack painterly involvement, the artist spends a great deal of time on preliminary sketches—there are scores of fragments of larger works meticulously detailed on graph paper—and the finished product is a result of constant decisions made by the artist in league with her assistants.[93]

It was not until the 1965 exhibit, "The Responsive Eye," at the Museum of Modern Art in New York, that Riley received the international critical and popular acclaim that she still enjoys. One of her two paintings in the show appeared on the catalogue cover; her one-woman show held simultaneously at the Richard Feigen Gallery was an immediate sell-out. The motif of one of her paintings even appeared as a pattern for a dress fabric. Since Riley firmly believes that the Op artist has made a significant contribution to the vocabulary of modern art, she was angered by such gimmickry and by the ensuing commercialization surrounding the Op art movement.

At least three male writers on art—Bryan Robertson, Maurice de Sausmarez, and Anton Ehrenzweig—have helped defend, define, and promote the art of Bridget Riley. Thus championed by men, she sees no need for a feminist art movement:

I have never been conscious of my own femininity, as such, while in my studio. . . . For the artist who is also a woman, I would not deny that society presents particular circumstantial problems. But in my opinion these are on the wane. . . . Women's Liberation, when applied to artists, seems to me a naive concept. It raises issues which in this context are quite absurd. At this point in time, artists who happen to be women need this particular form of hysteria like they need a hole in the head.[94]

NOTES

1. Martha Kearns, *Käthe Kollwitz: Woman and Artist* (New York: The Feminist Press, 1976), 20-25, 28. An excellent biography from a woman's point of view that relies heavily on Kollwitz's diaries and letters.

2. Hans Kollwitz, ed., *The Diaries and Letters of Käthe Kollwitz* (Chicago: Henry Regnery Co., 1955), 43.

3. Quoted in Kearns, *Kollwitz*, 26.

4. Mina C. and H. Arthur Klein, *Käthe Kollwitz: Life in Art* (New York: Holt, Rinehart & Winston, Inc., 1972), 20, 72; Kearns, *Kollwitz*, 36-37.

5. Kearns, *Kollwitz*, 39-41; Kollwitz, *Diaries and Letters*, 41.

6. Kearns, *Kollwitz*, 64; Kollwitz, *Diaries and Letters*, 53.

7. Kollwitz, *Diaries and Letters*, 53.

8. Kearns, *Kollwitz*, 76, 86, 195-96; Howard Devree, "Käthe Kollwitz," *Magazine of Art* (September 1939), 513.

9. Kollwitz, *Diaries and Letters*, 67.

10. Kearns, *Kollwitz*, 106.

11. Kearns, *Kollwitz*, 133; Kollwitz, *Diaries and Letters*, 87.

12. Kollwitz, *Diaries and Letters*, 177.

13. Her diary was first published as *Briefe und Tagebuchblätter* in 1920. Quoted in Martha Davidson, "Paula Modersohn-Becker: Struggle between Life and Art," *Feminist Art Journal* (Winter 1973-74), 1, 3-5.

14. Werner Haftmann, *Painting in the Twentieth Century*, Vol. 1 (New York: Praeger, 1965), 82.

15. Quoted in Davidson, "Paula Modersohn-Becker," 4.

16. Alfred Werner, "Paula Modersohn-Becker: A Short Creative Life," *American Artist* (June 1973), 67; Ellen Oppler, "Paula Modersohn-Becker: Some facts and Legends," *Art Journal* (Summer 1976), 366.

17. Quoted in Davidson, "Paula Modersohn-Becker," 4.

18. *Ibid.*; Hoetger designed the monument for her grave.

19. Oppler, "Some Facts and Legends," 364.

20. Werner, "A Short Creative Life," 16, 18; Oppler, "Some Facts and Legends," 366; Peter Selz, *German Expressionist Painting* (Berkeley: University of California Press, 1957), 82.

21. Oppler, "Some Facts and Legends," 365.

22. Werner, "A Short Creative Life," 16.

23. Juliane Roh, "Marianne von Werefkin," *Kunst und Das Schoene Heim*, Vol. 57 (December 1959), 452-55.

24. Roh, "Marianne von Werefkin," 453; Edouard Roditi, "Interview with Gabriele Münter, *Arts* (January 1960), 41.

25. Selz, *German Expressionist Painting*, 187.

26. Roditi, "Gabriele Münter," 40-41.

27. Munch used the serpentine line of Art Nouveau to create an art that revealed the anxiety and loneliness of modern man.

28. Roditi, "Gabriele Münter," 38-39.

29. Liselotte Erlanger Glozer, "Gabriele Münter: A Lesser Life?" *Feminist Art Journal* (Winter 1974-75), 11, 12.

30. Roditi, "Gabriele Münter," 41.

31. Glozer, "A Lesser Life?" 12.

32. Will Grohman, *Wassily Kandinsky: Life and Work* (New York: Harry N. Abrams, Inc.), 166. Glozer claims they also met in 1921 when there was a dispute over his paintings.

33. Glozer, "A Lesser Life?" 23.

34. Quoted in John E. Bowlt, *Russian Art*, 55-57.

35. Gloria Feman Orenstein, "Natalia Goncharova," *Feminist Art Journal* (Summer 1974), 3.

36. Founded in 1899 by Diaghilev, among others, the World of Art group introduced Western art to Russia, championed the interrelatedness of all the arts, and helped develop an art-buying public.

37. Quoted in Camilla Gray, *The Great Experiment: Russian Art 1863-1922* (New York: Harry N. Abrams, Inc., 1962), 69-70.

38. *Ibid.*, 128.

39. Orenstein, "Natalia Goncharova," 1, 3.

40. Gray, *The Great Experiment*, 88.

41. Roditi, "Gabriele Münter," 38.

42. John E. Bowlt, "Alexandra Exter: A veritable Amazon of the Russian avant-garde," *Art News* (September 1974), 43.

43. Alison Hilton, "When the Renaissance Came to Russia," *Art News* (December 1971), 39; Gray, *The Great Experiment*, 190.

44. Gray, *The Great Experiment*, 190.

45. Andrei B. Nahov, "Painting and Stage Design: A Creative Dialogue," in "Alexandra Exter: Artist of Theatre" (The New York Public Library, Spring–Summer 1974), 9-10.

46. N.D. Lobanov, "In Search of Exter's Work," in "Artist of Theatre," 26.

47. Quoted in Bowlt, *Russian Art*, 148.

48. The largest collection of the early avant-garde in Russia belongs to George Costakis. Douglas Davis visited and reviewed his treasures: see *Newsweek* (January 20, 1975), 48-51.

49. Quoted in Bowlt, *Russian Art*, 147-148.

50. Gray, *The Great Experiment*, 192.

51. Arthur A. Cohen, *Sonia Delaunay* (New York: Harry N. Abrams, Inc., 1975), 15; Cindy Nemser, *Art Talk* (New York: Charles Scribner's Sons, 1975), 37-39.

52. Quoted in Cohen, *Sonia Delaunay*, 39.

53. *Ibid.*, 45.

54. *Ibid.*, 47.

55. Robert Hughes, "Delaunay's Flying Discs," *Time* (August 23, 1976), 34; Jacques Damase, *Sonia Delaunay: Rhythms and Colors* (Greenwich, Conn: New York Graphic Society, 1972), 100.

56. Nemser, *Art Talk*, 40.

57. From her obituary, *Arts Magazine* (January 1956), 34.

58. Quoted in "Elfin Maidens of Marie Laurencin at Findley Gallery" *Art Digest* (November 15, 1932), 10.

59. Quoted in Nemser, *Art Talk*, 44.

60. Quoted in Margaret Davies, *Apollinaire* (London: Oliver & Boyd, 1964), 139.

61. Cecily Mackworth, *Guillaume Apollinaire and the Cubist Life* (New York: Horizon Press, 1963), 102.

62. "Marie Laurencin," *Dictionary of Modern Painting* (New York: Tudor Publishing Co., 1953).

63. Herbert Read, *The Art of Jean Arp* (New York: Harry N. Abrams, Inc., 1968), 32.

64. Quoted in *Ibid.*, 34.

65. Michel Seuphor, *The Sculpture of This Century* (New York: George Braziller, Inc., 1961), 337.

66. Belle Krasne, "Arp & Arp Exhibition at Janis Gallery," (February 15, 1950), 15.

67. Quoted in Read, *Art of Jean Arp*, 122.

68. Paul Guth, "Encounter with Germaine Richier," *Yale French Studies* (Spring 1957–Winter 1958), 82.

69. *Ibid.*, 79.

70. *Ibid.*, 80.

71. Sidney Geist, *Arts Magazine* (December 1957), 47.

72. Alexander Watt, "Visages d'Artistes: Vieira da Silva," *Studio* (May 1961), 172.

73. *Ibid.*

74. *Ibid.*, 170-72.

75. Patrick Waldberg, *Surrealism* (New York: McGraw-Hill, 1966), 110.

76. Marcel Jean, *The History of Surrealist Painting* (New York: Grove Press, 1960), 372.

77. Lynne M. Tillman, "Don't Cry . . . Work," *Art and Artists* (October 1973), 22.

78. Orenstein, "Women of Surrealism," 18; Tillman, "Don't Cry," 22.

79. Quoted in Tillman, "Don't Cry," 25.

80. José Pierre, *Dictionary of Surrealism* (London: Eyre Methuen, 1974), 36.

81. Quoted in Orenstein, "Women of Surrealism," 17.

82. Edward James, "Introduction" in "Leonora Carrington: A Retrospective" (Center for Inter-American Relations, New York, November 26–January 4, 1976), 11-12.

83. Quoted in Jean, *History of Surrealist Painting*, 323-24. Carrington also created superlative Surrealist dishes to which she treated her friends. Some of her recipes were published in *VVV*.

84. Leonora Carrington, "Commentary," in "A Retrospective," 23.

85. Barbara Hepworth, *A Pictorial Autobiography* (London: A. Zwemmer, 1959), 9.

86. *Ibid.*, 17.

87. J.P. Hodin, *Barbara Hepworth* (New York: David McKay Company, Inc., 1959), 15.

88. Barbara Hepworth, "Approach to Sculpture," *The Studio* (October 1946), 98.

89. Hodin, *Barbara Hepworth*, 24.

90. Quoted in Bryan Robertson, "Bridget Riley: Paintings and Drawings 1951-1971" (The Hayward Gallery, London, July 20–September 5, 1971), 8.

91. Quoted in *Ibid.*, 19.

92. See "The Pictorial Space of Bridget Riley," *Art International* (February 1965).

93. According to Bryan Robertson, Riley uses assistants for two reasons: without aid she would not be able to keep up with the pace of her ideas, and the final execution requires technical expertise rather than painterly expression; Robertson, "Bridget Riley," 7.

94. Bridget Riley, "The Hermaphrodite," in Hess and Baker, eds., *Art and Sexual Politics*, 82-83.

The American Moderns

FLORINE STETTHEIMER (1871-1944)

Florine Stettheimer's paintings are delightfully decorative and fanciful. They are replete with personal symbolism, amusing anecdote, and social satire. Stettheimer has been accused of being a primitive or naive artist, but this indictment reveals a lack of understanding of the artist's aims. After years of rigorous academic training under the Americans Kenyon Cox and Robert Henri, and with a variety of artists in Berlin, Stuttgart, and Munich from 1906 to 1914, she painted a number of obligatory academic nudes and works in the manner of Van Gogh (*Confirmation Day* and *The Fountain*) and Bonnard (*Family Portrait No. 1*, 1915). She was to arrive at her unique personal style by the age of forty-six.

Born in Rochester, New York, the second youngest of the four daughters and one son of Rosetta Walter and Joseph Stettheimer (scion of a wealthy German-Jewish banking family), Florine grew up in a matriarchy. When his children were still very young, Joseph "disappeared from the immediate life of the family," and after the son Walter and the eldest sister Stella married, Rosetta supervised the lives of the three remaining daughters, none of whom chose to marry. Their genteel lives were spent in intellectual and artistic pursuits.

One of the first paintings in Stettheimer's mature style is *Studio Party* (or *Soirée*), 1917 (Fig. 9-1). Many of her themes and subsequent devices are evident in this early conversation piece, which is, in fact, an intimate slice of her life: her friends Maurice Sterne, Gaston and Isabelle Lachaise, Albert Gleizes and his wife, Leo Stein, her sisters Ettie and Carrie as well as Florine herself are all gathered for one of her small evenings—the sisters enjoyed nothing better than to surround themselves with members of the New York cultural elite. Like the forms in Persian miniatures, her figures are flattened and defined by their arabesque-like movements as they sit in animated conversation or stand examining her paintings within the painting. The entire scene is viewed from above; the laws of conventional perspective have

been completely denied. Colors are bright and Fauve-like—the artist used white to heighten the brilliance of her otherwise pure pigments—and thickly applied with a palette knife; only in the details did she use a brush. Although there are many isolated groups within the painting, they are carefully composed to avoid fragmentation.

An original spirit, Florine Stettheimer was never concerned with the vicissitudes of art-world styles and politics, and after a poorly received one-woman show organized by a friend at the Knoedler Gallery in 1916, she rarely exhibited her work publicly. Indeed, no other gallery would acquiesce to her demand that she completely redecorate their space to resemble her own home so that her work could be exhibited in an environment like the one in which it was conceived. Moreover, since her father had left the family well provided for, she had no need for sales and was reluctant to part with her work, claiming that "letting other people have your paintings was like letting them wear your clothes."[1] Stettheimer did exhibit at the Independent Society of Arts annuals from 1917 to 1926, and was invited to show at the Carnegie International in 1924. At the suggestion of her friends Marguerite Thompson and William Zorach, one of her paintings was used to accompany the New York *Times* review of a Depression period exhibit advertised as an "All American Armory Show." Otherwise, attention from the press was sporadic. Friends attempted to publicize her work: the painter Marsden Hartley described her work as "chamber music meant to be heard by special sympathetic ears" and as the "ultra-lyrical expression of an ultra-feminine spirit." She was called "one of the three important women painters of this country" (the others being Georgia O'Keeffe and Peggy Bacon), in the May 1932 issue of *The Nation*. Perhaps the critic for the Pittsburgh *Post*, Penelope Redd, in her review of the Carnegie International, most succinctly captured the spirit of the artist when she wrote: "Miss Stettheimer is the only woman

FIG. 9-1. Florine Stettheimer, *Studio Party* (1917).
28¼″ × 30″. Yale University Art Gallery, New Haven.
From the estate of Ettie Stettheimer for the Yale Library.

painter in America, and indeed there would seem to be few elsewhere who project an individual point of view on canvas. . . . More than any other painter whom we know, she has developed a symbolic and decorative type of painting that also engages us by its human interest."[2]

In 1929 Virgil Thomson asked Stettheimer to do the sets and costumes for his opera, "Four Saints in Three Acts," with a libretto by Gertrude Stein. The production opened in Hartford, Connecticut, at the Wadsworth Atheneum in February, 1934, then moved to New York. The critics were universal in their praise for the sets, but found the opera "uncommunicative." The two "grande dames," Stein and Stettheimer, did not meet until after the production opened in Chicago. Thomson recorded the event: "Not a compliment passed between them. . . ."[3]

The photographer and writer, Carl Van Vechten described the series of portraits Stettheimer did of her friends (including himself): "She was more interested in the atmosphere of feeling of the character (which she often reproduced with deadly accuracy and a kind of mystic acumen) then she was in actual physical values, although often her physical likenesses were striking."[4] In the 1923 portrait of Marcel Duchamp, the subject sits cross-legged in a chair decorated with his initials (and also the names of subject and artist and the date of the painting), one

hand turning a crank which elevates a spiral coil on which sits "Rrose Sélavy," the name Duchamp used in Surrealist circles. Stettheimer conceived of Rrose Sélavy ("eros is life") as an effete young man dressed as a harlequin. With wit and invention, she created a visual pun that rivals the best work of her subject.[5]

Her monumental "cathedral" series—*Cathedrals of Broadway* (1929), *Cathedrals of Fifth Avenue* (1931), *Cathedrals of Wall Street* (1939), and *Cathedrals of Art* (Fig. 9-2) on which she was still working at the time of her death—are the artist's ultimate comments on the false gods worshiped by modern society. The complicated iconography of her last painting is centered around the grand staircase of the Metropolitan Museum of Art (the current owner of the painting). The infant "Art," positioned like a Greek sculpture of Eros that had recently been purchased by the museum, is being led by Frances Henry Taylor, then director, toward "High Art," symbolized by a Frans Hals portrait. The dealers Julien Levy and Pierre Matisse hold balloons that advertise the names of the artists in their stable; the director of the Museum of Modern Art, Albert H. Barr, Jr., rests complacently in a lounge chair of modern design observing his Picassos and Mondrians, while beneath him a pair of Picasso's neoclassical women romp past Rousseau's lion from *The Sleeping Gypsy*. The bemused artist stands under a canopy carrying a bouquet of flowers from

FIG. 9-2. Florine Stettheimer, *Cathedrals of Art* (1944). 60¼″ × 50¼″. Metropolitan Museum of Art, New York. Gift of Ettie Stettheimer, 1953.

which hang three bleeding hearts (representative of each of the sisters).[6]

Two years after her death, Florine Stettheimer was honored with her second one-woman show—a retrospective at the Museum of Modern Art. Her unique paintings have since been dispersed among the major art museums in America.

ROMAINE BROOKS (1874-1970)

The art of Romaine Brooks cannot be separated from her life. After a nightmarish childhood with an exotically unpredictable mother and insane brother, she escaped to independence and lived a life as part of the intellectual scene in Europe that was twice shattered in the aftermath of world wars. Not only did she seek to become a professional at a time when women of her class were trained to be decorative and decorous, but she dared to live openly as a lesbian within the homosexual circle that included John Brooks, Somerset Maugham, Jean Cocteau, Gertrude Stein, Alice B. Toklas, Una, Lady Troubridge, and Radclyffe Hall (the author of the first lesbian novel, *The Well of Loneliness*, London, 1928). Her lover was Natalie Barney, the wealthy and talented American poet whose Friday afternoons rivaled Stein's Thursday evening gatherings. Their fifty-year relationship, in which Barney handled most of

Brook's business affairs related to the sale and promotion of the artist's work, ended in 1969 when both were in their nineties. Paranoid and embittered, the irascible Brooks could no longer accept Barney's infidelities, and refused to see her again.

Brooks' portraits of her friends are not only powerful aesthetic statements, but also important records of the self-conscious world in which she lived. All members of "upper Bohemia," who because of their wealth and talent created their own system of values and priorities, the inhabitants of her paintings reflect an age of anxiety that bordered on decadence. Having outlived most of her contemporaries, she was alone and forgotten until 1968 when the French portrait painter Édouard MacAvoy, a professor at the Académie Julien and president of the Salon d'Automne, visited her and revived an interest in her work with an article in the March 1968 issue of the French journal *Bizarre*. (He had been influenced by her works at the Musée National d'Art Moderne while still a student.) In 1971, the group of paintings she donated to the National Collection of Fine Arts in Washington, D.C., were part of a major retrospective organized by that institution. She died before the exhibit opened, secure in the knowledge that she would at last be recognized in the country of her birth. Indeed, Hilton Kramer, art critic of the New York *Times*, was compelled to admit that after viewing work such as hers, it was obvious that the de-

FIG. 9-3. Romaine Brooks, *Le Trajet (The Crossing)* (1911). 45⅜″ × 75⅜″. Courtesy of National Collection of Fine Arts, Smithsonian Institution, Washington, D.C.

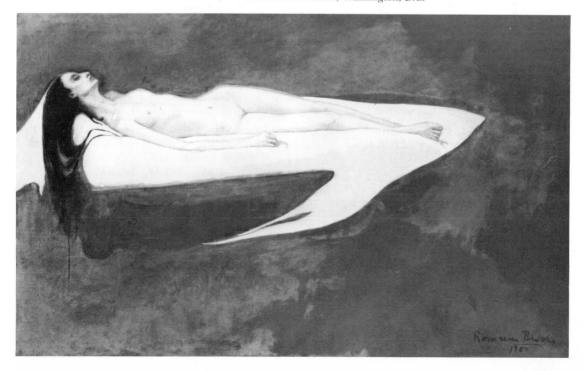

finitive history of American art had yet to be written.[7]

The fortune inherited by Romaine Goddard Brooks derived from the mines in Utah and Pennsylvania owned by her maternal grandfather, Isaac Waterman. Her mother married Harry Goddard, a minister's son, who left his peripatetic wife, his daughter Maya, and his insane son St. Mar shortly after Romaine was born. Ella Goddard hated her youngest daughter for being bright, healthy, and talented while her beloved son was insane. Since St. Mar behaved best in his sister's company, Romaine literally became her brother's keeper. In her memoirs, *No Pleasant Memories*, which she polished to perfection during the 1930s, she wrote that "the atmosphere [her mother] created was that of a court ruled over by a crazy queen."[8] There were periods of respite from this gothic entanglement, however: in 1880, when her mother departed on yet another trip to Europe seeking a cure for St. Mar, she was left without funds with the family laundress. Away from her mother she was happy; Mrs. Hicky let her draw, while her mother had promptly destroyed the only creative outlet that enabled her daughter ultimately to survive. There were four years at an Episcopal school in New Jersey, followed by two years at an Italian convent where her mother hoped she would become a novitiate, and then four years at Mademoiselle Bertin's private finishing school in Switzerland, where she became highly "accomplished" in both music and art, her two loves. Finally, in 1896, having come of age, she took an unprecedented step and declared her independence from her mother, whom she did not see again until 1901, when St. Mar died. After two years of attempting to support herself as an artist's model and singer, Romaine left for Rome to become the first female student at the tuition-free Scuola Nazionale, where her reception was anything but cordial. Typical of Brooks, while Paris was in artistic ferment, she chose to study in Rome; she was never part of an avant-garde movement.

With the small allowance a family retainer arranged for her to receive from her mother, Romaine rented an old chapel in Capri during the summer of 1899. It was there that she first met John Brooks, Maugham, and the other homosexuals who had fled England after the Oscar Wilde trial. A law graduate of Cambridge and occasionally a writer, Brooks lived for many years by his wit and charm, and through the indulgence of his many wealthy friends. After her mother died in 1902,[9] and she found herself an extremely wealthy woman, Romaine entered an "ephemeral" marriage with Brooks. Hoping to find companionship and the freedom of movement denied a single woman at the turn of the century,

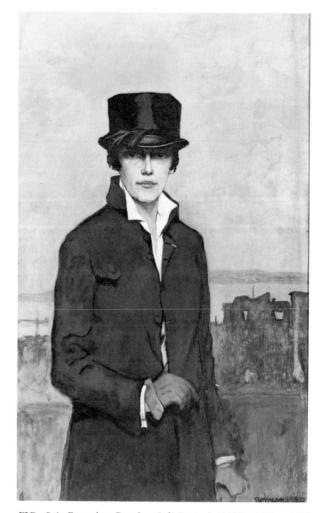

FIG. 9-4. Romaine Brooks, *Self-Portrait* (1923). 46¼" × 26⅞". Courtesy of National Collection of Fine Arts, Smithsonian Institution, Washington, D.C.

Romaine instead found herself constrained by the rituals of late Victorian society to which Brooks passionately subscribed, and against which she had rebelled all her life. To escape from her bondage to Brooks, she moved to London and settled in a studio near where Whistler had painted until his death.

Whistler was the only contemporary artist Romaine Brooks respected. "I wondered at the magic subtlety of his tones but thought his 'symphonies' lacked corresponding subtlety of expression."[10] It was in London, and at St. Ives on the Cornish coast, that Brooks did her first mature paintings. *The Charwoman* (1904) shows a wistful figure in semi-profile, sitting with folded hands as she contemplates the sea. The geometric composition is a symphony of greys, relieved only by the light on the model's face, hands, and apron. Softness and tenderness prevail in *Maggie* (1904), the portrait of a young woman with red hair. Both are in the Whistlerian tradition.

Back in Paris and lavishly established on the Right Bank, Brooks in 1910 had her first one-woman show at Durand-Ruel's for which she stripped the gallery of its red plush and hung beige material on the walls to enhance rather than compete with her subtle colors. D'Annunzio, the Italian writer, who was to remain a lifelong friend, wrote that Brooks was "the most profound and wise orchestrator of grays in modern painting." (The portrait she did of D'Annunzio was acquired by the Musée de Luxembourg in 1914 and may have led to her receiving the Croix de la Légion d'Honneur in 1920.) Apollinaire claimed that while the work had a "somber elegance," everything had the "same severity" and an all-pervasive "sadness."[11] Indeed, grouped together, her portraits have a haunting quality: she seemed always to be painting her own despair. In 1971, Kramer wrote: "There is nothing improvised or spontaneous in her style; there are few easy delights for the eye."[12]

The paintings exhibited in 1925 at the Galerie Jean Charpentier, Paris, at L'Apine Club Gallery, London, and at Wildenstein Galleries in New York consisted mostly of portraits of her friends. The graceful Ida Rubenstein, the dancer and actress who had appeared as Cleopatra in Diaghilev's Ballets Russes, was for a period the ideal androgyne of Parisian society. She appears as the icily erotic nude in *Le Trajet (The Crossing)* of 1911 (Fig. 9-3); in a 1917 portrait Brooks sets Rubenstein's delicately defined features against a turbulent sky, her hair and scarves blowing in the wind. The 1914 portrait of Jean Cocteau standing on a balcony with the Eiffel Tower in the background shows the as yet unknown artist as a condescending, elegant young fop. Her self-portrait (1923; Fig. 9-4) can be considered her definitive statement as an artist. Dressed in a black top hat that only slightly shades the penetrating stare of her large, dark eyes, Brooks is an isolated and commanding figure against the background of a decayed and desolate city. Painted in her customary blacks, greys, and whites, she is a haunting presence; it is the work of a woman "who has been disabused of most of the illusions life had to offer."[13]

The bulk of the artist's work lies in a large collection of delicate and eerie drawings, private statements emanating from a very disturbed world. After 1935, Brooks painted very little. Fearing the loss of her sight, she gradually withdrew into a world of semi-darkness and at sixty-five declared her career as an artist over. In 1961 she emerged from retirement to paint one more portrait, that of the Marchese Strozzi. Buoyed by the experience, the aged artist created a remarkably fresh painting. The scrawny frame of the Marchese seems ready to spring out of the large chair in which he was posed. As a final stroke, the artist left the eyes ambiguous, thereby emphasizing the sitter's shyness and aloneness.

Romaine Goddard Brooks composed her own epitaph. It reads: "Here remains Romaine, who Romaine remains."[14]

GEORGIA O'KEEFFE (b. 1887)

In the catalogue essay for a 1923 exhibit at the Anderson Gallery, Georgia O'Keeffe wrote:

. . . one day seven years ago I found myself saying to myself—I can't live where I want to—I can't go where I want to go—I can't do what I want to—I can't even say what I want to—. School and things that painters have taught me even keep me from painting as I want to. I decided I was a very stupid fool not to at least paint as I wanted to and say what I wanted to when I painted as that seemed to be the only thing I could do that didn't concern anybody but myself—that was nobody's business but my own.—So these paintings and drawings happened and many others that are not here.—I found that I could say things with color and shapes that I couldn't say in any other way—things I had no words for.[15]

It was at this juncture in her life that O'Keeffe sent a bundle of drawings to her school friend Anita Pollitzer in New York with instructions to show them to no one. So excited was Pollitzer with her friend's new discoveries that she rolled them up under her arm and took them to Alfred Stieglitz, the proprietor of the "291" Gallery and promoter of European and American modernists. After viewing the work he purportedly said, "Finally a woman on paper." Stieglitz included them in his next group show. The large, sensuous, organic abstract forms which she called *Lines and Spaces in Charcoal* can be immediately recognized as O'Keeffe's by those familiar with the artist's work. Although she varied her style, working from the "ideas in her head" as well as from nature, there has been an amazing consistency in her vision. For her first one-woman exhibit at "291" the following year, where, in addition to her very personal drawings, she showed oils, water colors, and sculpture, the young artist traveled to New York from Texas where she was teaching. Stieglitz became her patron and in 1924 her husband. For almost thirty years he was her chief advocate, organizing yearly exhibitions of her work at the Anderson Galleries in 1923 and 1924, at the Intimate Gallery which he ran from 1925 to 1930, and at An American Place, the gallery he owned until his death in 1946. After the meeting with Stieglitz, the struggle

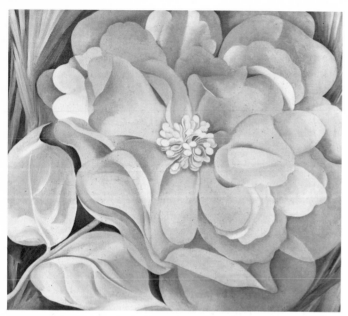

FIG. 9-5. Georgia O'Keeffe, *The White Flower* (1931). 30″ × 36″. Whitney Museum of American Art, New York.

FIG. 9-6. Georgia O'Keeffe, *Lake George Window* (1929). 40″ × 30″. Museum of Modern Art, New York. Acquired through the Richard D. Brixey Bequest.

for recognition as an artist was over for O'Keeffe; her reviews were consistently favorable and she always had a place to show. Today O'Keeffe is recognized as one of the pioneers in American abstract art.

With its vision of parched, sun-drenched open plains, Sun Prairie, Wisconsin, the small farming community where Georgia O'Keeffe was born, recalls the titles of many of her paintings. The second of seven children, O'Keeffe decided to become an artist when she was ten, and along with her two younger sisters began taking private lessons. In 1905 she enrolled at the Art Institute of Chicago and, in 1907, having moved to New York, she became a student of the Munich-trained William Merritt Chase at the Art Students League. Although she was an outstanding student, she quit the League after a year when she began to realize "that a lot of people had done this same kind of painting before I came along. It had been done and I didn't think I could do it any better. It would have been futile for me, so I stopped painting for quite a while."[16] She also destroyed all her work. In 1912 she came in contact with Arthur Wesley Dow of Columbia University, one of the few creative teachers in America, and felt encouraged "to find something of my own." O'Keeffe then accepted a post as supervisor of art in the Amarillo, Texas, public schools—an artistic exile for most, but like a rebirth for O'Keeffe. "That was my country," she wrote, "terrible winds and a wonderful emptiness."[17]

The flower paintings for which the artist is best known were begun in the 1920s. They are so large that they crowd the picture plane. Because of their unusual perspective and economy of means, they appear abstract, but they are nature "minutely studied" (Fig. 9-5). (In her "Corn Pictures" she watered the center of the cornstalk every morning to capture the exact fall of a dew drop.[18]) They are not unlike the abstract floral photographs that were an important part of Stieglitz's oeuvre of the period. O'Keeffe denies being influenced by her husband's work; resemblances between their work may have been the result of their sharing a similar aesthetic and seeking similar effects in separate media.

During any given period of time, the artist worked both abstractly and representationally. As she explained, "there must be changes. I paint what interests me and what I see. At times you can't find these shapes in your head and you have to find them as they are in the world."[19] Although the artist emphatically denies it, claiming that "the critics are just talking about themselves, not what I am thinking," there is obvious sexual symbolism in both her ab-

FIG. 9-7. Georgia O'Keeffe, *Red Hills and Bones* (1941). Philadelphia Museum of Art, the Alfred Stieglitz Collection.

stractions and representational paintings. It is difficult to describe an abstraction such as *Grey Line with Black, Blue and Yellow* (1923), a colorful work that in its technique may have influenced Helen Frankenthaler, without using sexually suggestive language. Lloyd Goodrich wrote that "the many-colored folds surround a dark cavity, whose mysterious depths are in dramatic contrast with the luminous folds around it."[20] In *Black Iris* (1926), the colors are more muted, mainly greys, grey-violets, and grey-blacks, but the sensuous petals unfold to reveal the dark mystery of the flower's interior. Even in the more hard-edged *Closed Clam Shell* and its companion *Open Clam Shell* (1926), the vaginal iconography is apparent.

From the 30th floor of their Manhattan apartment, O'Keeffe did a series of cityscapes in the late 1920s. The unusual perspective emphasized the geometric perpendicularity of the skyscrapers—*Radiator Build-*

ing at Night, New York (1927)—or the broad, horizontal expanse of the waterfront—*River, New York* (1928). For these paintings and for paintings such as the extremely simplified *White Barn, No. 1* (1932) and *Lake George Window* (1929; Fig. 9-6) where the artist has reduced architecture to its geometric forms, O'Keeffe has been identified with the American Precisionists Charles Sheeler and Charles Demuth. This constructivist orientation appears again in the series of patio paintings, beginning with *In The Patio I* (1946) and including *White Patio with Red Door* (1960), based on the adobe forms of her New Mexico environment. Unlike the Precisionists, however, whose cool, clear paintings show a respect for urbanized and mechanized America, O'Keeffe's works, with the exception of the New York City pieces, celebrate rural America and are far more sensual.

O'Keeffe first saw New Mexico in 1917. When she

spent the summer of 1929 in Taos, the direction of her life and art changed. She began to spend part of every year there, and after sorting out her husband's effects after his death in 1946, she moved there permanently. The colors, forms, and vegetation of the desert, with its red hills and badlands, with its bleached bones (which she found "strangely more living than the animals walking around") soon became the focus of her art (Fig. 9-7). She painted the symbols of the desert with the same "precision and refinement" and sensuality found in her flower paintings.[21] In *Cow Skull—Red, White and Blue* (1931) the large skull with antlers is positioned frontally against a red and blue background. The wide vertical shape in the center, when placed against the horizontality of the skull's antlers, suggests the symbol of the cross. The upper part of the skull is flat, while the lower half is a complex of craggy, three-dimensional forms. The "pelvis paintings" of the 1940s are less obviously symbolic: in *Pelvis with Distance* (1943), the immediacy of the elegantly formed bone confronts the viewer. As in her flower paintings, the close-up vision almost destroys the identity of the object, creating in the flower paintings an abstraction and in the pelvis paintings a surreal vision. The blue of the sky pokes through the cavities of the bone formations, creating a painterly counterpart of the organic sculptural forms of Henry Moore.

The perspective from an airplane window gave O'Keeffe another view of the starkness and vastness of the world, which found expression in her largest painting to date, the 24-foot-wide *Sky Above Clouds IV*, shown at her 1970 Whitney Museum retrospective. A proliferation of white cloud-like forms is placed against the blue of the sky. As the forms recede from view they get smaller and multiply; in the distance are the rose-hued colors of the setting sun. In this painting marking the eighth decade of O'Keeffe's life are found all the themes and variations of her previous work (the cloud-like forms first appeared in a charcoal drawing of 1916). At first glance, the painting looks like a mystical abstraction, but anyone who has experienced airplane travel will attest to its realism. The forms are coolly and precisely painted, yet retain the sensuous lyricism that is the hallmark of the artist's work.

For her independent lifestyle during the early years of the 20th century, Georgia O'Keeffe was labeled a "new woman." That spirit still remains. Suspicious of all the words that have been written about her, the artist wrote and supervised the publication of her own monograph at the age of eighty-nine.[22]

MARGUERITE THOMPSON ZORACH (1887–1968)

Most of what is known about Marguerite Thompson Zorach comes from the loving memoir written by her husband of fifty-four years, the sculptor William Zorach. Like the Delaunays, the Zorachs had a supportive, non-competitive relationship. Each was the other's most enthusiastic advocate and most respected critic. New ideas were explored simultaneously: the couple exhibited together, often collaborated on the same project, and shared in the management of their household and in the raising of their children. Until 1920, when William decided to concentrate on sculpture and Marguerite on tapestries, there was also a similarity in the work they produced. In the years between 1912 and 1920, they were considered artists of equal merit, but later as his reputation soared, hers diminished. It was only while engaged in research for a *catalogue raisonné* on William Zorach that Roberta K. Tarbell discovered the cache of paintings that Marguerite had rolled up for storage sixty years earlier. When these paintings were shown along with her other early works at the National Collection of Fine Arts in 1973, it became evident that she had played a significant role in the growth of the modern movement in American art.[23]

Marguerite Thompson was born in Santa Rosa, California, in 1887. Her father was a prominent lawyer for the Napa Valley vineyards; the family moved to Fresno in the 1890s, when the town was just emerging from frontier status. As descendants of old Massachusetts and Pennsylvania families, the Thompsons saw that their daughters were educated in the tradition of genteel young ladies. In addition to their regular schooling, Marguerite and her sister were tutored in French, German, and music. When her Aunt Addie, an amateur painter, and girlhood chum of Gertrude Stein, heard of her niece's interest in art, she insisted that Marguerite join her in Paris to study. Enroute Marguerite stopped at museums in Chicago and New York, where, thanks to the efforts of Mary Cassatt, she became aware of the Impressionists and post-Impressionists. Thus, when she arrived in Paris in 1908 and was immediately taken to the Salon d'Automne to see a Fauvist exhibit, she was not shocked. Indeed, so completely had she understood and absorbed this style, that she began imitating it. With its large, flat areas of complementary colors, heavy impasto, and boldly outlined forms, *Luxembourg Gardens*, painted the year she arrived in Paris, would look comfortable next to a Derain.

FIG. 9-8. Marguerite Thompson Zorach, *Man Among the Redwoods* (1912). 25¾″ × 20¼″. Collection of Roberta and James Tarbell, Hockessin, Delaware.

FIG. 9-9. William Zorach and Marguerite Thompson Zorach, *Marine Islander* (1918). Wool tapestry. 19½″ × 51½″. Courtesy of National Collection of Fine Arts, Smithsonian Institution, Washington, D.C.

It was at La Palette, the school run by the English Fauve John Duncan Ferguson, that Marguerite met William Zorach. When he first looked at the pink and yellow nude boldly outlined in blue on her easel, he was aghast and asked if she knew what she was doing, and why. She did. "But I just couldn't understand why such a nice girl would paint such wild pictures," explained her future husband in his autobiography.[24] Throughout her four years abroad, Marguerite helped support herself by writing weekly articles for the Fresno *Republican* on her European travels and on her experiences as an art student in Paris. In 1910 she showed with the American Women's Art Association, and in 1911 with the Societé des Artistes Indépendants and at the Salon d'Automne.

Aunt Addie disapproved of Marguerite's relationship with the Lithuanian Jewish emmigrant William, and arranged for her niece to take a seven-month voyage around the world before returning to Fresno in order to help her forget him. The images she found in the art of the ancient Eastern cultures—Egypt, Palestine, India, Burma, Malaysia, Indonesia, China, Korea, and Japan—affected the iconography of much of her later work. Once home, Marguerite found Fresno provincial and family life oppressive. No one understood her art, and in an attempt to secure her a position in Fresno society, her mother hid her paints and took her on a round of teas. The young artist "escaped" to the Sierra Mountains (camping with family and friends), where she produced the most exciting works of her career. Overwhelmed by the majesty of the mountains, she brought to her depictions of the American West all the sophistication of the most avant-garde European artists. Although *Man Among the Redwoods* (1912; Fig. 9-8) is a small canvas, she captured the grandeur of the mountains through the immediacy of the composition and the minuteness of the quickly sketched figure on the right. The greens and blues of the mountains and the orange foliage on the giant redwoods may or may not resemble the colors she found in nature, but the intensity is the artist's own. This freedom and exuberance—also found in *Windy Day in the Sierras* and *Waterfall*—were rarely repeated.

After exhibiting her European and California works in Los Angeles (where she made her first sale), the young artist removed the canvases from their stretchers, rolled them up, stashed them away, and left for New York to join William. They were married in 1912, and their "Post-Impressionist" studio became a gathering place for young avant-garde artists. They took part in all the independent art exhibits organized in New York, beginning with the Armory Show of 1913. William submitted two paintings, but it was Marguerite's work that attracted the most attention. A critic for the New York *American* (February 22, 1913) wrote:

In the "study" by Marguerite Zorach, you see at once that the lady is feeling very, very bad. She is portraying her emotions after a day's shopping. The pale yellow eyes and the purple lips of her subject indicate that the digestive organs are not functioning properly.[25]

Although Marguerite was familiar with the work of Picasso and Braque while still in Europe, it was not until after the impact of the Armory Show that she began to experiment with the overlapping planes of Cubism. A transitional painting is *The Bathers* (1913–14), painted during a summer at Chappaqua, where the Arcadian nudes of the Fauves are set against the geometricized forms of the landscape.

In 1915 the Zorachs' son Tessim was born, and when their daughter Dahlov arrived two years later a housekeeper was hired. Still, Marguerite was frustrated by the disruptions of children and household, and had difficulty finding uninterrupted time for painting. Indeed, running a household was difficult for both of them. William vividly described the chaos:

We would get up in the morning, have breakfast, leave everything and start working. When I was working in wood the place was full of chips. . . . Marguerite had little piles of wool and odd skeins for her embroidered tapestries everywhere.[26]

Marguerite had been working with embroidery for several years. As a colorist, she had at first been attracted by the brilliance and variety of wool yarns and had re-created some of her paintings in wool. With two young children she found it more convenient to work in a medium she could pick up at will, as William was able to do with his carvings. She experimented with stitchery, and her embroidered tapestries became works of art that fascinated both the public and critics alike. William too experimented with needlework, and there is at least one known collaboration—the horizontal *Marine Islander* of 1919 (Fig. 9-9) in which they created a classically structured summer seascape of islands, water, and nude bathers. Not so facile as his wife, William soon abandoned the medium. Embroidery absorbed most of Marguerite's creative efforts in the 1920s and 1930s (she returned to painting during the last twenty years of her life, exhibiting regularly at the Kraushaar Galleries, New York); although her

work was well received, her needlework may have contributed to the ultimate decline of her reputation as a "serious" artist. Nevertheless. her embroidered tapestries belong to the realm of fine art rather than decorative art. They have been described as "easel paintings embroidered on a linen base in dyed wool," and as William explained: "All the constructions and relations you find in painting are in the tapestries—just the technique and materials are different."[27]

KAY SAGE (1898–1963)

Although born in Albany, New York, into a family that prided itself on the fact that they were among the original settlers of New England, Kay Sage lived most of her early life in Italy and France. She returned home briefly during World War I to attend the fashionable Brearley and Foxcroft schools, and in 1925 she fulfilled the dreams of many socially ambitious mothers by marrying Prince Ranieri di San Faustino. (They were divorced in 1935.) With the onset of World War II she again returned to the United States, settling in Connecticut with her second husband, the Surrealist painter Yves Tanguy, whom she married in 1940. Their country home became the gathering place for many of the artists displaced by war, including the Surrealists Peter Blume and Hans Richter and the Constructivist sculptor Naum Gabo.

A largely self-taught artist—she studied only briefly in 1924 at Milan's Scuola Liberale delle Belle Arti—Sage developed an exacting technique that belied her lack of training. At her first exhibition in Milan in 1936 she showed mostly abstractions, but after becoming acquainted with Giorgio de Chirico's metaphysical paintings and meeting the Surrealists in Paris in 1937, she changed her approach to painting. According to James Thrall Soby, a friend and writer on art, Sage was most impressed with de Chirico's capacity to "endow arches, walls, and

FIG. 9-10. Kay Sage, *Tomorrow Is Never* (1955). 37⅞″ × 53⅜″. Metropolitan Museum of Art, New York. Arthur H. Hearn Fund, 1955.

piazzas with an oneiric intensity."[28] When the paintings she showed at the Salon des Indépendants in 1938 attracted the attention of both André Breton and Tanguy, she was invited to show with the Surrealists.

An early painting in the Surrealist mode, *Danger, Construction Ahead* (1940; Yale University Gallery of Art), is closer to Tanguy than her later architectural vistas. The strange shapes on the left are like icicles pointing upward. The land beyond resembles a windswept snow bank; the organic shapes in the distance on the right create a counterpoint to the forms on the left. At their joint retrospective at the Wadsworth Atheneum in 1954, the couple's separate styles became apparent: whereas Tanguy's paintings were concerned with organic, enigmatic forms in "moonscapes," Sage created an architecture of "poetic shelters." *Point of Intersection* (1951–52) is pure geometry, but not in the Cubist sense. Rather than the frontal Cubist grid, the tall, thin shapes on the right are seen receding into the horizon in a landscape of linear, rectangular forms. In *Tomorrow is Never* (1955; Fig. 9-10), a series of skeletal-like scaffolds mysteriously disappear into space. They seem to be set in the clouds as though viewed from the window of an airplane. In *Hyphen* (1954; Museum of Modern Art), an almost completed wooden tower is placed against a vast sky. Much of Sage's work in the 1950s is ambiguous as to time and place; nevertheless, there is always a feeling of landscape and a recognition of objects as well as an overall light that brings sharpness and clarity to her vision. But her strangely disquieting vistas are devoid of all humanity. It is as though the people have deserted the hemisphere, leaving their work half-completed.

In the last few years of her life, because of a worsening cataract condition, Sage had to abandon easel painting. What she did instead was to create three-dimensional constructions in the spirit of her paintings. Some almost look like board games: *Your Move* (1960) utilizes pegs of different sizes (her architectural forms?) variously set in a board (her plazas?). The spatial relationships are all designed with care. In some works, tower-like ladder shapes are hung with flowing weeds and glass-domed eyes; in others, real rocks have replaced the former meticulously painted rock forms. Neither painting nor traditional sculpture, these late works are an artist's creative response to physical affliction. Like Renoir and Degas before her, when her eyes began to fail, Sage extended her "vision" into "real" space.

Kay Sage was also a poet of wit and charm. She claimed that "there is absolutely no conflict between these two forms of expressions, painting and writing, nor do they have any connection. . . . I have always painted and I have always written, but never at the same time." She has written verse in three languages, claiming:

> English, French, Italian,
> I can write in all of these,
> but, at best, they are translations:
> I think in Chinese.[29]

ANNI ALBERS (b. 1899)

When Berlin-born Anni Albers entered the Bauhaus School in 1922, all the women students were assigned to the weaving workshop. Although she was a painter trained in art schools in Berlin and Hamburg, the young artist never regretted this sudden redirection of her career. As she explained in a 1965 interview: "The freedom of painting . . . was bewildering to me. There was such tremendous freedom you could do anything. . . . This weaving was a kind of railing to me—the limitations that come from a craft."[30]

Founded in 1919 by the architect Walter Gropius, the school had as its goal the integration of art, architecture, and the crafts. The staff espoused the American educator/philospher John Dewey's theory of "learning by doing" and insisted that every artist should first of all be a craftsperson and learn to respect his or her materials. When Albers entered the Bauhaus, it was still in an amorphous state; the methodology that was to redirect art education on two continents had not yet been formalized. Pupils explored with their material and learned the necessary techniques from the more experienced older students. "Unburdened by any consideration of practical application," wrote Albers, "this uninhibited play with materials resulted in amazing objects, striking in their newness of conception in regard to use of color and compositional elements—objects of often quite barbaric beauty." Albers stayed at the Bauhaus for seven years, long enough to see a change in direction. (She also, in 1925, married Josef Albers, one of her teachers.) The new emphasis was on usefulness—the functions of various fabrics were studied, as was the quantification of production. According to Albers, "A shift took place from the free play with forms to a logical building of structures." Training became more systematic and developmental, and like the Russian Constructivists, the students and faculty believed that by working with industry,

they could influence the quality of the objects of daily life.[31]

A Bauhaus tapestry of 1926 remains one of Albers' finest achievements (Fig. 9-11). The large weaving of vertical rectangles and squares overlaid by horizontal stripes of greys, black and off-whites creates a vibrant surface. This use of verticals and horizontals and the repetition of the right angle reflect not only the limitations of the craft, but the Constructivist aesthetic in which Albers was then immersed. After receiving her diploma in 1929 for a weaving that solved the sound problem in the Dessau auditorium then being built by Hannes Mayer (the school's director), she worked both in Dessau and Berlin. In 1933, after Hitler closed the Bauhaus, Anni and Josef Albers were invited to join the faculty of Black Mountain College in North Carolina, an experimental school that nurtured many of the talents that emerged in America after World War II. Anni became an Assistant Professor of Art and established a weaving workshop there. The couple remained for sixteen years and left only when Josef was appointed Chairman of the Art Department at Yale University. Anni continued her free-lance commercial work and her pictorial weavings. Together, the Albers have introduced several generations of art students to the Bauhaus aesthetic.

FIG. 9-11. Anni Albers, *Tapestry* (1926). 3-ply weave. 72" × 48". Courtesy of the Busch-Reisinger Museum, Harvard University, Cambridge.

FIG. 9-12. Anni Albers, *DR XV* (1974). Collection of the artist, Orange, Connecticut.

Anni Albers has been a consistent critic of the contemporary craft sensibility, finding most objects of daily use both functionless and aesthetically displeasing: "They are the intermingling of the beautiful with the practical, but not practical enough and not beautiful enough, for my feeling, to be of lasting beauty in the art sense." In all her writings she stresses the following: "I try to keep the functional, useful things serving and the useless things useless." In her designs for industry, she strives for a functional anonymity, but her pictorial weavings are another matter: "I find that I try to get my beliefs, feelings, and ideas into that other area which is in the direction of art. . . . Here, I'm concerned with form, line, color, proportions, and surface per se." With these she is very experimental—each new pictorial weaving is approached with the same sense of adventure that she experienced in her first days at the Bauhaus.[32] The weavings were exhibited at New York's Museum of Modern Art in 1949; it was her first one-woman show, and the only solo exhibit the musuem has ever given to a weaver.

In 1964, when Josef was invited to the Tamarind Workshop, Anni too tried her hand at lithography. Her first works were limited to "thread-like elements," but gradually she began to explore that medium, as well as screen-printing, photo-offset, etching, and aquatint. With graph paper she worked out her complex geometric compositions; the "internal irregularities–within–regularities" are carefully weighted and balanced to achieve perfect harmony, as in *DR XV* of 1974 (Fig. 9-12). Albers wrote in the catalogue to a 1973 Canadian exhibit of her drawings, prints, and pictorial weavings:

Rather than feeling dominant over material and process, I feel guided by them in my work and submit to the ideas that come from them to me.
In the many years that I was a weaver I learned to respect their suggestive power.
Now that graphics is my medium, I again acknowledge their formative influence.
Thus, signing my name to a work, I do it realizing the debt I owe them.[33]

Albers has noted in her research into ancient myths and cultures that "it was a goddess, a female deity, who brought the invention of weaving to mankind. When we realize that weaving is primarily a process of structural organization this thought is startling, for today thinking in terms of structure seems closer to the inclinations [that have been attributed to] men than women."[34] In more recent cultures it has been the tradition for women to make into useful objects that which men have planted and reaped or hunted and skinned.

Somehow, in the United States, the "art" in craft has been dislocated. Many of the European-born women (as well as the European-trained Marguerite Zorach) worked alternately with painting, printmaking, fabric design, stitchery, weaving, and tapestries, approaching the problems in each medium with equal intensity and respect. Since many contemporary craftspeople are women, and since weaving, spinning, and needlework of all kinds have traditionally been woman's work, many American feminists are now trying to eliminate the attitudinal gap between "art" and "craft."

LOUISE NEVELSON (b. 1899)

Louise Nevelson is an original. She created her own biography, eliminating those details that did not lead directly to her present self and elaborating on those which did. "My life had a blueprint from the beginning, and that is the reason that I don't need to make blueprints or drawings for my sculpture. . . . I did not become anything, I was an artist." She knew, also, that she would be a sculptor. When the school librarian asked her what she wanted to be, she answered, "I want to be a sculptor, I don't want color to help me."[35] The response, coming from the depths of her person, frightened the young girl. There were few interruptions in her singleminded pursuit of this goal. The first was her marriage to Charles Nevelson when she was twenty-one years old; only through marriage could a young woman leave Rockland, Maine for New York City, her ultimate goal. The second detour on her chosen path was the birth of her son, Mike, in 1922. "The greater restriction of a family situation strangled me, and I ended my marriage. . . . And so I gave myself the greatest gift I could have, my own life."[36] Nevelson raised her son (who is now a well-known sculptor) and is a great-grandmother, but she still feels guilty because she "wasn't maternal."[37]

Louise Berliawsky was born in Kiev, Russia. Her father dealt in lumber, as did his father before him, and when he emigrated to Rockland in 1902, he founded yet another lumberyard which eventually prospered. (His family, which was to include four children, joined him in 1905.) It was quite natural that young Louise's first creative efforts were with wood: indeed, she has been assembling wood scraps for over seventy years. The Russian-Jewish Berliaw-

skys must have been an unusual clan in Maine, but Louise recalls a happy childhood: "I adored my parents, my mother was freethinking and had strong socialist ideas. My father believed in equal rights for women. . . ."[38]

In New York before and after the birth of her child, Nevelson studied dance and drama to free her body, and voice with a Metropolitan Opera coach. In 1928 she enrolled in the Art Students League, studying with Kenneth Hayes Miller and Kimon Nicolaides, and in 1931, separated from her husband (they were not divorced until 1941), she left Mike with her family and went to Munich to study with Hans Hofmann. When the Nazi regime forced Hofmann to close his school, he left for America; Nevelson, after travel to Italy and Paris to study the old masters, returned to the League, again studying with Hofmann. She soon met the Mexican muralist Diego Rivera and his wife, the Surrealist painter Frida Kahlo, and along with the social realist Ben Shahn assisted Rivera in painting the Rockefeller Center and Rand School murals. Through the Riveras, Nevelson met the important artists of the day and also learned about Mesoamerican art, including that of the Mayas, whose majestic use of "low mass" was to influence her own and whose work she sought out on several trips to Mexico.[39]

In early 1936 Nevelson was one of the winners of a sculptural competition at the A.C.A. Galleries. Much to her delight, the *New York Times* critic was very receptive to her work: "Louise Nevelson is the most interesting of the contest winners . . . [the] five wooden sculptures [are] unlike anything else we've ever seen before. . . . They are . . . conceived abstractly and with special concern for the tensions of planes and volumes."[40] Her reputation secure after several group shows, the shy Nevelson invited Karl Nierendorf of the prestigious gallery that bore his name to see her work. Since she was completely self-sustaining, she was forced to assume the heretofore "unladylike" posture of selling herself in the commercial art world. Fortunately, Nierendorf was impressed and gave Nevelson her first one-woman show, thereby beginning a protective and supportive relationship that lasted until his death seven years later. No works or photographs from the exhibit remain, but reviews suggest that two lifelong characteristics were already present: the use of assemblage and the creation of an environment. For its blatant sexism, one review of that show is worth reporting:

We learned the artist was a woman, in time to check our enthusiasm. Had it been otherwise, we might have hailed

these sculptural expressions as by surely a great figure among the moderns.[41]

Thereafter, for almost ten years—from 1946 to 1955—Nevelson withdrew from the gallery scene. When she showed it was mostly the experimental prints she conceived during her visits to Stanley Hayter's Atelier 17. During this period she sponsored the Four O'Clock Forum, a series of Sunday afternoon panel discussions whereby artists such as Will Barnett, Ad Reinhardt, Mark Rothko, Max Weber, and Richard Lippold exhanged ideas about art and challenged the dominant mode of Abstract Expressionism. Their much discussed interest in "integrating North and South American Indian iconographic imagery into abstract American painting" helped change the direction of Nevelson's work.

From a collection of liquor boxes, milk crates, and lettuce crates stacked up against a wall in her studio, Nevelson created her first wall—*Moon Garden Plus One*. First exhibited as a total environment at the Grand Central Moderns Gallery in 1958, the group of columnar units and boxes was arranged in the gallery to take advantage of the room's peculiar light and space, thereby creating a unique landscape for the viewer. Within this environment she created what is now considered one of her masterpieces—*Sky Cathedral* (Fig. 9-13). Bathed in a cold blue light, the 11 foot by-10-foot wall is composed of various horizontal and vertical units stacked one upon the other and filled with the debris of lower Manhattan—finials, broken frames, scraps of crates, chair slats, etc. To divest the objects of their original associations the artist painted them black before construction began. No one had seen work like this before. As Hilton Kramer explained: "[Her walls] are appalling and marvelous, utterly shocking in the way they violate our received ideas on the limits of sculpture and the confusions of genres, yet profoundly exhilarating in the way they open an entire realm of possibility."[42]

All Nevelson's sources can be found in *Moon Garden Plus One*: the Cubist grid and the Constructivism it generated (except that Nevelson's work was intuitive rather than reasoned); the Surrealist pictographs of Adolph Gottlieb and William Baziotes; the assemblages and shallow relief sculptures of the Arps; the found objects of Duchamp's "readymades;" the sculpture and architecture of Mexico; the lack of focal point because of the dense proliferation of detail and the feeling of continued rather than self-contained space found in the paintings of Jackson Pollock.[43] The critical response was over-

FIG. 9-13. Louise Nevelson, *Sky Cathedral* (1958). Wood construction painted black. 11′3½″ × 10¼″ × 18″. Museum of Modern Art, New York. Gift of Mr. and Mrs. Ben Mildwoff.

FIG. 9-14. Louise Nevelson, *Atmosphere and Environment X* (1969). Steel. 16¾′ × 11′ × 6′. Lt. John B. Putnam, Jr. Memorial Collection, Princeton University.

whelmingly positive; Nevelson became a force in the art world, a celebrity, a woman to be feared (and controlled, as she soon found out when she was ignored by what she termed the "art world Mafia" for rejecting the dominant Abstract Expressionist mode which they had championed).[44] Still, however, she did not find a ready market for her work until the mid-1960s when she was sixty-five years old.

For her 1959 exhibit at the Museum of Modern Art, Nevelson created a "white show"—*Dawn's Wedding Feast*. The entire piece could not be viewed until its final assemblage at the museum. Included were *Dawn's Wedding Pillow, Mirror, Wedding Cake,* and *Wedding Chapel.* The use of white rather than black paint caused the sense of illusion and mystery to vanish, but the baroque quality of her unique juxtapositions was enhanced. The total effect was that of a New England Victorian morning in dazzling sunlight. Nevelson had hoped that the entire environment could remain intact; yet, although there were buyers for individual pieces, there was no purchaser for the complete "Feast" and after disassembling the show, she reused the unsold pieces in other works.

In 1961, Nevelson created a group of gold pieces which were exhibited at the Martha Jackson Gallery as *Royal Tides,* and in 1963, when she was invited to participate at the Venice Biennale, she took three rooms, painting them black, white, and gold respectively, and placed appropriately painted works in each room.

After a 1965 tour of a foundry, Nevelson ordered some metal castings and began a new phase of her career which demanded a new approach to her work.[45] For the first time she made small-scale models for large walls that were machine-cut in aluminum and corten steel. These larger pieces are more rigidly geometric and constructivist, more durable, and suitable for placement in the open air. Princeton University commissioned her first monumental outdoor piece in 1969: *Atmosphere and Environment X* (Fig. 9-14) is part of a series of works whose precisely cut circles, semi-circles, and S-curves fill the rectangular grids (most of which are open, thereby incorporating the land into the total vision). Another is in Fairmont Park, Philadelphia. Concomitant with these pieces, Nevelson created delicate and elegant plexiglass table pieces that change form with the light and movement of the viewer.

Especially interesting in her recent work are the flowers in the *Seventh Decade Garden* which were installed at the Pace Gallery in 1971. Harking back to her early columnar assemblages, they were welded together from the scraps of metal found at the factory that fabricated her steel sculptures.

Nevelson is a strong supporter of the feminist movement.[46] She considers her work "feminine" because she is a woman. "My work is delicate; it may look strong, but it is delicate. True strength is delicate. My whole life is in it, and my whole life is feminine."[47] Internationally honored, this "grand old mistress" of American art may be her own best assemblage: dressed in fabrics and jewels from a variety of cultures and civilizations, she has created a personal style both elegant and curious, which her tall, spare frame carries with aplomb. This indomitable woman has almost singlehandedly been responsible for the renaissance of sculpture in America.

ALICE NEEL (b. 1900)

Alice Neel's paintings constitute her autobiography. She has surrounded herself with these canvases—most have not been sold, since she never painted to please a sitter or the market place—as if at a family gathering over which she presides as matriarch. As she explained in a statement written for the 1960 publication, *The Hasty Papers*:

As for myself, being born I looked around and the world and its people terrified and fascinated me. I was attracted by the morbid and excessive and everything connected with death had a dark power over me.
I decided to paint a human comedy—such as Balzac had done in literature. In the 1930's I painted the beat of those days—Joe Gould, Sam Putnam, Ken Fearing, etc. I have painted El Barrio in Puerto Rican Harlem. I painted the neurotic, the mad and the miserable. Also, I painted some squares—Like Chichikov I am a collector of souls.[48]

The third of four children of Alice and George Neel—her father was the son of a Civil War veteran and her mother a descendant of a signer of the Declaration of Independence—Neel grew up on Philadelphia's Main Line. In 1921 she enrolled in the Philadelphia School of Design (Moore College of Art); her family thought she was studying to be an illustrator, but she had a secret life at school. After graduation, she married a Cuban student from a wealthy family and moved to Greenwich Village, where the couple became part of the bohemian atmosphere of the "roaring twenties." But their life was far from romantic; they had no money, and as a result their infant daughter died from diptheria in 1927. Neel's response to despair was to paint a picture. Actually, *Futility of Effort* (1930) is a dual

FIG. 9-15. Alice Neel, *Linda Nochlin and Daisy*
(1973). 55½″ × 44″. Collection of the artist, New York.

memorial: the artist had been moved by another
infant's tragic death by strangulation between the
bars of a crib. With a few lines and little color, she
was able to come to terms with her own grief.
Another daughter was born, and in 1930 her husband
took the child to Cuba. He then went to Paris with a
promise to send for Alice when he had saved some
money. The Depression began; Alice stayed in New
York, sharing a studio with a school chum and
painting to survive. Before the year was out, she
suffered a breakdown which incapacitated her for a
year. She did not see her daughter again until 1934,
and by then the marriage was over.

One of the artist's more notorious portraits of the
1930s is that of the poet, exhibitionist, and court
jester of Greenwich Village, Joe Gould. The nude
Gould is portrayed with three sets of genitals, and is
flanked on either side, in classical style, by two
frontally placed ultra-violet penises, one circum-

cised, the other not. Shown in 1973 at "The Male
Nude Exhibit" at the School of Visual Arts Gallery
(organized by John Perreault, whose reclining nude
portrait by Neel was the "centerfold" of the exhibit),
the Gould portrait set the sexist tone of the show.
Men were shown in their various roles—"sex object,
love object, beautiful object." Although the Gould
portrait was satirical, Neel's work is usually serious.
The artist is as much concerned with the formal
aspects of her paintings as with correct gesture of
limb or grimace of face. Neel's paintings are art, not
caricature.

Following the bohemian life of the 1930s, Neel
took a series of lovers in the Village, and then in
Spanish Harlem, where she lived for twenty-five
years, painting in an expressionistic manner the
poverty that surrounded her. With WPA aid she was
able to support herself and her two sons—Richard,
born in 1937, and Hartley, born in 1941. (Ironically,
her sons eventually became professional men, spurn-
ing the artistic aspirations she had for them.) Even
with two young sons to care for, Neel continued to
paint, working at night while they slept. As she
explained, if a woman stops painting for ten years to
raise her children she loses touch with her art and
becomes a dilettante.[49] To Neel, painting was more
than a profession; it was the only time she felt like
herself, that she felt she was not playing social roles;
painting was both cathartic and therapeutic.

Until recently, Neel's gallery shows were infre-
quent; many viewers were horrified by her human
comedy, but despite the long years of neglect she has
had as many supporters as detractors in the art
world.[50] After viewing her first one-woman show in
eight years, Kim Levin of *Art News* wrote that Neel's
portraits are "contemporary both in form and psy-
chology, proving that the portrait as an art form is
still vital. . . . She paints the shells [people] have
chosen and, penetrating their shell, probes and ex-
poses their inner being, their thoughts, their pan-
ics."[51] Her paintings are reduced to essentials—a
black line will define a hand, a broad stroke of grey a
jacket. While some paintings are carried to com-
pletion, with others, if she feels what is down on the
canvas captures the essence of the sitter, she feels no
need to finish it. Neel focuses on the face. The hands,
although their delicate gestures often reveal subtle
truths, are usually limp and structureless and the
torsos compressed.

According to one feminist critic, Alice Neel has
become a "symbol of both the discrimination and
neglect women artists have had to endure, and
artistic integrity and courage in the face of official

FIG. 9-16. Alice Neel, *Andy Warhol* (1970). 60" × 40". Whitney Museum of American Art, New York. Promised Gift of Timothy Collins.

hostility."[52] Her one-woman show at the Whitney Museum in 1974 was a result of petitions from the art community, many of whose members are portrayed on the walls as her "willing victims." Collectively, her portraits produce a disquieting experience: none of her sitters is without anxiety; even if the pose is relaxed, tension exists. "This lurking uneasiness," as Linda Nochlin describes it, "is not something that Neel reads into her sitters." It is how she views them, how they exist for her. When Nochlin and her daughter were sitting for the artist (Fig. 9-15), the puzzled Neel offered: "You know, you don't seem so anxious, but that's how you came out."[53] She had penetrated the surface, but could not explain how or why. Mother and child rest uncomfortably on Neel's couch; Linda's face is mask-like, while Daisy's still has the wide-eyed innocence that Neel reserves only for the portrayal of children (especially her own grandchildren). This is no madonna and child; the

mother tentatively restrains her child, who seems ready to bounce off the couch and out of the picture frame to carry on the activities of childhood. Brilliant purples, greens, yellows, and oranges predominate.

Neel's most devastating portrait may be that of Andy Warhol (1970; Fig. 9-16), now in the collection of the Whitney Museum. He is shown bare-chested, his breasts drooping toward the stitching and girdling of his wounded white flesh—the result of a near-fatal shooting. Warhol's body is tight and compressed as he sits uneasily on the couch; his closed eyes effectively shut out the viewer. Color is lightly brushed on bare canvas. The couch on which Warhol sits is defined by a thin grey line.

A perusal of the catalogue prepared for Neel's 1975 retrospective at the Georgia Museum of Art in Athens will serve to further introduce the reader to the variety of characters the artist has painted in her seventy-eight years. For Alice Neel, art is a form of history;[54] indeed, her oeuvre constitutes the social history of an epoch.

ISABEL BISHOP (b. 1902)

Isabel Bishop has been commuting from Riverdale, The Bronx, to her Union Square studio in lower Manhattan since her marriage in 1934 to the eminent neurologist Harold B. Wolff. (The marriage, a happy one, ended with Wolff's death in 1962.) According to Bishop, Wolff "found no contradiction between science and art," and was attracted to her "because of [her] commitment to art."[55] Her only concession to domesticity after the birth of her son in 1940 was that she went to her studio five days a week rather than six.

Bishop is a keen observer of the continuous and constant street activity—the fire sales, the bums, bargain hunters, working girls—from her large studio window. Sometimes she sits in the park making quick sketches of passersby; often she invites them to pose for her in the studio. But they are never still: to capture the spontaneity of movement, her models, like Rodin's before her, are constantly in motion. Indeed, movement and mobility—two aspects of flux—have been her primary concerns. Both involve transition: from one class or role to another, from one place to another. As she has explained on several occasions:

If they [the working women] want to move into another class they can, and it's that mobility that connected for me, something which I was absolutely focused on—the at-

tempt to make forms which to the spectator were mobile or move-able, that could move. Not that they were moving. I'm interested in something else now which is quite different, that is to say, I am interested in trying to convey movement taking place. . . . Movement can take place without mobility, as mobility can take place without movement.

The only sociological content in her work is its peculiarly American emphasis on mobility.

Bishop's father was a teacher of classics in the school that he ran in Princeton, New Jersey, before moving briefly to Cincinnati (where Isabel was born), and then to Detroit in 1904, where he accepted private school principalships. The family was poor, but elitist in terms of education and values. Since young Isabel was not allowed to play with the neighborhood children, she grew to envy their cama-raderie. She attributes her warm "feelings about all these Bronx and Brooklyn girls and even later the

FIG. 9-17. Isabel Bishop, *Nude #2* (1954). 31¾″ × 21½″. Mixed media. Des Moines Art Center, Rose F. Rosenfield Fund, 1958.

bums" (whom the artist considers the only true leisure class in America) to her feeling of isolation as a child. Since she was thirteen years younger than her nearest sibling and virtually grew up an only child, her sense of loneliness was increased. "All I could do was draw," claimed the artist, and so her family gave her what amounted to extraordinary art lessons: she began drawing from the nude female model when she was only twelve. An affluent relative sponsored her studies at the School of Applied Design for Women in New York, where she was supposed to learn illustration in order to be self-supporting.[56] After spending two years entrenched in academic banalities, the young artist enrolled in the Art Students League, studying first with Max Weber and Guy Pène du Bois and then with Kenneth Hayes Miller, who for a brief period became her mentor. It was from him that she learned the importance of a continuous, sustained commitment to art, and it was to him that she returned for additional study when depressed by the isolation of her studio.

Along with Miller and Reginald Marsh, Bishop first achieved celebrity in the 1930s as a kind of "urban regionalist;" she also was linked to the Social Realists. But her art protests nothing; she does not appeal to a viewer's sympathy; her derelicts and working people are not interpreted as either pictur-esque or depressed figures. Even the most down-trodden are often portrayed in a small moment of triumph: a man meeting a girl, a bum getting a free drink on a hot day, a derelict discovering a cigarette butt, two shopgirls sharing a snapshot, gossip, or food. She painted these people because they were there; hers was "an innately classical response to the dignity of the human spirit."[57]

The only one of her paintings that Bishop kept in her home—for almost forty years—was *Virgil and Dante in Union Square* (1932), a large frieze of New Yorkers coming and going against the architecture of the Square. The silhouetted figures of Virgil and Dante, viewed from the rear, appear perplexed by all the seemingly random movement. In this painting can be seen the sources of all the artist's subsequent work; it also harks back to her earlier Chardin-like still-lifes, in which the objects are spread, frieze-like, across a table, waiting to be used, waiting for motion. *Virgil and Dante* was first shown at the Midtown Galleries in 1932, inaugurating her long association with that gallery.[58]

The first painting Bishop sold to a museum was the *Nude* purchased by the Whitney Museum in 1934. Although she admits that the "female nude is an unlikely subject for a female artist," the nude

FIG. 9-18. Isabel Bishop, *Campus Students* (1972). Etching and aquatint. 8¼″ × 14¼″. Courtesy of Midtown Galleries, New York.

female, which has formed a major part of Bishop's oeuvres, can, according to the artist, "have the summing up possibility of a metaphor, if it can be made subjectively real."[59] "It is not only a subject but an artform . . . , one would have to have a rather special attitude to study the male nude."[60] Bishop's nudes are Rembrandtesque in their stockiness and sensuality. And like Degas' "keyhole" nudes, they are in motion—dressing, reaching, bending, pulling. The simple act of a pedicure becomes a grand gesture. *Nude, #2* (1954; Fig. 9-17) at the Des Moines Art Center in Iowa is also a testament to her superb draftsmanship.

Bishop completes only three or four paintings a year and, given the longevity of her commitment, has had few one-woman shows. Her elaborate working methods are legend: from the notations in her sketchbook or from sketches made in the studio, more formal drawings are made, then etchings and aquatints; gestures are constantly being modified, relationships corrected, and values established. (*Campus Students* of 1972—Fig. 9-18—is the etching and aquatint stage of the 1973 painting *High School Students #2*. In draftsmanship and clarity of design it surpasses the painting for which it was a study.) The prints are then photostatically enlarged in various sizes, and after choosing the appropriate size for the problem at hand, the artist begins to paint on her elaborately prepared panel. To produce the "irredescence and transparency" that characterizes her work, eight coats of gesso are first applied to masonite panel; the artist then applies "a ground of loose, uneven gray stripes composed of gelatin, powdered charcoal, and white lead to create a surface that will give a sense of vibration" and act to unify the various forms and movements.[61] Bishop has always used a limited palette of muted oranges, ochres, greens, and reds. "Color is not the original motif for me," she has stated. "My fundamentals are form, space and light."[62]

Since the 1960s her preferred theme has been students. Bound together for a brief period, they share a sense of purpose, but their attachments are shifting and temporary. They are the urban young passing somnambulistically through shallow, ambiguous

space. They appear and reappear, these vaguely suggested figures submerged in layers of paint, the texture and color of which extends beyond their sharply incised outlines. Again, in these late works, her concern with mobility and transitional states is apparent. With her retrospective at the Whitney Museum in 1975 came renewed public acclaim. Bishop was recognized as an artist who lovingly and poetically has recorded the life of an era. By deliberately limiting her subject matter in order to capture the essential gesture, she has demonstrated that the incidental can be a metaphor for the universal.

Although Bishop does not consciously attempt to create a "feminine" vision, she believes, like Nevelson, that her work must be feminine since it is a product of a feminine sensibility. Since women have world views distinct from men, the artist claims that critics should be able to "look at women's work from the point of view of finding content different from men's there, whether the women have consciously put it there or not."[63]

LEE KRASNER (b. 1908)

Leaving his wife and four children in a small village near Odessa, Russia, Joseph Krasner, like countless other Jews from his shtetl, made the steerage-class journey to America, and when the food market he set up in Brooklyn began to prosper, sent for his family. Lenore (known as Lee) was born nine months later. After attending Washington Irving High School in Manhattan—"the only girl's public high school at that time where I could major in art"—and in 1927 the Woman's Art School of Cooper Union, Lee Krasner enrolled in classes at the National Academy of Design. A self-portrait from this period (1931)—painted so that she might be promoted to the life class—is stylistically indebted to Monet and Cézanne, and reveals an independent, determined young woman with blue-grey eyes, red hair, and a large sensuous mouth. When the Museum of Modern Art opened its doors in 1929, she and the Academy students were "hit very hard by the first live contact with the Paris School . . . Picasso, Matisse . . . mostly Matisse."[64] Her painting during the next dozen years showed the influence of both artists.

After leaving school Krasner entered the bohemian life of Greenwich Village. She also started studying to become an art instructor. Teaching did not appeal to her, however, and when the WPA Federal Art Project was formed, she quickly joined and became

an assistant to the muralist Max Spivack. Caught in the left-wing political and intellectual turmoil of the period, Krasner came to view art as a vehicle for social change and became an influential member of the Artists Union. She also belonged to the American Abstract Artists, a group organized to introduce abstract art to the American public. At its 1938 exhibit, to which Léger and Mondrian were invited, Krasner perused the exhibit in the company of the latter. When Mondrian saw her work, he commented: "You have a strong inner rhythm. You must never lose it." Of the same work, Hans Hofmann (with whom she studied from 1938 through 1940) offered that ultimate accolade: "This is so good that you would not know it was done by a woman."[65]

Among the artists included in the McMillen Gallery's 1942 "American and French Painting" exhibit was Jackson Pollock. Surprised that there was an American artist unknown to her who could paint with such power, Krasner, "being of an impulsive nature," immediately visited his studio. When she looked at his paintings, she "almost died." "It was the same sort of thing that I responded to in Matisse, in Picasso, in Mondrian." When he saw her work, he too was generous with praise. They became each other's best critics and supporters until Pollock's death fourteen years later. As critic Clement Greenberg said, ". . . even before their marriage her eye and judgment had become important in his art, and continued to remain so."[66] Krasner introduced Pollock to Hofmann, to Mercedes and Herbert Matter (who saw that he met James Johnson Sweeney, the critic who first defended him in print), and to Sidney Janis, who reproduced Pollock's *She-Wolf* in his book on American abstract and Surrealist painting.

Ironically, Krasner existed in Pollock's shadow for years, and only recently has the extent of her talent been recognized. In the catalogue essay for her 1973 exhibition at the Whitney Museum, curator Marcia Tucker wrote that Krasner "is one of a generation of artists who changed the history of art in America and the world, successfully challenging the European establishment of aesthetic and cultural values."[67] According to B. F. Friedman, Pollock's biographer, although she "had confidence in the quality of her own work, she never thought of it in the same terms as those in which she thought of Jackson's. . . ."[68] When Friedman visited Lee and Jackson at Springs, the underdeveloped section of Long Island to which they had retreated in 1944 (the year of their marriage), he did not know that "Mrs. Pollock" was a painter. At that time she had had only one solo exhibit to

Jackson's dozen, and was known among the art community as "the great man's wife." Krasner emphatically rejects this image of herself, and has described their early years together thus:

He always slept very late . . . Morning was my best time for work, so I would be in my studio when I heard him stirring around. . . . We had this arrangement that neither of us would go into the other's studio without being asked. Occasionally, it was something like once a week, he would say, "I have something to show you" . . . he would ask, "Does it work?" Or in looking at mine, he would comment, "It works" or "It doesn't work." . . . We rarely had art talk, sometimes shop talk, like who's going to what gallery. . . . I did the cooking but he did the baking when he felt like it . . . We made an agreement about the garden when he said, "I'll dig it and set it out if you'll water and weed."[69]

When queried as to why she did not promote her work along with Jackson's, the artist responded bluntly:

I couldn't run out and do a one-woman job on the sexist aspects of the art world, continue my painting and stay in the role I was in as Mrs. Pollock. I just couldn't do that much. What I considered important was that I was able to work and other things would have to take their turn. Now rightly or wrongly, I made my decisions.[70]

Krasner seems not to have been dependent on Pollock; but consumed, rather, by his dependency on her.

It was in the small bedroom studio at Springs that Krasner began developing her "little images," or hieroglyphic paintings (Fig. 9-19). Composed of small self-contained geometric forms, each image has a different linear pattern that turns in on itself. The colors are limited mostly to black and white (with squiggles of yellow, red, red-orange and green) and the paint heavily impastoed and sometimes applied with a controlled drip. Encouraged by Jackson, she had her first one-woman show at the Betty Parsons Gallery at the end of 1951. Instead of showing the fully realized "little images," which she had worked on for five years, the artist showed transitional pieces that Pollock said had a "freshness and bigness that she didn't get before." Pollock was then associated with Betty Parsons, who recalled the initial transaction: "Jackson telephoned me and asked me to give her a show. . . . I said I never showed husbands and wives, but he insisted." When Jackson decided to break his contract with Parsons, Lee was summarily dropped. The result was an identity crisis and a period of depression. Her role as Mrs. Pollack had indeed superseded all others at this time. The artist cut up her paintings, and using scraps from Pol-

FIG. 9-19. Lee Krasner, *Untitled* (1949). 48″ × 37″. Museum of Modern Art, New York. Gift of Alfonso A. Ossorio.

lack's discarded canvases as well as black paper, she reworked them into collages that were shown at Eleanor Ward's Stable Gallery in 1955. Dominated by large, linear shapes which combine Fauvist color and Cubist space, they were conceived with great authority and according to Clement Greenberg "were a major addition to the American art scene of that era."[71] They were also more expansive and contained fewer images than the "little image" series.

For months after Pollock's death Krasner could not paint; she was immersed in legal details, gallery commitments, and in the interviews and financial complexities that befall the "art widow." In the first paintings following her husband's death—mural-sized works such as *The Seasons* (1957) and *The Eye is the First Circle* (1960)[72]—his influence is most

apparent. Large sweeping anthropomorphic and organic forms fill the canvas; open sprawling areas contrast with densely detailed ones. In *The Seasons,* especially, the imagery is suggestive of nature—large plant-like shapes are mixed with suggestions of fruit and genitalia in sweeping arabesques. By 1968, with *Pollination,* the number of forms has been reduced, but the arabesque movements and the heavy impasto are still present. With *Majuscule* (1971; Fig. 9-20) there is another change: the emphasis is on a single large image broken into smaller images; the forms are all self-contained, with an emphasis on the outline of each shape. Unlike the paintings of the 1950s and 1960s, the paint is applied in large flat areas, as if the artist were paying homage to Matisse's late *papiers coupés.* The contrast in color is striking—she now chose Kelly green, blue, grape purple, and a touch of red in the heart-shaped area in the upper left corner—all painted on a field of grey.

Krasner has a non-intellectual approach to her art. When she stands in front of a canvas, she has no idea what will emerge. One gesture suggests another; a form is created which demands another form. "I'm often astonished," she has said, "at what I'm confronted with when the major part comes through."[73] The Abstract Expressionist use of the spontaneous gesture remains with her, but it is the spontaneity of a well-trained sensibility. Her paintings are also rooted in nature: she "can't conceive of anything that

FIG. 9-20. Lee Krasner, *Majuscule* (1971). 69″ × 82″. FMC Corporation, Chicago.

doesn't have this kind or organic, rudimentary form."[74] When viewing her own work retrospectively at the Whitechapel Art Gallery in London in 1965 (an experience she recommends to all artists), Krasner became aware of the cyclical changes that seemed to occur in her work every four or five years. ". . . I no sooner settle into something than a break occurs. These breaks are always painful and depressing but despite them I see that there's a consistency that holds out," she wrote in an essay for the catalogue of the exhibit.[75] Her paintings are also autobiographical: the color, or lack of it, the passivity or turbulence of movement, the brushwork, the forms, all reveal a measure of the content of her life at the time of their creation.

DOROTHEA TANNING (b. 1910)

At age seven, without knowing it, Dorothea Tanning made her debut into the world of Surrealism: she made paper cubes in which she put little paper balls covered with messages destined for secret loves. She shook the cubes, listened to the noise, and dreamed ecstatically about the world they contained.[76]

Tanning was born in Galesburg, Illinois, the daughter of a Swedish immigrant who ran away from home to seek his fortune in America when he was seventeen. Halfway across the American continent, he met his bride and settled in her home town. Using the third person, the artist has described her background:

Dorothea was raised in an atmosphere of strict Lutheran piety. But at the same time there hovered over the Tanning roof a genie of extravagance which might have been named "Keeping Up." Thus, while dancing and card-playing were forbidden to the three little daughters of the house, they were to be found wearing lace, and velvet cloaks, and dresses that might have been Paris originals.[77]

At eighteen she entered Knox College in her native town and at twenty transferred to the Art Institute of Chicago. Despite her family's objections, she left for New York in 1935. Through Julien Levy, who had early recognized her originality and exhibited her work, she met the New York Surrealists. After viewing the landmark exhibit of Surrealist paintings at the Museum of Modern Art in 1936, she knew she had found kindred spirits. Since her work already contained images of "unexpected pictorial metaphors,"[78] the effect of the exhibit on the young artist was profound, her direction confirmed.

Armed with a letter of introduction to Max Ernst, Tanning left for Paris in 1939. With the threat of war, the artists had dispersed, and after four weeks of looking in vain for Van Dongen, Ernst, and others, she found herself exiled at her uncle's house in Sweden. Shortly after his arrival in New York in 1941, Ernst had married Peggy Guggenheim, owner of the Art of the Century Gallery.[79] It was through Julien Levy, in 1942, that Tanning finally met Ernst, and after re-establishing their relationship when he picked up some of Tanning's work to show at Art of the Century later that same year, the two became inseparable. They lived first in Long Island and then in Sedona, Arizona, a hamlet of fifty people which they transformed into a Surrealist community before returning to Europe in 1947, the year after their marriage. Tanning still lives and works in Paris, where she has received a multitude of honors. A major retrospective of her work was held at the Centre National d'Art Contemporain in Paris during the summer of 1974, and the only monograph on the artist is in French.

Tanning's best paintings date from the forties and early fifties. Concerned with women in their various stages of sexual awareness, she created precisely painted though ambiguous images that are both menacing and erotic. As Nochlin has stated, "In all of Tanning's iconography, woman's sexual initiation is depicted as at once ominous and attractive, and in either case inevitably implicated with Death."[80] Typical of the paintings of this period is *Eine Kleine Nachtmusik* of 1946: two young and nubile girls stand in a long hotel corridor; they are rigid and half-nude, their clothes in tatters below their waists. Down the long corridor are four doors, the last of which is slightly ajar, admitting a beam of light. But there is nothing beyond. A giant sunflower with long menacing tentacles—the symbol of defloration?—lies in wait on the landing. In *Birthday* (1942), the isolated image of the artist herself confronts us. Bare-breasted and shoeless, she has just opened a door, yet there are many more doors to be opened and closed. Strange weeds grow from her body, and a four-legged winged beast—the Pekingese dog Katchina that belonged to Max Ernst and appears in many metamorphoses in her work here has a pig's face and the wings of a bat—rests menacingly on the floor near her feet. Two of her recurrent images—the dog and the open and closed doors—appear already in this early work. In *Maternity* (1946; Fig. 9-21), an identically dressed mother and infant stand in a large yellow desert expanse, their bodies fused together. The mother's long white

FIG. 9-21. Dorothea Tanning, *Maternity* (1946). 44″ × 57″. Collection of Jeffrey H. Loria, New York.

gown is tattered in the abdomen area, and near her feet and sharing the blanket on which the mother stands, is the Pekingese. This time it is white and has the same face as the pink-cheeked infant. There is an open door to her left and another in the distance from which appears a biomorphic apparition constructed of tiny billowing sails. In this and other paintings of the 1940s, Tanning employs typical Surrealist devices: unusual juxtaposition of people and places, extended vistas, meticulous draftsmanship, and mirror-like application of paint. In the more satirical *Maternity II*, the mother squats on a bed, and has a face similar to the pup in the earlier maternity painting; her nude infants romp around her in various stages of sexual discovery.

In the late fifties and early sixties Tanning's paintings become more abstract. The forms in *Chien*

Ombrages (1958) are broken up into brilliant color prisms of light floating in ambiguous space like the paintings of the Chilean Surrealist Matta, whose work she must have seen at the Julien Levy Galleries in the 1940s. With her cloth sculptures of the late 1960s and early 1970s, Tanning has returned to earlier "erotic and menacing" themes. Using a variety of fabrics—tweeds, pink felt, synthetic furs— the artist created for her 1970 exhibit at the Galerie Point Cardinal in Paris images that ranged from the recognizable—the figures of *Nu Couché* (1969)—to the "larva-like" bent shapes of *Le Péché* (1969) and the "curly furry" *Cousins* (1970). The largest and most disturbing was the "double-humped" human-oid-shaped *Emma* (1970), made with pink felt trimmed in lace. Tanning created a Victorian environment for her, but rather than evoke nostalgic associations, the piece is more apt to "unsettle and disturb, and insinuate disquieting sexual connotations."[81]

André Breton paid little attention to the women artists of Surrealism. Indeed, Tanning commented recently that "the place of women among the Surrealists was no different from that which they occupied among the population in general."[82]

ELAINE DE KOONING (b. 1920)

When Elaine Fried was five, her mother took her to the Metropolitan Museum of Art for the first time. She remembers being "overwhelmed by the hush— the glamor of the place." Always drawing, by the time she was ten her peers were referring to her as "the artist." From then on, "I took it for granted— and began to compete."[83] Until she was seventeen, she thought all "real artists were dead or foreign," with the exception of Georgia O'Keeffe and John Marin, whose works she had seen exhibited at An American Place. Therefore, when she viewed the paintings at the American Abstract Artists Group in 1937, she was overwhelmed by the vitality of the new American art. The following year, she met the Dutch immigrant painter Willem de Kooning, who, along with Pollock, was to become a leader among the Abstract Expressionists; she became his student, and in 1943 his wife. (The couple were described as amicably separated in 1963.) At the time of their meeting, Willem was just beginning the series of paintings of women which became an important part of his oeuvre; Elaine posed for many of the early studies. In the summer of 1948, Willem was invited to teach at Black Mountain College (then headed by

Josef Albers), and in 1951 the couple followed Albers for a short tenure at Yale.

When Elaine de Kooning returned to New York in 1959 after a year of teaching at the University of New Mexico, her paintings had undergone a significant change. Responding to the openness of the sky and the land, to the color and light of the blazing sun, and to the spectacle of the bullfight, she produced a series of large—some almost twenty feet wide—horizontal canvases that revealed a new attitude toward color. De Kooning had always felt more at home with drawing because it had "more control, but it also imposes more ideas than color . . . so you get bogged down in ideas." Going West was a liberating experience for the artist. "When I went West," she stated in a 1960 interview, "the color experiences of New Mexico convinced me that 'feeling' was the thing."[84] Working from drawings of the bullfight done in terms of color, the artist created the "Arena" series which she showed at the Graham Gallery in 1960. One, entitled *Bull*, is a thirteen-foot-long battleground of red and orange. When the artist began thinking in terms of color instead of drawing, the size of her paintings greatly increased. Using an offset brush fit into an aluminum tube, she was able to work on the canvas from a ten-foot distance to create strokes up to eleven feet long. Although there is no recognizable subject matter in the "Arena" group, the paintings were inspired by observed places and events; the linear forces created by the large brushstrokes become the only forms: "Color then becomes a kind of super-drawing." The content that is communicated in this clashing of brilliant color and large gesture is that of an "embattled image," the same kind of struggle that the artist created in her paintings of athletes, and in such works of the 1950s as *Suicide* and *Squeeze Play*.[85] The energy exuded by these works can barely be contained even in a twenty-foot canvas.

A restless artist, De Kooning works on several paintings—both portraits and abstractions—simultaneously: "There is a point at which you can kill a painting if you keep at it too steadily." After spending all of 1947 on one painting, she finally coated it with white "to put myself out of my misery."[86] Before exploring the automatism of the Abstract Expressionists, she was recognized as an expert draftswoman. She drew from nature constantly; for a year, she and the painter Joop Sanders drew each other on a daily basis. Her weakest paintings are those portraits of the 1950s in which the figure barely emerges from the slashing brushstrokes; they are also the works which most closely resemble the paintings of

Willem. Elaine produced some exciting Abstract Expressionist paintings, but her most significant works are her portraits. With their "bold synthesis of abstract excitement and the simplicity of gesture peculiar to her subjects," her portraits at the Museum of Modern Art's 1962 show, "Recent Paintings U.S.A: the Figure", were considered by at least one reviewer among the best in that genre produced in this century.[87]

Elaine de Kooning's portraits are more than just summations of people—they are first and foremost paintings. As with her Abstract Expressionist paintings, she will start almost anywhere on the canvas. Rather than being interested in a photographic likeness, which she believes is ultimately meaningless, the artist seeks a "character resemblance." Each person has his or her own light: "One subject of mine has a silvery light that just isn't the same light that falls on others; another has a kind of lavender light."[88] Her subjects have included her family and the leaders of the art world; she also accepts commissions, secretly admitting that "some of my best paintings have been hidden away in portrait commissions."[89] In a conscious effort to capture the "spirit of the sitter," she "zooms in on the person." Yet, when compared to Neel's portraits, de Kooning's are flattering and sympathetic.[90] One of her most effective portraits has no features, yet the six-foot-high likeness of the late art critic and poet Frank O'Hara (1962) is instantly recognizable because the artist has captured his peculiar posture, the set of his head, and his languid stance. "First I painted the whole structure of his face; then I wiped out the face, and when the face was gone, it was more Frank than when the face was there."[91] The placement of the ear and the bone structure of the skull do indeed summarize the face.

Although de Kooning's portraits have been described as "hardly the sort that a board of directors would buy in a frame marked 'Our Founder,'" she was commissioned by the Board of Trustees of the Truman Library in Independence, Missouri, to paint a portrait of President Kennedy. From dozens of sketches from life of the late president reading, speaking, conferring, from photographs and from notations she made while watching him on TV, she produced four large oil portraits, three of which hung in the Massachusetts Pavilion at the New York World's Fair after Kennedy's death. They are large and loosely painted, with much of the raw canvas left exposed. With her portraits of the 1970s, the scale has been reduced—that of the late artist Gandy Brodie is a mere 63″ × 41″. Size is deceptive, however; the

FIG. 9-22. Elaine de Kooning, *Portrait of Gandy Brodie* (1972). 63″ × 41″. Graham Gallery, New York.

Gandy portrait (1972; Fig. 9-22) has the classic monumentality of a Cézanne. While she has concentrated on the artist's features, every part of the canvas is equally considered, though less finely honed. He looks out at us with his characteristically quizzical stare. The blues, greens, and ochres of the minute planes of the face are repeated in the background.

During the 1950s and up until about 1965, Elaine de Kooning was a "star" of the New York art world. In 1963, Lawrence Campbell concluded an article on her most recent exhibit: "Elaine de Kooning is one of the principal reasons for supposing that New York painting will continue to show vitality beyond the first wave of Abstract Expressionism."[92] However, for the next ten years—with Pop, Op, and Minimal

aesthetics preempting the art scene—little was heard from the artist. With the return of interest in the figure, de Kooning is once again actively exhibiting at the Graham Gallery, with which she has been associated for over fifteen years. Unlike many of the photo-realists, who, using commercial air brushes, work from photographs and enlarged color slides, there are no gimmicks in her work; hers is an art of pure painting.

Elaine de Kooning objects to being classified as a woman artist: "To be put in any category not defined by one's work is to be falsified."[93]

JOAN MITCHELL (b. 1926)

Joan Mitchell considers herself a traditonal painter in that she uses oil paint and canvas and relies on nature, albeit an illusionary or metaphoric interpretation of it, as a point of departure for her work. Unconcerned about the politics and vicissitudes of the New York art world, she told Marcia Tucker before her 1974 exhibit at the Whitney Museum that "My paintings aren't about art issues. They're about a feeling that comes to me from the outside, from landscape."[94] Unlike the Impressionists, she does not stand in front of a view and abstract from it: "I would rather leave Nature to itself. It is quite beautiful enough as it is. I do not want to improve it . . . I could certainly never mirror it. I would like more to paint what it leaves me with." Although she has been traditionally classified as a second-generation Abstract Expressionist, Mitchell rejects the category, claiming her work is not "autobiographical or emotionally self-expressive." "It comes from and is about landscape, not about me."[95] The stylistic label she finds least objectionable with regard to her work is the all-inclusive one of "New York School."[96]

The daughter of a wealthy and sophisticated Chicago family—her father was a physician and a Francophile, her mother a poet—Joan attended a progressive private high school where she received the support and encouragement of her art teacher. Her parents insisted that she perform well in everything she did: she excelled in sports and received many athletic awards, sensing always her father's disappointment that she was not a boy. The artist later recalled that her father competed with her, continually challenging her abilities with "You'll never speak French as well as I. You can't draw as well as I. You can't do anything as well as I because you are a woman."[97] After high school, Mitchell attended Smith College for two years and then transferred to the Art Institute of Chicago, where she received her Bachelor of Fine Arts degree in 1947. Her earliest sources were the Cézannes, Van Goghs, Matisses, and Kandinskys that she was able to examine at the Institute's museum. It was not until she arrived in New York in 1950, after having worked and traveled in Europe for two years as a Fulbright fellow, that she began her large, freely painted "landscapes."

The New York art world was in ferment, and after settling into her Greenwich Village studio, Mitchell became part of the local scene, attending lectures at The Club and frequenting the Cedars Tavern. Arshile Gorky, Willem de Kooning, and above all Franz Kline became her new models. Invited to exhibit in 1951 at the historic Ninth Street Show, where Abstract Expressionism was introduced in force to the art world, Mitchell has been exhibiting at respectable intervals ever since; her first one-woman show was also held in 1951. The artist is convinced that her self-deprecation about being a woman during a decidedly masculine phase of American art ultimately served her well. Although at first it was difficult to find a gallery, "I had it easier because I never even thought that I could be in the major competition, being female."[98]

The gestures of Mitchell's New York paintings before 1955—for example, *Number 12* (1952)—are built up with the dense horizontals and verticals of the city. In contrast, those painted from the remembered vistas of her travels to Mexico or the Midwest, or from her visits to Long Island, are more open and expansive. Rather than the all-over pulsating movement of the Abstract Expressionists, movement in a Mitchell painting is usually directed to a single, built-up area that is suspended in an ambiguous space. In *Ladybug* (1957; Fig. 9-23) the notations of her brush become forms that seem to dance on the shimmering surface; the small branch-like or bird-like strokes interact with each other to create a larger movement. Large gesture is mingled with small; purples clash with magentas before resting near deep blues. There are subtle relations of greens, blue-greens and yellow ochres with an occasional dash of red-orange. Filled with energy and excitement, the canvas belies the slow and contemplative way in which the artist actually works. Indeed, Mitchell is not an "action painter." While one is aware of her physical gestures and arm movements because of the sheer size of both brushstrokes and canvas, Mitchell spends much of her time simply contemplating the canvas. Moreover, she always starts with a charcoal

FIG. 9-23. Joan Mitchell. *Ladybug* (1957). 6′5⅝″ × 9′. Museum of Modern Art, New York.

sketch of the composition's structure, working in horizontal and vertical movements. Although the idea of landscape is always present when she starts a canvas, once she is lost in the act of painting the initial remembrance ceases to be important.

There are no accidents in a Joan Mitchell canvas. She has said: "I don't close my eyes and hope for the best. If I can get into the act of painting, and be free in the act, then I want to know what my brush is doing." During the painting process the artist tries to lose herself in her work: "I want to make myself available to myself. The moment that I am self-conscious, I cease painting. When I think of how I am doing it, I've been bored for some time and I stop."[99]

Abandoning the politics and polemics of the New York art world, Mitchell moved to Paris in 1959. Although she frequented the bars where other American expatriates congregated, she did not partake of the Parisian cultural life and maintained her artistic independence. She settled in Europe because it provided a neutral climate where she could develop her personal style away from the pressures of New York, where styles of art changed with each new season and consequently rendered many painters obsolete before the age of thirty. Indeed, Joan Mitchell was considered out of fashion in the 1960s (as was Grace Hartigan, another "darling" of the second-generation Abstract Expressionists), but she was unconcerned. "There will always be painters around," she told

FIG. 9-24. Joan Mitchell, *Clearing* (1973). 110¼" × 36". Whitney Museum of American Art, New York. Gift of Susan Morse Hilles in honor of John I. H. Baur.

John Ashbery in a 1965 interview. "It'll take more than Pop or Op to discourage them—they've never been encouraged anyway.... There have always been very few people who really like painting—like poetry.... I don't think you can stop visual painters and all the rest is an intellectual problem."[100]

Since 1969 the artist has lived in Vétheuil, a suburb of Paris, where the compound she shares with the Canadian artist Jean-Paul Riopelle adjoins that in which Monet once lived and worked. The paintings of the fields and gardens that surround her home are filled with the light and color of Monet, a light that does not exist in New York or Paris. Although she has no children of her own, she plays the maternal role for Riopelle's children and grandchildren. Now at the height of her powers, the artist was given a major one-woman show at the Everson Museum in Syracuse, New York, in 1972. In 1974, twenty-two works from the previous five years were installed at the Whitney Museum. Filled with light and energy, the diptychs and triptychs of the 1970s are even larger than her New York and early Paris paintings.

The huge triptych *Clearing* (1973; Fig. 9-24) cannot be viewed in one glance; one feels a passage of time and change in nature as one reads it or passes it by from left to right. The forms, while still suspended by miracles of gravity, are large and rectangular, or amorphous and doughnut-shaped—like Hof-

mann's works of the late 1950s, but with more air and light. Only in the central panel is there evidence of the early, fluttery, branch-like brushwork. The large black shape in the upper left corner finds its mate in the central panel and moves to the upper right corner in panel three. In the middle panel we see only the "hole" of the large blue-purple doughnut shape, which has floated almost intact to the third panel. There is a closer figure-ground relationship in panel two than in the first panel, and an opening and clearing of space in panel three.

HELEN FRANKENTHALER (b. 1928)

On the occasion of Helen Frankenthaler's one-woman exhibit at the Whitney Museum in 1969, Eugene Goossen, in his catalogue essay, paid her the ultimate tribute: "The recent history of American painting would have been notably different without her presence, and the absence of her work would deprive us of any number of major paintings upon which the premises of contemporary art rely."[101] Identified with the second generation of Abstract Expressionists, Frankenthaler has had countless one-woman exhibits, awards, honorary degrees, teaching positions, lectureships, and commissions.

She has been the subject of a large monograph and has been written about, interviewed, reviewed, and quoted in publications too numerous to list.

The artist was fortunate in many ways: born in Manhattan, she never had to fight the provincialism that many of her contemporaries found so devastating. Her father was the State Supreme Court Justice Alfred Frankenthaler, who was able to provide his daughters—Helen was the youngest of three—with everything that wealth and privilege had to offer in the city. She attended the Brearley School and then Dalton, where she studied with the Mexican artist Rufino Tamayo, which was indeed a rare opportunity for a high-school student. The old Guggenheim Museum was near her home, and with Tamayo she explored the galleries in search of advanced European art. In 1946, she enrolled at Bennington College, a school for the privileged, and one noted for its receptivity to avant-garde ideas. Her training with Paul Feeley there was thorough: "By the time I graduated I really understood how to paint a Cubist picture." During summers and non-resident breaks there was European travel and study at the Art Students League with Vaclov Vytlacil and with Wallace Harrison at his Fourteenth Street Gallery. After graduation, to prove to her parents her seriousness of purpose, Frankenthaler enrolled at Columbia University as a graduate student in art history, but after one semester she left to devote herself completely to painting. (By the time she married Robert Motherwell in 1958 she was a mature painter, as was he. Both had independent incomes and unique styles; they were separated in 1969 and later divorced.)

Frankenthaler was also fortunate in her choice of friends. While organizing a Bennington Alumnae show, she met the critic Clement Greenberg, who became her first mentor. It was he who took her to the Friday night sessions of The Club and to the Cedars Bar, where she met all the first-generation Abstract Expressionists; together they went to galleries and museums, analyzing and rating the paintings; it was Greenberg who suggested she study with Hofmann in Provincetown, where she spent the summer of 1950 (and many subsequent summers, though no longer as Hofmann's student.)

The following year 1951 proved significant for the young artist: along with Joan Mitchell she took part in the historic Ninth Street Show, had her first one-woman exhibit at the Tibor de Nagy Gallery, and was introduced to Jackson Pollock. When she visited his show at the Betty Parsons Gallery, she recalled: "It was as if I suddenly went to a foreign country but didn't know the language, but had read enough and had a passionate interest, and was eager to live there." Pollock and de Kooning were then the reigning forces in American art, and Frankenthaler succumbed to the power of Pollock—"With de Kooning, you could assimilate and copy: [but] Pollock instead opened up what one's own inventiveness could take off from." Greenberg brought her to Springs to meet Lee and Jackson. From the work of one (Pollock) and the analysis of the other (Greenberg), Frankenthaler developed "her own sense of knowing when to stop, when to labor, when to be puzzled, when to be satisfied, when to recognize beautiful or strange or ugly or clumsy forms and to be free with what you are making that comes out of you."[102] She began working on the floor, pouring and staining great fields of unsized cotton duck (the material used for sails), creating an "unprecedented unity of image with surface." Frankenthaler departed from Pollock in many ways. While both worked on the floor, thereby investing their work with physicality, and while Pollock on occasion had also used the staining technique, his paintings were heavy with impasto, had linear movements that created a vibrant surface, and still echoed Cubist space. Frankenthaler, by contrast, gradually eliminated drawing and line, and through the process of staining an unprimed canvas created a nebulous, ambiguous space. Colors, shapes, and lines that appear to be in deep space are actually resting next to each other: "her goal . . . has been the definition of space through a parity of color, line and area."[103]

B. F. Friedman claims that it was natural that Frankenthaler, a woman, should adopt the staining technique, since it is "free, lyrical and feminine." Her colors, too, he finds "seductive and feminine" and analogous to the *fêtes galantes* of the 18th-century "feminine" painters Watteau and Fragonard.[104] When asked if she believed there was a female quality in her art, the artist replied that "every fact of one's reality is in one's work: age, height, weight, history, nationality, religion, sex, pains, habits, attractions, and being female is one of many in this long list for me. . . . What you call 'female quality' is a serious fact that I enjoy, and part of the total working picture."[105]

Her first successful painting in the stained technique, *Mountain and Sea* (1952; Plate 4), is remarkable in that it showed both her sources and her subsequent searchings. In it can be seen Gorky's and de Kooning's biomorphism, as well as the playfulness and lyricism of Kandinsky's early improvisations. The painting had a profound effect on the

FIG. 9-25. Helen Frankenthaler, *Enigma* (1975). Acrylic. 10' × 5'10". André Emmerich Gallery, New York.

Washington artists Morris Louis and Kenneth Noland. As Greenberg explained, when Louis saw the painting, he "change[d] his direction abruptly."[106] With this painting Frankenthaler "added light and color to Pollock's technical breakthrough."[107] Painted after a summer spent doing water colors in Nova Scotia and Cape Breton, it evokes the spirit of landscape, as did many of her subsequent paintings, but it is in no way a memory of a specific scene or an abstraction of her water-color studies. What she has seen or experienced, what she has described as her "inner psychic surroundings as well as outside orbits," becomes the source of her imagery, but the specific identification of particular paintings with landscapes she views as a convenient "handle . . . held onto by people who want a clue as to how to read the surface of an abstract painting."[108]

Although Frankenthaler's paintings seem to e-

volve effortlessly, they are a result of long experience—of decades of working, plus hours of observation. There is no planning and much risk in her methodology. Since she cannot rework a painting, many are discarded. If a canvas does not work, she will cut off one of the edges, thereby denying the age-old adage that a painting is a self-contained universe; now there is movement beyond the picture surface and into the surrounding space, with a concomitant sense of expansion rather than containment. Frankenthaler tries for the immediate impact; she does not want her work to look labored, nor does she want the process revealed. To her, "A really good picture looks as if it's happened at once. It's an immediate image. For my own work, when a picture looks labored and overworked . . . there is something in it that has not got to do with beautiful art to me. And I usually throw those out, though I think very often it takes ten of those over-labored efforts to produce one really beautiful wrist motion that is synchronized with your head and heart, and you have it, and therefore it looks as if it were born in a minute."[109] From the Surrealists she learned to use her unconscious, to allow the spontaneous and the intuitive to take hold. But intuition serves only the prepared mind; without rigorous training it becomes mere solipsism or self-indulgence.

When, in 1963, the artist turned from oils to acrylic paint, a new world of possibilities emerged. The acrylic did not leave the "halo" residue of turpentine-thinned oil, and since it did not soak into the raw canvas so quickly, it lent itself to flooding rather than staining, thereby allowing her to control the edges of her forms more easily. In paintings of the mid-sixties (*Four-Color Space, Five-Color Space, One O'Clock*), movement flows out from a nebulous center; the edges have assumed paramount importance. This concern with edge was apparent as early as 1959 with a most untraditional *Nude* in a landscape, in which the ten-foot-high amorphous white central form, although slightly dripped upon, is actually the raw canvas. Movement flows outward from the empty center. Other paintings of the 1960s such as *Dawn Shapes, Arcadia*, and *Approach*, with their humorous, biomorphic, floating forms pay homage to Miró.

The large, seemingly effortless and graceful paintings of the 1970s have a sense of inevitability about them—as though, according to Thomas Hess, created "from the hands of God."[110] The large central shape in *Enigma* (1975; Fig. 9-25) is attached to the frame at the lower left—was it sliced off there?—like a peninsula in a vast ocean. Within the subtle

gradations of color can be seen elements of nature; the intricacy of the forms within and without the large splotches of color attest to the artist's masterly control of her medium.

Frankenthaler continues to work and grow, exploring certain themes until a new one emerges, continually challenging herself within the technique she has made her personal signature. "I'd rather risk an ugly surprise than rely on things I know I can do."[111] After her retrospective at the Whitney Museum, the artist's public expanded and she became "mother" to a generation of lyrical abstractionists rebelling against the hard-edged geometry of the Minimalist aesthetic then dominating the New York art world.

MARISOL (b. 1930)

With charm, humor, and a bit of devastating wit, Marisol became the Daumier of the 1960s. By combining drawing, painting, modeling, casting, and found and purchased objects to make monumental images, she ridiculed our rituals, our leaders, and our institutions. Her influences were varied and unorthodox: pre-Columbian sculpture first seen at a New York gallery, an early American carved coffee-grinder, Mexican tin and painted folk sculpture, old wooden hat forms, and the "push-pull" painterly technique of her teacher Hans Hofmann. She became famous quickly, and each new exhibition attracted hordes of the uninitiated. But her work was rarely treated with the respect it deserved: she was referred to as a "dollmaker," and the popular journals were more apt to describe her dark beauty, faint voice that only infrequently broke through her long hermetic silences, and extravagant clothes than her art. Indeed, for a brief period Marisol epitomized the traditional 18th- and 19th-century role of the female artist as a glamorous, elegant, mysterious figure. For a few years, the artist cooperated in the creation of the Marisol mystique. It allowed her to experience various roles and make contacts; only she knew she was role-playing. Most of her time was spent working in her studio, and although her active social life inspired some of her best pieces, it detracted from her seriousness of purpose, and after a few years she again withdrew into the solitude of work.

The daughter of wealthy Venezuelan parents, Marisol Escobar (she dropped her last name early in her career "to stand out from the crowd") was born in Paris, and recalls a happy childhood filled with

FIG. 9-26. Marisol, *The Generals* (1961–62). Mixed media. 87″ × 76″ × 28½″. Albright-Knox Gallery, Buffalo, New York. Gift of Seymour H. Knox.

travel. The family left Paris in 1935 and commuted between Caracas and the United States during World War II before settling, in 1946, in Los Angeles, where she studied at the fashionable Westlake School for Girls, and with Rico Lebrun at the Jepson School. In 1948 she enrolled at the École des Beaux-Arts in Paris, but by 1950 she was in New York, which was quickly supplanting Paris as the mecca for young art students. After a brief period of study at the Art Students League with Yasuo Kuniyoshi, she enrolled in Hofmann's classes. Although Marisol liked all the schools she attended, she stated later that her "main influence has been the street and bars, and not school and books."[112] After three years with Hofmann, the young artist abandoned painting and "as a kind of rebellion" began, in 1953, to make erotic and amusing clay figures. "Everything was so serious. I was very sad myself and the people I met were so depressing. I started doing something funny so that I would become happier—and it worked. I

FIG. 9-27. Marisol, *The Party* (1956–66). Mixed media. 199″ ×88″ × 192″. Collection of Mrs. Robert B. Mayer. Courtesy of Sidney Janis Gallery, New York.

was also convinced that everyone would like my work because I had so much fun doing it," she told Grace Glueck in a 1965 interview, "and they did."[113] With financial support from her family, she never had to do any work besides her art—nor did she have to produce anything salable.

Marisol began exhibiting her small terra-cotta figures in group shows at the small galleries that had begun blossoming along Tenth Street in Manhattan's Lower East Side. There, in 1957, she was "discovered" by the dealer Leo Castelli and given her first solo uptown show, which was well received. The initial publicity frightened her, and she fled to Rome for three years to find "a better way of life—a more relaxed and happier one."[114]

After her 1962 exhibit at the Stable Gallery, her reputation was secure; the publicity mills were at work and she became a household name. Some of her most important work dates from that exhibit: *The*

Family, a compendium of five unappealing dust-bowl migrants, complete with real shoes of the period and constructed as a single unit, was purchased by the Museum of Modern Art; *The Generals* (Fig. 9-26), a satire on military pomposity in which two Napoleonic officers sit on a horse created from a barrel, was claimed by the Albright-Knox Art Gallery in Buffalo, New York.

In *Church Wedding*, an elaborate tableau of bride, groom, bridesmaid, and American Gothic church shown at her 1964 exhibit, Marisol's face appears on both bride and bridegroom. Her care in composition is apparent in this highly complex Cubist grouping: the triangle of the church spire is repeated, in reverse form, in the opening of the groom's tuxedo jacket and in the shape of the bride. Marisol's sculptural groups are meant to be viewed frontally, but little surprises occur as one walks around the groupings. These are not afterthoughts; every detail is carefully

planned. Indeed, her transitions are a marvel to observe. A drawing leads to a painted shape, then to a three-dimensional carved form; from an area of untouched wood will emerge a hand, a pair of breasts, or a foot. A *trompe l'oeil* drawing will lead to a real three-dimensional object as two dimensions merge into three. The artist knows exactly when to stop, when to let the eye complete a movement.

In *The Party* (1965; Fig. 9-27), the most ambitious of her society satires, fifteen figures stand trance-like, frozen in social ritual, all elegantly gowned and regally coiffed. In the head of one, a miniaturized working TV set repeats the banalities of the medium; in the midriff of another is a well-lit slide of a diamond necklace. The three-headed butler with his tray of real glasses seems the perfect solution to the servant problem. Marisol's features appear in painted, penciled, carved, photographed, or plaster form on all the figures. Much has been written about this seemingly narcissistic indulgence. It is a part of her continuing search for her "self," as well as a matter of convenience. As she explained, "I use my own face because it is easier. When I want to make a face or hands for one of my figures, I'm usually the only person around to use as a model."[115]

Marisol is a self-taught sculptor: "If I wanted to know something, I asked someone how to do it. It is like going to school. Sometimes I telephoned other sculptors or a factory. It is not difficult to learn."[116] From the hardware store she buys nails, glue, barrels, and chair legs; from a taxidermist she bought the dog's head for *Women and Dog* of 1964. She uses power tools, axes, chisels, sandpaper, and rasps, conventional carpenter's tools, as well as the traditional sculptor's tools and materials; she also does her own electrical installations. All her pieces are constructed so they can be easily disassembled, and since the cubes are hollow inside, they are not as heavy as they appear.

The artist's work in the sixties was filled with both social and political satire; she tried to make it easily accessible to the general populace, but after the Nixon débacle, she retreated from the political arena. Her "Heads of State" series of the 1960s was a biting comment on the imperiousness of Western political leaders. The imposing *L.B.J.* (1967) stands bold and erect, his three women perched on his platter-shaped left hand. *President Charles de Gaulle* (1967) stands rigidly on a four-wheeled carriage; the small hand glued to his left shoulder discreetly waves to his constituents. Depressed by the social and political climate in America in the late 1960s, Marisol again fled the country, this time to Asia. Awed by the beauty and serenity of the people and their art, she found herself unable to work when she came back to her New York studio. She left again on another trip—this time to Central and South America.

The work of the 1970s represents a complete departure for the artist. There is no longer any social or political criticism in her work; it is a private rather than a public art. Her search for something pure and beautiful led to isolated fish images, mostly sharks, barracudas, and tiger fish—some evil, sleek, and weaponlike. Joined to the bodies of these predatory monsters are the variety of faces that belong to Marisol. They are beautifully finished pieces, mostly in mahogany, and up to six feet long; she has worked on some for up to six months.

Marisol is not aware of having had any difficulties in her career because she was a woman: "I always knew I would have them, whoever I was, because of the way I have always lived outside society. I never expected to be treated nicely by people and their customs I was rebelling against."[117]

NOTES

1. "Florine Stettheimer," *New Yorker* (October 5, 1946).
2. Parker Tyler, *Florine Stettheimer: A Life in Art* (New York: Farrar, Straus and Co., 1963), 115–16; "Florine Stettheimer" (Low Memorial Library, Columbia University, February 8–March 8, 1973), 8–9.
3. Tyler, *Florine Stettheimer*, 47, 51, 63, 147.
4. *Ibid.*, 52.
5. While Stettheimer liked Duchamp, she disdained his work. In fact, the only contemporary artist she respected was the exiled Russian Surrealist Pavel Tchelitchew, a former student of Alexandra Exter, whom she met in the 1930s.

6. Tyler, *Florine Stettheimer*, 142.
7. Hilton Kramer, "Revival of Romaine Brooks," *New York Times*, April 24, 1971, 19.
8. Meryle Secrest, *Between Me and Life: A Biography of Romaine Brooks* (New York: Doubleday & Co., 1974), 18. A section of the memoirs were published in an English journal in 1938, but Brooks could find no one to publish the complete manuscript.
9. Brooks described her reaction to the two deaths in her memoirs: "The death of my mother and brother had not liberated me mentally and I felt that some part of me still remained with them;" quoted in Secrest, *Between Me and Life*, 173.

10. *Ibid.*, 186.

11. *Ibid.*, 196–98.

12. Hilton Kramer, "Romaine Brooks," *New York Times*, April 14, 1971, 52.

13. Kramer, "Revival of Romaine Brooks," 19.

14. Secrest, *Between Me and Life*, 6.

15. "Alfred Stieglitz Presents One Hundred Pictures, Oils, Watercolors, Pastels, Drawings by Georgia O'Keeffe, American, 1923" (Anderson Gallery, New York, 1923).

16. Quoted in Lloyd Goodrich and Doris Bry, "Georgia O'Keeffe" (Whitney Museum of American Art, New York, October 8-November 29, 1970), 8.

17. Anita Pollitzer, "That's Georgia," *Saturday Review* (November 12, 1970), 105.

18. *Ibid.*, 43.

19. Douglas Davis, "Return of the Native," *Newsweek* (October 12, 1970), 105.

20. Goodrich and Bry, "Georgia O'Keeffe," 15.

21. *Ibid.*, 23.

22. Georgia O'Keeffe, *Georgia O'Keeffe* (New York: Viking Press, 1976).

23. See William Zorach, *Art is My Life* (New York: World Publishing Co., 1967) and "Marguerite Zorach: The Early Years, 1908–1920" (Smithsonian Institution, Washington, D.C., December 7, 1973–February 3, 1974).

24. Zorach, *Art is My Life*, 23.

25. Quoted in Roberta K. Tarbell, essay in "Marguerite Zorach," 36.

26. Zorach, *Art is My Life*, 56.

27. Review in *American Magazine of Art* (December 1935), 14, of an exhibit in which she showed nineteen panels, bedspreads, and rugs; quoted in Tarbell, "Marguerite Zorach," 50.

28. James Thrall Soby, "Double Solitaire," *Saturday Review* (September 4, 1954), 30.

29. Quoted in Jean, *History of Surrealist Painting*, 355.

30. Quoted in Neil Welliver, "Conversation with Anni Albers," *Craft Horizons* (July-August 1965).

31. Anni Albers, *On Designing* (Middletown, Connecticut: Wesleyan University Press, 1961), 38–39.

32. Welliver, "Conversation with Anni Albers." See also Albers, *On Designing* and *On Weaving*.

33. Anni Albers, "Drawing, Prints, Pictorial Weavings" (Pollock Gallery, Toronto, September 30–October 27, 1973.)

34. Albers, *On Designing*, 19.

35. Arnold B. Glimcher, *Louise Nevelson* (New York: Praeger, 1972), 19.

36. *Ibid.*, 20.

37. Nemser, *Art Talk*, 70.

38. Glimcher, *Louise Nevelson*, 27.

39. "The power of Pre-Columbian art was an immediate identification," Nevelson has said. "In my own consciousness I always knew they existed and they were only a confirmation of that awareness." *Ibid.*, 71.

40. *New York Times* (September 12, 1936), quoted in *Ibid.*, 43.

41. *Cue* (October 4, 1941), 16, quoted in *Ibid.*, 43.

42. Hilton Kramer, *Arts* (June 1958), 54.

43. Martin Friedman, "Nevelson: Wood Sculptures" (Walker Art Center, Minneapolis, November 10-December 30, 1973), 8; Robert Rosenblum, "Louise Nevelson," *Arts Yearbook 3* (1959), 136–39.

44. Nemser, *Art Talk*, 66.

45. Since 1952 Nevelson has worked with an assistant, and beginning in 1960 she began ordering her crates from a commercial firm.

46. Nemser, *Art Talk*, 60.

47. Glimcher, *Louise Nevelson*, 23.

48. From Alice Neel's Doctoral Address, Moore College of Art, reprinted in "Alice Neel: The Woman and Her Work" (Georgia Museum of Art, Athens, Georgia, September 7-October 19, 1975).

49. Nemser, *Art Talk*, 125.

50. Her chief detractor seems to be the powerful art news editor of the *New York Times*, Hilton Kramer. In his review of her 1974 Whitney show, he called her late style "a very personal version of expressionist caricature that turns everyone into a compelling grotesque" and wondered why so many have subjected themselves to such "unflattering treatment." ("Alice Neel Retrospective," *New York Times*, February 9, 1974, 25).

51. Kim Levin, *Art News* (October 1963), 58.

52. Pat Mainardi, "Alice Neel at the Whitney," *Art in America* (May-June 1974), 107–108.

53. Linda Nochlin, "Some Women Realists; Painters of the Figure," *Arts Magazine* (May 1974), 30.

54. Letter to the author, January 16, 1976.

55. Sheldon Rich, essay in "Isabel Bishop: The First Retrospective Exhibition Held in American Museums of Paintings, Drawings, Etchings and Aquatints" (University of Arizona Museum of Art, Tucson, 1974), 22–23.

56. Were it not for the assistance of this relative, a small inheritance, and her husband's income, she would not have been able to support her studio. Although an exhibiting artist for over forty years, and in most major art collections in the country, Bishop was not able to sustain herself through sales until the early 1970s.

57. Cindy Nemser, "Conversation with Isabel Bishop," *Feminist Art Journal* (Spring 1976), 14–20; John Canaday, "A Certain Dignity for the Figure," *New York Times*, June 1, 1975, 31.

58. Bishop admits that "some galleries have made it hard for a woman to be accepted." As a matter of policy, the Midtown Gallery "has never made any distinction between men and women artists," and the artist herself has never been discriminated against because of her sex. Letter to the author, June 28, 1976.

59. Karl Lunde, *Isabel Bishop* (New York: Harry N. Abrams, Inc., 1975), 60.

60. Rich, "Isabel Bishop," 27.

61. Lunde, *Isabel Bishop*, 62. This technique is based on Max Doerner's description of Rubens' technique, described in the *Materials of the Artist* (New York: Harcourt, Brace and Co., 1934).

62. Sarah Denz, "Isabel Bishop," *Womansphere* (September 1975), 12.

63. Nemser, "Conversation with Isabel Bishop," 20.

64. B. H. Friedman, *Jackson Pollock* (New York: McGraw-Hill Book Co., 1972), 66–68.

65. Nemser, *Art Talk*, 85.

66. Friedman, *Jackson Pollock*, 49–53; A. T. Baker, "Lee Krasner: From Disciple to Individualist," *Time* (November 19, 1973), 76.

67. Marcia Tucker, catalogue essay in "Lee Krasner: Large Paintings" (Whitney Museum of American Art, New York, 1973), 7.

68. Friedman, *Pollock*, 220–21.

69. Quoted in *Ibid.*, p. 87.

70. Quoted in Cindy Nemser, "The Indomitable Lee Krasner," *Feminist Art Journal* (Spring 1975), 7.

71. Friedman, *Pollock*, 179–85.

72. Since Krasner usually does not title her paintings, the chore is left to others. She dislikes titles because they limit the spontaneity of a viewer's response.

73. Tucker, "Lee Krasner," 11.

74. Emily Wasserman, "Krasner in Mid-Career," *Art Forum* (March 1968), 42.

75. Quoted in Tucker, "Lee Krasner," 8.

76. From her autobiographical notes in Alain Bosquet, *La Peinture de Dorothea Tanning* (Paris: Jean-Jacques Pauvert, 1966), 150.

77. Quoted in John Russell, *Max Ernst: Life and Work* (New York: Harry N. Abrams, Inc., 1962), 138.

78. Jean, *History of Surrealism*, 309.

79. Guggenheim was an active supporter of modern art (the collection she amassed is now housed in her palazzo in Italy). She was an early supporter of Jackson Pollock, and it was on the stipend she gave him in return for the paintings he produced that the Pollocks were able to live.

80. Linda Nochlin, "Dorothea Tanning at CNAC," *Art in America* (November 1974), 128.

81. Exhibition review in *Art International* (October 1970), 77.

82. Quoted in Nochlin, "Dorothea Tanning," 128.

83. Elaine de Kooning and Rosalyn Drexler, "Dialogue," in Hess and Baker, eds., *Art and Sexual Politics*, 66–68.

84. Lawrence Campbell, "Elaine de Kooning Paints a Picture," *Art News* (December 1960), 42.

85. *Ibid.*, 40-43, 61-64.

86. "Elaine de Kooning," *Art News* (December 1960), 61.

87. Valerie Petersen, "U.S. Figure Painting: Continuity and Cliche," *Art News* (Summer 1962), 51.

88. "Instant Summing," *Time* (May 3, 1963), 68.

89. Interview with Gerrit Henry, *Art in America* (January-February, 1975), 35.

90. Although de Kooning is a great admirer of Neel, she refused to sit for her (Isabel Bishop did), telling the artist that it would be a duel: "If you attack me in this area, I'm going to attack you." *Ibid.*, 36.

91. *Ibid.*, 35.

92. Lawrence Campbell, "Elaine de Kooning: Portraits in a New York Scene," *Art News* (April 1963), 64.

93. Elaine de Kooning and Rosalyn Drexler, "Dialogue," 57.

94. Marcia Tucker in "Joan Mitchell" (Whitney Museum of American Art, New York, March 26-May 5, 1974), 6.

95. *Ibid.*, 7-8.

96. Irving Sandler, "Joan Mitchell Paints a Picture," *Art News* (October 1957), 14.

97. Cindy Nemser, "An Afternoon with Joan Mitchell," *Feminist Art Journal* (Spring 1974), 6

98. Tucker, "Joan Mitchell," 7.

99. Sandler, "Joan Mitchell Paints a Picture," 45, 47.

100. John Ashbery, "An Expressionist in Paris," *Art News* (April 1965), 64. The following anecdote related by Mitchell to Nemser will serve to reveal the competitiveness of the New York art world. While Mitchell and Frankenthaler were friends in the old days, she learned that the "stainer" refused to see one of her recent shows because she did not like "impasto" painting (Nemser, "Afternoon with Joan Mitchell," 24).

101. Eugene C. Goossen, "Helen Frankenthaler" (Whitney Museum of American Art, 1969), 8.

102. Barbara Rose, *Frankenthaler* (New York: Harry N. Abrams, Inc., 1972), 30-31.

103. Goossen, "Helen Frankenthaler," 13.

104. B. F. Friedman, "Towards the Total Color Image," *Art News* (Summer 1966), 32.

105. Frankenthaler's response to Cindy Nemser in "Interview with Helen Frankenthaler," *Arts Magazine* (November 1971), 54.

106. Goossen, "Helen Frankenthaler," 9.

107. Rose, *Frankenthaler*, 60.

108. Nemser, "Interview," 51.

109. Rose, *Frankenthaler*, 85.

110. Thomas B. Hess, "Abstract Acrylicism," *New York* (December 8, 1975), 112.

111. Rose, *Frankenthaler*, 105.

112. Letter to the author, July 1, 1976.

113. Grace Glueck, "It's Not Pop, It's Not Op—It's Marisol," *New York Times Magazine* (March 7, 1965), 46.

114. *Ibid.*, 48.

115. *Ibid.*, 34.

116. "Marisol" (Worcester Art Museum, September 23–November 14, 1971).

117. Letter to the author, July 1, 1976.

Bibliography

BOOKS: General

Bainton, Roland H. *Women of the Reformation.* Minneapolis: Augsburg Publishing House, 1971.

Bell, Susan G., ed. *Women: From the Greeks to the French Revolution.* Belmont, Calif.: Wadsworth Publishing Co., 1973.

Blease, W. Lyon. *The Emancipation of English Women* (1910). New York: Benjamin Blom, Inc., 1971.

Burckardt, Jacob. *The Civilization of the Renaissance in Italy*, 2 vols. New York: Harper & Brothers, 1929.

Calhoun, Arthur W. *A Social History of the American Family.* Cleveland: Arthur H. Clark Co., 1918.

Collins, Marie, and Sayre, Sylvia Weil, eds. *Les Femmes en France.* New York: Charles Scribner's Sons, 1974.

Cuddeford, G. M. *Women and Society.* London: Hamish Hamilton, 1967.

De Maulde la Clavière, Renè. *The Women of the Renaissance: A Study of Feminism.* New York: G. P. Putnam's Sons, 1905.

Dexter, Elizabeth Anthony. *Colonial Women of Affairs.* Boston: Houghton Mifflin & Co., 1931.

Dunbar, Janet. *The Early Victorian Woman.* London: George G. Harrap & Co., Ltd., 1953.

Flexner, Eleanor. *Century of Struggle.* New York: Atheneum, 1974.

Goncourt, Edmond and Jules. *The Woman of the Eighteenth Century: Her Life, from Birth to Death, Her Love and Her Philosophy in the Worlds of Salon, Shop, Street.* London: 1928.

Holiday, Carl. *Woman's Life in Colonial Days.* New York: Frederick Ungar, 1922.

Irwin, Inez Haynes. *Angels and Amazons.* New York: Doubleday, Doran & Co., Inc., 1933.

Kamm, Josephine. *Rapiers and Battleaxes.* London: George Allen & Unwin, Ltd., 1966.

Kelso, Ruth. *Doctrine For the Lady of the Renaissance.* Urbana: University of Illinois Press, 1956.

Kerber, Linda K. "Daughters of Columbia: Educating Women for the Republic, 1787–1805." *The Hofstadter Aegis*, ed. by Stanley Elkins and Eric McKitrick. New York: Alfred A. Knopf, 1974.

Langdon-Davies, John. *A Short History of Women.* New York: Viking Press, 1927.

Leonard, Eugenie A., Sophie H. Drinker, Miriam Y. Holden. *The American Woman in Colonial and Revolutionary Times, 1565–1800.* Philadelphia: University of Pennsylvania Press, 1962.

Lerner, Gerda. *The Woman in American History.* Menlo Park, Calif.: Addison-Wesley Publishing Co., 1971.

Mosse, George L. *The Reformation.* New York: Holt, Rinehart & Winston, Inc., 1966.

O'Faolain, Julia, and Martines, Lauro, eds. *Not in God's Image.* New York: Harper Torch Books, 1973.

O'Neill, William L. *Everyone was Brave.* Chicago: Quadrangle Books, 1969.

Philips, M. and Tomkinson, W. S. *English Women in Life and Letters.* Oxford University Press, 1926.

Robinson, Mabel. *The Great Literary Salons of the XVII and XVIII Centuries: Lectures of the Musée Carnavalet.* London: 1930.

Rossi, Alice, ed. *The Feminist Papers.* New York: Bantam Books, 1973.

Sachs, Hannelore. *The Renaissance Woman.* New York: McGraw-Hill Book Co., 1971.

Sapieha, Virgilia; Neely, Ruth; and Collins, Mary Love. *Eminent Women: Recipients of the National Achievement Award.* Menasha, Wisc.: George Bank Publishing Co., 1948.

Sochen, June. *Herstory: A Women's View of American History.* New York: Alfred Publishing Co., Inc., 1974.

Art

Albers, Anni. *Anni Albers: On Weaving.* Middletown, Conn.: Wesleyan University Press, 1965.

Arnason, H. H. *History of Modern Art.* New York: Harry N. Abrams, Inc., 1968.

Art: A Woman's Sensibility. Feminist Art Program, California Institute of the Arts, 1975.

Bate, Percy. *The English Pre-Raphaelite Painters: Their Associates and Successors.* London: George Bell and Sons, 1901.

Beaux, Cecilia. *Background with Figures.* Cambridge, Mass.: Riverside Press, 1930.

Bergstrom, Ingvar. *Dutch Still-Life Painting in the Seventeenth Century.* New York: Thomas Yoseloff Inc., 1956.

Bernt, Walther. *The Netherlandish Painters of the Seventeenth Century*, 3 vols. London: Phaidon Press Ltd., 1970.

Bittner, Alan, ed. *Käthe Kollwitz: Drawings.* New York: Thomas Yoseloff Inc., 1959.

Black, Mary and Lipman, Jean. *American Folk Painting.* New York: Bramhall House, 1966.

Bosquet, Alain. *La Peinture de Dorothea Tanning.* Paris: jean-Jacques Pauvert, 1966.

Bowlt, John E., ed. *Russian Art of the Avant-Garde: Theory and Criticism, 1902–1934.* New York: Viking Press, 1976.

Bowness, Alan, ed. *The Sculpture of Barbara Hepworth 1960–69.* New York: Praeger, 1971.

Breeskin, Adelyn. *Mary Cassatt: A Catalogue Raisonné of the Oils, Pastels, Watercolors, and Drawings.* Washington, D.C.: Smithsonian Institution Press, 1970.

Breton, André. *Surrealism and Painting.* Paris: Editions Gallimard, 1965.

Bullard, E. John. *Mary Cassatt: Oils and Pastels*. Washington, D.C.: National Gallery of Art, 1972.

Caffin, Charles H. *The Story of Dutch Painting*. New York: The Century Co., 1909.

Canaday, John. *Mainstreams of Modern Art*. New York: Simon & Schuster, 1959.

———. *The Lives of the Painters*, 4 vols. New York: W. W. Norton & Co., Inc., 1969.

Carr, Cornelia, ed. *Harriet Hosmer: Letters and Memoirs*. New York: Moffat, Yard and Co., 1912.

Clayton, Ellen C. *English Female Artists*, 2 vols. London: Tinsley Brothers, 1876.

Cassou, J.; de la Souchère, D.; Limbour, G.; de Mandiargues, A. P. *Germaine Richier: 1904-1959*. Paris, 1966.

Chamot, Mary, *Goncharova*. Paris: La Bibliothèque des Arts, 1972.

Clement, Clara Erskine, *Women in the Fine Arts*. Boston: Houghton, Mifflin & Co., 1904.

Cohen, Arthur A. *Sonia Delaunay*. New York: Harry N. Abrams Inc., 1975.

Coughlan, Robert. *The Wine of Genius: A Life of Maurice Utrillo*. New York: Harper & Brothers, 1950.

Cowdrey, Mary Bartlett, ed., *National Academy of Design Exhibition Record 1826_1860*, 2 vols. New-York Historical Society, 1943.

———. *American Academy of Fine Arts and Art-Union*, 2 vols. New-York Historical Society, 1953.

Damase, Jacques. *Sonia Delaunay: Rhythms and Colours*. Greenwich, Conn: New York Graphic Society, 1972.

Daumier, Honoré. *Lib Women (Bluestockings and Socialist Women)*. Preface by Franpoise Parturier. Paris: Leon Amiel Publisher, Inc., 1974.

Davies, Margaret. *Apollinaire*. London: Oliver & Boyd, 1964.

De Sausmarez, Maurice. *Bridget Riley*. Greenwich, Conn: New York Graphic Society, 1970.

A Documentary Herstory of Women Artists in Revolution. New York: Women's Interart Center, 1973.

Duret, Théodore. *Manet and the French Impressionists* (1910). Freeport, N.Y.: Books for Libraries Press, 1971.

Ellet, Elizabeth Fries Lummis. *Women Artists in All Ages and Countries*. New York: Harper & Co., 1859.

Elliot, Maude Howe. *Art and Handicraft in the Woman's Building of the World's Columbian Exposition, Chicago, 1893*. Chicago: Rand, McNally & Co., 1894.

Fine, Elsa Honig. *The Afro-American Artist: A Search for Identity*. New York: Holt, Rinehart & Winston, Inc., 1973.

Fleming, William. *Arts and Ideas*. New York: Holt, Rinehart & Winston, 1974.

Fourreau, Armand. *Berthe Morisot*. London: John Lane the Bodley Head Ltd., 1925.

Friedman, B. H. *Jackson Pollock*. New York: McGraw-Hill Book Co., 1972.

———, ed. *School of New York: Some Younger Artists*. New York: Grove Press, 1959.

Gaunt, William. *A Concise History of English Painting*. New York: praeger, 1964.

George-Day. *Marie Laurencin*. Paris: Editions due Dauphin, 1947.

Glimcher, Arnold B. *Louise Nevelson*. New York: Praeger, 1972.

h, Lloyd, and Bry, Doris. *Georgia O'Keeffe*. New York: Whitney Museum of American Art, 1970.

Goossen, Eugene C. *Helen Frankenthaler*. New York: Whitney Museum of American Art, 1969.

Grant, Colonel M. H. *Rachel Ruysch 1664-1750*. Leigh-on-Sea, England: F. Lewis, Publishers, 1956.

Gray, Camilla. *The Great Experiment: Russian Art 1863_1922*. New York: Harry N. Abrams, Inc., 1962.

Grohman, Will. *Wassily Kandinsky: Life and Work*. New York: Harry N. Abrams, Inc., 1958.

Haftmann, Werner. *Painting in the Twentieth Century*. 2 vols. New York: Praeger, 1965.

Hale, Nancy. *Mary Cassatt*. Garden City, N.Y.: Doubleday & Company, Inc., 1975.

Hammacher, A. M. *Barbara Hepworth*. London: A. Zwemmer, 1959.

Hartcup, Adeline. *Angelica*. London: William Heinemann, Ltd., 1954.

Hepworth, Barbara. *A Pictorial Autobiography*. New York: Praeger, 1970.

Hess, Thomas B., and Baker, Elizabeth C., *Art and Sexual Politics*. New York: Collier Books, 1971.

Hodin, J. P. *Barbara Hepworth*. New York: David McKay Company, 1959.

Huisman, Philippe. *Morisot: Enchantment*. New York: French & European Publications, 1963.

Ives, Colta Feller. *The Great Wave: The Influence of Japanese Woodcuts on French Prints*. New York: The Metropolitan Museum of Art, 1974.

Jean, Marcel. *The History of Surrealist Painting*. Paris: Editions du Seuil, 1959.

John, Augustus. *Chiaroscuro*. New York: Pellegrini & Cudahy, 1952.

Kearns, Martha. *Käthe Kollwitz: Woman and Artist*. Old Westbury, N.Y.: The Feminist Press, 1976.

Klein, Mina C. and H. Arthur. *Käthe Kollwitz: Life in Art*. New York: Holt, Rinehart & Winston, 1972.

Klumpke, Anna Elizabeth. *Memoirs of an Artist*, ed. by Lilian Whiting. Boston: Wright & Pottes Printing Co., 1940.

———. *Rosa Bonheur: Sa vie, son oeuvre*. Paris, 1908.

Kollwitz, Hans, ed. *The Diary and Letters of Kàthe Kollwitz*, trans. by Richard and Clara Winston. Chicago: Henry Regnery, 1955.

Lahnstein, Peter. *Münter*. Buch Kunstverlag Ettal, 1971.

Lippard, Lucy. *From the Center: Feminist Essays on Women's Art*. New York: E. P. Dutton, 1976.

Lunde, Karl. *Isabel Bishop*. New York: Harry N. Abrams Inc., 1975.

Mackworth, Cecily. *Guillaume Apollinaire and the Cubist Life*. New York: Horizon Press, 1963.

Maclaren, Neil. *The Dutch School*. London: National Gallery of Art, 1960.

Mander, Carel van. *Dutch and Flemish Painters* (1604). New York: McFarlane, Ward, McFarlane, 1936.

Manners, Lady Victoria, and Williamson, Dr. G. C. *Angelica Kauffmann, RA*. London: John Lane, 1924.

Mathey, François. *The Impressionists*. New York: Praeger, 1961.

Mayer, Dorothy Moulton. *Angelica Kauffmann, R.A. 1741-1807*. London: Colin Smythe, 1972.

Methuen, Eyre. *Dictionary of Surrealism*. Paris: Fernand Hazan, 1972.

Modersohn-Becker, Paula. *Briefe und Tagebuch Blätter*. Munich, 1920.

Mongan, Elizabeth. *Berthe Morisot: Drawings, Pastels, Watercolors, Paintings*. New York: Tudor, 1960.

Morgan, John Hill. *Gilbert Stuart and His Pupils*. New-York Historical Society, 1939.

Munsterberg, Hugo. *A History of Women Artists*. New York: Clarkson N. Potter, Inc., 1975.

Muehsam, Gerd, ed. *French Painters and Paintings from the Fourteenth Century to Post-Impressionism*. New York: Frederick Ungar, 1970.

Nagel, Otto. *Käthe Kollwitz*. Greenwich, Conn.: New-York Graphic Society, 1963.

Nemser, Cindy. *Art Talk*. New York: Charles Scribner's Sons, 1975.

Nevelson, Louise. *Dawns and Dusks: Taped Conversations with Diana Mackown*. New York: Charles Scribner's Sons, 1976.

O'Connor, Francis V., ed. *Art for the Millions*. Greenwich, Conn.: New York Graphic Society, 1973.

O'Keeffe, Georgia. *Georgia O'Keeffe*. New York: Viking Press, 1976.

Osten, Gert van der, and Vey, Horst. *Painting and Sculpture in Germany and the Netherlands 1500-1600*. Baltimore: Penguin Books, 1967.

Passez, Anne-Marie. *Adelaïde Labille-Guiard: Biographie et catalogue raisonné de son oeuvre*. Paris: 1973.

Pauli, Gustav. *Paula Modersohn-Becker*. Leipzig: Kurt Wolff Verlag, 1919.

Pecirka, Jaromir. *Woman in European Art*. London: Spring Books, 1960.

Petersen, Karen, and Wilson, J. J. *Women Artists: Recognition and Reappraisal*. New York University Press, 1976.

Pevsner, Nikolaus. *Academies of Art Past and Present*. Cambridge University Press, 1940.

Pissarro, Camille. *Letters to His Son Lucien*. Mamaroneck, N.Y.: Paul P. Appel, 1972.

Polnay, Peter de. *Enfant Terrible: the Life and Work of Maurice Utrillo*. New York: William Morrow & Co., Inc., 1969.

Ponce, Juan Garcia and Lenora Carrington. *Lenora Carrington*. Mexico: Ediciones Era, S.A., 1974.

Ragg, Laura M. *The Women Artists of Bologna*. London: Methuen & Co., 1907.

Read, Herbert. *The Art of Jean Arp*. New York: Harry N. Abrams, Inc., 1968.

Rewald, John. *History of Impressionism*. New York: Museum of Modern Art, 1946.

Roland-Michel, M. *Anne Vallayer-Coster 1774-1818*. Paris: 1970.

Rose, Barbara. *American Art Since 1900: A Critical History*. New York: Praeger, 1967.

——. *Frankenthaler*. New York: Harry N. Abrams, Inc., 1972.

——, ed. *Readings in American Art Since 1900*. New York: Praeger, 1968.

Rothenstein, John. *Modern English Painters*. London: Eyre & Spottiswoode, 1952.

Rouart, Denis, ed. *The Correspondence of Berthe Morisot*. London: Lund Humphries, 1957.

Russell, John, *Max Ernst: Life and Work*. New York: Harry N. Abrams Inc., 1962.

Schmidt, Georg, ed. *Sophie Taeuber-Arp*. Basel: Holbein-Verlag, 1948.

Secrest, Meryle. *Betwen Me and Life: A Biography of Romaine Brooks*. New York: Doubleday & Co., 1974

Sellers, Charles Coleman. *Patience Wright*. Middletown, Conn.: Wesleyan University Press, 1976.

Selz, Peter. *German Expressionist Painting*. Berkeley: University of California Press, 1957.

Short, Ernest. *A History of British Painting*. London: Eyre & Spottiswoode, 1953.

Slive, Seymour. *Frans Hals*. London: Phaidon Press Ltd., 1970.

Sparrow, W. C. *Women Painters of the World*. London: Hodder & Stoughton, 1905.

Stanton, Theodore, ed. *Reminiscences of Rosa Bonheur*. New York: D. Appleton & Co., 1910.

Storm, John. *The Valadon Drama: The Life of Suzanne Valadon*. New York: E. P. Dutton, 1959.

Sweet, Frederick A. *Miss Mary Cassatt: Impressionist from Pennsylvania*. Norman: University of Oklahoma Press, 1966.

Taft, Larado. *The History of American Sculpture*. New York: Macmillan Co., 1903 (rev. ed., 1924).

Tufts, Eleanor. *Our Hidden Heritage: Five Centuries of Women Artists*. London: Paddington Press, Ltd., 1974.

Tyler, Parker. *Florine Stettheimer: A Life in Art*. New York: Farrar, Straus & Co., 1963.

Vigée-Lebrun, Élisabeth. *The Memoirs of Mme. Élisabeth Vigée-Lebrun*, trans. by Gerald Shelley. London, 1926.

Weiler, Clemens. *Marianne von Werefkin. Briefe an einen Unbekannten*. Cologne, 1960.

Willet, John. *Expressionism*. New York: McGraw-Hill Book Co., 1970.

Wilson, Ellen. *American Painter in Paris: A Life of Mary Cassatt*. New York: Farrar, Straus & Giroux, 1971.

Zorach, William. *Art is My Life*. New York: World Publishing Co., 1967.

ARTICLES: General

Hufton, Olwen. "Women in the Revolution, 1789-1796." *Past and Present* (November 1971), 90-108.

Lytle, S. H. "The Second Sex, 1793." *Journal of Modern History*, 17 (1955), 14-26.

Racz, Elizabeth. "The Women's Rights Movement in the French Revolution." *Science and Society*, 16 (1952), 151-74.

Art

Affauser, Helen H. "The Role of Women in the Art of the Netherlands in the 16th and 17th Century." Unpublished Master's Thesis, Smith College, 1947.

"A Letter from Georgia O'Keeffe." *Magazine of Art*, 70 (February 1944), 70.

Alloway, Lawrence. "Women's Art in the 70s." *Art in America* (May-June 1976), 64-72.

"An Exhibit, and a Defense of Women." *Art Digest* (November 15, 1936), 17, 23.

"Anni Albers: Her Weaving Becomes a Modern Art." New Haven *Register*, January 3, 1960.

Art Journal, XXXV (Summer 1976). Entire issue devoted to women and art.

Ashbery, John. "An Expressionist in Paris." [Joan Mitchell] *Art News*, 64 (April 1965), 44-45, 63-64.

Baker, A. T. "Out of the Shade." [Lee Krasner] *Time* (November 19, 1973), 76.

Bayles, P. "Eva Gonzalès." *Renaissance*, 15 (June 1932), 110-15.

Bergmans, Simone. "The Miniatures of Levina Tearling." *Burlington Magazine*, LXIV (1934), 232-36.

Berrigan, Ted. "The Portrait and Its Double." *Art News* (January 1966), 30-33, 63-64.

Bishop, Isabel. "Isabel Bishop Discusses 'Genre' Drawings." *American Artist* (June 1953), 46-47.

Bissell, Ward. "Artemisia Gentileschi—A New Documented Chronology." *Art Bulletin* (June 1968), 153-63.

Bowlt, John E. "A Veritable Amazon of the Russian Avant-

Garde." [Alexandra Exter] *Art News* (September 1974), 41-43.

Braude, Beatrice. "Severine: An Ambivalent Feminist." *Feminist Art Journal* (Fall 1973), 14-15.

Cailleux, Jean. "Royal Portraits of Mme. Vigée-Lebrun and Mme. Labille-Guiard." *Burlington Magazine*, CXI (March 1969), i-vi.

Campbell, Lawrence. "Elaine de Kooning: Portraits in a New York Scene." *Art News* (April 1963), 38-39, 63-64.

———. "Elaine de Kooning Paints a Picture." *Art News* (December 1960), 40-43, 61-64.

———. "Marisol's Magic Mixtures." *Art News* (March 1964), 38-41.

Canaday, John. "A Certain Dignity for the Figure." *New York Times* (May 11, 1975), 31.

Chamot, M. "The Early Work of Goncharova and Larinov." *Burlington Magazine*, XCVII (June 1955), 170-74.

Crehan, Hubert. "Introducing the Portraits of Alice Neel." *Art News* (October 1962), 44-46, 68.

Dallier, Aline. "Fear of Feminism in France." *Feminist Art Journal* (Spring 1975), 15-18, 30. Translated by Gloria Feman Orenstein.

Davidson, Martha. "Paula Modersohn-Becker: Struggle Between Life and Art." *Feminist Art Journal* (Winter 1973-1974), 1, 3-5.

Davis, Douglas. "Hidden Treasure in Moscow." *Newsweek* (January 20, 1975), 48-51.

———. "The Invisible Woman is Visible," *Newsweek* (November 15, 1971), 130-31.

———. "The Unknown Eakins." *Newsweek* (May 28, 1973), 80.

De Kooning, Elaine. "Painting a Portrait of the President." *Art News* (Summer 1964), 37, 64.

Denz, Sarah. "Isabel Bishop." *Womansphere* (September 1975), 12-13.

Devree, Howard. "Käthe Kollwitz." *Magazine of Art*, 32 (September 1939), 512-17.

Diamonstein, Barbaralee. "Louise Nevelson at 75." *Art News* (October 1974), 48-49.

Duncan, Carol. "Happy Mothers and Other New Ideas in French Art." *Art Bulletin* (December 1973), 570-83.

"Elizabeth Butler: Our Living Arts." *Magazine of Art*, 11 (1879), 257-62.

Freivogel, Elsie F. "Lilly Martin Spencer." *Archives of American Art Journal*, 12, (1972), 9-14.

Friedman, B. H. "Towards the Total Color Image." [Helen Frankenthaler] *Art News* (Summer 1966), 31-32, 67-68.

Gardner, Albert Ten Eyck. "A Century of Women." *Metropolitan Museum of Art Bulletin* (December 1948), 110-18.

Gardner, Elizabeth. "Four French Paintings from the Berwind Collection." *Metropolitan Museum of Art Bulletin* (1962), 26-71.

Garrard, Mary D. " 'Sono Io la Pittura:' a 17th-Century Idea Whose Time Has Come." Paper presented at College Art Association meeting, February 1977.

Geist, Sidney. "Review of Germaine Richier." *Arts*, 32 (December 1957), 47.

Geldzahler, Henry. "An Interview with Helen Frankenthaler." *Art Forum*, 4 (October 1965), 36-38.

Gibson, Walter. "Breugel's 'Dulle Griet' and Sexist Politics in the Sixteenth Century." Paper presented at College Art Association meeting, February 1975.

Glozer, Liselotte Erlanger. "Gabriele Münter: A Lesser Life?" *Feminist Art Journal* (Winter 1974-75), 11-13, 23.

Glueck, Grace. "It's Not Pop, It's Not Op—It's Marisol." *New York Times* Magazine (March 7, 1965), 34, 35, 45-49.

Guhl, Ernst. "Die Frauen in der Kunstgeschichte." Reviewed in *Westminster Review* (American edition; July 1858), 91-104.

Guth, Paul. "Encounter with Germaine Richier." *Yale French Studies*. 19-20 (Spring 1957-Winter 1958), 78-84.

Henry, Gerrit. "Ten Portraitists: Interviews/Statements." [Elaine de Kooning and Alice Neel] *Art in America* (January-February 1975), 35, 40.

Hepworth, Barbara. "Approach to Sculpture." *Studio*, CXXXII (October 1946), 97-100.

Hess, Thmas B. "Abstract Acrylicism." *New York* (December 8, 1975), 112.

———. "The Miracle of Union Square." *New York* (May 19, 1975), 89-90.

H. B. T. "Women in Art." *Brooklyn Museum Quarterly* (January 1932), 12-16.

Hilton, Alison. "When the Renaissance Came to Russia." *Art News*, 7 (December 1971), 34-39, 56-62.

Hofrichter, Frima Fox. "Judith Leyster's 'Proposition.'" Paper presented at College Art Association meeting, February 1975.

Holland, Clive. "Lady Art Student's Life in Paris." *International Studio*, 21 (1904), 225-31.

Hughes, Robert. "Myths of 'Sensibility.'" *Time* (March 20, 1972), 73-77.

John, Augustus. "Gwendolen John." *Burlington Magazine* (October 1942), 895.

Kagan, Andrew. "A Fogg 'David' Reattributed to Madame Adélaïde Labille-Guiard." *Acquisitions Report 1969-1970*. Cambridge: Fogg Art Museum (1971), 31-40.

Kramer, Hilton. "Bringing Cubism to the Stage." [Alexandra Exter] *New York Times* (May 25, 1974), 21.

———. "Revival of Romaine Brooks." *New York Times* (April 24, 1971), 19.

———. "Romaine Brooks." *New York Times* (April 14, 1971), 52.

Levitine, G. "Marguerite Gérard and her Stylistic Significance." *Baltimore Museum Annual*, III (1968), 21-37.

Lippard, Lucy. "Why Separate Women's Art?" *Art and Artists* (October 1973), 8-9.

Mainardi, Pat. "Alice Neel at the Whitney." *Art in America* (May-June 1974), 107-8.

Manners, Lady Victoria. "Catherine Read: The 'English Rosalba.'" *Connoisseur*, 88 (1931), 376-86.

"Maria Cecilia Louise Cosway." *Dictionary of National Biography*, VI (1873), 1203-4.

"Mary Beale." *Dictionary of National Biography*, II (1873), 2, 3.

Michelson, Annette. "Vieira da Silva." *Arts Yearbook 3* (1955), 114-17.

Munro, Eleanor C. "The Found Generation." [Joan Mitchell] *Art News*, 60 (November 1961), 38-39, 75.

Nemser, Cindy. "An Interview with Joan Mitchell." *Feminist Art Journal* (Spring 1974), 5-6, 24.

———. "Conversation with Isabel Bishop." *Feminist Art Journal* (Spring 1976), 14-20.

———. "Interview with Helen Frankenthaler." *Arts* (November 1971), 51-54.

———. "The Indomitable Lee Krasner." *Feminist Art Journal* (Spring 1975), 4-9.

Nochlin, Linda. "Dorothy Tanning at C.N.A.C." *Art in America* (November 1974), 128.

———. "Some Women Realists." *Arts Magazine* (May 1974), 29-33.

Oldcastle, John. "Elizabeth Butler." *Magazine of Art* (1879), 257-62.

"Old Master and Mistress." [Gabriele Münter] *Time* (March 18, 1957), 88, 90.

Oppler, Ellen. "Paula Modersohn-Becker: Some Facts and Legends." *Art Journal* (Summer 1976), 364-69.

Orenstein, Gloria Feman. "Natalia Goncharova: Profile of the Artist—Futurist Style." *Feminist Art Journal* (Summer 1974), 1, 3-6, 19.

————. "Women of Surrealism." *Feminist Art Journal* (Spring 1973), 1, 15-21.

Palmer, J. Wood. "Gwen John." *Connoisseur* (October 1962).

Pearson, Ralph M. "A Modern Viewpoint: Women as Artists." *Art Digest* 21 (May 15, 1947), 23.

Pollitzer, Anita. "That's Georgia." *Saturday Review* (November 4, 1950), 41-43.

Portalis, Roger. "Adélaïde Labille-Guiard." *Gazette des Beaux-Arts*, II (1901), 476-94; I (1902), 325-47.

Redmond, R-L. "Review of the Year." *Metropolitan Museum of Art Bulletin* (1961), 44.

Renraw, R. "The Art of Rachel Ruysch." *Connoisseur*, XCII (1933), 397-99.

Robertson, Bryan. "The Nature of Lee Krasner." *Art in America* (November-December 1973), 83-87.

————. "Bridget Riley: Color as Image." *Art in America* (March-April 1975), 69-71.

Roditi, Edouard. "Interview with Gabriele Münter." *Arts* (January 1960), 36-41.

Roh, Juliane. "Marianne von Werefkin." *Kunst und das Schöne Heim*, 57 (December 1959), 452-55.

Rose, Barbara. "Vaginal Iconology." *New York* (February 1974), 59.

Rosenblum, Robert. "Louise Nevelson." *Arts Yearbook 3* (1959), 136-39.

Sandler, Irving. "Joan Mitchell Paints a Picture." *Art News* (October 1957), 44.

Scheerer, Constance. "Maria Cosway: Larger-than-Life Miniaturist." *Feminist Art Journal* (Spring 1976), 10-13.

Seiberling, Dorothy. "The Female View of Erotica." *New York* (February 1974), 54-58.

Slatkes, Leonard J. "The Age of Rembrandt." *Art Quarterly*, XXXI (1968), 86-88.

Soby, James Thrall. "Double Solitaire." [Kay Sage] *Saturday Review* (September 4, 1954), 29-30.

Sterling, Charles. "A Fine 'David' Reattributed." *Metropolitan Museum of Art Bulletin*, IX (January 1951), 121-32.

Tillman, Lynne M. "Don't Cry . . . Work." *Art and Artists*, 8 (October 1973), 22-26.

Usher, John. "Romaine Brooks: A True Painter of Personality." *International Studio*, 83 (February 1926), 46-50.

Valentiner, W. R. "Allegorical Portrait of Rachel Ruysch." *North Carolina Museum of Art Bulletin*, V (Summer 1957), 4-8.

Van Enden, Frieda. "Judith Leyster, a Female Frans Hals." *Art World* (March 1918), 501-3.

Walsh, Elizabeth. "Mrs. Mary Beale, Paintress." *Connoisseur* (1953), 1-8.

Wasserman, Emily. "Krasner in Mid-Career." *Artforum* (March 1968), 38-42.

Watt, Alexander. "Visages d'Artistes: Vieira de Silva." *Studio*, 161 (May 1961), 170-72.

Weber, Nicholas Fox. "Anni Albers and the Printerly Image." *Art in America*, 63 (July 1975), 89.

Welliver, Neil. "A Conversation with Anni Albers." *Craft Horizons* (July/August 1965).

Werner, Alfred. "Paula Modersohn-Becker: A Short Creative Life." *American Artist* (June 1973), 16-23, 68.

Willard, Charlotte. "Women of American Art." [Georgia O'Keeffe, Louise Nevelson, Grace Hartigan, Helen Frankenthaler, Claire Falkenstein, Joan Brown, Lee Bontecou] *Look* (September 27, 1960), 70-75.

"Woman's Chance." *Art Digest* (May 15, 1932), 26.

"Women and the Arts." *Arts in Society*, 11 (Spring-Summer 1974). Entire issue devoted to women.

"Women Artists in Ascendance." *Life* (May 13, 1957), 74-77. [Jane Wilson, Joan Mitchell, Nell Blaine, Grace Hartigan, Helen Frankenthaler]

"Women's Art." *Art Digest* (April, 1931), 7.

Young, Mahonri Sharp. "Thief of Souls: Romaine Brooks." *Apollo* (May 1971), 425-27.

EXHIBITION CATALOGUES

"Alexandra Exter: Artist of Theatre." The New York Public Library at Lincoln Center, Spring-Summer 1974.

"Alice Neel: The Woman and Her Work." The University of Georgia Museum of Art, Athens, September 7-October 19, 1975. Catalogue essay by Cindy Nemser.

"Bridget Riley: Paintings and Drawings 1951-71." The Hayward Gallery, London, July 20-September 5, 1971.

"Cecilia Beaux: Portrait of an Artist." Pennsylvania Academy of the Fine Arts, Philadelphia, September 6-October 20, 1974. Catalogue essay by Frank H. Goodyear, Jr.

"The Excellent Mrs. Mary Beale." Jeffrye Museum, London, October 13-December 21, 1975. Catalogue essays by Richard Jeffries and Elizabeth Walsh.

"Florine Stettheimer." Low Memorial Library, Columbia University, New York, February 8-March 8, 1973.

"Four Generations of Commissions." The Peale Collection of the Maryland Historical Society, March 3-June 29, 1975.

"French Painting 1774-1830: The Age of Revolution." Detroit Institute of Arts, Michigan, March 5-May 4, 1975.

"Georgia O'Keeffe." Whitney Museum of American Art, New York, October 8-November 29, 1970. Catalogue essays by Lloyd Goodrich and Doris Bry.

"Gwen John: a Retrospective Exhibition." Davis & Long Co., October 14-November 1, 1975. Catalogue essay by C. Langdale.

"Helen Frankenthaler." Whitney Museum of American Art, New York, 1969. Catalogue essay by Eugene C. Goossen.

"Isabel Bishop: the First Retrospective Exhibition held in American Museums of Paintings, Drawings, Etchings, and Aquatints." University of Arizona Museum of Art, Tuscon, Arizona, 1974. Catalogue essay by Sheldon Rich.

Joan Mitchell: My Five Years in the Country." Everson Museum of Art, Syracuse, New York, March 25-April 21, 1972. "Lee Krasner: Large Paintings." Whitney Museum of American Art, New York, 1973. Catalogue essay by Marcia Tucker.

"Leonora Carrington: a Retrospective Exhibition." Center for Inter-American Relations, New York, November 26-January 4, 1976. Introduction by Edward James.

"Lilly Martin Spencer: The Joys of Sentiment." National Collection of Fine Arts, Washington, D.C., June 15-September 3, 1973. Catalogue essay by Robin Bolton-Smith and William H. Truettner.

"Marguerite Zorach: the Early Years, 1908-1920." Smithsonian Institution, Washington, D.C., December 7, 1973-February 3, 1974. Catalogue essay by Roberta K. Tarbell.

"Marisol." Worcester Art Museum, Massachusetts, September 23-November 14, 1971.

"Nevelson: Wood Sculptures." Walker Art Center, Minneapolis, November 10-December 30, 1973. Catalogue essay by Martin Friedman.

"Old Mistresses: Women Artists of the Past." Walters Art Gallery, Baltimore, April 17-June 18, 1972. Catalogue essays by Elizabeth Broun and Ann Gabhart.

"Paula Modersohn-Becker: zum hundertsten Geburtstag." Austelling Bremen, February 4-April 6, 1976. Catalogue essays by Gunther Busch and staff.

"The Peale Family: Three Generations of American Artists." Detroit Institute of Arts, Michigan, 1967.

"The Pennsylvania Academy and its Women, 1850 to 1920." Pennsylvania Academy of the Fine Arts, May 3-June 16, 1974. Catalogue essay by Christine Jones Huber.

"Romaine Brooks, 'Thief of Souls.'" Smithsonian Institution, Washington, D.C., February 24-April 4, 1971. Catalogue essay by Adelyn Breeskin.

"7 American Women: The Depression Decade." Vassar College Art Gallery, Poughkeepsie, New York, January 19-March 5, 1970. Catalogue essays by K. A. Marling and H. Harrison.

"Susan Macdowell Eakins, 1851-1938." Pennsylvania Academy of the Fine Arts, Philadelphia, Pennsylvania, May 4-June 10, 1973. Catalogue essay by Susan P. Casteras and Seymour Adelman.

"White, Marmorean Flock: 19th-Century American Women Neo-Classical Sculptors." Vassar College Art Gallery, Poughkeepsie, New York, April 30, 1972. Catalogue essay by William H. Gerdts.

"Women: a Historical Survey of Works by Women Artists." Salem Fine Arts Center, Winston-Salem, North Carolina, February 27-March 19, 1972. Catalogue essay by M. B. Hill.

"Women Artists: 1550-1950." Los Angeles County Museum of Art, California, December 21, 1976-March 13, 1977. Catalogue essays by Ann Sutherland Harris and Linda Nochlin.

"Women Artists of America 1707-1964." Newark Museum, New Jersey, April 2-May 16, 1965. Catalogue essay by William H. Gerdts.

Index *

Photographic Credits

AMSTERDAM: Rijksmuseum, Fig. 2-1. AUSTIN: Elisabet Ney Museum, Fig. 5-12. BALTIMORE: The Baltimore Museum of Art, Mrs. Elsie Daingerfield Collection, Fig. 3-8; The Cone Collection, Fig. 8-20. The Maryland Historical Society (Lightner), Figs. 5-6, 5-7. Walters Art Gallery, Figs. 1-6, 1-12. BERLIN-DAHLEM: Staatliche Museen Preussischer Kulturbesitz (Jörg P. Anders), Fig. 8-1. BOLOGNA: Basilica di San Petronio (Alinari-Scala), Fig. 1-3. Pinacoteca (Alinari-Scala), Fig. 1-11. BOSTON: Courtesy of Museum of Fine Arts, Forsyth Wickes Collection, Fig. 1-13; Maria Hopkins Fund, Fig. 6-4. BREMEN: From the holdings of the Ludwig-Roselius Collection, Fig. 8-5; (Lars Lohrisch), Fig. 8-6. BUFFALO: Albright-Knox Gallery, Gift of Seymour H. Knox, Fig. 9-26. CAMBRIDGE: Girton College (Edward Leigh), Fig. 4-13. CAMBRIDGE, MASS. Busch-Reisinger Museum, Harvard University, Fig. 9-11. Fogg Art Museum, Harvard University, Grenville L. Winthrop Bequest, Fig. 3-5. CHATSWORTH UNITED KINGDOM: Devonshire Collection, By permission of the Trustees of the Chatsworth Collection (Courtauld Institute of Art, London), Fig. 4-10. CHICAGO: Courtesy of the Art Institute of Chicago, Figs. 3-1, 6-5, 6-7, 8-28. FMC Corporation (Marlborough Gallery—Robert Mates and Paul Katz), Fig. 9-20. COOPERSTOWN: Courtesy of New York State Historical Association (Lebel and Laskouski), Fig. 5-3. DES MOINES: Des Moines Art Center, Rose F. Rosenfield Fund, Fig. 9-17. DETROIT: The Detroit Institute of Arts, Gift of Leslie H. Green, Fig. 1-9. DRESDEN: Gemäldegalerie Alte Meister (Staatliche Kunstsammlungen), Fig. 2-7. FLORENCE: Rovigo, Academia dei Concordi (Alinari-Scala), Fig. 1-14. Galleria Uffizi (Alinari-Scala),Figs. 1-7, 2-10. FRANKER: Collection of City Hall (Copyright Piter Doele), Fig. 2-4. THE HAGUE: Johan Maurits van Nassau Foundation, Fig. 2-6. HARTFORD: Wadsworth Atheneum (E. Irvington Blomstrann), Fig. 5-14; Gift of A. C. and S. G. Dunham,Fig. 5-13. LONDON: Directors of the Lamport Hall Preservation Trust Ltd. (The Tate Gallery), Fig. 4-1. The National Gallery, Courtesy of The Trustees, Fig. 2-2. National Portrait Gallery, Figs. 4-2, 4-9, 4-12. St. James's Palace, Copyright Reserved (Rodney Todd-White & Son), Fig. 1-10; (A. C. Cooper Ltd.), Fig. 4-3. The Tate Gallery, Figs. 4-16, 4-17, 8-10, 8-16. Victoria and Albert Museum (J. C. Lee), Fig. 4-8. Westminster Abbey, Courtesy of the Dean and Chapter, Fig. 5-2. MADRID: The Prado Museum, Fig. 2-3. MANCHESTER: City of Manchester Art Galleries, Fig. 4-7. MELBOURNE: National Gallery of Victoria, Fig. 4-15. MUNICH: Städtische Galerie im Lenbachhaus, Fig. 8-8. NAPLES: Gallerie Nazionali di Capodimonte (Soprintendenza Gallerie), Figs. 1-5, 4-6. NEW HAVEN: The Beinecke Book and Manuscript Library, Yale University, Fig. 2-8. Yale University Art Gallery, Estate of Ettie Stettheimer for the Yale Library (Joseph Szaszfai), Fig. 9-1. NEW YORK: Collection of the artist, Judith Bernstein, Fig. 7-3. André Emmerich Gallery (Geoffrey Clements), Fig. 9-25. The Galerie St. Etienne, Figs. 8-2, 8-3. Ronald Feldman Fine Arts Inc. (eeva-inkeri), Fig. 7-1. Collection of the artist, Helen Frankenthaler, on loan to the National Gallery of Art, Washington (National Gallery of Art), Plate 4. Courtesy of the Frick Art Reference Library, Fig. 5-8. Graham Gallery, Fig. 9-22. The Solomon R. Guggenheim Museum (Robert E. Mates), Fig. 8-11. Courtesy of Leonard Hutton Galleries, Figs. 8-7, 8-9, 8-13, Plate 3. Courtesy of M. Knoedler & Co., Inc., Fig. 8-14. Courtesy Pierre Matisse Gallery, private collection (Eric Pollitzer), Fig. 8-25. Collection of Mrs. Robert B. Mayer, Courtesy of Sidney Janis Gallery (Geoffrey Clements), Fig. 9-27. McCrory Corporation (O. E. Nelson), Fig. 8-15. The Metropolitan Museum of Art, Gift of Julia Berwind, 1953, Fig. 3-4; Gift of Cornelius Vanderbilt, 1887, Fig. 3-13; The Moses Lazarus Collection, 1888, Fig. 5-4; Gift of the Artist in memory of Rosa Bonheur, 1922, Fig. 5-23; Gift of Paul J. Sachs, 1916, Fig. 6-6; The Robert Lehman Collection, 1975, Fig. 6-9, Plate 2; Bequest of Miss Adelaide Milton de Groot, 1967, Fig. 6-10; Gift of Ettie Stettheimer, 1953, Fig. 9-2; Arthur H. Hearn Fund, 1955, Fig. 9-10; The Mr. and Mrs. Isaac D. Fletcher Collection, 1917, Plate 1. Courtesy of Midtown Galleries (O. E. Nelson), Fig. 9-18. The Museum of Modern Art, Mary Anderson Conroy Bequest in memory of her mother, Julia Quinn Anderson, Fig. 4-18; Philip Johnson Fund, Fig. 8-16; Gift of Theodore R. Racoosin, Fig. 8-18; Acquired through the Richard D. Brixey Bequest, Fig. 9-6; Gift of Mr. and Mrs. Ben Mildwoff, Fig. 9-13; Gift of Alfonso A. Ossorio (O. E. Nelson), Fig. 9-19; Museum Collection, Fig. 8-24; (Rudolf Burckhardt), Fig. 9-23. From the collection of the artist,

Alice Neel (Eric Pollitzer), Fig. 9-15. The New York Historical Society, Fig. 5-5. The New York Public Library at Lincoln Center, D. Lobanov Collection, Fig. 8-12. From the collection of the artist, Faith Ringgold, Fig. 7-12. Victor D. Spark, Fig. 5-9. United Nations, Fig. 8-27. Whitney Museum of American Art (Geoffrey Clements), Fig. 9-5; Promised gift of Timothy Collins, Fig. 9-16; Gift of Susan Morse Hilles, Fig. 9-24. ORANGE, CONN.: From the collection of the artist, Anni Albers, Fig. 9-12. OTTERLO: Rijksmuseum Kröller Müller, Fig. 8-21. OXFORD: By courtesy of the President and Fellows, Trinity College (Thomas Photos), Fig. 4-5. PARIS: Musée du Louvre (Musées Nationaux Paris), Figs. 3-3, 3-6, 3-9, 3-10; on loan to Fontainbleau (Musées Nationaux Paris), Fig. 3-12; in Jeu de Paume Galerie (Musées Nationaux Paris), Fig. 6-2. Musée National d'art moderne (Musées Nationaux Paris), Figs. 8-17, 8-22. UNESCO Headquarters, Fig. 8-19. PHILADELPHIA: Courtesy of the Pennsylvania Academy of the Fine Arts, Figs. 5-19, 5-20. Philadelphia Museum of Art, The Alfred Stieglitz Collection, Fig. 9-7. POZNAN: Muzeum Narodowe w Poznaniu, Fig. 1-4. PRINCETON: The Lt. John B. Putnam, Jr. Memorial Collection, Princeton University (Taylor & Dull, Inc.), Fig. 9-14. RALEIGH: Collection of the North Carolina Museum of Art, Fig. 2-9. RICH-MOND: Virginia Museum of Fine Arts, Fig. 5-1. TOLEDO, OHIO: The Toledo Museum of Art, Fig. 5-21. TUSKEGEEE: Carver Museum, Tuskegee Institute (Polk's Studio), Fig. 5-16. VERSAILLES: Musée National du Chateau de Versailles (Musées Nationaux Paris), Figs. 3-2, 3-6. VIENNA: Kunsthistorischen Museum, Fig. 1-18. WALTHAM: Courtesy of Brandeis University Art Collection, Rose Art Museum, Fig. 6-8. WASHINGTON, D.C.: Hirshhorn Museum and Sculpture Garden, Smithsonian Institution, Fig. 8-4. Howard University, James A. Porter Gallery of Afro-American Art (Scurlock Studios), Fig. 5-15. Courtesy of National Collection of Fine Arts, Smithsonian Institution, Figs. 5-11, 9-3, 9-4, 9-9. National Gallery of Art, Figs. 2-5, 6-1, 6-3. National Portrait Gallery, Smithsonian Institution, Fig. 5-22. The Phillips Collection, Fig. 8-23. LOCATION UNKNOWN: (Terry Moore, Knoxville), Figs. 1-1, 1-2. Courtesy of C. Scheerer, Fig. 4-11. PRIVATE COLLECTIONS: Boston, William Postar (Smithsonian Institution), Fig. 5-10. Hockessin, Delaware, Roberta and James Tarbell, Fig. 9-8. New York, Jeffrey H. Loria, Fig. 9-21; Mr. and Mrs. John D. Rockefeller III (O. E. Nelson), Fig. 5-18. Roanoke, Mary "Peggy" Macdowell Walters (Wayne Newcomb), Fig. 5-17.